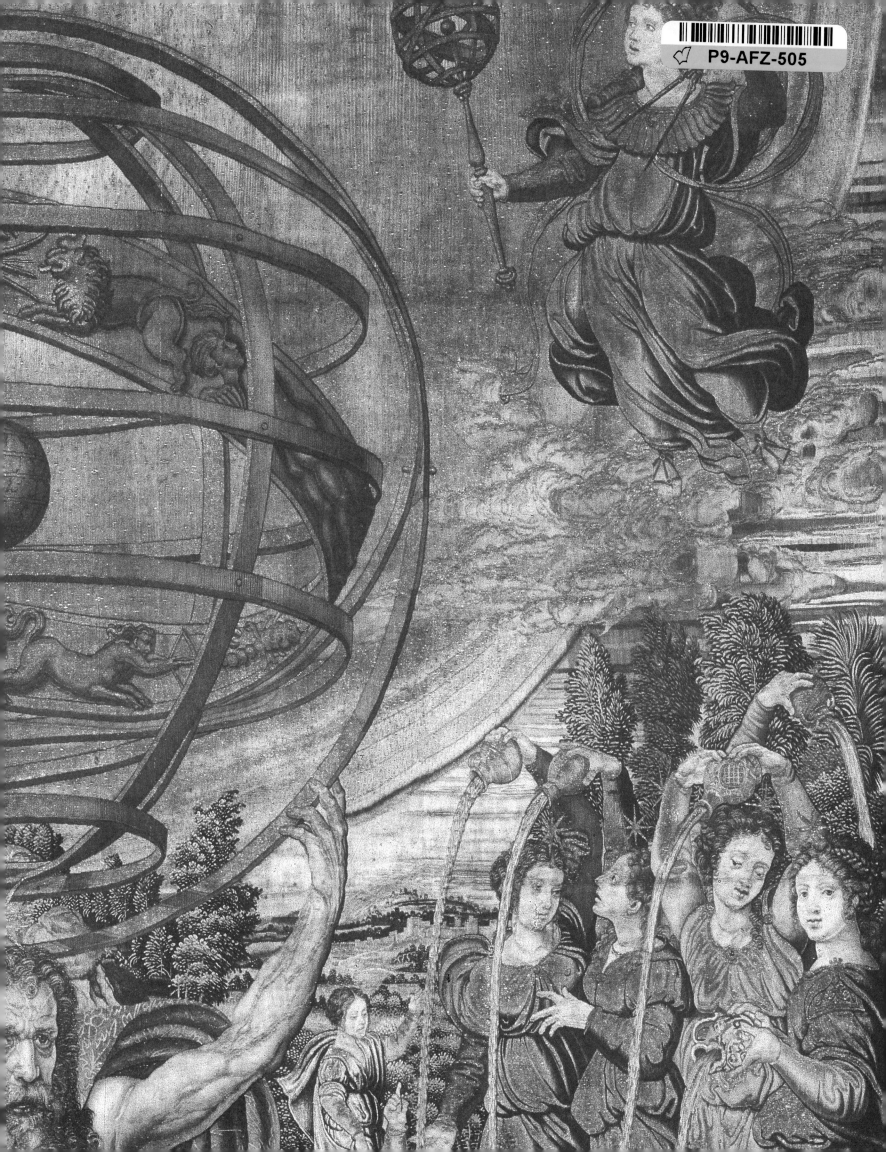

SPAIN IN THE AGE OF EXPLORATION

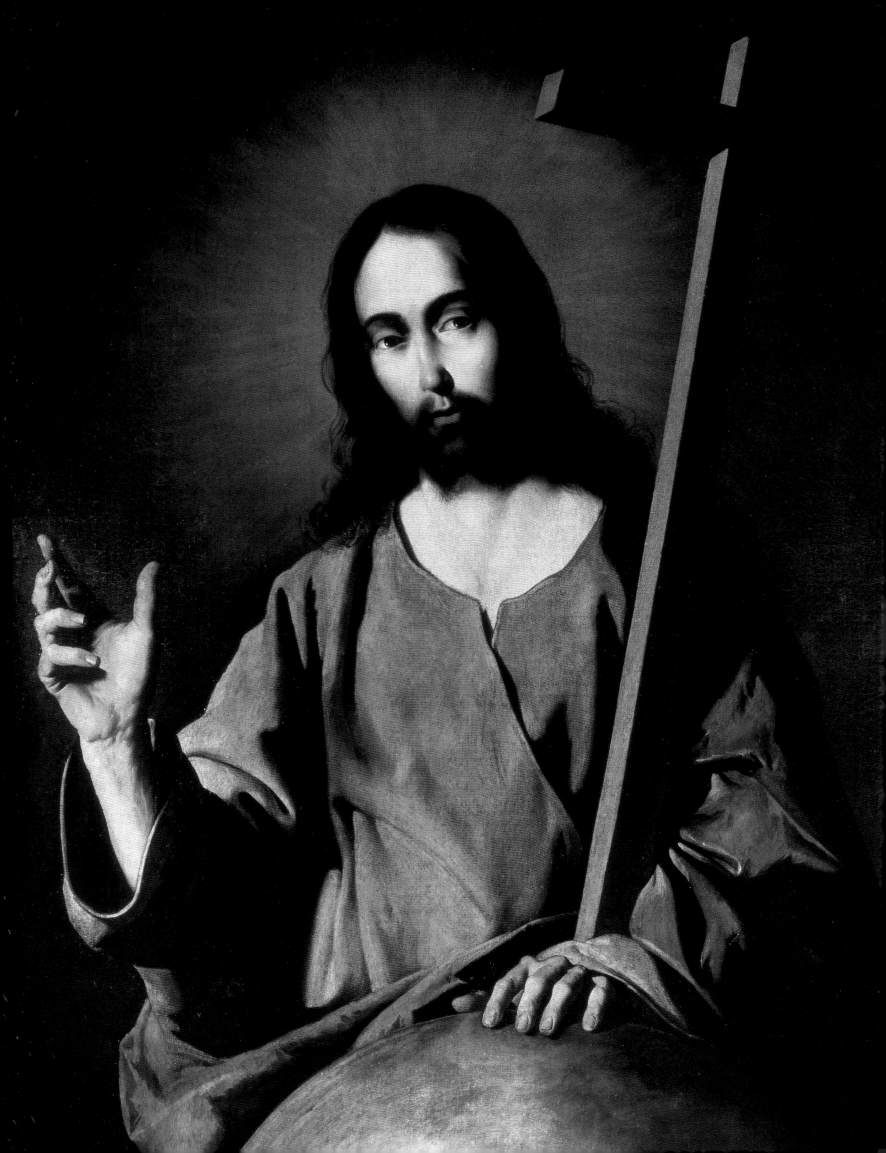

SEATTLE ART MUSEUM

UNIVERSITY OF NEBRASKA PRESS

Edited by Chiyo Ishikawa

1492

SPAIN IN THE AGE OF EXPLORATION

1819

MY LATE UNCLE ROBERT LEHMAN fervently wished that future generations would experience the arts with the same wholehearted enjoyment that he did throughout his life. For this reason, he charged his foundation with the task of continuing his constant support of the visual fine arts. The foundation's sponsorship of *Spain in the Age of Exploration, 1492–1819* is consistent with our objective of supporting a select series of fine exhibitions that enable museum visitors to experience and enjoy great works of art. The foundation is honored to be a participant in an exhibition of masterpieces of art and science from Spain.

Philip H. Isles
President, Robert Lehman Foundation, Inc.

THE BOEING COMPANY IS PLEASED to support the Seattle Art Museum as a Presenting Sponsor of *Spain in the Age of Exploration, 1492–1819.*

Partnering with the Seattle Art Museum is part of the long Boeing tradition of supporting the cultural health and diversity of our region. We recognize that the arts play an integral role in enhancing the quality of life in our communities. For this reason, we support exhibitions and programs in Seattle and communities throughout the world where our employees live and work.

It is a particular pleasure to sponsor this unique cultural and educational exhibition of artifacts from Spain. It is our hope that it will increase understanding and appreciation of Spain's history of philosophical and cultural inquiry, technology development, and artistic achievement.

David C. Fennell
Vice President–Chief Information Officer, Boeing Commercial Airplanes

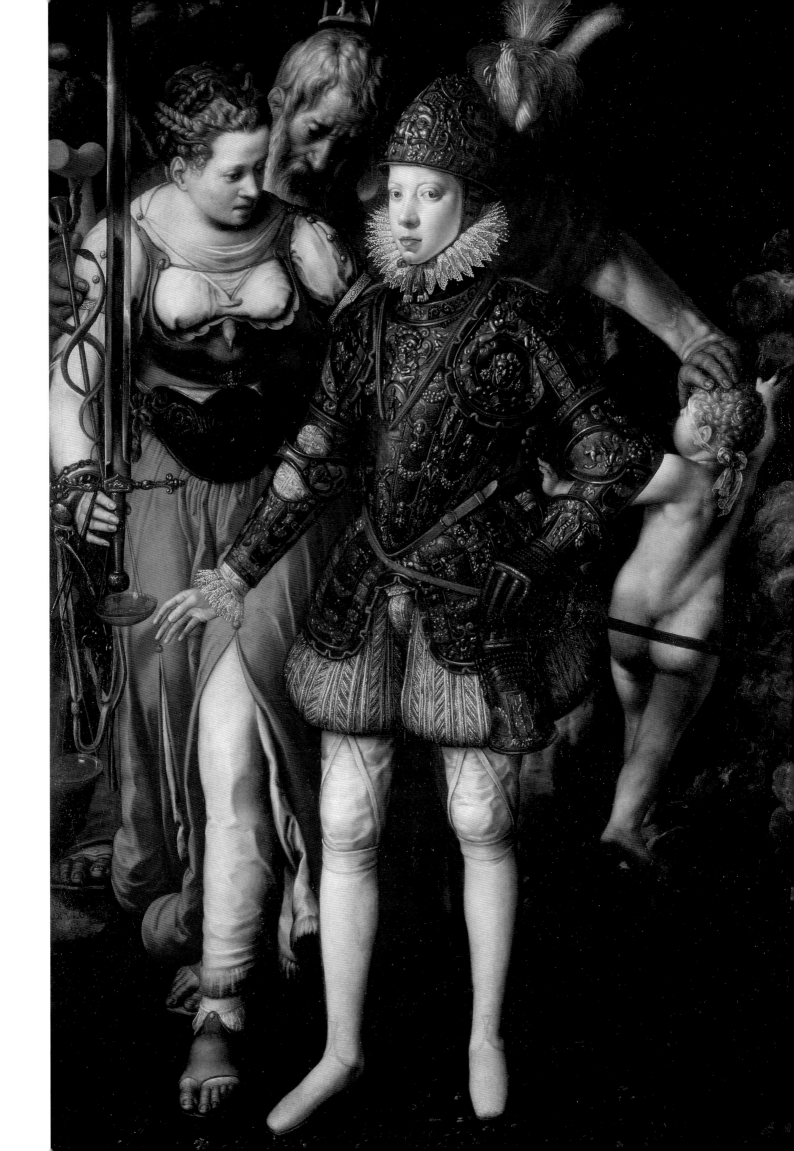

Spain in the Age of Exploration, 1492–1819 was organized by the Seattle Art Museum
in collaboration with Patrimonio Nacional, Madrid. The exhibition is supported
by an indemnity from the Federal Council on the Arts and the Humanities.
The publication has received generous support from the Embassy of Spain
and Spain's Ministries of Culture and of Foreign Affairs.

PATRIMONIO NACIONAL

The exhibition has been generously supported by

Presenting Sponsors
Robert Lehman Foundation, Inc., and The Boeing Company

Sponsors
Microsoft Corporation, Iberia Airlines of Spain,
Accenture, Starbucks Coffee Company, The Seattle Times,
and the Seattle Art Museum Supporters

Samuel H. Kress Foundation, National Endowment for the Arts,
4Culture King County Lodging Tax Fund,
and Kreielsheimer Foundation Exhibition Endowment

Spain's Ministries of Culture and of Foreign Affairs

Contributors to the Annual Fund

Library of Congress Cataloging-in-Publication Data
 Spain in the age of exploration, 1492–1819 /
edited by Chiyo Ishikawa.
 p. cm.
 Includes bibliographical references and index.
 ISBN 0-8032-2505-9 (hardcover : alk. paper)
 1. Art, Spanish—Exhibitions. 2. Spain—
Civilization—Exhibitions. 3. Art—Spain—
Exhibitions. 4. Patrimonio Nacional—Exhibitions.
I. Ishikawa, Chiyo. II. Seattle Art Museum.
N7104.S73 2004
709´.46´074797772—dc22 2004012309

Distributed to the trade by the University of
Nebraska Press

Edited by Suzanne Kotz
Proofread by Sharon Vonasch
Translations by Lauro H. Flores (Morales Vallejo,
 de la Sota Ríus) and Anthony L. Geist
 (Yarza Luaces)
Index by Norma Roberts
Designed by John Hubbard
Color separations by iocolor, Seattle
Produced by Marquand Books, Inc., Seattle
 www.marquand.com
Printed and bound by CS Graphics Pte., Ltd.,
 Singapore

Details:
 page 1: *"Convolvulus queretarensis"* (pl. 79)
 page 2: Francisco de Zurbarán, *The Savior Blessing,*
 1638 (pl. 20)
 page 5: Justus Tiel, *Allegory of the Education of the
 Prince (Philip III),* c. 1590 (pl. 51)
 page 8: Francisco José de Goya y Lucientes, *Shipwreck,*
 c. 1793–94 (pl. 24)
 page 15: Francisco Pulgar, *"Sida retrorsa l'héritier"*
 (pl. 76)
 page 47: Georg Wezeler, *Atlas Supporting the Armillary
 Sphere,* c. 1530 (pl. 16)
 page 137: Isidro Galvez y Gallo, *"Calyplectus
 acuminatus"* (pl. 75)

EXHIBITION ITINERARY
Seattle Art Museum
October 16, 2004–January 2, 2005

Norton Museum of Art, West Palm Beach,
 Florida
February 2, 2005–May 1, 2005

CURATORS
Chiyo Ishikawa, Seattle Art Museum
Javier Morales Vallejo, Patrimonio Nacional

CURATORIAL ASSISTANTS
Feliza Medrano
Eva Pol de Dios

The Seattle Art Museum wishes to thank the
 following people and institutions in Spain:

PATRIMONIO NACIONAL, Madrid
El Duque de San Carlos (Presidente del
 Consejo de Administración)
Miguel Ángel Recio Crespo (Consejero Gerente)
Juan Carlos de la Mata González (Director
 de Actuaciones Histórico Artísticas)
Rosario Díez del Corral Garnica (Vocal asesora
 de programas culturales)

CURATORIAL DEPARTMENT
Gabriel Moya Valgañón (Jefe de Área)
Amelia Aranda Huete (Conservadora de la
 Colección de Relojes)
Carmen Díaz Gallegos (Conservadora de la
 Colección de Pintura s. XVIII–XIX)
Carmen García Frias (Conservadora de la
 Colección de Pintura s. XVI–XVII)
Concha Herrero Carretero (Conservadora de
 la Colección de Tapices)
Mª Jesús Herrero Sanz (Conservadora de la
 Colección de Escultura)
Fernando Martín García (Conservador de la
 Colección de Plata)
Álvaro Soler del Campo (Conservador de la
 Real Armería)

REAL BIBLIOTECA
María Luisa López-Vidriero Abello (Directora)

REAL MONASTERIO DE EL ESCORIAL
R. P. Jose Luis del Valle Merino (Director de
 la Biblioteca)

CONSERVATION DEPARTMENT
Angel Balao González (Jefe de Departamento)
Lourdes de Luis Sierra (Jefe de Servicio)
Esperanza Rodríguez Arana

EXHIBITION SERVICES
Paloma Callejo Garrido
Elisa Esteban Martínez
Mª Luisa Fuente Martínez

ART HANDLING
Sonsoles Castillo Aguilar
Julián Jiménez Moreno
Juan Carlos Malnero Santos
Alberto Prieto Ortiz

PHOTOGRAPHIC SERVICES

DIGITAL IMAGING
Fuensanta Cano Arco
Mª Carmen Núñez-Milara
Eloy Martín Bermejo
Rita López Santos
Inmaculada Pascual Jiménez
Mercedes Pérez Martínez

WE ALSO THANK:
Primitivo Artiaga García
Eugenia Gómez Camacho
Javier Hernández Cortés
Justo Pueyo Alcázar
Manuel Terrón Bermúdez

SPECIAL GRATITUDE TO:
Susana María Ramírez Martín (Profesora
 Asociada de la Universidad Carlos III
 de Madrid)
Patricia Barciela Durán (Directora técnica
 de Domus)
Ramón Navarro García (Profesor emérito
 Instituto de Salud Carlos III)

ARCHIVO GENERAL DE INDIAS, Seville
Magdalena Canellas Anoz (Directora)
Pilar Lázaro de la Escosura (Departamento de
 Referencias)

ARCHIVO HISTÓRICO NACIONAL, Madrid
Concepción Contel Barea (Directora)
Jesús Gaite Pastor (Subdirector)
Jose Luis de la Torre Merino (Jefe Departamento
 de Referencias)
Juan Ramón Romero Fernández-Pacheco
 (Jefe Departamento de Conservación)
Ignacio Panizo Santos (Jefe de Sección)
Laboratorio de Restauración del Archivo
 Histórico Nacional

UNIVERSITAT DE VALENCIA,
 BIBLIOTECA HISTÓRICA
María Cruz Cabeza Sánchez-Albornoz
 (Directora)

REAL JARDÍN BOTÁNICO, Madrid
María Teresa Tellería Jorge (Directora)
José Félix Muñoz Garmendia (Jefe de la Unidad
 Archivo y Biblioteca)
María del Pilar San Pío Aladrén (Conservadora)

MUSEO DE AMÉRICA, Madrid
Paz Cabello Carro (Directora)
Concepción García Sáiz (Conservadora del
 Departamento del América Colonial)
Ana Castaño Lloris (Departamento de
 Documentación)

MUSEO ARQUEOLÓGICO NACIONAL,
 Madrid
Miguel Ángel Elvira Barba (Director)
Angela Franco Mata (Conservadora Jefe
 Departamento de Antigüedades Medievales)
Carmen Mañueco Santurtún (Conservadora
 Jefe del Departamento de Edad Moderna)
Francisco Jose García Llanos (Departamento
 de Documentación)

MUSEO NACIONAL DE CIENCIA Y
 TECNOLOGÍA, Madrid
Amparo Sebastián Caudet (Directora)
Mª Josefa Jiménez Albarrán (Conservadora)

MUSEO NAVAL, Madrid
Fernando Riaño Lozano (Director)
Mª Dolores Higueras Rodríguez (Directora
 Técnica)
Rosa Abella Luengo (Departamento de
 Exposiciones)

MUSEO NACIONAL DEL PRADO, Madrid
Miguel Zugaza Miranda (Director)
Gabriele Finaldi (Director adjunto)

SHIPPING AND TRANSPORTATION
SIT, Transportes Internacionales

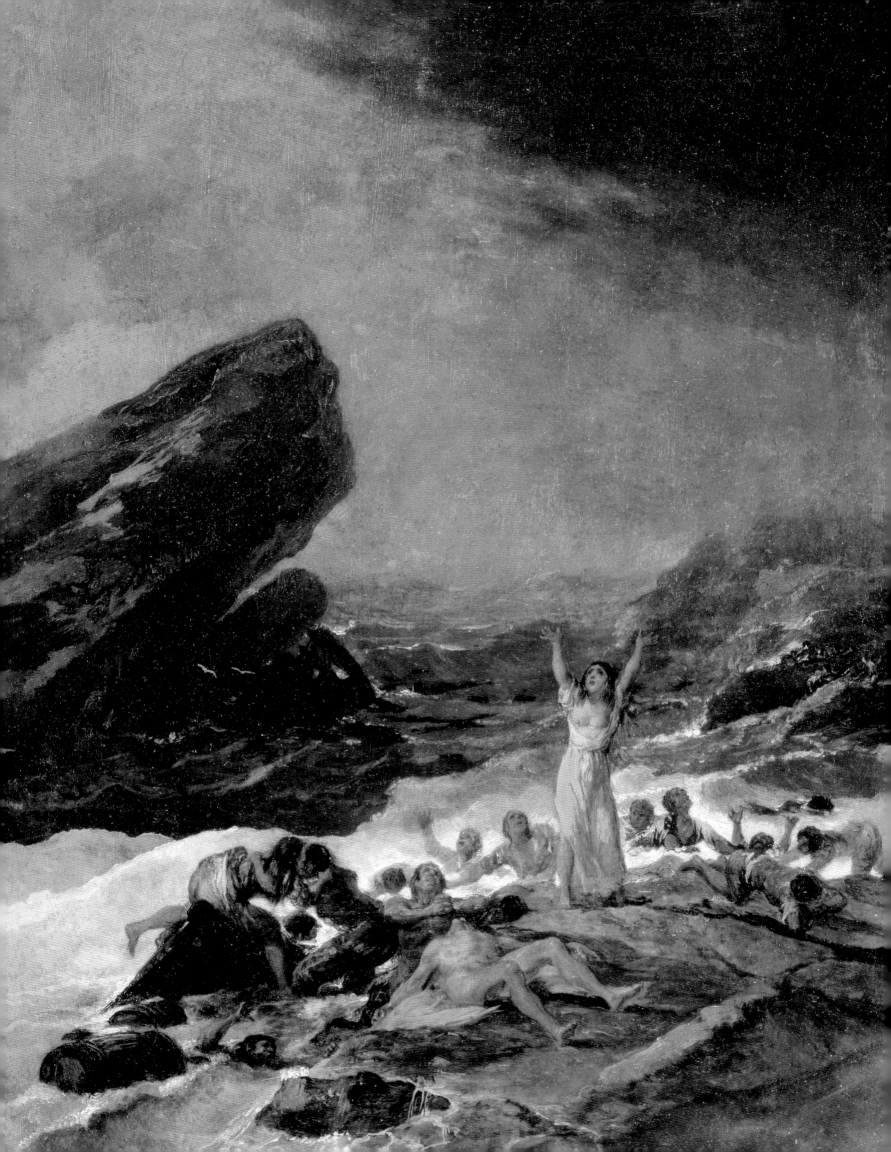

Contents

Foreword

Through the lens of great works of Spanish art and art made for Spanish royalty, this exhibition explores how Spain's view of itself and of the globe changed as its empire expanded mightily. As the Spanish empire grew, so too did its curiosity and understanding of the world. Spanning more than three centuries, from Christopher Columbus's exploration of the New World in 1492 to the Adams-Onís Treaty of 1819, when Spain relinquished its territorial claims in the northwestern United States and Florida, this project represents a dynamic partnership between the Seattle Art Museum and Spain's Patrimonio Nacional, which is charged with oversight of the Spanish royal collections. At a time when war and tension rage throughout the world, international cultural collaboration is essential in building a mutual understanding of the history of human achievement, past and present.

The partnership between the Patrimonio Nacional and the Seattle Art Museum provided a marvelous opportunity to exhibit a choice selection of the extraordinarily rich resources of the Spanish royal collections, and, more important, to acknowledge the primary role of the royal court in initiating international exploration and overseeing Spanish territories as distant from Madrid as India and the Philippines. In addition, the court was responsible for creating a potent image of empire, whose sense of grandeur and dignity was transmitted internationally. As this exhibition demonstrates, the court was both the face of the empire and the engine behind it.

The Spanish presence in the Northwest at the end of the eighteenth century, decades before the arrival of Lewis and Clark, is a too little known part of American regional history. No fewer than six crown-sponsored expeditions plied the waters of the north Pacific Ocean, reaching as far north as Alaska. These expeditions, initiated during the Spanish Enlightenment, are still the source of important information about the villages, clothing, canoes, and rituals of Northwest Coast indigenous cultures from that period, recorded by expedition artists; the artifacts and works of art brought back to Spain are among the earliest known works of the Chugach, Tlingit, Makah, and Nuu-chah-nulth peoples. Seattle visitors will recognize the close visual relationship of these objects to works of art in our own prized collection of Northwest Coast art.

This exhibition and publication feature a magnificent array of Spanish art and culture, including paintings, sculpture, armor, manuscripts and documents, maps, and decorative arts. We are most grateful to the lenders of works of art, who have generously shared their treasures so that our audiences could enjoy and learn from these unique masterpieces of art and science, some of which have never before left Spain. In addition to the tremendous contribution of the Patrimonio Nacional, we gratefully acknowledge the significant participation of the Museo Nacional del Prado,

Museo de América, Museo Naval, Museo Arqueológico Nacional, Museo Nacional de Ciencia y Tecnología, Archivo General de Indias, Universitat de València, Archivo Histórico Nacional, Real Jardín Botánico, and Mr. Placido Arango. We also thank the American lenders who have generously offered major works of art from their collections: the Meadows Museum, Dallas, Texas; the Metropolitan Museum of Art, New York; the Rienzi Collection and the Museum of Fine Arts, Houston, Texas; the John and Mable Ringling Museum of Art, Sarasota, Florida; and the National Gallery of Art, Washington, D.C.

In a project that explores the development of new contacts between peoples and cultures, it is most appropriate that scholarship be advanced through international cultural collaboration. Together co-curators Javier Morales, on behalf of the Patrimonio Nacional, and Chiyo Ishikawa, Chief Curator of Collections and Curator of European Painting and Sculpture at the Seattle Art Museum, conceived the exhibition, establishing the key themes, visiting all the royal sites, securing loans from other institutions, and planning the exhibition layout and interpretation. These two knowledgeable and dedicated art historians deserve our heartfelt gratitude. Our thanks are also due the distinguished group of scholars who so willingly gave their advice and expertise.

Another international venture is this book itself, whose essays are written by leading Spanish and American scholars who specialize in the history of Spain and its splendid art and culture. We are pleased to work with the University of Nebraska Press, whose academic distribution of this publication will bring it to a wider audience.

This exhibition will also be seen at the Norton Museum of Art, West Palm Beach, Florida. With Ponce de Leon's arrival in 1513, Florida was the site of the first Spanish occupation on the American mainland, and its ties to Spain are still strongly felt today. Director Christina Orr-Cahall and Roger Ward, Chairman of the Curatorial Department and Curator of European Art, have been valued partners in shaping the development of the exhibition and its content for the Florida audience. Thanks to this collaboration, the artistic and scientific achievements of Spain will be enjoyed on both the east and west coasts of the United States of America.

This exhibition project began only two and one-half years ago, a very short time for such an ambitious undertaking. We are very grateful to Philip Isles, a trustee of the Seattle Art Museum and mutual friend who gave us constant encouragement, and to our friend Barbara Johns, who provided the Seattle Art Museum with a fortuitous introduction to Luis Fernando Esteban, Honorary Vice-Consul of Spain in Seattle. Fernando Esteban has worked tirelessly on both sides of the Atlantic to make this exhibition a uniquely beautiful and rich show, one that exemplifies the greatness of Spanish history and culture. This is only his latest and most spectacular accomplishment in a twenty-six-year career devoted to building friendly ties and mutual understanding between Spain and the State of Washington. We are also most grateful to Carmen González de Amezua, Minister for Cultural Affairs, Embassy of Spain, Washington, D.C., for her steadfast encouragement, tireless support, and finely honed sense of humor.

International projects of this scale and importance require significant financial underwriting. *Spain in the Age of Exploration, 1492–1819* has received a lead sponsorship grant from the Robert Lehman Foundation, Inc. The Boeing Company continues its tradition of generous support with a major grant. We are also grateful to Iberia Airlines of Spain, Microsoft Corporation, Accenture, Starbucks Coffee Company, the Seattle Times, the Seattle Art Museum Supporters, the Samuel H. Kress Foundation, the National Endowment for the Arts, the 4Culture King County Lodging Tax Fund, the Kreielsheimer Foundation Exhibition Endowment, and contributors to the Seattle Art

Museum's Annual Fund. Additional support was provided by the Program for Cultural Cooperation between Spain's Ministry of Education, Culture, and Sports and United States Universities, the Embassy of Spain, and Spain's Ministries of Culture and of Foreign Affairs.

The exhibition is supported by the indemnity from the Federal Council on the Arts and the Humanities. We applaud this important government program that provides such vital support for international exhibitions in the United States.

It is our sincere hope that this exhibition will substantially enhance America's knowledge and appreciation of the depth and richness of Spain's art, culture, and history, and, in particular, Spain's historic ties to our region. The Seattle Art Museum and the Patrimonio Nacional of Spain are honored to co-organize this splendid exhibition for the enjoyment of all.

Mimi Gardner Gates
The Illsley Ball Nordstrom Director
Seattle Art Museum

El Duque de San Carlos
President
Patrimonio Nacional

Acknowledgments

This exhibition would not have been possible without the support, goodwill, and advice of countless friends and colleagues. It is a pleasure to acknowledge their assistance here. Our many valued colleagues in Spain are listed separately. I must single out, however, my cocurator Javier Morales Vallejo for his tireless work and dedication on behalf of this project.

For important contributions to the conception of the exhibition and this book, and for excellent counsel throughout the development of the exhibition, I am grateful to our Advisory Committee: Jonathan Brown, Richard Kagan, Benjamin Schmidt, Andrew Schulz, Sarah Schroth, and William Jordan.

Many curatorial colleagues at other museums offered advice and support and were instrumental in securing important loans for the exhibition. I would particularly like to thank Alejandro Vergara and Gabriele Finaldi of the Museo Nacional del Prado; Mark Roglán of the Meadows Museum; Aaron de Groft of the John and Mable Ringling Museum of Art; Philip Conisbee and Alan Shestack at the National Gallery of Art; E. Peters Bowron from the Museum of Fine Arts, Houston; Everett Fahy at the Metropolitan Museum of Art; and Marcus Burke of the Hispanic Society. Roger Ward has been a valued collaborator as the organizing curator for the exhibition at the Norton Museum of Art; his excellent suggestions have strengthened the show.

Luis Fernando Esteban, Honorary Vice-Consul of Spain in Seattle, was a collaborator in every stage of the exhibition, helping establish relationships between the Seattle Art Museum and Spanish institutions. We could not have completed the project without his tireless enthusiasm and commitment.

This exhibition and the accompanying book represent a momentous undertaking for the Seattle Art Museum. I am grateful for the unstinting support, creativity, and good humor of my colleagues here. Mimi Gates, the Illsley Ball Nordstrom Director, wholeheartedly endorsed the exhibition from the start, and her spirited support inspired us all. I would also like to thank Maryann Jordan, Senior Deputy Director, and Robert Cundall, Chief Financial Officer, for supporting this ambitious project at a time when the museum is undertaking two expansion projects.

In the Curatorial Division, Lisa Corrin, Deputy Director of Art, made it possible for me to take time from regular curatorial duties to work exclusively on the exhibition and book. Barbara Brotherton, Curator of Native American Art, advised on the Northwest Coast objects and shared a Native perspective on Spanish activity in our region. Julie Emerson, Ruth J. Nutt Curator of Decorative Arts, was an invaluable sounding board. Liz Andres and Sarah Berman attended to many practical details that helped ensure our success. Sheryl Ball edited and improved grant proposals with efficiency and keen interest. I am especially grateful to Zora Hutlova Foy, Manager of

Exhibitions and Publications, who managed every aspect of a complex exhibition and publication with typical grace, resourcefulness, and excellent judgment. Finally, I am very pleased to acknowledge the innumerable contributions of Feliza Medrano, Curatorial Assistant for European Art, who managed virtually every detail of exhibition planning and supervised two excellent research interns, Maya Procel and Jacob Gaboury, whose work is also reflected in these pages. In her efficiency, patience, attention to detail, and enthusiasm, Feliza set a new standard.

Working with Senior Registrar Lauren Mellon, Philip Stoiber ably oversaw the complex process of applying for federal indemnity and supervising the movement of works of art from many lenders. Michael McCafferty, Chief Exhibition Designer and Director of Museum Services, designed the exhibition layout in collaboration with the curators; his many excellent ideas immeasurably improved the presentation. Nicholas Dorman, Chief Conservator, ensured the well-being of precious works entrusted to our care. Under the leadership of Jill Rullkoetter, Kayla Skinner Director of Education and Public Programs, educators Deborah Carl, Paula McArdle, Anne Pfeil, and Louisa Schreier designed creative and exciting educational programming to accompany the exhibition. Librarian Traci Timmons was constantly helpful in procuring research materials. Our excellent Development staff, Erik Pihl, Jill Robinson, Laura Bales, Carol Mabbott, and Laura Hopkins, sought and secured significant grants in support of the exhibition. I would also like to acknowledge the fine work of Susan Bartlett, Christina DePaolo, Laura Lutz, Sarah Kleiner, Victoria Moreland, Cara Egan, and Erika Lindsay.

It has been a pleasure to work with the authors of the essays that follow; they have all contributed important insights of lasting value. I would also like to acknowledge the fine work of translators Lauro Flores and Anthony Geist.

Once again we have been fortunate to work with Marquand Books, which has produced another beautiful design under the skilled leadership of Ed Marquand. John Hubbard brought his customary creativity to the design of the book, and Marie Weiler guided us through a demanding production schedule. We are especially grateful to Suzanne Kotz, whose work went far beyond the usual tasks associated with editing. Her knowledge, expertise, and professionalism helped ensure the success of the book.

I would like to extend my thanks to other friends and colleagues who have provided helpful advice and encouragement. They include Conchita Romero, Soni Veliz, Miguel and Carola Condé, Hester Diamond, and Dawson Carr. My most personal thanks go to Mark Calderon and to my children, Lucy and Nap Cantwell, for their patience, loving support, and interest in this wonderful project.

Chiyo Ishikawa
Chief Curator of Collections and Curator of European Painting and Sculpture
Seattle Art Museum

Introduction

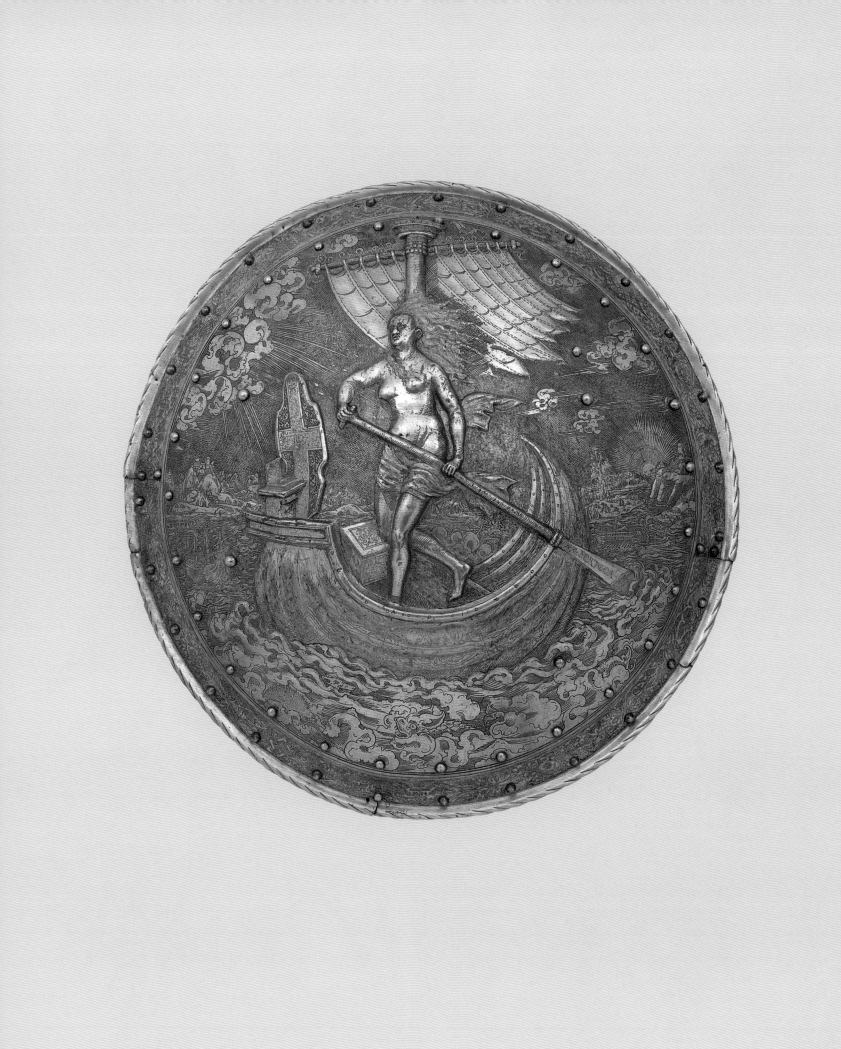

Spain in America
Explorations and Civilization

THE PATRIMONIO NACIONAL, the oldest and most important Spanish cultural institution, administers the properties formerly vested in the Spanish crown but now belonging to the Spanish state. It comprises one of the most valuable groups of royal palaces, historical gardens, royal monasteries, and art collections in the world. Preserving original decorations throughout the centuries—at times lavish and solemn, as in the palaces of the eighteenth century, at times intimate, as in the monasteries—the Patrimonio Nacional represents the visible essence of Spain's history. The Patrimonio Nacional is unique among similar organizations in that its collection is actively used in a practical manner. The royal sites serve as residences for His Majesty the King and members of the royal family, for personal and official functions.

The 50,000 manuscripts housed in the library of El Escorial and the 15 kilometers of shelves in the archives of the Royal Palace in Madrid reflect a large part of the history of Spain, Europe, and the Americas. The best and major part of the great collections—Titian, Veronese, Dürer, Bosch, Velázquez, Rubens, Tiepolo, Mengs—that became the Prado Museum in 1819 came from the royal palaces as an uncoerced donation to the Spanish people. This is a unique case among European museums of royal origin, most of which were established as a result of revolutions or coups d'état.

As a result of Philip II's mandates in the sixteenth century, the royal collections of the Patrimonio Nacional encompass all art forms: 7,000 paintings; 2,500 sculptures; 700 clocks; 3,000 weapons and armors; 2,000 tapestries or tapestry fragments; carriages and royal ships; and countless historical pieces of furniture, all dating from medieval times until the nineteenth century. The political and human activities that unfolded inside the royal palaces and monasteries were quietly witnessed by all these artworks. The most crucial decisions affecting Spain, Europe, and, more specifically, the Americas over more than three hundred years were made in these buildings: the first laws, in the sixteenth century, that organized the American domains as provinces—not colonies—of the Spanish kingdom; resolutions concerning the protection of indigenous languages and the mass production of dictionaries and grammars, which are preserved still today; the establishment, from the sixteenth century, of advanced courses on the major indigenous languages in the most important universities of the Americas.

Continuously arriving at these palaces were reports, chronicles, and other accounts describing the rich American civilizations—the Inca, Maya, Aztec, and many others (pl. 2). Recorded were their customs, poetry, dance, and theater (pls. 3, 4 a–c), and their medical knowledge, such as the use of quinine (fig. 4), which initiated a therapeutic revolution that came to save many lives in Europe.

PLATE 2

Relación de Michoacán

1539–40

Compiled by Fray Jerónimo de Alcalá (?)

Manuscript with illustrations, 8¹¹⁄₁₆ × 6½ in. (22 × 16.5 cm)

© Patrimonio Nacional, Biblioteca del Real Monasterio de San Lorenzo
de El Escorial (C.IV. 5)

PLATE 3

Religious Rituals of Nayarit (Mexico)

1672

Ink and wash drawing, 23 1/16 × 16 3/4 in. (58.6 × 42.6 cm)

© España Ministerio de Educación, Cultura y Deporte. Archivo General

de Indias, Seville (MP. Estampas, 25)

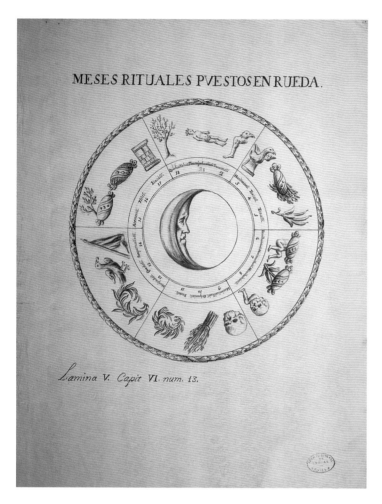

MESES RITUALES PVESTOS EN RUEDA.

Lamina V. Capit. VI. num. 13.

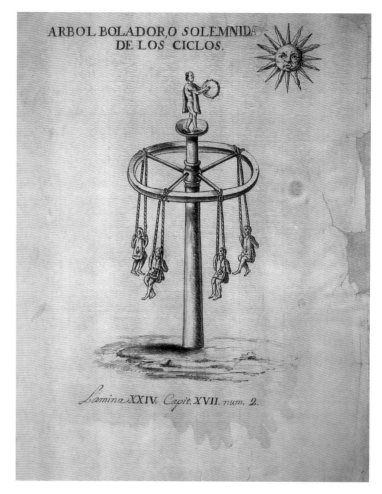

ARBOL BOLADOR, O SOLEMNIDA
DE LOS CICLOS.

Lamina XXIV. Capit. XVII. num. 2.

PLATE 4 a–c

LORENZO BOTURINI BENADUCI (1702–1755)

Drawings recording indigenous customs of Mexican peoples

1749

Historia general de America septentrional, vol. 1

Ink drawings, each 12⅜ × 9 1/16 in. (31.5 × 23 cm)

© España Ministerio de Educación, Cultura y Deporte. Archivo General

de Indias, Seville (MP. Mexico, 170, 172, 177)

SIMBOLOS DE LOS
DIAS DEL AÑO CIVIL.
TABLA I.

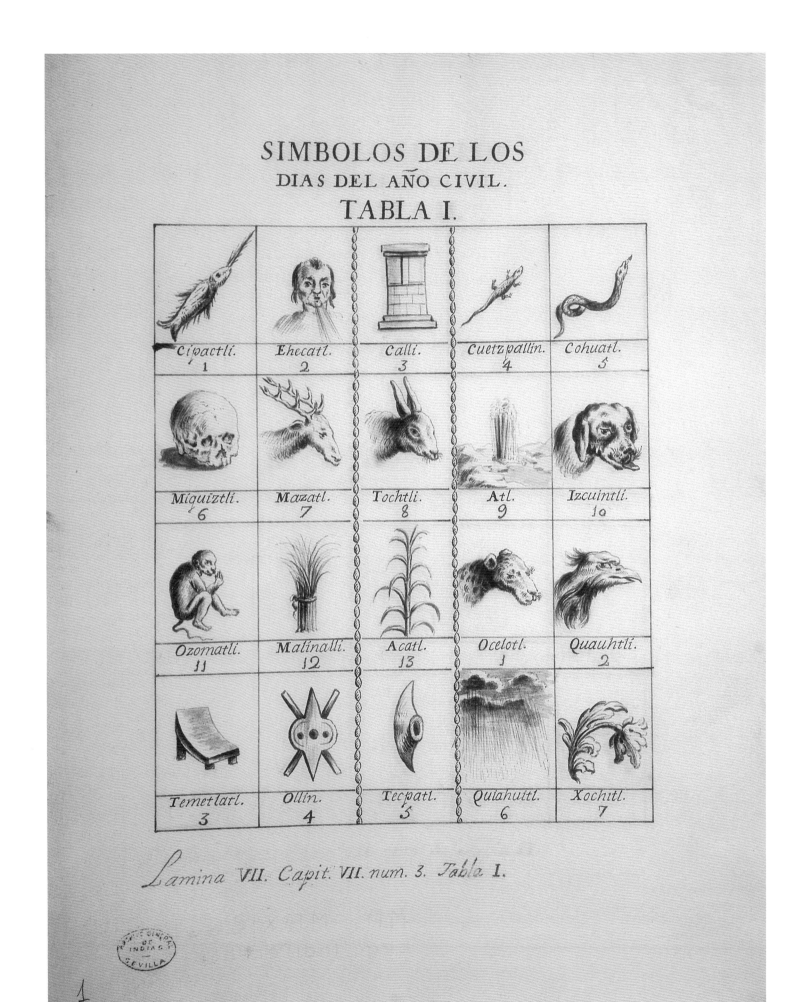

Cipactli. 1	*Ehecatl.* 2	*Calli.* 3	*Cuetzpallin.* 4	*Cohuatl.* 5
Miquiztli. 6	*Mazatl.* 7	*Tochtli.* 8	*Atl.* 9	*Izcuintli.* 10
Ozomatli. 11	*Malinalli.* 12	*Acatl.* 13	*Ocelotl.* 1	*Quauhtli.* 2
Temetlatl. 3	*Ollin.* 4	*Tecpatl.* 5	*Quiahuitl.* 6	*Xochitl.* 7

Lamina VII. Capit. VII. num. 3. Tabla I.

1

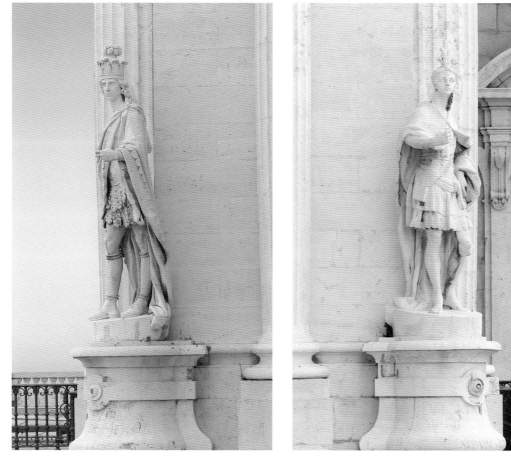
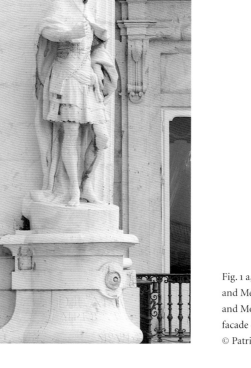

Fig. 1 a, b Sculptures of the Incan and Mexican emperors Atahualpa and Mocteçuma, on the exterior facade of the Royal Palace, Madrid. © Patrimonio Nacional, Madrid

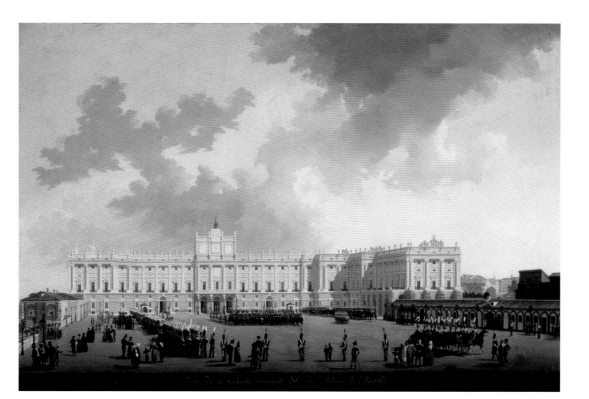

Fig. 2 Fernando Brambila (1763–1834), *Principal Facade of the Royal Palace of Madrid and the Plaza de la Armería,* 1829–34. Oil on canvas, 35¹³⁄₁₆ × 55⅛ in. (91 × 140 cm). © Patrimonio Nacional, Palacio de la Zarzuela, Madrid (10055556)

From these palaces a fruitful exchange was organized around American products previously unknown in Europe, and vice versa, bringing about an unprecedented alimentary revolution. From America came corn and potatoes—which saved several generations of European peasants from hunger—sweet potatoes, cacao beans, strawberries, and tomatoes. And via Spain, in a deliberately organized endeavor, America received wheat, rice, garbanzo beans, rye, beans, oranges, bananas, sugar cane, figs, apricots, and the grape vine. Spain also introduced horses, sheep, goats, ducks, chickens, cattle, donkeys, mules, and many other animals that reached the most remote places of the Americas. Roses, carnations, and lilies arrived in the Antilles in 1520, and in Peru in 1552, amid great popular festivities. All these exchanges entailed logistical operations that ensured trees, seeds, and animals would arrive in good condition and in sufficient quantities.

So great was the fascination with the New World that King Philip V (r. 1700–46) ordered two beautiful and enormous statues erected in the main façade of the present Royal Palace of Madrid to honor and recognize the most sophisticated and important civilizations of America. Thus, since the beginning of the eighteenth century, as symbols of the Enlightenment, the Inca emperor Atahualpa and the Mexican emperor Moctecçuma have flanked the doors of the palace, alongside other Spanish kings (fig. 1 a, b).

From the halls of these palaces—some luxurious, others monastically austere—the crown and its advisors fomented the creation of American universities with the same structure as those in Spain, such as Salamanca and Alcalá de Henares, two of the most important European institutions of the sixteenth and seventeenth centuries. The first American university was founded in 1538 in Santo Domingo, the same city where the only Gothic cathedral was built on the continent. At the beginning of the nineteenth century, when the inevitable dynamics of history fragmented America into the present independent nations and Spain had to abandon her American responsibilities, the network of universities, scientific academies, and other similar institutions numbered about one hundred. In fact, it was the education of an American leading class that made possible their cultural and political emancipation (pl. 5).

The great monuments and historical urban centers of hispanic America (many of them named in UNESCO's World Heritage List) preserve in their stone the ethical and responsible consciences of the Spanish kings—some better, some worse. From 1492 until 1824 they were the force that propelled the American continent to engage with Western culture and its Christian values, without which neither Europe nor America can be fully understood. The Spanish built these monuments next to those erected by the great indigenous American civilizations, making visible the process of hybridization that has come to shape what we are today on both sides of the Atlantic: millions of individuals united by the same language and, even more importantly, by the same values and beliefs (pls. 6, 7).

Spain in the Age of Exploration, 1492–1819 is the third exhibition the Patrimonio Nacional has sent to the United States since 2001. These exhibits were not planned as a series but emerged through the initiative of various North American institutions, with the continuous support of the Embassy of Spain in the United States and the Ministry of Culture of the Spanish government. The discourse articulated by these projects has been extremely well received by our American audiences. The sites for these shows have not been large capital cities, making it possible for persons living far from big museums to view first-rate works of art, to become acquainted with the art of Spain, and to consider the historical ties that bind Spain and the Americas.

This shared history has receded from the awareness of many Americans. The Spanish-American War of 1898, in which Spain lost her last provinces in America and Asia—Cuba, Puerto Rico, the

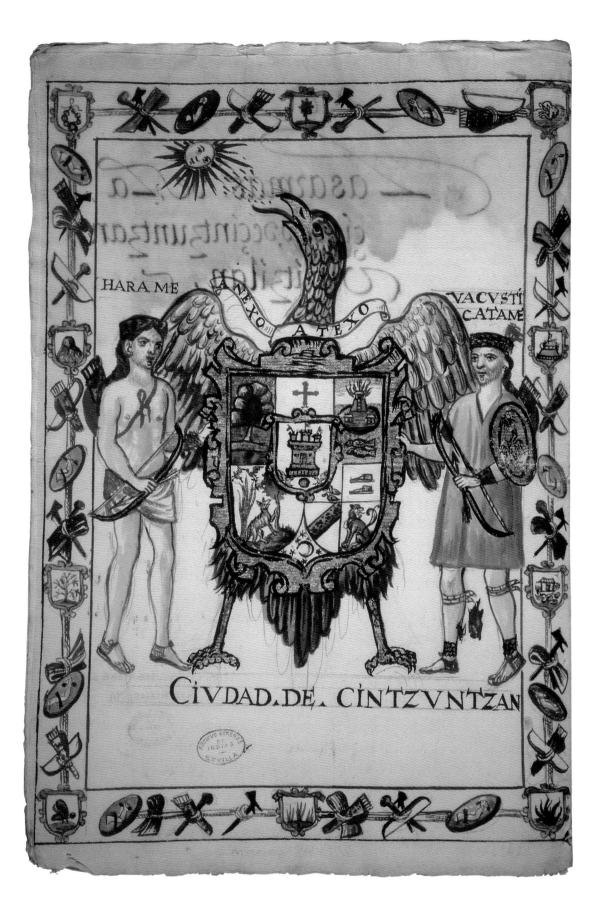

PLATE 5

Shield of the city of Tzintzuntzan, granted by Philip II

1595

Colored ink drawing, 11⅝6 × 8⅛ in. (28.7 × 20.7 cm)

© España Ministerio de Educación, Cultura y Deporte. Archivo General

de Indias, Seville (MP. Escudos y árboles genealógicos, 168)

PLATE 6

Letter from Yucatán Indians to Philip II, requesting Franciscan priests who could speak the Mayan language

Yucatán, February 11, 1567

Ink on paper, 12³⁄₁₆ × 8⁷⁄₁₆ in. (31 × 21.5 cm)

© España Ministerio de Educación, Cultura y Deporte. Archivo General de Indias, Seville (Mexico, 367)

PLATE 7

FRAY PEDRO DE GANTE (1490–1572)

Catechism

c. 1525–28

Manuscript with illustrations, 3⁹⁄₁₆ × 2¾ in. (9 × 7 cm)

© España Ministerio de Educación, Cultura y Deporte. Archivo Histórico Nacional, Madrid (Códice 1257)

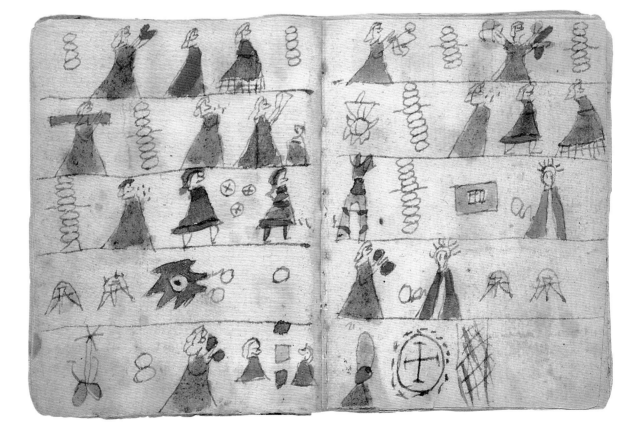

PLATE 8

Port of Bayahá

1551–1600

Watercolor on parchment, 14¾ × 24⁷⁄₁₆ in. (37.4 × 62 cm)

© España Ministerio de Educación, Cultura y Deporte. Archivo General

de Indias, Seville (MP. Santo Domingo, 3)

Philippine Islands, and various other archipelagos in the Pacific—was a military conflict but also a media war that mobilized public opinion to a great degree. Spain was defeated on both fronts and was lost in a haze of negative views. At worst, it simply ceased to exist in the American mind.

The first of these exhibitions, *The Majesty of Spain,* was shown in Jackson, Mississippi, in 2001 and included 650 artworks in the royal collections. Its objective was to document Spain's influence in the South and the assistance offered by the armies of Charles III to George Washington during the Revolutionary War. Among the fascinating vignettes brought to light were the fact that the uniforms U.S. soldiers wore in Yorktown, as well as their rifles and ammunition, were Spanish; the French fleet was mobilized with a million gold pesos paid by the Spanish governor of Cuba, following the orders of the king of Spain; and the Spaniards who immigrated to the New Orleans region from the Canary Islands in the eighteenth century were among the first generation of free North Americans.

The second exhibit involving the Patrimonio Nacional was coordinated with the state of Louisiana to commemorate the bicentennial of the Louisiana Purchase of 1803. This immense region had long been a Spanish territory: the first European to travel the lower Mississippi basin

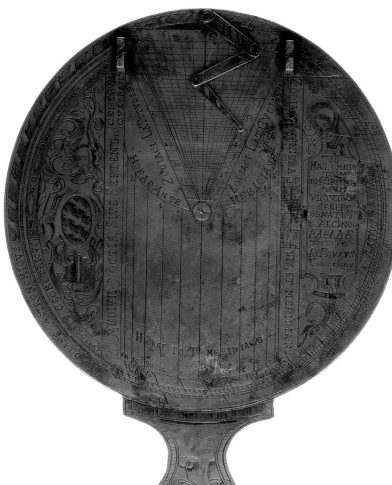

PLATE 9

JOHANNES PAULOS CIMERLINUS (ACT. C. 1544–1585)
Altitude dial (Regiomontanus type) and nocturlabe

Verona, before 1582
Brass, 5¹¹⁄₁₆ × ¹⁄₁₆ in., handle: 3¹⁄₁₆ in. (14.5 × .2 cm, handle: 7.7 cm)
© Archivo Fotográfico, Museo Arqueológico Nacional, Madrid (1993/89/1)

Navigators calculated latitude and time at night with this instrument by sighting the North Star Polaris through the hole in the center and aligning it with markings on the perimeter. What makes the instrument exceedingly rare is that it could also be used to tell time during the day.

PLATE 10

MICHEL PIQUER (ACT. C. 1542–1580)
Universal astrolabe

Louvain, c. 1550
Brass, 9⅝ × 7¾ × ⅞ in. (24.4 × 19.7 × 2.3 cm)
© Museo Nacional de Ciencia y Tecnología (MCyT), Madrid (1999/009/0001)

The astrolabe is an early time-telling instrument used to calculate the positions of the sun and stars in the sky at a given moment and location. Developed in the Islamic world, the astrolabe could determine prayer times as well as the direction to Mecca. In Europe, it was a fundamental tool for astronomical education. In the 16th century, the finest instruments were made in Louvain, in present-day Belgium.

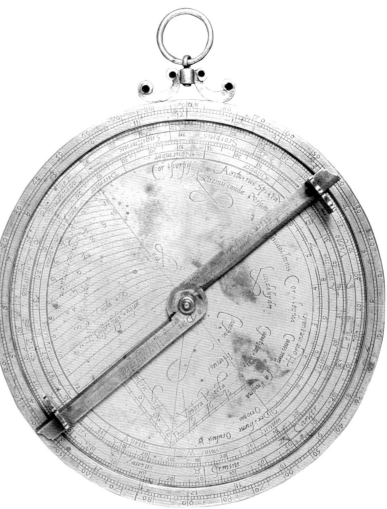

DEMOSTRACION
DE LAS EFICACES VIRTUDES
NUEVAMENTE DESCUBIERTAS
EN LAS RAICES DE DOS PLANTAS
DE NUEVA-ESPAÑA,
ESPECIES DE ÁGAVE Y DE BEGÓNIA,
PARA LA CURACION
DEL VICIO VENÉREO Y ESCROFULOSO,
Y de otras graves enfermedades que resisten
al uso del Mercurio, y demas remedios
conocidos.

POR EL LICENCIADO
DON FRANCISCO XAVIER BÁLMIS,
Cirujano Consultor de los Reales Exércitos, y Socio
de la Real Academia Médica-Matritense, Comisio-
nado por S. M. para la comprobacion que se ha
hecho en Madrid y Sitios Reales, de la eficacia
de ámbas raices.

MADRID MDCCXCIV.
EN LA IMPRENTA DE LA VIUDA DE D. JOAQUIN IBARRA.
CON SUPERIOR PERMISO.

Fig. 3 Francisco Javier Balmis
described a number of traditional
Amerindian botanical remedies in
*Demostracion de las eficaces virtudes
nuevamente descubiertas en las raices
de dos plantas de Nueva-España.*
Madrid, Viuda de Don Joaquin Ibarra,
1794. © Patrimonio Nacional, Real
Biblioteca del Palacio Real, Madrid
(VIII/1852)

Fig. 4 Quina tree, from Baltasar Jaime
Martínez Compañón, *Trujillo del Peru*,
18th century. Vol. 4, plate 31, black ink
and watercolor. © Patrimonio Nacional,
Real Biblioteca del Palacio Real, Madrid
(II/346)

Fig. 5 Amerindian smallpox victim,
from Baltasar Jaime Martínez Com-
pañón, *Trujillo del Peru*, 18th century.
Vol. 2, plate 197, black ink and water-
color. © Patrimonio Nacional, Real
Biblioteca del Palacio Real, Madrid
(II/344).

was Hernando de Soto, in 1540. Spanish missionaries were a presence in the territory for decades, and soldiers of the Spanish crown built many forts and outposts in the basin of the Río Padre de las Aguas. *The Heart of Spain,* organized by the Patrimonio Nacional and supported by loans from six other Spanish museums, was shown in Alexandria, Louisiana, and featured religious works by Zurbarán, El Greco, Mengs, Veronese, Ribera, Ribalta, Cano, Murillo, Coello, and other artists from the fifteenth through nineteenth centuries. The assembled works reflected the best and most beautiful of a culture with an undeniable and deep complexity, formed by the spiritual and ethical values of the great Mediterranean cultures and transformed by the values of Western Christian culture, which defined and defended individual rights and human dignity. Spain, in turn, transmitted these mores to the whole of the Americas during its three hundred years on the continent.

This brings us to the third exhibition, *Spain in the Age of Exploration, 1492–1819.* It emerged through the initiative of the Seattle Art Museum, with the chosen theme of Spain's presence in the Americas, seen from the perspective of scientific explorations. Thus it represents a point of view complementary to the previous exhibits.

It may be surprising to some that in an exhibition focused on scientific endeavor the portraits of the kings of Spain and works of art, especially religious works, occupy an important place side by side with astrolabes and maps (pls. 8–10). But the responsibility of the crown's enormous power profoundly influenced developments in the Americas. The Spanish monarchs were very conscious that they had to render a strict accounting of their actions to their own conscience and before God. They were also aware that their heirs apparent must experience a solid humanistic, scientific, and religious education that would perpetuate the crown's ethical responsibilities.

The scientific expeditions were prompted not only by a natural desire for knowledge, but by a sense that the world and its governance would be improved by such knowledge. Betterment became a veritable obsession among the best kings of the lengthy period of exploration, such as Philip II or Charles III. For this reason, this exhibition ends symbolically with a scientific expedition that is not represented by works of art, one that, in itself, represents one of the most valuable and humane contributions of Spain to America and the world.

In 1803, concerned with the serious health problem posed by deadly smallpox epidemics (fig. 5), King Charles IV organized and financed the first large-scale international public health operation. Known as the Royal Philanthropic Vaccine Expedition, it was the most fruitful of all the Enlightenment expeditions characteristic of the late eighteenth century. The smallpox vaccine had just been discovered, but not a means by which to transport it. The king's physician, Francisco Javier Balmis, developed such a method and thus made possible the massive inoculation of millions of individuals in the whole of the Americas and the Philippines. Reaching as far as China and circumnavigating the globe, the unprecedented logistical operation lasted from 1803 until 1806. In the words of the Mexican physician Ignacio Chávez, it was "one of the cleanest, most humane, and most authentically civilized pages ever written in history."[1] Balmis died in Madrid in 1819, the same year, symbolically, that marks the closing period of this exhibition. It was also the year that Florida and the Northwest became definitive parts of the United States.

If an exhibition is always a message to society, this is the finest message of solidarity and responsibility, the greatest work of art.

NOTE

1. E. Balaguer and R. Ballester, *Real Expedición Filantrópica de la Vacuna,* 2d ed. (Bilbao: Asociación Española de Pediatria, 2004).

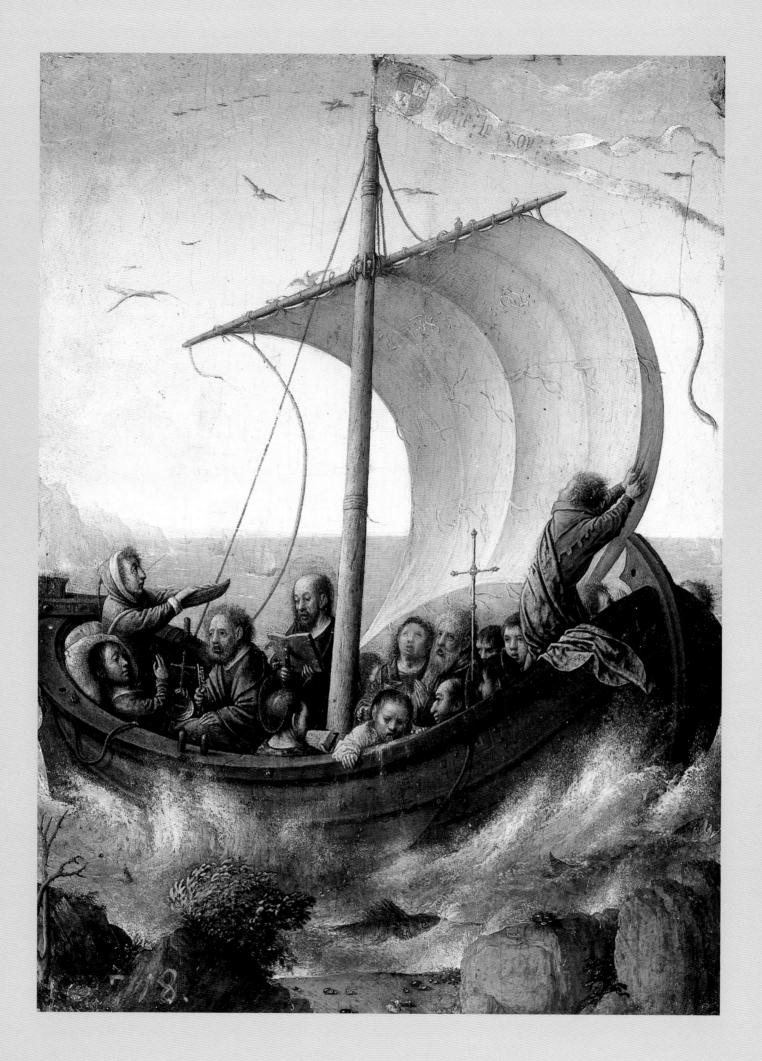

Spanish Art and Science in the Age of Exploration

"A map of the real world is no less imaginary than a map of the imaginary world."
—Alberto Blanco, Mexican poet

TWO FIFTEENTH-CENTURY IMAGES OF A SHIP, one literary and one visual, provide an appropriate starting point for this discussion of Spanish art and science in the age of exploration. The first, an excerpt from a long poem by Fray Iñigo de Mendoza (c. 1424–c. 1507), celebrates the ascension to the throne of Ferdinand and Isabel in 1474. Mendoza crafted a complex maritime metaphor, in which the Spanish state is a ship in disrepair, brought low by the corruption and neglect of the monarchs' predecessor, Henry IV. Under the guidance of Justice, the ship is repaired and made strong, with Ferdinand—"that enlightened king . . . appointed by God"—securely at the helm.[1]

> Now that the ship is hung with the sail
> Eminent king, as it should be,
> Let the mast be raised,
> Firmly welded and quilted
> With the cloths of Faith.[2]

The second naval image is a small painting, *Christ Calming the Storm* (pl. 11), commissioned by Queen Isabel from her court painter Juan de Flandes about 1496. Jesus and his disciples are huddled in a tiny boat tossed by waves as it crosses the Sea of Galilee. The disciples respond to the storm with fear, prayer, and physical illness, while the helmsman and a crew member struggle to bring the vessel under control. But the boat's fate rests with the recumbent figure of Christ, who had been asleep in the stern. Clutching the crystal orb that represents dominion over the earth, he raises his right hand and the seas beyond instantly become calm. The taut cord near Christ's hand leads our eyes upward to the sturdy mast, which, with its crossbar, forms a cross. At the very top, a white standard, anachronistically bearing the shield of the Spanish kingdoms of Castile and León, flutters in the breeze; the legend Vyve le Roy—"long live the king"—dances across its surface.[3]

The message of these two images is the same: the Spanish ship of state sails safely because it is under God's protection. The same unshakable conviction propelled the actual voyage of the most celebrated Spanish ships in history, the three boats captained by Christopher Columbus in search of a new sea route to India in 1492. As surely as the three Magi followed the star that led them to Jesus' manger in Bethlehem, Columbus interpreted a calm sea, cloud masses, and sightings of birds and vegetation as signs from God that endorsed his endeavor and confirmed his

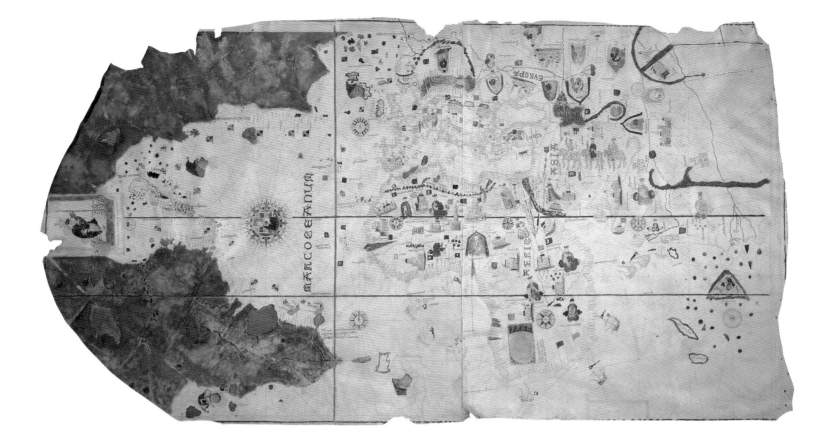

PLATE 12

JUAN DE LA COSA (C. 1460–1510)
World map

1500 (facsimile, 1975–80)
Parchment, 37¹³⁄₁₆ × 72¹⁄₁₆ in. (96 × 183 cm)
© Museo Naval, Madrid (2603)

PLATE 13

AHMAD IBN ABD AL-RAHMAN AL-DUHMANI
Novus-type quadrant

Morocco, dated 1450
Brass, 6¹³⁄₁₆ × ³⁄₁₆ in. (17.3 × 0.4 cm)
© Archivo Fotográfico, Museo Arqueológico Nacional,
Madrid (50.856)

Used in celestial navigation, the quadrant, which efficiently
performs the functions of an astrolabe in one quarter of the
area, determines the altitude of stars and thus a measure of
latitude. In use in North Africa from the eighth century, it
was introduced into Europe by the thirteenth century.

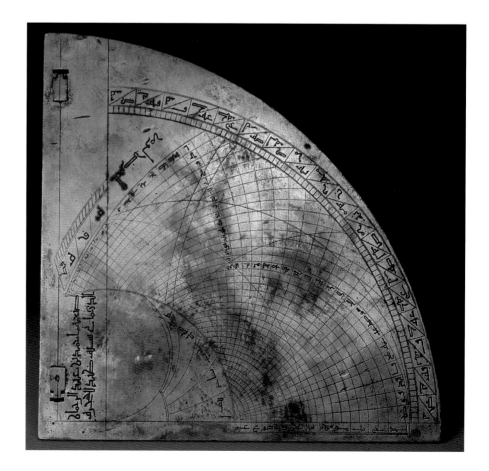

purpose.[4] In supporting his voyage, Ferdinand and Isabel had expected to enlarge the Spanish kingdom and enrich the wealth of the crown, but they were also eager to disseminate Christianity to a broader audience. This attitude mixing dominion and conversion permeated Spanish thinking of the time. One example is an important scientific document from 1500, the earliest surviving map of the New World (pl. 12), a sophisticated portolan chart diagramming the distances across featureless bodies of water. Its author, Juan de la Cosa, the cartographer who had sailed with Columbus, embellished the chart with two prominent Christian images. Within the compass rose, the basis for the viewer's orientation, are pictured the Virgin and Child, and at the far left edge is Saint Christopher, patron saint of travelers, with whom Christopher Columbus personally identified. He signed his letters *Christo Ferens* (Bearer of Christ) and repeatedly proclaimed that his ultimate mission was the restoration of Christianity to Jerusalem, to be achieved through worldwide navigation, occupation, and conversion.

The relation between faith and public policy sketched above is an undeniable part of the story of the Spanish age of exploration. This period has been heavily studied, particularly in the decade following the quincentenary of Columbus's voyage. The traditional romantic and heroic narrative of triumphant discovery and inevitable domination, written uncritically from a European perspective, has been balanced by a greater sense of pre-Columbian life and consternation over the conquest of native American civilizations. In the face of such a vast body of literature, much of it polemical, this book is distinguished by its historical perspective on Spanish responses to the New World, presented in essays and through superb works of art. Leading American and Spanish scholars have identified major themes related to the broader subjects; their insightful essays concerning the empire feature the image of the king, the makeup and history of the royal collection, and the rise of science in Spain. Together they tell how an insular body of small kingdoms transformed itself into a global superpower, and suggest the attendant responsibilities, anxieties, and accomplishments that accompanied such a dramatic metamorphosis.

The first essay, by Richard Kagan and Benjamin Schmidt, establishes the historical framework for our project and introduces the principal themes. The authors examine in particular how moral, economic, and dynastic anxieties accompanied the unprecedented wealth and international fame and power resulting from Spain's expanded global role. Historical conditions, personalities, and even dynasties come and go over this long period, but the authors demonstrate that certain constants—among them a fascinating tension between receptivity and intransigence—run through Spanish history. Less familiar is the prominent role of science in the Spanish imperial enterprise, from the accomplishments of early navigators (see pls. 13, 14) and cartographers to the attempts by groundbreaking observers to classify unfamiliar flora and fauna in overseas Spanish territories. Their approach finally became institutionalized in the eighteenth century with the founding of the Royal Botanical Garden and the Royal Cabinet of Natural History. Another, unofficial, institution was the Spanish royal collection, one of the grandest in Europe, which began with Isabel the Catholic's paintings, tapestries, and precious objects and expanded dramatically under the Habsburg and Bourbon dynasties, which commissioned and collected paintings by Titian, Bosch, Velázquez, Mengs, and Goya, among many others.

The eminent Spanish art historian Joaquín Yarza Luaces discusses how the reign of Isabel and Ferdinand was marked by a sophisticated use of art and architecture to create a widely disseminated image of power. The queen's personal taste leaned heavily toward Flemish art, and her court painters were northern artists who had moved to Spain; the Italian Renaissance was all but ignored in Spain until the mid-sixteenth century. Isabel and Ferdinand undertook all their enterprises in

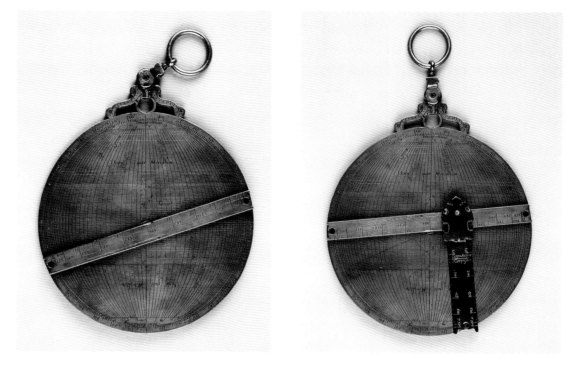

PLATE 14

Universal astrolabe

Spain, 1563
Brass, diam. 13 1/16 in. (33.1 cm)
© Museo Naval, Madrid (1280)

Unlike the planispheric astrolabe, which required a separate plate for each latitude, the universal astrolabe could be used from any location. This versatility enabled a broader range of applications, including marine navigation. To accommodate its increased data and maintain accuracy, the astrolabe was enlarged; its heaviness and greater cost prevented the universal astrolabe from achieving widespread popularity.

the name of Christianity—including their efforts to make the Spanish peninsula a homogenous Christian society, their sponsorship of Spanish activity in the New World, and their shaping of the royal art collection, which was dominated by paintings and tapestries with religious subjects. Though today Columbus's success in reaching the American shore is the most widely remembered accomplishment of their reign, the monarchs themselves were far prouder of reclaiming the Moorish kingdom of Granada for Christian Spain.

In the commotion of New World activity that followed the 1492 voyage, Spanish explorers, settlers, missionaries, and conquistadors interacted with indigenous peoples in a complex environment of exploitation, admiration, knowledge gathering, and cross-fertilization. Much of what we know about native languages, for example, is the work of Franciscan missionaries who understood the importance of communication in transmitting Christian doctrine and facilitating conversion. Alonso de Molina (c. 1510–1584) was still a child when his parents took him to Mexico in 1523. There he learned the Aztec language Nahuatl and was an interpreter for Franciscan monks who settled in New Spain. Later, as a member of the Franciscan order, he published several of the first books printed in the New World, including the first Spanish/Mexican dictionary and a Nahuatl translation of *Imitatio Christi,* Thomas à Kempis's influential devotional book (pl. 15).[5]

Another figure, Pedro de Gante (Peter of Ghent, 1490–1572), a distant relative of Charles V, was among the first three Franciscan missionaries to come to Mexico in 1523. He founded a school, which initially educated native children in reading, writing, singing, and Christian teaching, and eventually included instruction in manual arts. His was one of the strongest voices to argue that the indigenous populations be treated as equals with the Spanish. His catechism uses Testerian writing, a rebuslike combination of pictographs and phonetic characters in the Nahuatl language, to create a vivid depiction of Christian doctrine and practice (see pl. 7).

The Tarascan people lived in Michoacán, the region west of present-day Mexico City. The Franciscan friar Jerónimo de Alcalá compiled a richly illustrated record of their religious ceremonies, government, and customs which remains a key document for understanding what life was like there before Spanish domination (see pl. 2).

PLATE 15

THOMAS À KEMPIS (1379/80–1471)
Imitatio Christi

Mid-16th century

Nahuatl translation by Alonso de Molina (c. 1510–1584)

Manuscript with illustrations, 6⁵⁄₁₆ × 4¾ in. (16 × 12 cm)

© Patrimonio Nacional, Biblioteca del Real Monasterio de San Lorenzo
de El Escorial (D.IV-7)

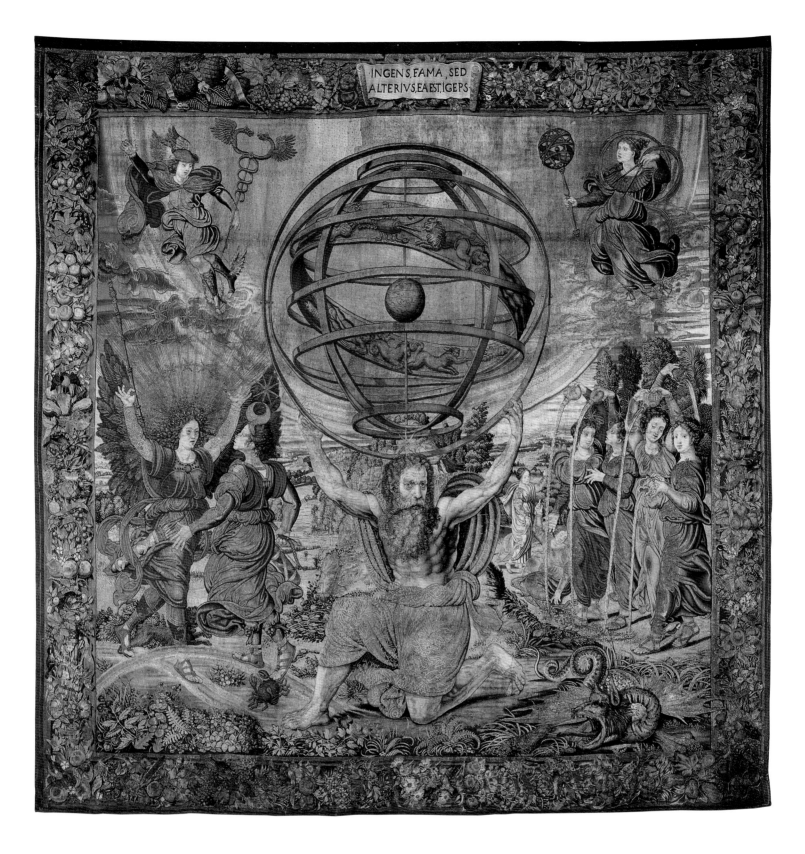

INGENS.FAMA.SED
ALTERIVS,EA EST.IGEPS

PLATE 16

GEORG WEZELER (ACT. C. 1520–1549)
Atlas Supporting the Armillary Sphere

Brussels, c. 1530

After a cartoon attributed to Bernaert van Orley (c. 1491–1541/42)

Gold, silver, silk, wool, 137¹³⁄₁₆ × 136⅝ in. (350 × 347 cm)

© Patrimonio Nacional, Palacio Real, Madrid (10005824)

Other sixteenth-century explorers, such as Gonzalo Fernández de Oviedo and Francisco Hernández, brought information about the New World back to Spain. They were hired by the court to prepare extensive, illustrated descriptions of botanical and ethnographic subjects. Jesús Carrillo Castillo discusses how this early form of natural science, when published in Spain, described American nature in a powerful language of direct experience, which contributed to a sense that the New World could be understood, codified, and controlled in the service of empire.

In the early sixteenth century, Spain annexed vast amounts of American territory, and King Charles I was named Holy Roman Emperor. While Christian associations remained inseparable from the Spanish royal image, that image needed to be amplified to suit Spain's expanding global role. Classical heroes such as Julius Caesar and the legendary Hercules became part of the emperor's personal iconography, helping to create an aura of wisdom and invincibility that was disseminated internationally and continued to play a role in royal iconography even after Charles's death. For example, a spectacular tapestry of about 1530 (pl. 16), originally created for the king of Portugal and later acquired by the Spanish crown, features Atlas, the Titan of Greek myth, who kneels to support a huge armillary sphere. The tapestry is part of a series known as *The Spheres,* whose overall theme of cosmological harmony as a consequence of virtuous leadership was embraced by subsequent Spanish rulers. The intentionality with which dazzling objects such as this were displayed in royal residences was part of the image-building enterprise at the Spanish court—an undertaking crucial to upholding the tone of divinely ordained responsibility in the far-flung Spanish territories. Sarah Schroth considers the complex ways in which this strategic imperative was addressed in the sixteenth and seventeenth centuries through the royal collection, portraiture, and armor. As Schroth demonstrates, in portraits the king's leadership qualities were conveyed not so much by asserting his personality but through a sophisticated combination of coded visual messages that were widely understood by an international audience and intended to elicit the same respect that the king himself would command. That this formula was ultimately European rather than exclusively Spanish can be seen in a portrait by the Flemish master Peter Paul Rubens, who painted the Archduke Ferdinand, younger brother of Philip IV, when he became governor of the Netherlands in 1635 (pl. 17)

One of the most prominent elements in the creation of the Spanish image was the imposing edifice of El Escorial, built by King Philip II in 1563–84. A massive granite complex in the mountains about 35 miles northwest of Madrid, El Escorial was considered a new Temple of Solomon and combined the functions of monastery, royal mausoleum, and palace. The king closely supervised the building and furnishing of El Escorial, which intertwines dynastic and religious themes and whose severe simplicity embodies Philip's values of *gravedad y decoro* (gravity and decorum). Within the basilica at the center of the complex, thirty-three altarpieces represented pairs of saints. A painting by Alonso Sánchez Coello shows two of the Latin Fathers of the Church, Saints Jerome and Augustine (pl. 18). In his right hand Saint Augustine supports a book, probably his famous treatise *The City of God,* which presents an ideal heavenly city as symbolized by Jerusalem. In Sánchez Coello's painting, the model of this ideal city, resting on the book, is a simplified rendering of El Escorial itself. Thus El Escorial, a Spanish royal edifice constructed to embody architectural and moral ideals, is consciously equated with the conceptual City of God. This correspondence may further be associated with the Spanish building of cities in the New World, organized according to European models and consciously evoking a New Jerusalem—reminiscent of Columbus's earlier conception of a Christian utopia.

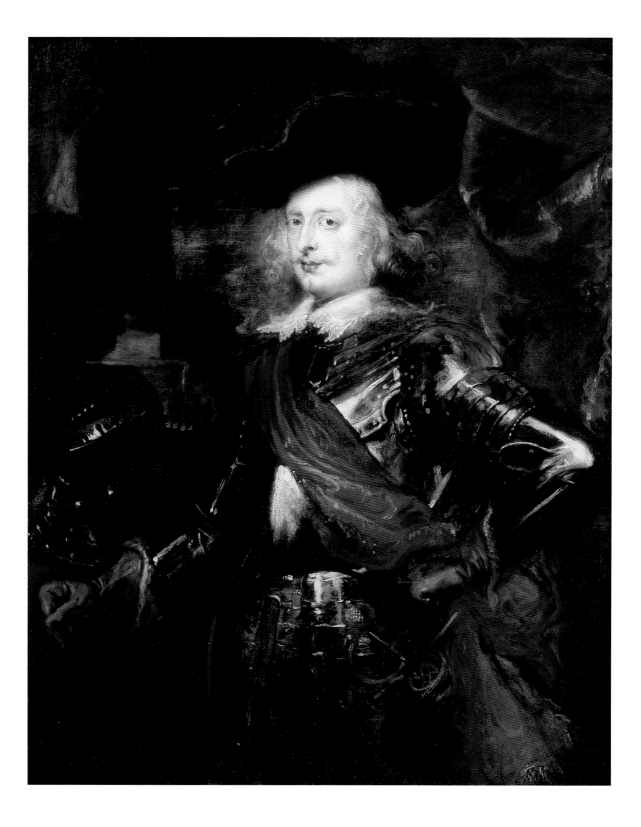

PLATE 17

PETER PAUL RUBENS (1577–1640)
Portrait of the Archduke Ferdinand

1635
Oil on canvas, 45¾ × 37 in. (116.2 × 94 cm)
John and Mable Ringling Museum of Art, Sarasota, museum purchase,
State Art Museum of Florida

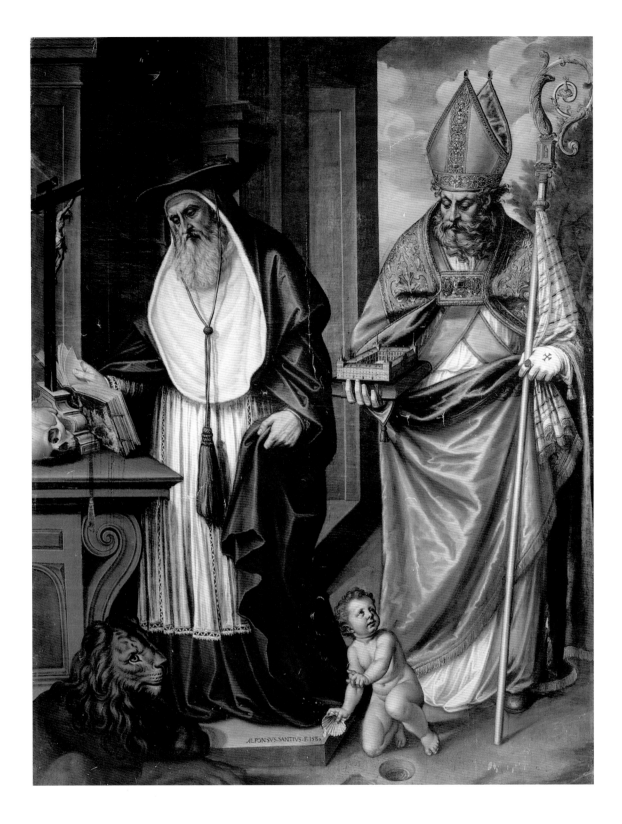

PLATE 18

ALONSO SÁNCHEZ COELLO (1531/2–1588)

Saint Jerome and Saint Augustine

Dated 1580

Oil on canvas, 91¾ × 71⅝ in. (233 × 182 cm)

© Patrimonio Nacional, Real Monasterio de San Lorenzo de
El Escorial (10034845)

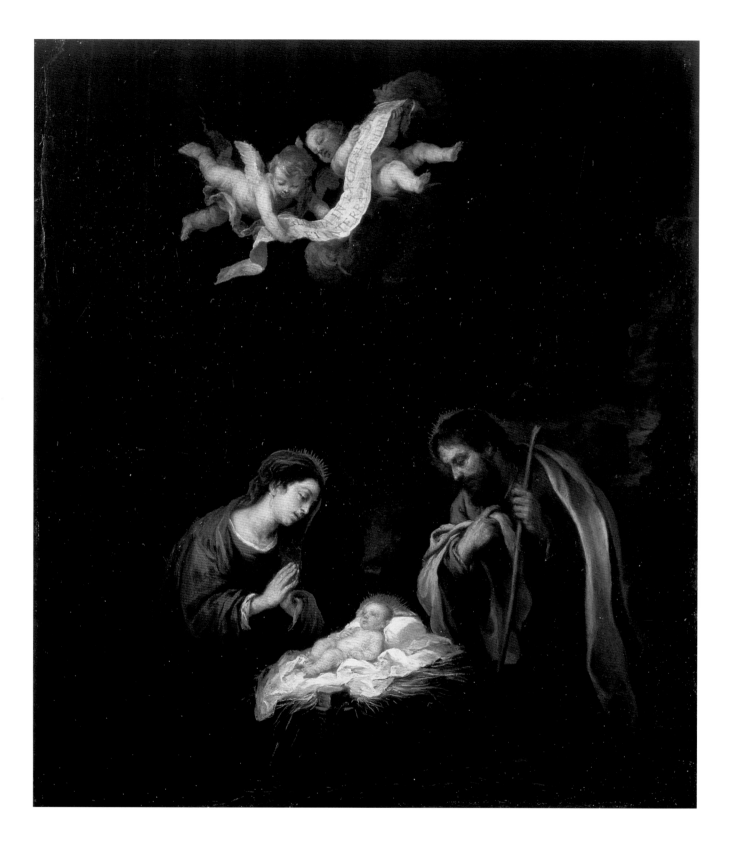

PLATE 19

BARTOLOMÉ ESTEBAN MURILLO (1618–1682)
Nativity

c. 1665–70

Oil on obsidian, 15¹⁄₁₆ × 13⁷⁄₁₆ in. (38.3 × 34.2 cm)

© The Museum of Fine Arts, Houston, The Rienzi Collection,

gift of Mr. and Mrs. Harris Masterson III

Throughout this period there was a rich exchange between Spain and its colonies abroad. Through trade authorities such as the *Casa de Contratación,* established by Isabel in Seville in 1503, the crown authorized private merchants to institute trading relationships in the New World. Seville, the only authorized port to the New World, was transformed into a cosmopolitan international trade center and the most prosperous city in Spain. Its leading painter in the seventeenth century was Bartolomé Esteban Murillo, who served not the Spanish court but a network of prosperous religious institutions and private collectors in Seville. A versatile artist who could work in a monumental scale suitable for enormous altarpieces, Murillo also painted domestically scaled portraits, genre paintings, and intimate devotional works. An example of the latter is the exquisite *Nativity* (pl. 19) painted on obsidian. The obsidian support, extremely rare for a European painting, probably came from Mexico or Central America. Murillo could have acquired the stone through his son Gabriel, who had settled in Central America, or through his patron Justino de Neve, who had family trade connections there.[6] The stone, highly polished on one side and left rough on the reverse, is similar to other shaped and finished slabs of obsidian that have been identified as Aztec smoking mirrors. The smoking mirror was the attribute as well as the translation of the name of a powerful Aztec god, Tezcatlipoca. Murillo may not have been aware of the probable original use of the obsidian. But, his transformation of an object embodying one type of cultural reverence into a Christian devotional painting is a vivid emblem of how Spain superimposed its own values on the New World.

Caravaggesque realism was a powerful influence on Spanish painters in the seventeenth century. Strongly lighted religious images of divine figures are endowed with a directness and physicality that suggest a vivid presence. In Francisco de Zurbarán's *The Savior Blessing,* the viewer is allowed an unusually proximate encounter with Christ, who is separated from our space by only a large globe (pl. 20). A wooden cross leans against his left side. Together the cross and the globe express God's earthly dominion, as in the painting by Juan de Flandes (pl. 11) already discussed; the crystal orb that symbolized the concept in that painting is here rendered realistically.

By the mid-eighteenth century, the Spanish presence in the Americas had been solidly established for more than two centuries. Under the Bourbon dynasty, which came to power in 1700, a series of Spanish expeditions explored the last uncharted American territory, the northwest corner of North America and the west coast of Canada. Organized originally to protect Spanish sovereignty on the continent from the Russians and the British, the voyages also had another purpose: to gather and disseminate information about the geography, people, landscape, flora, and fauna of these regions. As José de la Sota Ríus describes, these expeditions, led by figures such as Bodega y Quadra and Alessandro Malaspina, consciously emulated the work of the scientific explorers of the sixteenth century. The drawings, literary accounts, and articles of trade—some, such as the Northwest Coast objects now considered important works of art—were to be gathered in a royal natural history collection. For example, Tomás de Suria's portrait of Maquinna, a chief from Nootka, British Columbia, shows him in a carefully rendered whaling hat, woven with images of a whale hunt (pl. 21). The expedition also collected examples of this type of hat itself (pl. 22). This collecting and classifying of natural and man-made objects from around the world in the Royal Cabinet of Natural History exemplifies Enlightenment thinking, as Andrew Schulz explains in the final essay of the book. Unlike the more ideological aspects of the Enlightenment in France, eighteenth-century initiatives in Spain—whether engineering projects, economic, social, and educational reform, or even artistic matters—were solidly rooted in practical application. *School Scene* by the French court painter Michel-Ange Houasse (pl. 23) is one of a series of

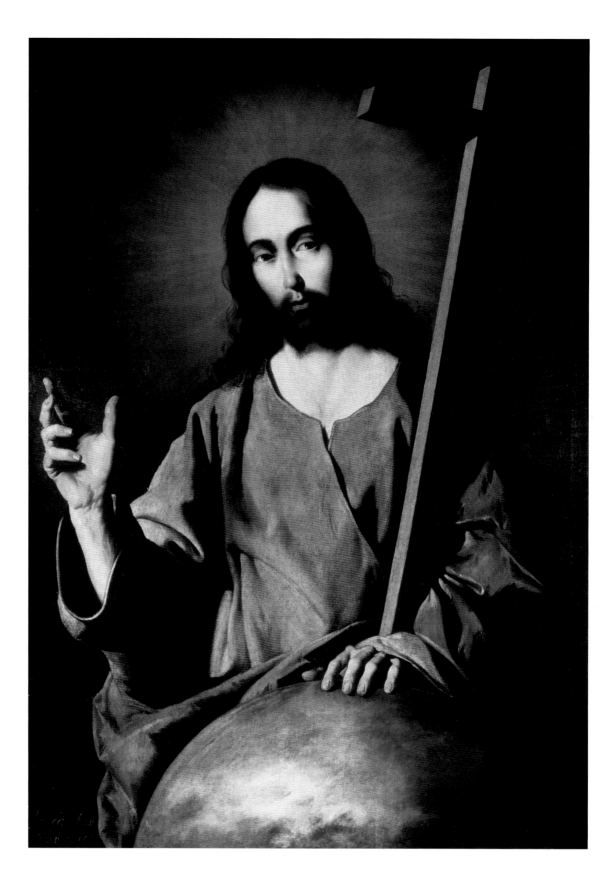

PLATE 20

FRANCISCO DE ZURBARÁN (1598–1664)
The Savior Blessing

1638
Oil on canvas, 39 × 27¹⁵⁄₁₆ in. (99 × 71 cm)
© Museo Nacional del Prado, Madrid (6074)

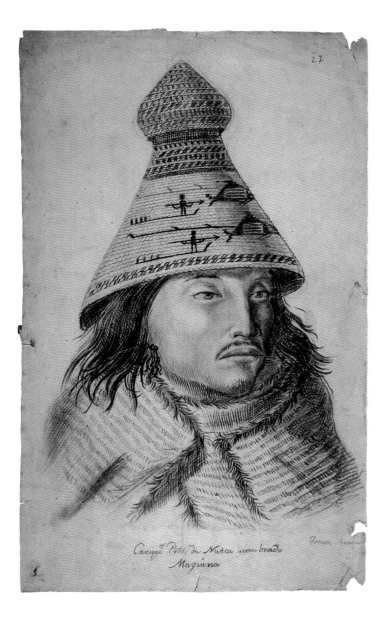

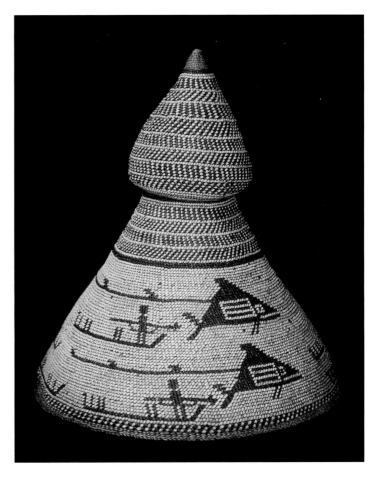

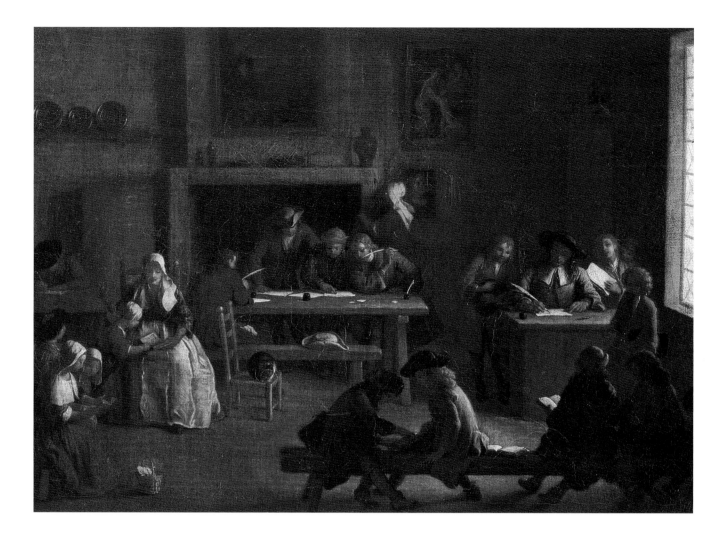

PLATE 23

genre paintings by the artist reflecting a new interest in Spanish life across different social levels. In a well-lit, orderly classroom, students attentively practice reading or huddle together over a problem. The quiet, unified sense of purpose suggests the optimistic faith in knowledge characteristic of the Enlightenment.

As Schulz describes, the idealistic ambitions of the Enlightenment were ultimately unfulfilled, and its grand plan for the unification of arts and sciences was not realized. At the end of the eighteenth century, Spain, which had already lost significant international holdings, was weakened by debt, diminished resources, and war within Europe. In that sense, Francisco de Goya's *Shipwreck* (pl. 24), a small cabinet painting, is almost too perfect a visual metaphor for Spain's declining fortunes. It shows a bedraggled, helpless group of survivors whose ship has been destroyed by a storm. One woman raises her arms and looks heavenward, seeking deliverance from above. The contrast could not be stronger between this tragic, chaotic image and Juan de Flandes's tidy painting of a ship delivered from danger which opened this essay. Some may equate Goya's painting

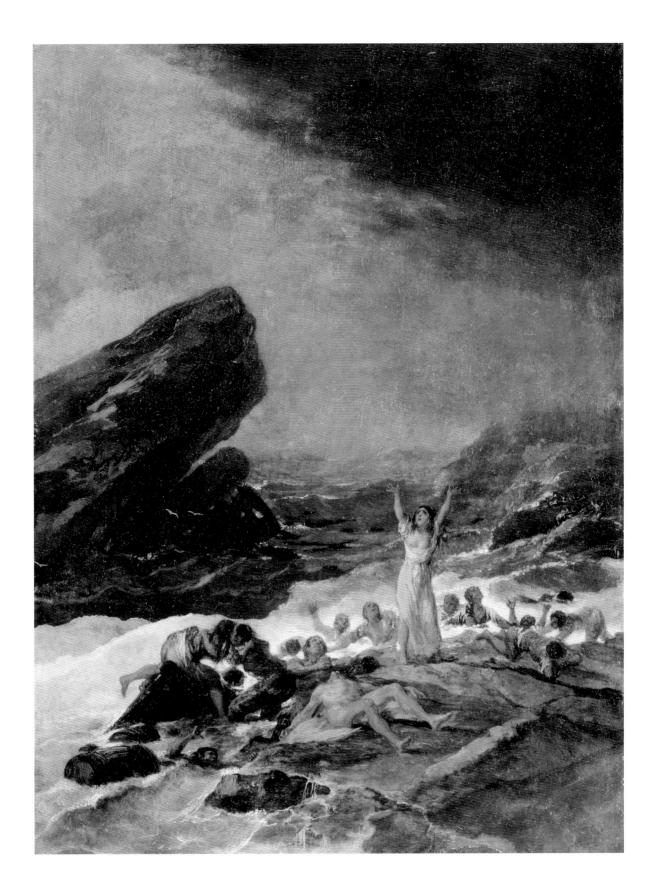

PLATE 24

FRANCISCO JOSÉ DE GOYA Y LUCIENTES (1746–1828)

Shipwreck

c. 1793–94

Oil on tin, 16¹⁵⁄₁₆ × 12½ in. (43 × 31.8 cm)

Placido Arango Collection, Madrid

with the uncertainty and upheaval experienced by Spain and other European nations following the French Revolution. Goya himself, however, who spoke of his cabinet pictures as simply outlets for "*capricho* and invention," may not have intended specific political allusions but instead a grand vision of nature's terrible power.[7]

NOTES

1. "El qual rey esclarescido/Es el que es de Dios ungido . . ." Julio Rodríguez-Puértolas, ed., *Fray Iñigo de Mendoza: Cancionero* (Madrid: Espasa-Calpe, 1968), 339.

2. "El navio asi toldado, /Alto rey, segun que fue / Sea el mastel levantado, / Muy soldado y estofado / Con los lienços de la Fe . . ." (ibid., p. 343). The focus on Ferdinand throughout the poem pointedly justifies his right to the throne of Castile/Léon at a time when his entitlement was still controversial.

3. It is likely that Isabel ordered the juxtaposition of the arms of Castile/Léon with the inscription glorifying the king as a form of homage to her husband. See Chiyo Ishikawa, *The Retablo of Isabel la Católica by Juan de Flandes and Michel Sittow* (Turnhout: Brepols, 2004), p. 160.

4. See Oliver Dunn and James E. Kelley, Jr., trans., *The Diario of Christopher Columbus's First Voyage to America, 1492–1493, Abstracted by Fray Bartolomé de las Casas* (Norman:

University of Oklahoma Press, 1989), and Stephen Greenblatt, *Marvelous Possessions: The Wonder of the New World* (Chicago: University of Chicago Press, 1991), 86–90.

5. This approach is identical to that used after the conquest of Granada, when the new archbishop of Granada, Hernando de Talavera, taught himself Arabic to aid in the conversion of the conquered Moors.

6. Justino de Neve was probably the first owner of *Nativity;* see William B. Jordan, "A Forgotten Legacy: Murillo's Cabinet Pictures on Stone, Metal, and Wood," in *Bartolomé Esteban Murillo (1617–1682): Paintings from American Collections* by Suzanne L. Stratton-Pruitt (New York: Harry N. Abrams, 2002), 65–68; see also Olivier Meslay, "Murillo and 'Smoking Mirrors,'" *The Burlington Magazine* 143, no. 1175 (February 2001): 73–80.

7. Robert Hughes, *Goya* (New York: Alfred A. Knopf, 2003), 130, 135–36.

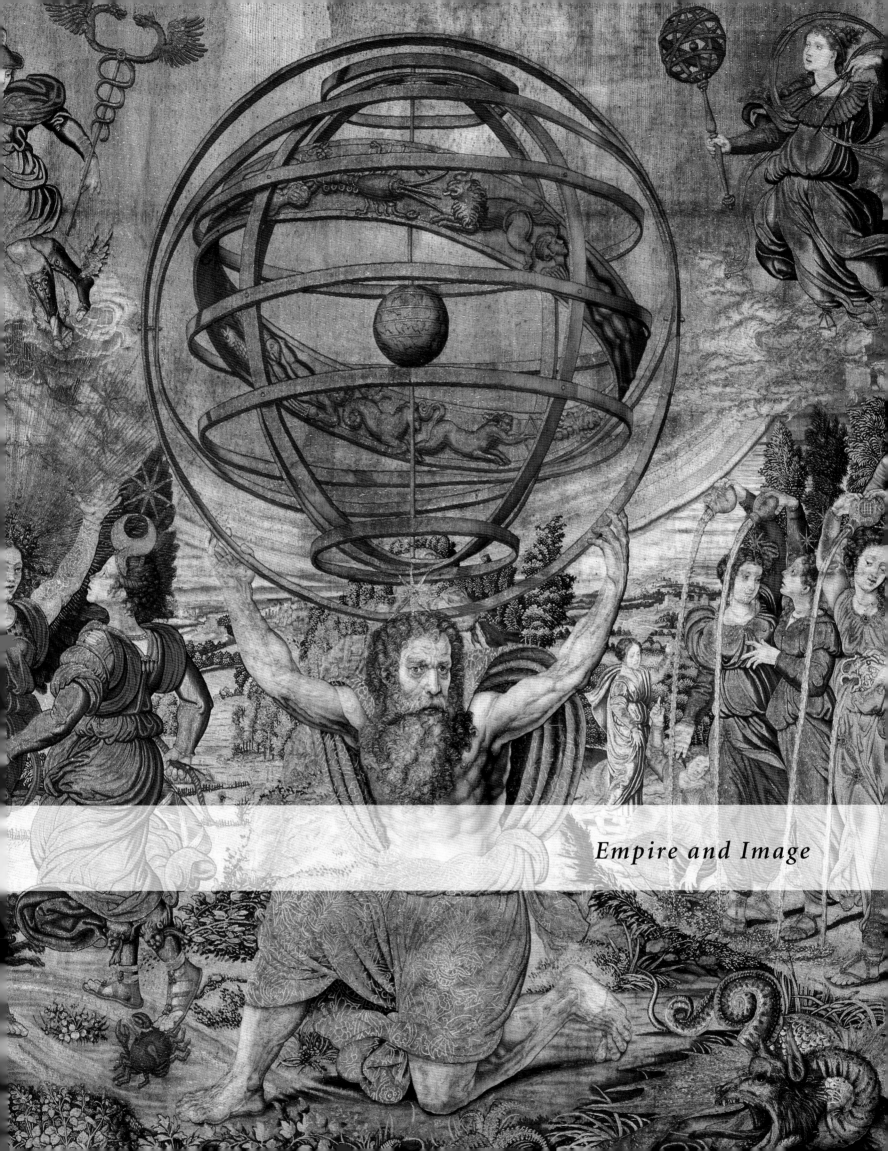

Empire and Image

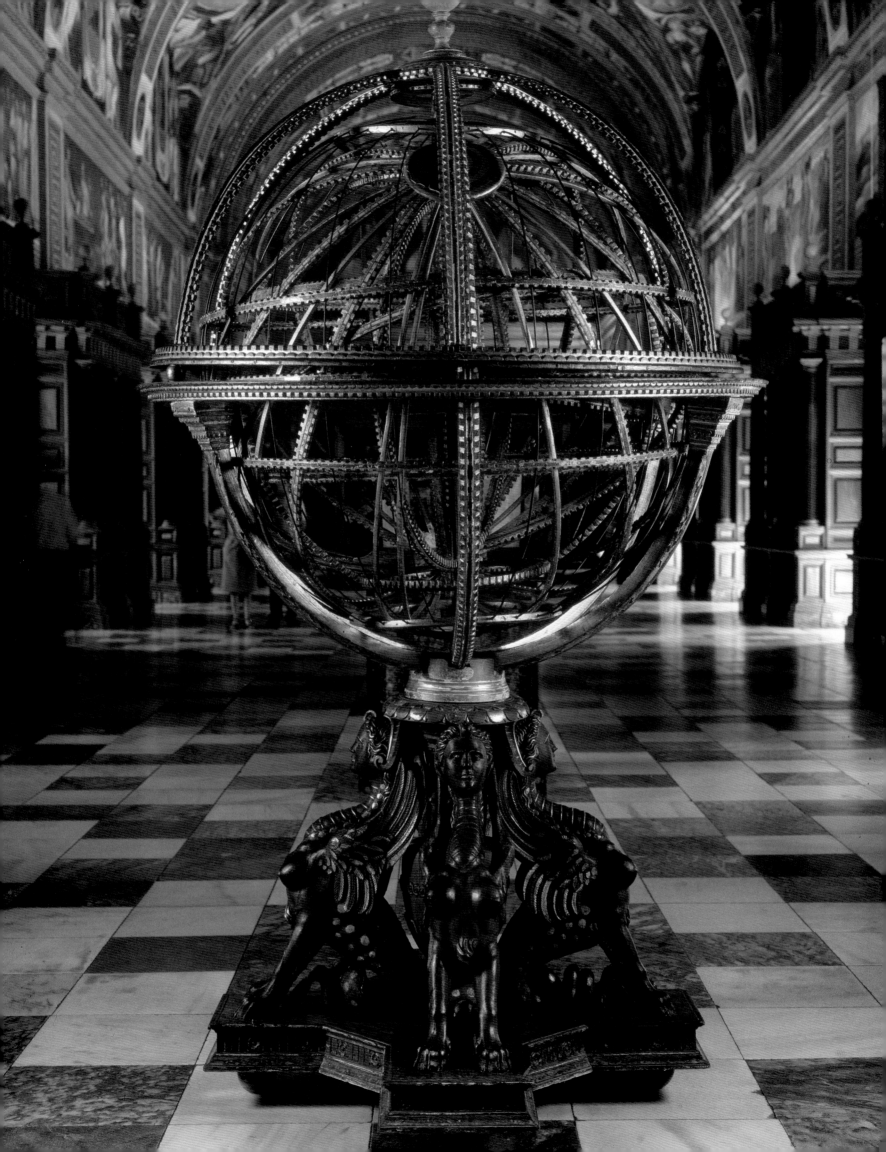

RICHARD L. KAGAN AND
BENJAMIN SCHMIDT

The World of Early Modern Spain
Empire and Its Anxieties in the Golden Age

THE WORLD OF EARLY MODERN SPAIN—the spectacular global expansion and remarkable explosion of political and economic power that took place in the early modern period, as the relatively peripheral kingdom of Castile transformed itself into a bona fide superpower, or "universal monarchy," in the argot of the day—is commonly introduced with reference to two signal events. Both are magical "moments" of historical drama: vivid episodes that are understood to encapsulate the spirit of the age and the trajectory of a nation, characteristic affairs that, with hindsight, are believed to have been instrumental in the launching of the Spanish empire. Both took place in the final decades of the fifteenth century, and both are regularly recounted by chroniclers and historians, from as early as the sixteenth century and through the late twentieth.

The first is a poignant tale of two young "lovers"—so, at least, the romantic biographers of the nineteenth century traditionally describe them—whose clandestine marriage in 1469 united the kingdoms of Castile and Aragon and served as the foundation for a single, Spanish-speaking nation on the Iberian Peninsula. The heroine is the incomparable Isabel of Castile, who had been shopped on the royal marriage market and all but thrust into the arms of Alfonso of Portugal. The match would have solidified Castile's dynastic links with its western neighbor, but rather than serve as a pawn in the court's game of international diplomacy, the spirited young Isabel fiercely resisted and contrived to marry the equally hardheaded Ferdinand of Aragon (fig. 6). "It has to be he and absolutely no other," pronounced the seventeen-year-old princess. The Isabel of this historical drama enjoyed a reputation for great beauty—strawberry-blond hair and stunning turquoise eyes, according to court observers—and Ferdinand was likewise known for his good looks and youthful vigor. Yet the Aragonese prince gained greater renown for his cunning: for this occasion, he slyly disguised himself as a manservant and slummed it to the northern city of Valladolid, where the couple met for the first time on a cool October evening in 1469. The rest, as they say, is history: the young lovers married, lived happily ever after, and united the freshly invigorated crowns of Castile and Aragon, thus paving the way for the empire of Spain. Or so the story is traditionally told.[1]

This second story follows directly from the first, yet the emphasis is on war and conquest rather than love and marriage. The year is 1492, the *annus mirabilis* of Spanish history, and the setting is the great Moorish city of Granada, the keys to which the victorious king and queen will claim on the day after the New Year. After two decades of marriage, political consolidation, and economic expansion, Ferdinand and Isabel have established their dominance over the peninsula. They are about to put out the last embers of Islamic resistance, and, within a matter of weeks, they will extinguish the final flickers of a once luminous Jewish community in Spain. Their majesties

PLATE 25

ANTONIO SANTUCCI
(D. 1613)
Armillary sphere
Dated 1582
Painted and gilded wood and metal,
90⁹⁄₁₆ × 52 in. (230 × 132 cm)
© Patrimonio Nacional, Biblioteca del
Real Monasterio de San Lorenzo de
El Escorial (10034500)

49

are approached by a little-known Genoese sailor, who describes to them a far-fetched plan to sail west in order to arrive east: to navigate the uncharted Atlantic Ocean to reach the spice-rich Indies and the empire of the Great Khan (China), who might ally with the Christians. Though initial returns from the voyage seem meager—a modest amount of gold and a few slaves—Christopher Columbus's epochal journey to the so-called New World turned out to be far more profitable than the monarchs could possibly have imagined. America was their bonanza. For in the coming years, Spanish galleons would return with increasingly heavier cargoes of gold and silver, which would finance not only the territorial expansion of the Spanish monarchy but also the religious evangelization promoted by Isabel the Catholic. Castile and Aragon would henceforth supervise a universal monarchy in both name and reality.

There is a third story that rarely gets told, which, neither romantic nor martial, triumphant nor tender, encapsulates another essential, perhaps even quintessential, moment in the making of Spain. On September 18, 1517, after a horrendous two-week journey capped by an awful bout of Atlantic weather, the young Charles of Ghent and his Burgundian entourage dropped anchor off the coast of Asturias. At the sight of the forty-ship fleet, the sheepherding locals fled to the hills, armed with staffs and knives. The peasants returned a few days later, though only after their scouts reported that the alien was no invader but their newly named royal majesty. This reconciliation notwithstanding, matters only deteriorated for the future king. Since bad weather had thrown the ships off course, those locals who had greeted the prince with such circumspection were now obliged to assemble a crew of oxcarts and mules to convey him and the two hundred noblemen of his court to Tordesillas, some 150 miles inland. Charles, already thoroughly ill from the ocean voyage, insisted on being taken away from the sea air, which meant driving the mules into the mountains and the torrential seasonal rains, and following back roads utterly unfit for the royal party. It took more than a month and a half to reach Tordesillas, during which time Charles could ponder the dourness of the country he would soon rule and the grave suspicion the populace harbored toward him, the new "Spanish" monarch. For the sixteen-year-old Habsburg prince, raised by Burgundians and Austrians and fluent in Flemish and French, was by inheritance sovereign of Castile and Aragon.[2]

This last story suggests a somewhat more inauspicious opening to Spain's imperial drama than the first two. It also points to a factor in Spanish history not so readily admitted by the chroniclers and historians: plain good luck. Within two years of Charles V's ascent to the Spanish thrones (as Charles I of Castile; he was the fifth Holy Roman Emperor of that name), he received reports from the New World of the conquest of Mexico and the acquisition of a fabulous empire in New Spain. The following decades brought more good news from America—most dramatically, the conquest of Peru—along with the bullion that financed the expansion and consolidation of Charles's territories in the Netherlands, Germany, Austria, Hungary, Italy, and the Mediterranean islands that he inherited together with the kingdom of Aragon. Charles, above all, was the beneficiary of excellent royal genes: he was on one side the grandchild of the Spanish monarchs, Ferdinand and Isabel, and, on the other side, heir to vast lands in Central Europe, the German-speaking

lands, and the Low Countries. The immense princely privileges and sprawling global territories of Charles's birthright were staggering. For reasons that had to do with complex dynastic ties, untimely princely deaths, and inadequate (male) heirs, Charles ruled an empire the likes of which Europe had not seen since the days of Charlemagne. His birth produced the perfect imperial storm.

There is a simple moral to these stories, as pertinent to the world of early modern Spain as to other imperial moments in modern history. Empires happen, yet they do not necessarily or even commonly follow scripted plots. Luck is underrated. The awkward, poorly orchestrated arrival of Charles of Ghent in Spain was emblematic of the accidental, almost inadvertent empire that the prince had inherited and would soon enlarge upon. From its inception, Spain's imperial enterprise, even at its peak in the mid- to late-sixteenth century, had little to do with strategic planning and calculated design. It has the appearance, in retrospect, of a slapdash affair: a hodgepodge of widely separated and loosely coordinated states, which were difficult to govern and costly to defend. It was a structure originally built on the planks of opportunism and improvisation. The rapid transition from peripheral kingdom to global empire, moreover, caused not insignificant anxiety among rulers and subjects alike. Luck giveth, every Spanish monarch well knew (even while imagining good fortune as divine providence), just as easily as it taketh away. And though it is true that the combined resources of the empire catapulted both Spain and its monarchy to the pinnacle of international glory, it also engendered broad resentment from subject populations; chronic warfare and bloodshed; economic hardship and sacrifice; and, inevitably, a steep loss of prestige and cultural decline. Before the decline, of course, came the stunning rise. In its efforts to fashion itself as a global power, the Spanish monarchy gave its support—or provided inspiration—to a magnificent flourishing of culture that we now know as the Golden Age.

BEGINNINGS

The origins of Spain's empire are found in the Middle Ages and the so-called Reconquest (*Reconquista*), the centuries-long struggle to recapture those territories lost following the Muslim invasion of the peninsula in 711. In the course of the eighth century, Muslim armies swept through much of what is now Spain and Portugal, settling eventually in the temperate regions along the peninsula's Mediterranean littoral and its southern portion, otherwise known as Andalusia (from the Arabic, al-Andalus). A majority of the Christian population in these areas converted to Islam, and initial efforts to oust the invaders were few and mild. The triumphal notes struck by later Spanish balladeers and chroniclers notwithstanding, only gradually did the idea emerge of creating a wholly Christian Hispania—to use the former Roman name for Iberia. Throughout much of the Middle Ages, Spain was relatively and peacefully multicultural. Yet a subsequent combination of religious zeal and territorial ambitions gave the Reconquest a fresh push, and in the first half of the thirteenth century Iberia's principal Christian states—Portugal to the west, Aragon in the east, and Castile and León in the center and north—successfully ousted Muslim rulers in every part of the peninsula except the southern mountains around Granada. At this point, however, the Reconquest lost momentum, and military policy ceded to fiscal realities: Christian rulers, especially the kings of Castile, preferred to tax Granada rather than launch new crusades, and what few attacks took place in the later Middle Ages generally took the form of opportunistic raids organized by individual noblemen more interested in plunder than faith.

This situation changed when the kingdoms of Castile and Aragon united, thus centralizing the scattered efforts to reclaim the peninsula. The 1469 Union of the Crowns, as Isabel and

Ferdinand's marriage came to be known, created a whole that far surpassed the sum of its parts—a development that Isabel seemed to have intuited in her willful pursuit of the young Aragonese prince. In many ways, however (and certainly to many of the queen's advisors, who pushed for the Portuguese alliance), it was an odd fit. Castile was a mountainous, sparsely populated region whose economy, based primarily on animal husbandry and the export of wool to northern Europe, had little in common with its neighbor to the east. Aragon's economy by this time comprised and was dominated by the commercially inclined regions of Catalonia and Valencia. The Aragonese, and especially those residing in the thriving coastal cities of Barcelona and Valencia, inhabited a wholly different world than the sheepherders of Castile. They were oriented toward the Mediterranean and its trade in luxury goods; their merchants enjoyed closer ties to the Italian city-states than to the hamlets of the central Iberian plateau. Whereas Aragon traditionally faced the East, Castile, meanwhile, had begun to look westward through Seville and other Andalusian ports. Taken together, these differences account for the reluctance of the new rulers to create a single, truly unified kingdom, yet they also suggest how much the two economies and polities stood to gain from the new arrangement. In the end, Castile and Aragon remained separate entities, each with their own laws, traditions, and institutions, and they would remain so until the early eighteenth century, when Philip V created the polity known as Spain. Yet the joined monarchies operated in coordination and with notable cooperation.

Despite their divisions—or perhaps, cannily, because of them—Ferdinand and Isabel embarked on multiple collective enterprises that soon assumed a unified, imperial form. The combined resources of their kingdoms enabled the monarchs to pursue a more strenuous and concerted effort than hitherto feasible. This meant, first of all, the definitive conquest of Granada. Starting around 1480, and in an effort plainly designed to rally popular (Christian) support, Ferdinand and Isabel announced the launch of a new crusade against the last remaining Muslim stronghold on Iberian soil. After a tiring and costly campaign, their moment of triumph finally arrived on January 2, 1492, when the king and queen entered the Moorish city and raised their standard above its imposing citadel, the Alhambra. The victory earned the monarchs enormous prestige, at home and abroad. It also brought them the title "the Catholic Monarchs," which they received from a grateful papacy in recognition of their perceived service to the Christian faith.

The monarchs took their new moniker seriously. On the heels of their 1492 victory, Ferdinand and Isabel pushed their kingdoms farther along the road to empire by taking two signal actions. Both policies, historians now agree, not only shaped the course of Spain's Golden Age but also redirected the flow of Western history. The first was the decree of March 31, 1492, requiring all Jews within their realms to choose between conversion to Christianity or expulsion from the Spanish kingdoms. The second, announced just weeks later, was the monarchs' decision to underwrite Columbus's proposal to reach the "Indies" by sailing a still uncharted trans-Atlantic route. The two moves were not unrelated, in that both hinted at the strong spiritual drive propelling the new Spain, particularly the devout Isabel. The expulsion decree fit the monarchs' firm desire to recreate Hispania in a fully Christian guise. It correlated to an earlier decision, in 1478, to create the notorious Spanish Inquisition: a special ecclesiastical tribunal charged with the extirpation of heresy among the substantial population of *conversos,* or converted Jews, residing in Isabel and Ferdinand's respective kingdoms. Most *conversos* were in fact practicing Christians, and the Inquisition, rather than hunting down Jews per se (many of whom had long since left the peninsula), was designed to assure orthodoxy among these so-called New Christians. As such, it was staunchly opposed by the *conversos* themselves, many of whom considered themselves—and comported

themselves as—loyal Catholics. Yet the monarchs, as anxious as they were energetic in their pursuit of religious unity, looked to the Inquisition to guarantee the religious purity and cultural uniformity of the realm. In its formative stages, then, the Spanish empire was conceived as a spiritual empire; its guiding policies sought to suppress all forms of religious practice inconsistent with orthodox Catholicism.

The arrival of Columbus with his fabulous navigational scheme in many ways fit Spain's broader agenda. Spain, famously, was not first. The Italian navigator had been peddling his theories for some time to multiple European princes. Court scholars of the day had sensibly rejected his calculations of the globe's circumference and the disposition of its continents— calculations that led Columbus to conclude that China was a relatively easy sail from the Canary Islands, with no major landmass en route—and the Spanish monarchs, too, initially had been skeptical. But in the immediate aftermath of the expulsion decree, their opinions changed. The precise arguments that Columbus used to convince them remain unknown, but he apparently piqued their interest by appealing to them on three levels. He promised, first, the profits they would collect by tapping into the lucrative Asian trade in spices, jewels, and other precious commodities. This commerce had long been dominated by the Venetians and other Italian merchants, and lately encroached upon by the Portuguese, who had reached India by rounding the Cape of Good Hope. Columbus's new route, if successful, would enable Ferdinand and Isabel to best the Italians and outmaneuver Castile's longtime Portuguese rivals. Second, Columbus would have tempted the Catholic Monarchs with religious arguments—God as well as gold. His voyage, they hoped, might lead to the conquest and conversion of Asia, particularly the subjects of the Great Kahn, of whom Marco Polo had so favorably reported. Medieval Christianity had long considered the evangelization of Asia as a necessary first step on the road to universal Christianity, itself a precondition for the second coming of Christ. Columbus harbored a personal interest in such matters, as his more apocalyptic writings and references to himself as *Christo Ferens* (Bearer of Christ) suggest, and these arguments no doubt pleased Isabel, who strongly supported the church. Their attraction for the more secular-minded Ferdinand points to a third line of appeal: imperial expansion, spiritual or not. For Ferdinand—who would later become a model for Machiavelli's *Prince*—harbored a notion of himself as a latter-day Alexander the Great, whose destiny was to conquer not merely the holy city of Jerusalem but the edges of India as well. Ferdinand never got that far, yet such imperial musings encouraged him, following Isabel's death in 1504, to launch several crusades against Muslim outposts in North Africa in the hope of eventually expanding his domains.

Whatever their motivations, the monarchs agreed in April 1492 to lend their support to Columbus, who prepared to depart in August of that year. And whatever the expectations, the results of that epochal voyage were unequivocally stunning. For upon his return in early 1493, Columbus conveyed to the king and queen the astonishing news of having reached the "Indies"— which he believed, to his dying day, represented islands off the shores of the Far East. He reported discovering "timorous" yet welcoming aboriginals, whom he imagined readily converting to Christianity. (This sentiment did not prevent him from forcing a handful of captured Tainos to make the return journey in shackles, an act that shocked the queen, who ordered them freed at once.) He sketched and brought back with him maps of the islands he had explored. And, most sensationally, he described the "marvelous" flora, fauna, and mountains of gold that awaited their majesties.[3] Such wonderful descriptions enticed the monarchs, who moved quickly to fund further voyages (Columbus undertook another three) and to support their admiral's plans to

establish a permanent settlement on Hispaniola. This he soon did, and though Columbus's promised riches were slow to materialize, the effects of his explorations were immediate and extensive. Printed pamphlets trumpeting his discoveries and the reputed wealth of the New World circulated throughout Europe, adding immeasurably to the Catholic Monarchs' prestige. As early as 1494, the papacy confirmed in the Treaty of Tordesillas Spain's exclusive title to the Americas, Brazil excepted, with the proviso that they and their successors pledge to extend and protect the faith in whatever lands they should conquer. The "enterprise of the Indies" had been launched.[4]

During the course of the next decade, Ferdinand and Isabel brought the exploration and settlement of the New World under royal supervision, establishing a pattern that would last, in its basic form, for the next three centuries. The first of many royal governors arrived in Hispaniola in 1501, and two years later the monarchs established in Seville the House of Trade, or *Casa de Contratación,* to monitor all commerce with the Indies and to oversee the production of sea charts and navigational instruments for Spain's newly invigorated maritime industry (pl. 26). The king and queen also granted Seville's merchants exclusive licenses, or monopolies, to trade with the Indies, a privilege they guarded until the eighteenth century. For itself, the crown reserved the right to a "royal fifth": a 20-percent tax on all wealth imported from the Americas. Perhaps more symbolically than practically, King Ferdinand issued in 1512 a series of laws meant to monitor the developing colonial society of America. Named after the town in which they were promulgated, the Laws of Burgos responded to unsettling reports that the colonists had been enslaving and otherwise brutalizing the native population (see pl. 46). The crown officially disapproved and, with these laws, intended to protect the rights of the Indians (now legally Spanish subjects), to hasten their conversion to Christianity, and to strengthen royal authority overseas. The Laws of Burgos quite bluntly decried Spanish exploitation of the natives and proscribed colonial rights. Tragically, however, the laws were widely disregarded in America. While they remained a source of contention and even a rallying cry for those who would protect native rights, they functioned mostly to establish a legal precedent: the crown would be the ultimate governing power overseas.

The events of 1492 shifted the strategic gaze of the Spanish monarchs. With the kingdom of Granada finally subdued, they could now turn their attention away from the south, which had long mesmerized them, and focus on other opportunities. The west may have been the most dramatic, yet, in fundamental ways, the east and the north also attracted the monarchs' interest. Indeed, for all its importance, America was by no means the Catholic Monarchs' main area of concern. Italy, particularly Naples and Sicily, both of which had been Aragonese possessions since the early fifteenth century, was far more strategically significant and economically critical in the short run. Italy and the eastern Mediterranean were lately threatened—in some places dominated—by the Ottomans, and in 1500 Ferdinand dispatched a large expeditionary force commanded by "*El Gran Capitán,*" Gonzalo Fernández de Córdoba, to turn back an Ottoman force that had been menacing the sea lanes and settling bases in southern Italy. In doing so, Ferdinand initiated what would ultimately amount to a two-century history of Spanish involvement in Italian affairs. Also engaged in Italy were the French, and the Valois king posed another set of worries. In this case, the Spanish monarchs launched a two-pronged attack, at once military and diplomatic. The wars in Italy included ongoing and ultimately costly fighting against the armies of France; Spain generally had the upper hand. Yet in an effort to isolate the French crown, Ferdinand and Isabel used their children to forge alliances and further dynastic interests. They arranged to wed their daughter Isabel to Emmanuel I of Portugal, and they married Catherine of Aragon to Arthur, heir to the English throne. Upon the latter's premature death—and after much diplomatic maneuvering,

both with England and the pope—they arranged for the marriage to be annulled and for Catherine to become the wife of Arthur's brother, the new king, Henry VIII. This marriage, famously, failed, the resulting divorce causing Henry's break from the Roman Catholic Church. Ferdinand and Isabel also solidified their alliances with the Habsburgs, matching their only son, Juan, and another daughter, Juana, with the two children and heirs of Maximilian of Austria and his wife, Mary of Burgundy. This established closer relations with the Low Countries, one of the wealthiest regions of Renaissance Europe, and it encouraged important exchanges with the flourishing markets and cultural centers of Flanders. One of the many expressions of that exchange was Isabel's patronage of Juan de Flandes—John of Flanders—who produced many of the paintings that filled the queen's collection (pl. 27).

Ultimately, the marriage offensive more than military campaigns propelled Spanish power to hitherto undreamed-of heights. The untimely deaths of Juan (1497) and Juana's husband, Archduke Philip the Fair (1506), led to an unforeseen yet critical turn of affairs. This wholly un-predictable turn excellently illustrates the accidental nature of the Spanish empire. Though right-ful heir to both Ferdinand and Isabel's kingdoms, Juana was deemed mentally unstable (unjustly, historians now believe) and therefore unfit to rule Castile and Aragon: hence the name Juana la Loca, or Joan the Mad. As a result, Juana's Spanish inheritance passed through a joint kingship to her eldest child, Charles, who also inherited, from his paternal grandmother, vast lands in the Low Countries and northern France. Ten years later (1516), on the death of his grandfather Ferdinand, Charles became king (as Charles I) of Aragon, Navarre, Granada, Naples, Sicily, and

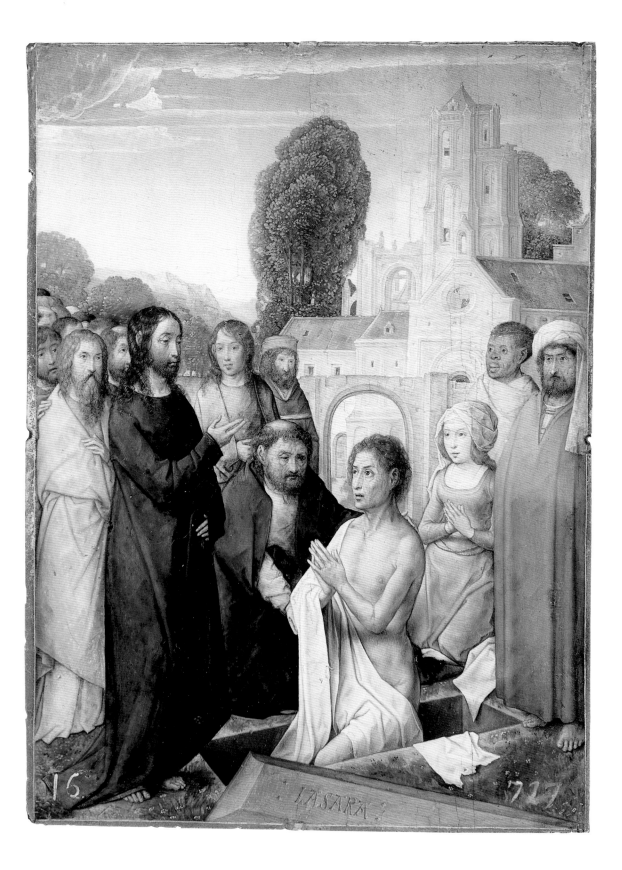

PLATE 27

JUAN DE FLANDES (ACT. 1496–1519)
Raising of Lazarus

 C. 1504
 Oil on panel, approx. 8¼ × 6³⁄₁₆ in. (21 × 15.7 cm)
 © Patrimonio Nacional, Palacio Real, Madrid (10002019)

Sardinia; and now Castile formally devolved to him. With the passing in 1519 of Charles's paternal grandfather, Emperor Maximilian I, the young prince (as Charles V) came into the hereditary lands in Germany and central Europe of the Austrian House of Habsburg. Thus was born the largest empire Europe had seen since the days of Charlemagne. Thus, too, in this roundabout way, the nascent Spanish empire of Charles I—king of Castile and Aragon, and in possession of a growing dominion in the Indies—merged with the Habsburg empire of Charles V of Germany. This linkage earned glory and fame for Charles and, by extension, the monarchies of Spain. Yet it also imposed a heavy burden on the king's Spanish subjects, particularly the Castilians, as it involved them in the affairs of northern and central Europe at the very moment when their energies were directed westward, toward the Americas. It produced, moreover, an anxiety born of the sudden transformation from isolated kingdom to sprawling empire. The ascendance of Charles had abruptly thrust Castile onto the center of the European—indeed global—stage of history.

"THE WORLD IS NOT ENOUGH"

While Charles V's birthright must be considered among the most dynastically auspicious in European history, what is most impressive about Charles's life—and, by extension, the history of the Spanish empire, whose fortunes rose and fell along with the monarchy's—is not merely the remarkable good luck of his ascension to power, but the magnificent dimensions and the brisk succession of luck's good strokes. The inheritance of Charles was substantial enough, yet it quickly grew to be more. By the age of nineteen and by the sheer good fortune of his ancestry, Charles had gained control of a sprawling conglomeration of territories, peoples, and privileges—an "empire" more in theory than in practice, since the teenage prince had barely assumed power in one state before the next came into his possession. In 1520, the year following the death of his final grandparent—Emperor Maximilian I—Charles was elected Holy Roman Emperor, which furnished the fledgling ruler even more prestige and power (Voltaire's witty dismissal notwithstanding: neither holy, Roman, nor imperial, the philosopher legendarily quipped). And the next year brought another generous helping of good news: word reached the Spanish court that Hernán Cortés had captured the powerful Aztec ruler, Mocteçuma, and seized control—in the name of his sovereign—of the capital city, Tenochtitlán. By the next decade, the Incan empire of Atahualpa would likewise fall to the Spanish and Charles's jurisdiction, and the mineral wealth of Peru, with that of the rest of Spanish America, promised more conquests to come. Charles had swiftly gone from fantastically rich to fantastically richer—and so, too, Spain.

In capturing Mocteçuma, Cortés made much of the imperial transfer of power: the one "emperor" ceded sovereignty to the other. In truth, this tactical (and legal) strategy represented an audacious, improvisational maneuver by a soldier in the field appealing to his minders at court.[5] Though Charles by now had been officially elected Holy Roman Emperor—a largely ceremonious position that pertained more to German affairs than Roman—he was not emperor per se of his other territories, Spanish or American. What did it mean to be an emperor in early modern Europe? Prompted precisely by the novel situation of Charles, this question was hotly debated if hardly resolved. Support for the idea came initially from one of his advisors, Mercurino Gattinara, who conceived of Charles as an emperor capable of uniting Christendom and creating a world monarchy. "Sire," wrote Gattinara, in an oft-quoted missive,

> God has been merciful to you; he has raised you above all kings and princes of Christendom to a power such as no sovereign has enjoyed since your ancestor Charles the

Great [that is, the Carolingian king Charlemagne]. He has set you on the way toward world monarchy, toward the uniting of all Christendom under a single shepherd.[6]

A similar message came from Luigi Marliani, the Italian humanist and physician who designed Charles's famous heraldic device: the Pillars of Hercules inscribed with the words *Plus Ultra.* While Gattinara's "world monarchy" had plainly religious, even eschatological, implications—uniting Christendom was understood as hastening the second coming of Christ—the Pillars of Hercules denoted a secular message that invoked classical mythology. They referred to the supposed Spanish lineage of the Greek hero, and to the Strait of Gibraltar, the limits of the Herculean realm. The phrase *Plus Ultra*—"even further"—implied that Charles was destined to carry his empire beyond the legendary pillars to Africa, Asia, and the world beyond—which now included America. For Marliani, Charles's destiny resided in a bona fide empire, and this was a concept the young ruler embraced as his own.

In fact, Charles did find himself ruler of an immense expanse of territories and peoples, and the challenges were likewise vast, both for the ruler and his often beleaguered subjects—especially those in Spain. The emperor had to wage war, quiet uprisings, and defend the faith in a time of historic unrest. Above all, he had to balance the demands of an enormous and expensive military, which found itself challenged on multiple fronts and without pause for the duration of Charles's reign. This all cost copious amounts of money, and herein lies the great Achilles' heel of empire—Charles's and most others. Shortly after his arrival in Spain, the new king turned to his Castilian subjects to help pay for his imperial election. Yet just as he prepared to depart for his German lands, he faced organized resistance in an armed uprising, known as the Revolt of the Comuneros, against his taxation. The revolt was an embarrassment for Charles, and it limited the time he could spend on another front, the Diet of Worms, where he had to face down Martin Luther's religious challenge. But it did little to dampen his appetite for expansion. Indeed, in keeping with his universal ambitions, the emperor led a resolutely warrior life, as the magnificent suits of armor in which he regularly had himself depicted suggest (pl. 28; see also pl. 48). Charles assumed the role of a *miles christianus*, a Christian knight who pledged to defend not only the territorial integrity of his empire but also the spiritual unity of the Catholic Church. This expanded his responsibilities and his enemies, which at various times included the kings of France, the Ottoman sultans, the Protestant princes, and even the pope. In the course of his reign, Charles necessarily evolved from a chivalric warrior, who relished princely combat, into an "impresario of war": a ruler concerned with planning strategy, raising troops, and funding campaigns.[7] This last task could not be done without his subjects, and increasingly the emperor looked to Spain—Castile in particular—to pay his bills. He also helped himself to his share of Mexican and Peruvian treasure—one-fifth of the mined wealth was his by law, though more could be extracted through imaginative levies. American bullion, converted into coin, paid for Charles's often mutinous soldiers and served as collateral for loans. In exchange for their support, Charles's Castilian allies received patronage of various sorts—honors, titles, lucrative offices—although most ordinary men and women of the realm got little more than higher taxes or hard service as foot soldiers in the king's armies. Spain, in short, had to learn the hard lesson of empire: whatever its heady triumphs, it was exceedingly expensive.

Charles's four-decade reign was glorious yet taxing. The greatest ruler of Europe developed crippling gout and other infirmities from a relatively early age; by midlife he was all but immobile. Beginning in the 1550s and at the height of his power, the emperor did what few men of great

PLATE 28

FILIPPO NEGROLI (RECORDED 1525–1551) AND
FRANCESCO NEGROLI (RECORDED 1542–1553)
Battle armor of Charles V

c. 1546
Gold, steel, silver, h. 69⅞ in. (177.5 cm)
© Patrimonio Nacional, Real Armería, Palacio Real, Madrid (19000283)

personal authority succeed in doing: he voluntarily relinquished the reins of power and prepared to retire to a monastery in secluded Extremadura. This meant splitting up the empire. In 1554 Charles gave Naples and Milan (the latter won through war) to his eldest son, Philip II, to whom he likewise turned over the rich provinces of the Netherlands in 1555. The following year, the emperor abdicated the crowns of Castile and León, also to Philip, and by this time he all but surrendered his control of the Austrian lands to his brother, Ferdinand, who officially became "emperor" in 1558. This formally separated the Austrian branch of the Habsburgs from their Spanish cousins, and in the process, removed the Spanish monarchies from the crises and confessional developments in Germany.

The abdications of Charles V opened a new chapter in the history of Spain. Though his sovereign reach in no way approached that of his father, Philip II (r. 1556–98) assumed the throne as Europe's most powerful monarch. In fact, his empire was still expanding, if in other directions. The Spanish crowns, the Italian possessions, and the Netherlands already constituted a considerable realm. On top of this came the West Indies and Mexico. In the Americas, moreover, royal officials successfully suppressed a rebellion led by the Pizarro brothers, which allowed them to establish Spanish rule over much of the Andes. Farther north, Spaniards based in Mexico had begun to push into what is now lower ("baja") California and the American Southwest. Philip could also lay claim to territories in Asia, such as the eponymous Philippines in the western Pacific. In 1521 the Portuguese mariner Ferdinand Magellan had discovered the so-called Western Islands while in the emperor's employ. The territory was subsequently renamed after Prince Philip in the year of his birth (1527), and it served, by the 1550s, as a crucial stop in the circular trade of the Indies. Reaching east as well as west, Philip's grand empire could now be described as one on which the sun never set—as it was by (among others) the great Italian poet Torquato Tasso. Yet the Spanish monarchy remained restless. In 1580 Philip took advantage of the death of Sebastian of Portugal to invade that kingdom and annex it to his own, bringing under Spanish control Portugal's considerable possessions in Africa, South Asia, and Brazil. Philip even set his sights on China, and although these plans never materialized, his territorial ambitions were conspicuous in virtually all his policies, domestic as well as foreign. They are also reflected in a commemorative medal, struck in Lisbon around 1582, with the telling inscription *Non sufficit orbis:* "The world is not enough." By this time, Philip's world was more expansive than even his father's.[8]

Under Philip II, Spain reached the pinnacle of its power, and Madrid, made capital after 1561, stood at the center of the largest global empire Europe had known since the ancient Romans. Yet power on a global scale, as the Romans had learned, posed multiple challenges, not least of which was finding ways to govern and defend a series of noncontiguous states spread across several continents. "Distance," as one scholar of the Spanish empire has noted, "was enemy number one" and a problem the Habsburgs (not unlike other aspirants to imperial rule) could never quite overcome.[9] There were, most essentially, technological handicaps. It took a full year to retrieve a message sent from Madrid to Mexico City, far longer if the message had to go on to Manila or the Portuguese Moluccas. Compounding such naturally insurmountable difficulties were problems of Spain's own making. The Habsburg culture of governance, particularly the tendency to centralize their affairs, crippled expediency. This can best be seen in the practice of housing authority in a series of councils based in Madrid which ultimately answered to the king. As a result, the royal bureaucracy that governed the empire (or the *maquina* [machine], as it was sometimes called) rarely functioned efficiently. Such practices also encouraged officials in distant lands to circumvent metropolitan authority, an attitude immortalized in the colonial shibboleth *Obedezco sino no*

cumplo—"I obey but do not comply"—uttered regularly by administrators who opted not to implement those royal instructions that arrived long after problems had come and gone.

The empire certainly brought Spain advantages as well. It influenced the economy and society of the metropolis in myriad ways, some with profound and long-lasting effects. Starting early in the sixteenth century, Spain's overseas colonies opened new markets for domestic products, which sparked an economic boom in and around Seville and brought enormous profits to that city's commercial class. Seville, furthermore, grew exponentially in this period. It became a favorite destination for merchants on the make, both Spanish and foreign, and it attracted thousands of would-be émigrés who felt the lure of the New World. By the late sixteenth century, Seville had become one of the most cosmopolitan cities in Spain as well as Europe. It was a veritable "Babylon" according to observers, foreigners comprising a sizable proportion of a population that surpassed 100,000 by the end of the century.[10] Seville and the rest of Spain also benefited from an emporium of imported goods that changed the way Spaniards lived: chocolate, tobacco, tomatoes, and pepper all made welcome contributions, with time, to the Spanish diet. And there was much more. New plants entered Spanish botanical gardens; new animals roamed Spanish menageries; and new fabrics, such as increasingly less expensive cottons from the Indies or more refined silks from China (by way of Manila), filled Spanish wardrobes. Imported products, habits, and peoples gave the Iberian Peninsula a profoundly global look.

The polyglot, multicultural qualities of cities like Seville echoed the broadening, multi-national accent of the empire, and this points to the more pervasively cultural resonance of the Habsburg expansion. As Henry Kamen has recently asserted, Spain's empire was never entirely Spanish. Rather, it consisted of officials drawn from various parts of the world that came under the rule of Madrid.[11] Charles V's courtiers commuted from Flanders and Italy and, only later, from Castile itself; while Philip II's (and his sons') finest military commanders—such as the duke of Parma, Alessandro Farnese, or the Genoese general and financier Ambrosio Spínola, who served both Philip III and Philip IV—commonly hailed from abroad. From 1580 through 1640, when Portugal formed a part of the Catholic monarchy, Lusitanian aristocrats occupied important positions at the Castilian court. In a sense, early modern Spain continued the tradition of openness that had been the hallmark of medieval Spain—yet with a difference. The earlier coexistence of the competing Christian and Islamic monarchies gave birth to cultural and religious *convivencia,* as it was known; Jews, too, were tolerated, until the pogroms of the late fourteenth century and the expulsions that followed. Sixteenth-century imperial Spain was no model of religious tolerance, to be sure, yet it was open in the sense of welcoming a population of international provenance and diverse cultural backgrounds, who mixed in the cities, the courts, and even the countryside. Spain, in this way, was more sympathetic to foreigners and foreign ideas than is generally suspected.

This receptivity extended to other areas, especially the arts. Contrary to the belief that early modern Spain closed its doors to artists from abroad and to imported styles and cultural practices of the Renaissance, the sixteenth century was an exciting period of borrowing and experimentation in Spanish art, architecture, and theater. This impulse may have originated, in part, from the many sophisticated royal servants stationed abroad, who took home with them newfangled interests and fresh perspectives from their host countries: an attraction to classical literature and antique forms, as was pervasive in Italy and the Low Countries; a fondness for Flemish painting and the gardening styles of the North; a love of German armor and expertly printed books. In many spheres of cultural interest, the Spanish monarchs led the way, none more so than the reputedly

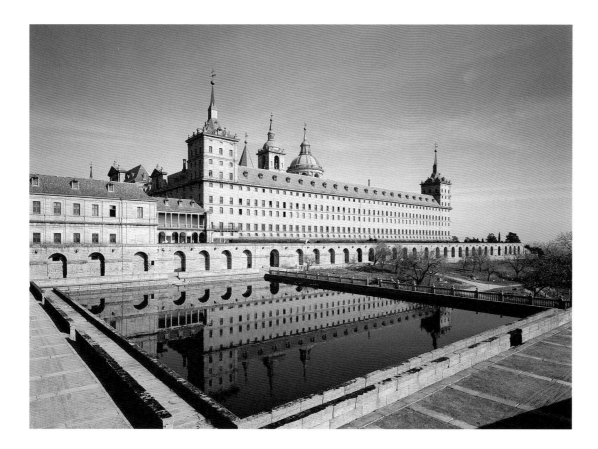

Fig. 7 Real Monasterio de San Lorenzo de El Escorial, located about 30 miles outside Madrid and constructed during the reign of Philip II as a monastery, royal burial site, and palace. © Patrimonio Nacional, Madrid

closed-minded Philip II, who avidly collected and commissioned artists from abroad. Born in Valladolid and generally regarded as the first genuinely "Spanish" Habsburg, Philip tended to favor either Italian or Flemish painters or, in the case of court portraitist Alonso Sánchez Coello, Portuguese. Even his beloved court cum monastery of San Lorenzo de El Escorial, the building most closely identified with Philip's taste, displayed an enthusiastic mixture of architectural elements from Italy, Portugal, and the Low Countries (fig. 7). The monastery itself was built on a grand scale in a small mountain town northwest of Madrid, and it embodied the cultural range of the empire. Initially intended to commemorate the Spanish victory over the French at the battle of Saint-Quentin on August 10, 1557, the feast day of St. Lawrence, Philip emended the original designs so that building could also serve as a mausoleum for his father, Emperor Charles V, and a showcase to demonstrate the breadth of Philip's artistic tastes. Titian supplied his masterly *Adoration of the Magi* (pl. 29) a work intended for the original tomb of Charles V. Philip commissioned many other Italian or Italianate artists to supply paintings, including Jacopo Bassano (pl. 34), Frederico Zuccaro, Pellegrino Tibaldi, and the Venetian-trained (and Greek born) El Greco (pl. 31). In the course of his reign, Philip transferred to El Escorial much of his private art collection, at that time heavily weighted to paintings from his northern European domains—works by the Flemish master Rogier van der Weyden, for example, and the enigmatic Hieronymus Bosch (pl. 30). The library of El Escorial was likewise designed to celebrate Philip's intellectual range. Organized around the theme of the seven liberal arts, it included rare manuscripts in Greek, Latin, Hebrew, and Chaldean, published books in a variety of languages, and maps and engravings gathered from across Europe (fig. 8). It housed an invaluable collection of items reflecting Philip's curiosity about the Americas, among them a magnificent series (now lost) of botanical drawings by Francisco Hernández, a physician sent by Philip to Mexico in the 1570s on what was arguably the first scientific expedition to the New World. Even the throne room evoked an imperial theme. To emphasize

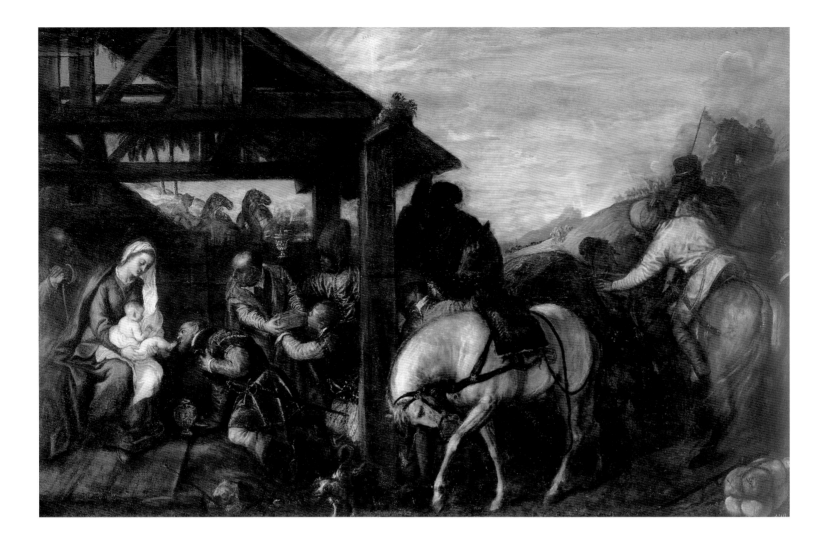

PLATE 29

TITIAN (TIZIANO VECELLIO, C. 1485–1576)

Adoration of the Magi

1559–60

Oil on canvas, 57½ × 90³⁄₁₆ in. (146 × 229 cm)

© Patrimonio Nacional, Real Monasterio de San Lorenzo de El Escorial (10014835)

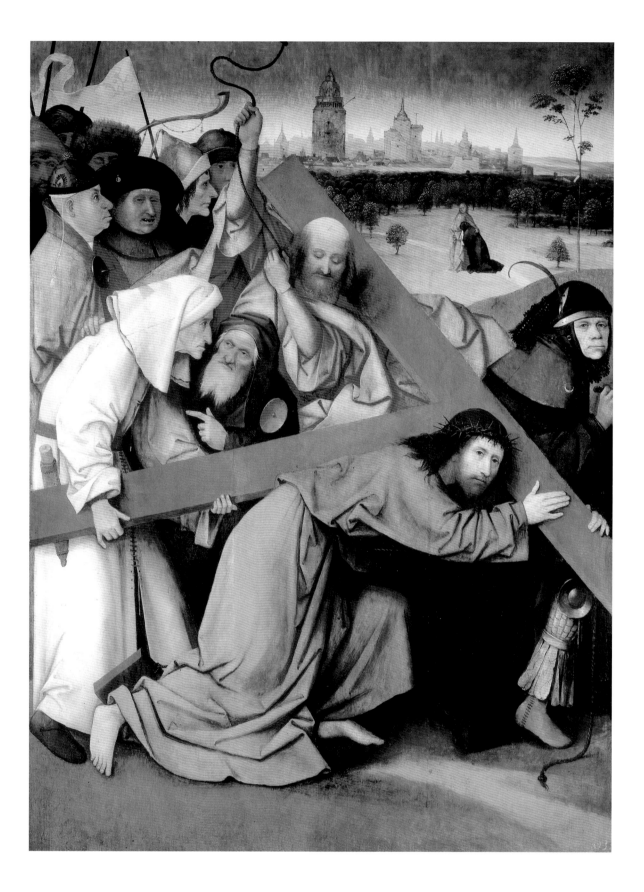

HIERONYMUS BOSCH (C. 1450–1516)

Christ Carrying the Cross

1505–7

Oil on panel, 55⅛ × 40⅜ in. (140 × 102.5 cm)

© Patrimonio Nacional, Real Monasterio de San Lorenzo de El Escorial (10014739)

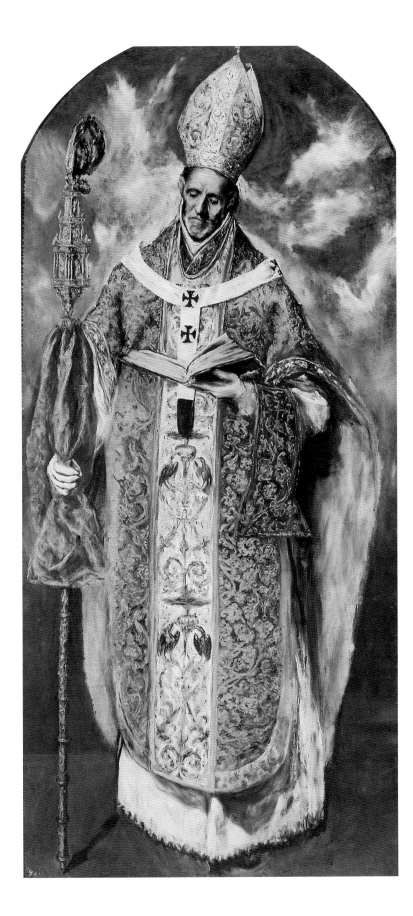

PLATE 31

EL GRECO (DOMENIKOS THEOTOKOPOULOS, C. 1541–1614)

Saint Ildefonso

1608–14

Oil on canvas, 86¼ × 41⁵⁄₁₆ in. (219 × 105 cm)

© Patrimonio Nacional, Real Monasterio de San Lorenzo de El Escorial (10014686)

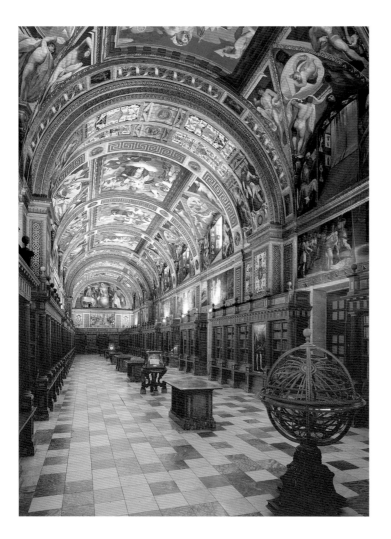

Fig. 8 The setting and furnishings of the great library of El Escorial embody the Spanish court's veneration of learning. Frescoes of the Liberal Arts and Sciences by Pellegrino Tibaldi decorate the ceiling. The magnificent armillary sphere in the foreground, by Antonio Santucci, astronomer to the Medici court, was acquired for the library by Philip II (see also pl. 25).
© Patrimonio Nacional, Madrid

the grandeur of the Spanish Habsburgs, Philip had the room decorated with maps of his many realms taken from Abraham Ortelius's *Theatrum orbis terrarum* (pl. 32)—as graphic a statement imaginable of imperial majesty and dominion.

Such was the perspective from Philip's airy mountain retreat in central Castile. The view from the ground could look somewhat different—and different, too, depending on which piece of ground in Spain's vast territories one stood. Lofty ambitions gave way to earthier, if not baser, instincts. For most ordinary Spaniards, empire was little more than a road to riches; America registered less as a source of exotic wonder or princely prestige than colonial service or quick wealth. The same can also be said of the Netherlands and Italy, where the preponderance of Spain's military served. Bernal Díaz del Castillo, a foot soldier who fought alongside Cortés in Mexico, spoke for many of his peers when he curtly observed, "[We came] to serve God and His Majesty, to give light to those who are in darkness, and also to get rich."[12] Those riches came at the expense of the colonies themselves, and, as Bernal Díaz discovered, did not come easily. Worse, they commonly entailed the exploitation of colonial populations—especially the Native Americans, whose ranks were decimated by European-borne diseases such as measles and smallpox. To replace their potential labor, the Iberians imported thousands of enslaved Africans to the New World, thus extending not the majesty but the misery of empire to the whole of the Atlantic world. The Spanish monarchy, beginning with Queen Isabel, passed laws prohibiting the enslavement of Indians (though not Africans) and requiring settlers to treat native populations humanely. As Spanish legal scholars and theologians alike agreed, the Americans were subjects of their majesties and therefore deserving of the full protection of the crown's (and God's) law. Yet abuses persisted

PLATE 32

ABRAHAM ORTELIUS (1527–1598)

Map of the world from *Theatrum orbis terrarum*

Antwerp: C. Plantin, 1588

Atlas with hand-colored engravings, full sheet approx. 18½ × 23½ in.

(47 × 59.7 cm)

© España Ministerio de Educación, Cultura y Deporte. Archivo General

de Indias, Seville (Biblioteca, LA SXVI-1)

and plagued colonial society, prompting critics, like Bartolomé de Las Casas, to pen harsh assessments of Spain's mission abroad. The "Apostle of the Indians," as Las Casas came to be known, composed his infamous *Brevíssima relación de la destruyción de las Indias* in 1542, a scathing indictment of Castile's comportment in America. This tract directly addressed the king and bluntly detailed the suffering inflicted on the Indians. Making liberal use of biblical simile and employing lurid rhetorical flourishes, Las Casas doubtlessly embellished his brief, but in its published form, the text had a profound influence on European readers. It served as the cornerstone for the so-called Black Legend of Spanish tyranny, as the collective indictment of Spain's imperial history was known, and it was widely promoted by Philip's many enemies. Las Casas's histories, in the hands of Dutch and English printers, propagated a dark vision of Spain's imperial rule, a narrative of cruelty, inhumanity, and injustice that still colors many recitations of Spain's colonial record.

Spain's antagonists swelled during Philip II's reign, as one crisis after another demanded the king's attention, goaded the imperial army, and taxed the royal treasury. Indeed, the final decades of the sixteenth century represented a transitional period for a monarchy that seemed to be inciting enmity on every front. In the Mediterranean, the Ottomans posed a persistent threat that crested in 1571, when Philip II's half-brother, Juan of Austria, as commander of the forces assembled by the Holy League, defeated a Turkish fleet in the waters off Lepanto in southern Italy. The crown celebrated by ordering a *Te Deum* sung in every Spanish church; El Greco commemorated the event with a small painting, *Adoration of the Name of Jesus (Allegory of the Holy League)*, which later found its way into El Escorial; and Miguel de Cervantes Saavedra, who participated in the battle as a young man, looked back wistfully to this imperial moment in his prose works of the early seventeenth century. Philip II had little time to savor this triumph, however, since he soon found himself challenged again, this time from the Protestant North: England and the Netherlands. With the former, Philip's problems began in 1558 upon the death of Mary Tudor (daughter of Catherine of Aragon), to whom he had been unhappily wed for three years. During her brief sovereignty (1553–58), Mary had restored Catholicism to England, but the end of her reign led to the succession of her Protestant half-sister, Elizabeth I, who rapidly became one of Spain's most implacable enemies. The entrenchment of Protestantism in England would have been affront enough, yet the Elizabethan regime intensified its challenge of Philip's empire by supporting Francis Drake and other English privateers determined "to singe the king of Spain's beard."[13] The broader goal of the more hard-line Protestants in the circle of Leicester and Ralegh was to establish a maritime empire in America—New Albion—to rival that of Spain.

Meanwhile, the Netherlands launched what would ultimately become the greatest sustained challenge to early modern Spain: a full-blown revolt that would endure for nearly a century and substantially drain the monarchy's resources. The origins of the Dutch Revolt were political at their core yet, as in most sixteenth-century affairs, had a critically religious dimension. Members of the Flemish and Dutch elites (members, thus, of the Spanish court) had first approached the royal governor in 1566 to protest the intrusiveness of the Inquisition; they wished for local authorities to have greater sway in the maintenance of orthodoxy for this as-yet Catholic region. But Philip II, a hard-liner in matters of faith ("I do not . . . desire to be the ruler of heretics," he once remarked), would not yield, and this provoked the population at large, which began to shift their sympathies to the (minority) Calvinist camp.[14] Hostility toward the Spanish regime only worsened after a series of harsh measures were carried out by the king's military commander, the duke of Alba. So began a protracted war—it lasted until the Peace of Münster in 1648—which pitted the

Dutch determination to form an independent state against Philip's single-minded zeal to preserve the religious and territorial integrity of his empire. Toward this end, Spain committed huge resources: silver from America, tax revenues from Castile, cash loans from Italy, soldiers from the entire empire. While fighting was initially confined to the Low Countries, it soon spread to England, where members of the Elizabethan court lent support to their Protestant brethren. The joining of the two "heretic" nations would provoke Philip to disastrous ends. In 1588, hoping to cut the rebels off from their English allies, the Spanish monarch sent his "Invincible Armada" on a poorly planned—and enormously expensive—mission to depose Elizabeth and replace her with a Catholic monarch favorably disposed to Spain. The resulting defeat ranks among the grandest of European history. It utterly dampened the optimism that until then had characterized Philip's rule.

If the start of Charles V's reign marked the stunning ascendance of Spain, then the close of Philip II's may likewise be seen as a major turn in the fortunes of the monarchy. It is not that Spain, following the stinging defeat of its armada, abruptly collapsed. On the contrary, the monarchy and its empire continued to exist and even dominate European and American affairs for the coming decades; deep into the seventeenth century, Spain still carried the status of superpower. Yet the telltale signs of decline—imperial fragility, military defeat, fiscal exhaustion—began to show by the final years of the sixteenth century, a period of relentless setbacks for the monarchy. Just one year after the battle of Lepanto, the Ottomans assembled another fleet to menace the Spanish; Tunis, captured by Don Juan in 1573, was presently lost—as was Spanish momentum in the Mediterranean. Emboldened by 1588, England launched a series of raids against the Spanish mainland culminating in their sacking of Cádiz in 1596. And the Dutch, after enduring the worst of Alba's offensive, regrouped and reunited, pooling their resources and efforts to mount a "patriotic" resistance against that which they termed the "tyranny" of Spain. In 1581 William the Silent (known as the Dutch George Washington) publicly renounced his loyalty, as the leading Dutch nobleman, to the monarchy, a step that prompted the States General to declare their independence from Spain. The empire was beginning to unravel. The costs of empire, moreover, were proving more than Philip could bear, even as the war against "heresy"—the Dutch—took precedence over all else. These years witnessed a fiscally reckless borrow-and-spend policy that put the future of the Spanish kingdoms at risk. Rooted in a strategic calculus that resembled the mid-twentieth-century theory of the "domino effect," Philip's aim was to resist Calvinism (Communism, in the modern analogy) at all costs. An equally apt reference might be to the quagmire into which the Spanish army had sunk. Military expenditures, and especially the war in the Netherlands, caused a series of royal bankruptcies in 1596, 1607, 1627, 1647, and 1653. Spain was overextended.

Despite the stream of bad news, Philip would not retrench. His absorption in the details of his government made it easy for him to ignore the advice of one experienced soldier who warned that Spain's army was "sick": it so needed structural reform that it was incapable of ever defeating the Dutch. That soldier, Marcos de Isaba, also worried about the effects of the war on Spain's image abroad—its sagging *reputación*—and this might have more interested the crown:

> In the past Spaniards were well-loved by all peoples, but for the last ninety years we are hated and detested on account of the ongoing wars. Spanish soldiers have fought with much valor and courage and with great loyalty to their king. They have worshiped and served the cause of God. . . . And because of His infinite goodness, Spaniards have achieved authority and grandeur on earth; but because envy is like a worm that never rests, it is the source of the enmity and hatred shown to us by the Turks, Moors,

Arabs, Jews, French, Italians, Germans, Bohemians, English, and Scots, all of whom are enemies of Spain. Even in the New World, the sound of Spanish arms causes hatred and resentment.[15]

The cautious irony of the final line—Spain was perhaps nowhere more despised than in America—fell on deaf ears. However remote the possibility of victory, Philip doggedly favored war, with nary regard for the sacrifices, human and material, that it extracted.

Following a protracted illness, Philip II died on September 13, 1598. Upon learning the news, Protestants in northern Europe rejoiced. Meanwhile, Catholics throughout Europe lamented the loss of their most steadfast defender of the faith. His successor, Philip III (r. 1598–1621), lacked his father's capacity for hard work and his intense interest in culture and the arts. Hunting was his main pastime. Yet if Philip III is generally considered the least vigorous monarch of Spain's Golden Age, he was hardly the indifferent figurehead his detractors made him out to be. He pushed the monarchy and the empire in vital ways—though not in the direction that Philip II had so intractably followed.

Philip III's reign stands as something of an interlude between that of his ferociously focused father and his able and energetic son, Philip IV. Guided by his chief advisor, the duke of Lerma, Philip III initially pledged to continue his predecessor's policies. But Spain's economic crisis had so worsened and its population so declined (the result of plague, ongoing wars, and migration to America), that the king soon decided to change course. Starting in 1601 he entered into a series of peace treaties—first with the French, then with the English—and, in 1609, the Twelve-Year Truce with the Dutch, which provided respite from a generation of war. Once freed from the crushing military burden of the Low Countries, Philip took new interest in the Indies; he even considered a proposal that would have granted independence to the Dutch if they would refrain from meddling in the New World. Philip supported a fresh geographic survey of Spain's American possessions, and he sent an expedition to explore the so-called terra incognita around the Strait of Magellan (the Nodal voyage of 1618–19). Yet Philip III is most remembered for a 1609 decree ordering the remnants of Spain's former Muslim population, the *moriscos,* expelled from the peninsula. The decision was controversial. It pleased clergymen who saw the expulsion as an act of ritual purification, cleansing the Spanish kingdoms of the infidel. Certain groups of nobles, however, especially those who relied on *morisco* labor to operate their estates, opposed the decision. Tragically reminiscent of an earlier pattern of Spanish xenophobia, the expulsion also upset foreign observers and confirmed the Protestant impression of Spain as a kingdom given to religious bigotry. In this way Philip III, like his father, helped to sustain the Black Legend of Spanish perfidy. To many critics in Europe and the empire alike, the foundations of the monarchy's reputation had begun to crumble irrevocably.

REPUTACIÓN AND THE POLITICS OF GRANDEUR

In early modern Spain, the politics of reputation did not directly mirror the politics of empire, though the two certainly followed correlative patterns. As prospects for the one declined, efforts toward the other seemed almost perversely to increase; as Spain met with setback after setback in the management of its geopolitical affairs, the monarchy expended more and more energy to enhance its image. There is an irony, of course, to the politics of reputation thus practiced— "spin," as it might be termed by its modern practitioners. For it is precisely when sagging reputations need the most bolstering that attempts to do so appear least sustainable: image collides with

reality. The reign of Philip IV (1621–65) witnessed just such a moment. As the empire received blow after blow from maritime rivals, as royal finances spiraled further out of control, as internal unrest led to not one but two revolts on the peninsula, the king and his advisors staged a drama of royal power and princely grandeur that bravely defied the grim news. However damaged Spain's reputation in Amsterdam or Lisbon, London or Lima, the impression in Madrid was of an indomitable, vigorous, "universal" monarchy assiduously maintaining its empire.

The politics of reputation as practiced in seventeenth-century Spain also betray the anxieties of empire. Possessing a global empire was not only difficult and costly; it was foolish and morally corrupting as well, according to contemporary critics. Las Casas had pointed to Spain's sins in America, and the Dutch and English had railed against the political no less than religious "tyranny," as they called it, of the Catholic monarchs of Castile. Closer to home, a chorus of complaints also came to express the growing dissatisfaction with the state of Spain, the sheer madness of its imperial aspirations, and the corrupting worldliness of its empire. A class of quasi-professional critics of the regime, known as *arbitristas,* began to compose programs for reform directly addressed to the king. These ranged from schemes to right the economic ship of state to plans for fixing the weakness of the royal monarchy. And if pitched optimistically to affect national revival, the *arbitristas'* tracts could not help but strike a tone of pessimism in detailing the fallen state of affairs, waxing nostalgic even for the days of Ferdinand and Isabel. Direct criticism was necessarily muted and disguised—royal censorship had certainly not ceded its vigor—which meant that negative assessments often came in subtle, artistic forms. It was in the early decades of the seventeenth century that Cervantes published his account of the hapless Don Quixote who, blinded by visions of bygone triumphs, seemed unable to accept his fall from grace. Other poets and playwrights of the Spanish Golden Age—Luis de Góngora, Lope de Vega, Francisco de Quevedo, Tirso de Molina, Pedro Calderón de la Barca—likewise worked into their writings a delicate critique of Castilian decline, while also conveying a wider sense of imperial anxiety. In the visual arts the task could be more complicated: most painters were commissioned to do religious works or portraits, genres that did not readily lend themselves to imperial exposition. Still, there is evidence of this sensibility in still lifes or even the sensitive genre paintings of the young Velázquez. The latter's portrait of the ancient philosopher Democritus, shown in contemporary Spanish garb and laughing at the folly of the world, in this case embodied by a globe that displays Spain and the Atlantic world, surely offers commentary on the foolish, vain, and ultimately dangerous risks of imperial adventure (fig. 9).

Yet even as Velázquez worked on his *Democritus* (1628–29), he also labored to render that imperial adventure and the monarchy that sponsored it in all its triumphant glory. For the reign of Philip IV—for whom Velázquez served as court painter—was predicated, above all else, on the politics of grandeur, and it presents a remarkable case study of the court's investment in its *reputación* (pl. 33). Philip's rule began on an auspicious note. Prompted by his energetic minister, the count-duke of Olivares, the new king embarked on an ambitious program of economic, political, and educational reform, all in an effort to improve Spain's domestic condition and revive its imperial fortunes. Taking their cue from the Italian political theorist Giovanni Botero, Philip and Olivares endeavored to transform the Madrid court into a glittering showcase for Spanish power. Their strategy was explicitly celebratory: to fete the crown through the calculated use of festivals, theatrical presentations (often composed by authors otherwise critical of the court), and royal portraiture. Images promoted the monarchy. Most impressively, Olivares oversaw the construction of a new royal palace, the Buen Retiro, designed expressly to "exhibit" the young king—especially his

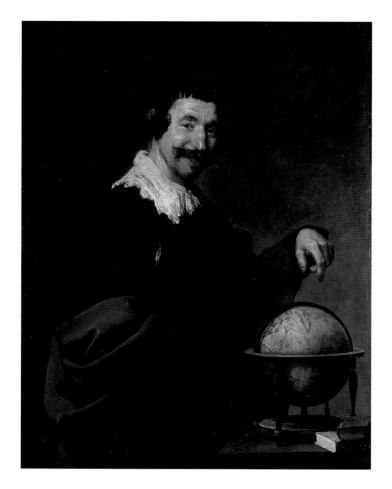

Fig. 9 Diego Rodríguez de Silva y Velázquez (1599–1660), *Democritus*, 1628–29. Oil on canvas, 39¾ × 31⅞ in. (101 × 81 cm). Rouen, Musée des Beaux Arts de Rouen, © Musées de la Ville de Rouen. Photograph: Didier Tragin/ Catherine Lancien

growing picture collection—and thus impress upon foreign visitors the wealth, taste, and stature of a monarch who wished to be known as *El Rey Planeta:* the Planet King.

The visual arts, in particular, were enlisted for this project. While the collection that Philip IV had inherited from his predecessors was certainly impressive, it had not grown appreciably since his grandfather's death in 1598. Philip III had not been active in building his galleries; he was not interested in art *per se,* and many of his portraits had to be done posthumously. By contrast, Philip IV loved painting and acquired over four thousand works in the course of his reign, including superb samples of the Italian masters—Raphael, Titian, Veronese— and works of contemporary luminaries such as Rubens and Van Dyck. His was a "mega-collection," as Jonathan Brown has termed it, which Europe's other princes could only envy.[16] Philip also gave patronage to the great Spanish painters of his day, above all his magnificent image-maker, Diego de Velázquez. In addition to executing flattering portraits of the king and the royal family, Velázquez advised on the purchase and display of art, including classical and contemporary works purchased in Italy (pl. 35), which proved instrumental in propagating a model of royal taste. Owing to such expansive largesse, the reign of the Planet King is equated with Spain's *Siglo de Oro,* or Golden Age. The early and middle decades of the seventeenth century especially saw the flourishing of art, theater, and poetry, a phenomenal cultural efflorescence that was both inspired by, and sought to contend with, the power and plight of the Spanish monarchy.

Political and diplomatic efforts, in the meantime, did not fare nearly as well as the king expected. Despite the glittering images and triumphant message projected in Madrid, the messy situation on the battlefield and high seas was hardly luminous. The politics of grandeur ceded to the overwhelming opposition of Europe's competing powers. Endless war, ultimately, sank the monarchy, though Philip heroically pressed on. In an important sense, the politics of reputation may be best understood in the context of chivalric honor—the celebration of "just" war—which explains the king's unwavering instinct to fight. Soon after assuming power, Philip made clear his displeasure with the Dutch; it pricked his sense of duty that the rebels had exploited the truce to make inroads into the Atlantic. Worse still, they had dishonorably preyed upon Spanish (and Portuguese) shipping in the New World, in some cases prompting fortification near valuable Spanish resources (pl. 36), and these attacks represented personal affronts to the king. Like his grandfather, Philip IV believed that the monarchy's reputation depended on force of arms and battlefield victory. Accordingly, he and Olivares allowed the Twelve-Year Truce to expire in 1621 and went on the offensive against the Dutch, hoping for a swift and decisive victory. For a time, Philip's armies won a number of key battles—notably in 1625, when Ambrosio Spínola, captain-general of the army of Flanders, captured the city of Breda after a costly, eighteen-month siege. Lope de Vega wrote a play celebrating the victory, which was soon immortalized by Velázquez in his magnificent *Surrender of Breda.* This epic painting was specially commissioned by Philip for the Hall of Realms, the principal room of the recently opened Buen Retiro. Together with other

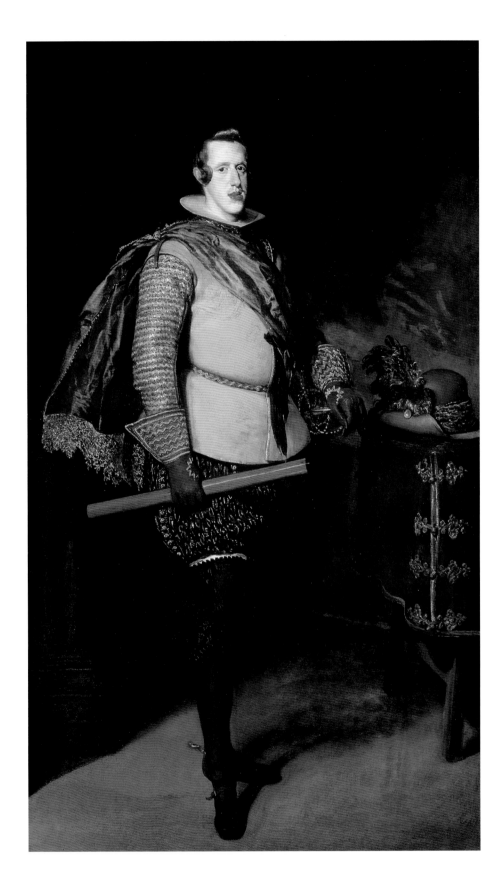

PLATE 33

DIEGO RODRÍGUEZ DE SILVA Y VELÁZQUEZ (1599–1660)
Philip IV, King of Spain

c. 1625–28

Oil on canvas, 82⅜ × 47⅝ in. (209.3 × 121 cm)

John and Mable Ringling Museum of Art, Sarasota, bequest of John Ringling,

State Art Museum of Florida

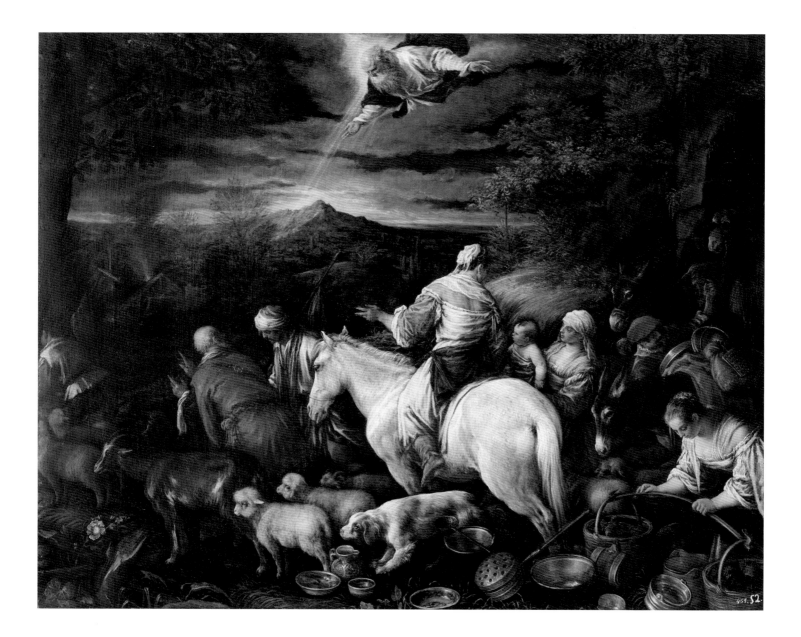

PLATE 34

JACOPO BASSANO (C. 1510–1592)
Abraham's Journey to Canaan

c. 1573
Oil on canvas, 58¹¹⁄₁₆ × 76 in. (149 × 193 cm)
© Patrimonio Nacional, Real Monasterio de San Lorenzo de El Escorial (10014470)

PLATE 35

GIANLORENZO BERNINI (1598–1680)

Crucifix

c. 1656

Bronze and wood, 103¹⁵⁄₁₆ × 65⅜ in. (264 × 166 cm)

© Patrimonio Nacional, Real Monasterio de San Lorenzo de El Escorial (10014979)

The World of Early Modern Spain 75

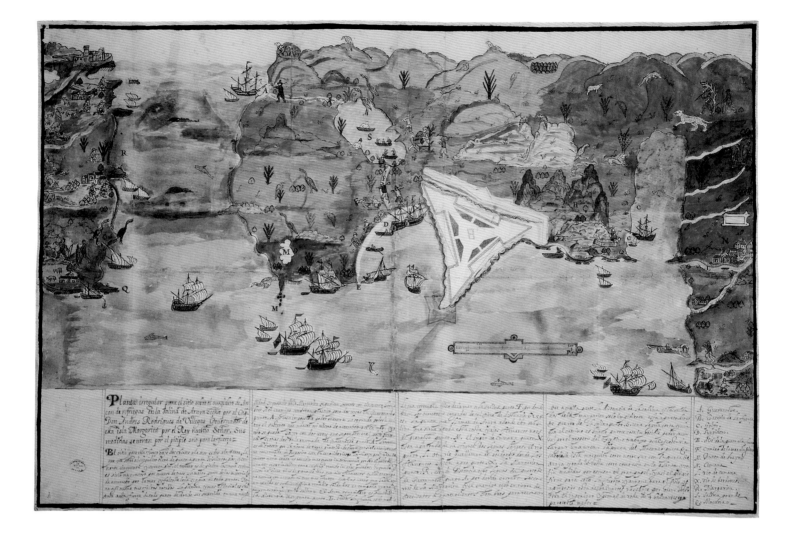

PLATE 36

depictions of recent Spanish triumphs, it was meant to symbolize Spain's imperial preeminence and the magnanimity of its military servants.

Yet around the time this painting first went on display (1635), the tides of war had shifted. The monarchy was already engaged in battles on multiple fronts: against the Dutch in the Netherlands; against the French in Italy, where the Bourbons sought to seize several key states; in central Europe, where Philip IV had come to the aid of his Habsburg cousin, Emperor Ferdinand; in scattered conflagrations of Protestantism across transalpine Europe; and in the New World, where the Dutch occupied part of Brazil and the English, in North America, lately posed a threat. On top of all that, the Spanish vessel of state took on a further blow with a surprise declaration of war, in 1635, by Cardinal Richelieu and Louis XIII. Olivares responded at once, and by the following year Spanish troops nearly reached Paris. But the French resisted, and Philip now found himself locked

in a costly war of attrition against an enemy with a population three times greater than Spain's and resources to match. The king was soon on the defensive. By 1638 French troops had crossed into northern Spain and besieged the border stronghold of Fuenterrabía. Two years later, the king's fortunes spiraled still further out of control when two key components of the monarchy, Catalonia and Portugal, rose in revolt. The French seized this opening by allying with the Catalan rebels, to whose aid they rushed. Philip IV found himself suddenly engaged in a titanic struggle to prevent the dismemberment of his empire. The monarchy's resources already at the breaking point, the symbolic turning point came in 1643, when its famous *tercios* (infantry) were soundly defeated by French troops at the battle of Rocroi.

The defeats of the 1630s and 1640s spelled the effective end to the imperial expansion of Spain. The rest of Philip IV's reign would be spent on the defensive. Even so, the king, ever determined to preserve his territorial inheritance, did not surrender. Never mind that the economy was in disarray and the crown, short of cash, needed to declare bankruptcy with alarming regularity. From the king's perspective, the preservation of his empire and the maintenance of his reputation took precedence over all else, and he was resolved to soldier on to win an honorable peace— *paz honesto.* There were modest victories: with France momentarily consumed by internal revolt, Philip's troops entered Barcelona in 1651 and ended the Catalan revolt. Yet in 1648 Philip was forced to concede defeat on his northern flank by granting the Dutch, in the Treaty of Westphalia, what three generations of Habsburgs had fought to prevent: full independence. And there was still a war with Portugal, lately allied with England, and financial crises as far as the eye could see. Under such dark clouds, a determined, if somewhat despondent, Philip IV wrote to his spiritual advisor:

> Everywhere our enemies are preparing against us, and we have little left with which to resist them. But what is most at stake in this war is religion, and therefore I trust that God will provide the means for our defense. As for myself, I am ready to continue [the war] to the last drop of my blood.[17]

And so he did—though less by martial means than by the age-old Habsburg strategy of dynastic marriage. In the Treaty of the Pyrenees (1659), Philip IV achieved what he finally considered *paz honesta.* He made peace with France by matching his daughter María-Teresa with the young French king, Louis XIV. He also managed to retain control of the southern Netherlands and his possessions in Italy, yet was obliged to relinquish control of Portugal and its possessions overseas—a painful concession for the Planet King. Though the Spanish crown still retained kingdoms in Europe, colonies in America, and outposts in Asia, the wheel of imperial fortune had definitively turned. While it still could be said that the sun never set on the Spanish empire, the power, splendor, and supremacy of Spain now yielded to the Sun King, Louis XIV. As for the exhausted Philip IV, after a lifetime dedicated to the politics of reputation, he found—like his grandfather and great-grandfather before him—solace in religion, perhaps with the understanding that empire, earthly glory, and worldly riches are ephemeral, the only certainty death. That came on September 8, 1665.

The reign of Charles II (1665–1700), the last of the Habsburg monarchs, is generally considered one of the bleakest moments in Spain's imperial history. Thanks in large part to the Indies, the Spanish monarchy remained a formidable power. But a fatal combination of economic weakness and poor government allowed other European powers—led by the ascendant Louis XIV and the restored English monarchy—to make important inroads into the New World. The English seized Jamaica, and the French soon helped themselves to the western part of Hispaniola, later

renamed Haiti. Another sign of Spanish weakness was the monarchy's failure to provide adequately for the defense of its colonies, thus rendering them vulnerable to Caribbean pirates (tagged by the contemporary neologism "buccaneers"), such as the notorious Henry Morgan. Though the colonists pleaded for military assistance, the monarchy, saddled with its own problems, could do little to help. Forced to take charge of their own defense, local elites in the Americas diverted funds that would otherwise have been remitted to Madrid. At the same time, these American elites, anxious for manufactured goods, which the weakened economy of Spain could hardly provide, regularly traded with European interlopers in open violation of the crown's monopoly of American trade. Smuggling became a way of life for many merchants. Handsomely bribed or otherwise remunerated, Spanish royal officials in the Americas simply looked the other way as English cloths and French clocks found their way into the markets of Lima, Mexico City, and other New World cities. The gradual separation of these colonies from Spain had begun.

These developments, for all their historical importance, barely attracted notice in Madrid. Charles II was chronically ill and often incapable of personal rule; little hope was vested in his monarchy. Effective control of the government soon passed into the hands of various noble factions, more interested in self-enrichment than supporting the empire and all it represented. Reputation was irrelevant. Furthermore, as news leaked out that the sickly Charles was incapable of siring an heir, court politics focused increasingly on the question of his successor. By the 1690s, the two main contenders promised Spain very different futures. The French claimant, Philip of Anjou, was the grandson of Louis XIV and his Spanish wife, María-Teresa (which made him the great-grandson of María-Teresa's father, Philip IV). Philip's claim, however, was complicated by the fact that, upon his marriage in 1659, the French renounced future claims to the Spanish throne. The other aspirant was a Habsburg, Archduke Charles of Austria, who had the support of France's adversaries, England and the Netherlands, both of which staunchly opposed the ascent of a French Bourbon to the Spanish throne. Spain may no longer have been a superpower, but its American possessions represented too important a prize for Europe's great maritime nations to ignore. The outcome to this political finagling aside, the interference of Europe's newest power brokers in the dynastic future of Spain plainly spelled out that, whatever its self-promoted *reputación,* the once mighty Spanish monarchy had reached a state of dismal decay.

CHANGE OF DIRECTION

In November 1700, Charles II lay on his deathbed—a moment long awaited by court watchers in Madrid. According to the resident English ambassador William Coxe, the dying monarch, having designated Philip of Anjou as his successor, exhorted the French-born prince "not to permit the slightest dismemberment or diminution of the Monarchy established by my forefathers to their greater glory."[18] Philip respected the dying king's wishes, but the brutally destructive war that followed the Bourbon succession led precisely to the dismemberment and diminution that Charles had sought to forestall. What the ailing king could not have perceived, however, is how the Spain that would emerge from this crisis would possess, besides a new dynasty, new energy and interests as well.

How this change of direction occurred is a story in itself. Shortly after the young monarch arrived in Madrid in February 1701—he was just seventeen—his ministers, the majority of whom were French, moved quickly to take charge of his new realm. In many ways, Philip's situation was reminiscent of that of Charles V, another foreigner who found himself, by accident of birth, heir to the Spanish throne and its overseas possessions: both, moreover, were greeted by crises

and subtly expressed voices of opposition. Yet while Charles V's arrival had sparked an internal rebellion—the Revolt of the Comuneros—Philip V confronted a challenge of an entirely different order. In 1702 England and its continental allies, the Austrian emperor and the Dutch Republic, forged the so-called Grand Alliance in order to challenge the Bourbon claim and promote Archduke Charles to the Spanish throne. Hostilities began almost at once. Starting in 1704 the alliance, aided by Portugal, attacked the Spanish mainland, marched on Madrid, and, at one point, drove Philip and his court from town. Meanwhile, Philip received help from his Bourbon cousins—the French—and this allowed the War of the Spanish Succession to expand, escalate, and eventually mushroom into a global conflict fought on several continents, including North America, where it became known as Queen Anne's War.

The war ended in a compromise hammered out by Europe's major powers at the Treaty of Utrecht (1713), which ultimately determined Spain's future. The treaty granted Philip V full rights to Spain and its American empire, but only upon the condition that he accept the "dismemberment" and "diminution" of those territories that he had resolutely fought to oppose. A small but strategic loss was Gibraltar, which had been seized by the English

Fig. 10 Jean Ranc (1674–1735), *Philip V,* c. 1720. Oil on canvas, 56¹¹⁄₁₆ × 45¼ in. (144 × 115 cm). © Museo Nacional del Prado, Madrid (2329)

in 1704—a symbolic pillar gone, thus, from Charles V's coat of arms. Another was the Mediterranean island of Minorca, which had also been captured by the English. Of a larger order was the forfeit of Spain's remaining possessions in northern Europe and in Italy, notably Naples, Sicily, and Milan. Philip, whose first and second wives were both Italian, was devastated by the loss of Sicily and never totally abandoned hopes of restoring Spain's Mediterranean empire. But it would not be: Ferdinand of Aragon's original contribution to the Spanish monarchies was forever lost.[19]

Ferdinand's model of vigorous rule was not replicated either—a theme harped upon by Spanish chroniclers since the decline of the seventeenth century. Under Philip V (as under Charles II, another pale shadow of his namesake), Spain suffered from the weakness, personal and political, of its monarch. Reforms stalled for lack of a strong, personal push from the king. Indeed, once the Treaty of Utrecht was signed, the Bourbon regime was ready to move Spain in new directions, but the king, who proved mentally unstable, was rarely up to the task. Exhausted and frustrated by the many obligations of sovereignty, the king temporarily abdicated in 1721 in favor of his son, Luis; once back on the throne, he tended to avoid his responsibilities by isolating himself from the court. He often stayed in bed, refusing to shave or change his clothes for weeks at a time, or otherwise worked at nights while the court slept. Fortunately, the monarchy was blessed with a string of able administrators who, in the course of Philip V's reign (1700–46) and that of his son, Ferdinand VI (1746–59), gradually implemented reforms that strengthened the royal government, improved the economy, and generally sought to remake Spain in the image of France. Among the first changes was the abolition of the boundaries that traditionally separated Castile, Aragon, and the other parts of the kingdom, creating a single unified polity now officially known as Spain. The bureaucratically minded administrators also abolished many of the privileges and liberties traditionally enjoyed by Catalonia and the Basque Country. These were replaced with new laws

meant to be uniformly applied, throughout the kingdom, by a network of royal *intendentes.* There were also efforts to reinvigorate the economy and to promote trade by abolishing internal tariffs and licensing foreigners to do the work that native industry had allowed to languish. Spain in this period established arsenals and iron foundries to build the ships and forge the armaments needed to defend itself and its colonies. By contrast, direct royal efforts to stimulate the economy through the creation of state-sponsored (as opposed to outsourced) industries met with mixed results. Royal factories dedicated to the production of high-value luxury goods—glassware, porcelains, tapestries—fared tolerably well, but the larger and more ambitious enterprises devoted to textiles did not. On balance, though, while not everything attempted by the new regime met with success, Spain did recuperate from the destruction associated with the war of succession: its population recovered, its economy gained momentum, and the monarchy put its finances back on firm footing.

Nowhere did change come faster and perhaps more visibly than in the realm of arts and letters. As in matters of government, the Bourbon strategy was to integrate the peninsula into trends developing on the other side of the Pyrenees. Spanish universities, to cite but one example, had languished after a robust period of growth in the sixteenth century, when Francisco de Vitoria and other theologians attached to the so-called School of Salamanca placed Castile on the forefront of European scholarship. By the eighteenth century, once-great faculties in Salamanca, Valladolid, and Alcalá had greatly deteriorated and remained cut off from the latest developments in natural sciences, medicine, philosophy, and history. The Augustinian scholar Benito Jerónimo Feijoo addressed this decline in his best-selling *Teatro crítico universal* (1726–39), a nine-volume, encyclopedic work that endeavored to introduce Spaniards to European intellectual trends. The monarchy also sought to modernize Spanish scholarship through the creation of a national library (1711), the Spanish Royal Academy (1713), the Royal Academy of History (1735), and several specialized colleges devoted to the study of surgery and medicine. Not all of these new institutions lived up to the high expectations set for them—a notable exception was the Royal College of Surgery in Cádiz—but they succeeded insofar as they promoted a new spirit of debate, open inquiry, and research that came to fruition during the latter part of the eighteenth century. The fresh intellectual energy of Spain also found institutional expression in the creation of dozens of local debating societies (called economic societies in Spain), which took up the question of modernization and improvement within Spanish society. It was during the reign of Charles III (1759–88) that the Spanish Enlightenment can truly be said to have begun.

The Bourbons also moved Spanish art in new directions. Charles II had taken relatively little interest in the visual arts, although he was responsible for bringing the prolific Neapolitan painter Luca Giordano to Madrid in 1689. Otherwise, by the end of the Habsburg regime, the artists synonymous with Spain's *Siglo de Oro*—Velázquez, Jusepe de Ribera, Francisco de Zurbarán, Bartolomé Murillo—were all gone, and it was to preserve their memory that the "Spanish Vasari," Antonio Palomino, wrote his *El museo pictórico y escala óptica* (1715–24) with over two hundred biographies of Spanish painters. By the time this work appeared, however, Philip V, his two Italian wives, and his courtiers had already moved Spanish culture and art in a new direction. The new king's favorite court artists were primarily French—Michel-Ange Houasse (pl. 38), Jean Ranc, Hyacinthe Rigaud, Louis-Michel van Loo—and his taste in music was Italian. (He reportedly had the legendary castrato Farinelli sing him the same five Italian arias every night for more than a year.) Architecture also underwent a revival. The new royal palace, designed by the Sicilian-born Filippo Juvarra and begun in 1734, was built in accordance with the neoclassical design popularized

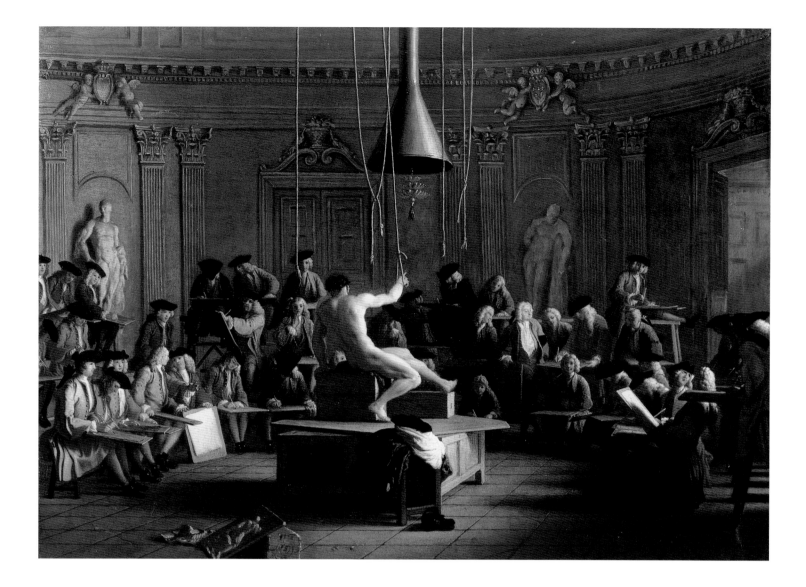

by Louis XIV. This immense structure became the artistic showcase of the Bourbon regime, featuring mostly works by artists imported from abroad: Giaquinto, Mengs, Tiepolo, among others. Only in the reign of Charles III and Charles IV (1788–1808) did a new generation of Spanish-born artists come of age. Among them were Mariano Salvador Maella and Francisco Bayeu, whose disciple, Francisco de Goya, emerged as the most talented and innovative artist of his age.

Politically, the most decisive development of the Spanish eighteenth century was the importance that the Bourbon monarchy accorded its possessions overseas. These had long been neglected; by the early eighteenth century, the crown lacked the ships and soldiers to defend them, let alone to prevent interlopers from poaching colonial trade. The regime's first inclination was backward looking: to restore the trading monopoly instituted by the Catholic Monarchs in 1503 and to treat the colonies as if they were little more than a source of silver and gold. Yet the 1720s also brought several new initiatives, notably joint-stock companies that were designed to raise capital, promote new enterprise, and foster economic growth. For these companies to be effective, much still needed to be learned about the Indies and the kinds of enterprise likely to profit. To this end, Philip V allowed several French scientists to collect information about various parts of South America, and in 1735 the monarchy, as part of an agreement with the French Academy of Sciences, ordered two young naval lieutenants, Jorge Juan and Antonio de Ulloa, to accompany a scientific expedition headed by Charles-Marie de La Condamine. This expedition passed through the Strait of Magellan, sailed on to Panama, and then returned to Quito, where La Condamine sought to determine whether the earth bulged around its equator. Meanwhile, Juan and Ulloa took copious notes on the flora and fauna they encountered as well as matters pertaining to the colonies' economy and governance. Upon their return to Spain, they published their *Relación histórica del viaje a la América meridional* (1748), a pioneering, five-volume work that incorporated many of their findings about the region's geography and resources and laid the groundwork for future Spanish scientific expeditions to America. Charles III supported several of these missions, the most ambitious of which was headed by the Tuscan-born Alessandro Malaspina. It left Cádiz in July 1789 en route to the Pacific Northwest, mapping the region and gathering botanical and ethnographic information along the way. Materials collected during the expedition were deposited in Madrid's new National History Museum, a building that was later converted into an art gallery and opened to the public (1819) as the now famous Museo del Prado (see pl. 109).

The Malaspina expedition represents a new phase in Spain's engagement with the New World. In the sixteenth century, Spaniards tended to view the Indies almost exclusively through an imperial lens. It was an arena for conquest and conversion, and, most crudely, for material gain. The natives were only of importance insofar as they constituted a source of cheap labor and, from the clergy's perspective, a pool of heathen souls wanting conversion. There was certainly some interest in the region's geography and natural history, as Gonzalo Fernández de Oviedo's *De la natural historia de las Indias* (1535–37), José de Acosta's *Historia natural y moral de las Indias* (1590), and Francisco Hernández's unpublished botanical survey of New Spain all suggest. In most of these works, nature trumped the natives, and only a handful of friars bothered to collect information about Indian institutions, customs, and beliefs. They generally did so, however, less from deep intrinsic interest in native culture than as a means to hasten their conversion to Christianity.

By the eighteenth century, these attitudes had been replaced by ideas more in keeping with the European Enlightenment, which sought to understand the Americas on their own terms. *Casta* paintings, which depicted the extraordinary variety of New World ethnic and racial types (see pl. 104 a–p), represented one aspect of this new exploratory impulse, as did the scientific

PLATE 39

JOSÉ GUÍO Y SÁNCHEZ (D. 1804)
"Chile/Talcahuano an fritillariae spec"

Malaspina Maritime Expedition (1789–94)
Watercolor on paper, 19⁵⁄₁₆ × 12 in. (49 × 30.5 cm)
© Archivo del Real Jardín Botánico, Madrid, CSIC (Div. VI, 53)

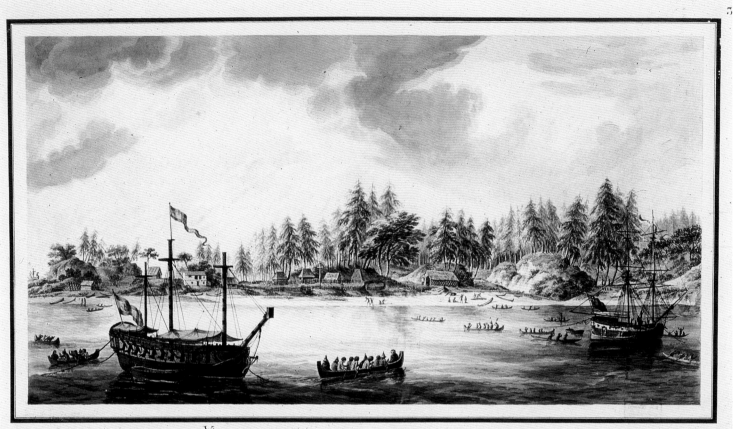

Vista del establecimiento y puerto de Nutka

PLATE 40

FERNANDO BRAMBILA (1763–1834)
View of Nootka Port and Settlement

Malaspina Maritime Expedition (1789–94)
Watercolor and sepia ink on paper, 11 × 19⅞ in. (28 × 50.5 cm)
© Museo de América, Madrid (2.271)

expeditions sponsored by Charles III. Still, this new impetus hardly comes under the rubric of "pure," disinterested science. Juan and Ulloa took less interest in American natives than in military and political matters, and they reported their recommendations on Spain's economic and political interests in the Americas only in confidential reports for the ministry in Madrid. Similarly, when José Galvez showed a curiosity in northern California (in the 1760s), he did so less in the spirit of geographic learning than religious expansion; his primary aim was to establish a string of missions in *alta California*. Even the Malaspina expedition, ostensibly organized for scientific purposes, was dispatched to gather information about the French, English, and Russian activities on the Pacific Northwest coast. Its findings, generally celebrated for their contribution to historical and ethnographic studies, also enabled the monarchy to formulate strategic policies aimed at maintaining its monopoly in that part of the world. Then, as now, the process of gathering geographic knowledge was implicated in larger, often political agendas.

The eighteenth century for Spain thus represented a period of progress, in certain ways, yet also of continuity. This is especially true of the monarchy's colonial policy relating to both

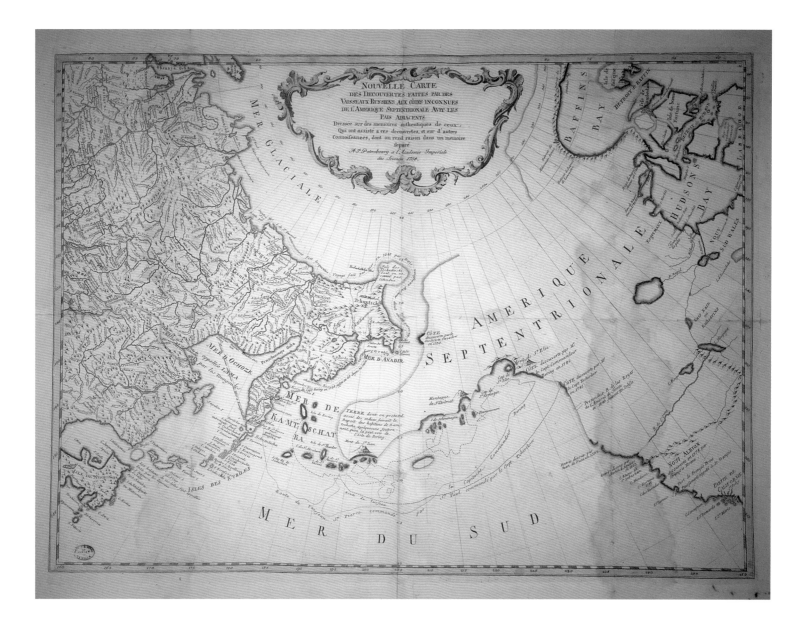

PLATE 41

Map of Russian discoveries in North America and Asia

1758

Colored engraving, 21¹¹⁄₁₆ × 29⁷⁄₁₆ in. (53.5 × 74.7 cm)

© España Ministerio de Educación, Cultura y Deporte. Archivo General

de Indias, Seville (MP. Mexico, 526)

economy and government. During the reign of Charles III, old laws restricting Indies-bound traffic to the ports of Cádiz and Seville were gradually relaxed, a move codified by a wide-reaching decree of October 1778 in which the king dismantled the traditional framework of colonial trade by lowering tariffs and encouraging free commerce between Spain and the Indies. These reforms established the basis of a new and more prosperous era in Spain's colonial relations, but in many ways they were, classically, too little and too late. The granting of free trade only encouraged America's creoles to demand further freedoms, especially in matters of taxation and governance. By the late 1780s, however, when the less able Charles IV assumed the Spanish throne and by which time the regime-shattering French Revolution was under way (1789), the Spanish crown was hardly amenable to further change. The new king and his domineering minister, Manuel Godoy, sought instead to reestablish what was then understood as the old regime, both in Spain and its colonies. They reversed many of the economic reforms instituted by Charles III, imposed new restrictions on colonial trade, and inhibited the scholarly explorations of the prior generation. The results were almost foreseeable. Within the course of the next generation, Spain's American colonies, taking their cue from the newly formed United States, embarked on their own, admittedly long and divisive, road to independence. Meanwhile back in Spain, the spirit of the Enlightenment that had pushed the monarchy in the direction of progress and change was all but thwarted. As the eighteenth century came to a close, the kingdom once again entered another and protracted era of war.

OF EMPIRE AND ELEPHANTS

The business of empire is undoubtedly a difficult one: few nations ever get the chance to amass and manage imperial domains, and fewer still emerge from the experience even vaguely triumphant. Empires require a certain amount of hubris at their opening: they need "great expectations of themselves," as Machiavelli once wrote in regard to the rapidly expanding sovereign reach of Ferdinand of Aragon. The Spanish empire that rose so swiftly in the sixteenth century had its origins in both the shrewd maneuvers of Ferdinand and the fabulous good fortune of his heirs. It expanded in ways that no one, circa 1492, could have imagined. "No other European empire," writes the historian Anthony Pagden, "was spread so widely or embraced so many different peoples."[20] And the early years of Spanish imperial rule certainly reveal great expectations: the Catholic Monarchs were confident of conquering the world, converting its nations, and glorifying God and Crown in the process. Spain was indomitable:

> Not only do we dominate
> The lands that we have conquered,
> We also sail across
> Unnavigable seas.
> We are almost invincible.[21]

Yet the poets—if not the monarchs—wisely qualified. To be "almost invincible" is to allow for divine inscrutability, to heed the role of Fortuna, and to recognize, quite simply, that empires follow their own logic. Spain was reminded time and again of this logic, perhaps never more eloquently than when the sultan of Jolo, in the distant Philippines, noted to his local imperial minder that "although it is true that we may be likened to a dog and the Spaniards to an elephant, the elephant may one day find the dog on top of it."[22]

Spain's imperial experience was decidedly mixed. For a time, the empire produced unrivaled gold and glory for the monarchy and nation, while greatly enriching Spanish art and culture. The empire also facilitated the export of Spanish customs, language, and religion abroad and, ultimately, enabled Spaniards to leave an indelible imprint on Europe, the far reaches of Asia, and, most profoundly, virtually all the Americas—from Tierra del Fuego in the south to the San Juan Islands in the north. Yet however tangible its benefits, empire, as the Spaniards quickly learned, did not come cheaply. Power engendered jealousies, challenges, and hostilities from rival states. It also meant deprivation and war, and over time the burden of maintaining and defending empire required tremendous outlays that tired and ultimately defeated the proverbial imperial elephant. Spain swiftly ascended to imperial heights in the sixteenth century, only to descend into a morass of debt and decline over the following two centuries. Empire was ultimately the death of Spain. One seventeenth-century writer, Sancho de Moncada, acutely observed that "conquest" and the "conservation" of empire was a "natural cancer in the body of Spain," the very source of its tragic *declinación* (decline).[23]

A century later, even as the Bourbons endeavored to invigorate Spain's imperial rule and institute colonial (and domestic) reform, critics remained. As one minister perceived it, conquest and expansion, far from revitalizing Spain, had contributed to its debilitation. The count of Aranda, in a memorandum prepared for Charles III around 1783, recommended the empire's dismemberment. "Your majesty should dispossess himself of all his dominions in the Americas," he wrote, suggesting that Charles create a loose commercial federation of independent states under nominal Spanish control.[24] Yet Charles, like so many other empire-builders past and present, was unwilling to listen. What followed was almost predictable: a generation of destructive revolutionary warfare that, if resulting in the independence of Spain's former colonies, also impoverished them in ways which continue to influence their history today. For Spain, too, reluctance to relinquish its empire spelled impoverishment, which was compounded by a loss of power and prestige. The great elephant inevitably collapsed. The imperial lessons of Spanish history are abundantly clear, if rarely heeded, and today's global elephants might take note: empire is a tough road to track, and one never knows when the dogs will bite back.[25]

NOTES

1. Among the most stirring renditions is William Hickling Prescott's *History of the Reign of Ferdinand and Isabella, the Catholic* (Philadelphia: Lippincott, 1837). On Prescott's influence on Spanish historiography, see Richard L. Kagan, "Prescott's Paradigm: American Historical Scholarship and the Decline of Spain," *American Historical Review* 101 (1996): 423–46. A modern, if less romantic, version of the story can be found in Peggy K. Liss, *Isabel the Queen: Life and Times* (New York: Oxford University Press, 1992).

2. The life of the emperor is narrated in William Robertson and William Hickling Prescott, *The History of the Reign of Emperor Charles V,* 2 vols. (London: George Routledge, 1857). A modern revision, which considers more centrally Charles's northern European heritage, is Hugo Soly and Wim Blockmans, eds., *Charles V, 1500–1558, and His Time* (Antwerp: Mercatorfonds, 1999).

3. The so-called First Letter of 1493 is reprinted in Christopher Columbus, *The Four Voyages of Columbus,* trans. and ed. Cecil Jane, 2 vols. (1930–33; reprint, New York: Dover, 1988), 1:2–19; see 4–6 (et passim) for the description of the natives and marvels of the Caribbean.

4. See Columbus, *Four Voyages,* 2:2.

5. The battlefield reports of Cortés are accessible in Hernán Cortés, *Letters from Mexico,* trans. and ed. Anthony Pagden, 2d ed. (New Haven: Yale University Press, 1986); on their legal cum imperial context, see the excellent introductory essays in that volume by John H. Elliott (xi–xxxviii) and Pagden (xxxix–lx).

6. Cited in Karl Brandi, *The Emperor Charles V* (New York: Knopf, 1939), 12.

7. See James Tracy, *Emperor Charles V, Impresario of War: Campaign Strategy, International Finance, and Domestic Politics* (Cambridge: Cambridge University Press, 2002).

8. See Geoffrey Parker, *The Grand Strategy of Philip II* (New Haven: Yale University Press, 1998), 4.

9. Parker, *Grand Strategy,* 47.

10. For the growth of Seville and the wonder it invoked from contemporaries, see Ruth Pike, *Aristocrats and Traders: Sevillian Society in the Sixteenth Century* (Ithaca: Cornell University Press, 1972).

11. Henry Kamen, *Empire: How Spain Became a World Power, 1492–1763* (New York: HarperCollins, 2003), xxiv.

12. Bernal Díaz del Castillo, *Historia verdadera de la conquista de la Nueva España,* ed. Miguel León-Portilla (Madrid: Historia 16, 1984), 2:465.

13. Cited in Colin Martin and Geoffrey Parker, *The Spanish Armada* (New York: W. W. Norton, 1988), 127.

14. Philip II cited in Geoffrey Parker, *Philip II* (Boston: Little, Brown, 1978), 53.

15. Marcos de Isaba, *Cuerpo enfermo de la milicia española* (1594; Madrid: Ministerio de Defensa, 1991), 217.

16. See Jonathan Brown, *Kings and Connoisseurs: Collecting Art in Seventeenth-Century Europe* (Princeton: Princeton University Press, 1995).

17. Cited in Robert A. Stradling, *Philip IV and the Government of Spain, 1621–1665* (Cambridge: Cambridge University Press, 1988), 276.

18. Cited in John Lynch, *Bourbon Spain* (Oxford: Blackwell, 1989), 23.

19. In accordance with the terms of the treaty, Spain ceded Sicily to the Italian king of Savoy. Milan, Naples, and Sardinia, together with the Spanish Netherlands (roughly modern Belgium), went to the Austrian emperor. Further territorial realignment occurred in succeeding decades.

20. Anthony Pagden, "Great Expectations of Themselves," *London Review* 25, no. 8 (April 17, 2003): 32–33.

21. Juan de Narváez, as cited in Kamen, *Empire,* 28 (translation slightly revised).

22. Cited in ibid., xxiii (translation slightly revised).

23. Cited in Anthony Pagden, "Heeding Heraclides: Empire and Its Discontents, 1619–1812," in *Spain, Europe, and the Atlantic World: Essays in Honour of John H. Elliott,* ed. Richard L. Kagan and Geoffrey Parker (Cambridge: Cambridge University Press, 1995), 320.

24. Pagden, "Heraclides," 332.

25. For further background on Spain and its empire, see John H. Elliott, *Imperial Spain, 1469–1716,* 4th ed. (New York: Penguin, 2003), and Kamen, *Empire.* General accounts of the political and social history of the Spanish kingdoms include Teofilo Ruiz, *Spanish Society, 1400–1600* (Harlow, England; New York: Longman, 2001); John Lynch, *Spain, 1516–1598: From Nation State to World Empire* (Oxford: Blackwell, 1992); Lynch, *The Hispanic World in Crisis and Change, 1598–1700* (Oxford: Blackwell, 1992); and Lynch, *Bourbon Spain.* Studies more specifically oriented toward Spanish overseas activity include Hugh Thomas, *Rivers of Gold: The Rise of the Spanish Empire* (London: Weidenfeld and Nicolson, 2003); John H. Elliott, *The Old World and the New, 1492–1650,* rev. ed. (Cambridge: Cambridge University Press, 1992); and Charles Gibson, *Spain in America* (New York: Harper and Row, 1966). On the Netherlands, see Geoffrey Parker, *Spain and the Netherlands, 1559–1659* (London: Penguin, 1979); on Rome, see Thomas Dandelet, *Spanish Rome, 1500–1700* (New Haven: Yale University Press, 2001); and for a comparative perspective, see Anthony Pagden, *Lords of All the World: Ideologies of Empire in Spain, Britain and France c. 1500–c. 1800* (New Haven: Yale University Press, 1995).

Art in the Time of the Catholic Monarchs and the Early Overseas Enterprises

HOWEVER WE MAY JUDGE ITS POLITICAL AND RELIGIOUS DECISIONS, the government of the Catholic Monarchs represents an exceptional moment in Spanish history. Its protagonists, Ferdinand and Isabel, had distinct personalities, each with a very strong character but quite different from one another. Their marriage sowed the seed that made it possible for their grandson, Emperor Charles V, to achieve the fusion of their various kingdoms into a unified Spanish state.

Ferdinand and Isabel were both aware of the uses of art in creating an image of power, particularly in architecture or, on an ideological plane, in the figurative arts. In this sense they built on concepts of the royal image that had been developed during the reign of Isabel's father, John II of Castile. Texts from the first half of the fifteenth century mention the words "majesty" and "sovereignty" as royal virtues distinguishing the monarchs from the nobility. During the reign of Ferdinand and Isabel, all major architectural projects were justified in one way or another along these lines. The monumental monastery of San Juan de los Reyes in Toledo (fig. 11) was built to commemorate Isabel's triumph over Portuguese factions that supported Juana, daughter of Henry IV, in a dispute over who had claim to the crown of Castile. The monument was intended as a funerary space for the royal family, to compete in grandeur with those constructed by the great noble lineages of Europe. A major architectural feature of the interior was the repetition of the royal coat of arms, supported by the enormous eagle of Saint John, Isabel's patron saint, whose outspread wings suggested protection under the Christian faith. Another use for the building emerged during the War of Reconquest, when Christian prisoners freed from Granada deposited their chains and shackles on the exterior of the building. Assuredly there were other motives for the building as well, such as favoring the Franciscan order to which the queen felt strong sentimental and devotional ties.[1] Moreover, Isabel deposited there a significant part of her library, which later was lost in a fire.

In some cases the monarchs favored particular monasteries in order to have a palace area within them, as with the Hieronymite monastery in Guadalupe and the Dominican monastery of Saint Thomas in Avila.[2] A German traveler visited the royal precinct in Guadalupe and reported: "The kings of Castile have their own magnificent palaces here, with fountains before them and with exquisitely prepared rooms, in which we see numerous servants of the queen guarding many chests belonging to the monarchs; and many birds, among which there was one with five colors —a gray head, green throat, black breast, red tail, and blue wings terminating in green. . . . The queen enjoys this monastery exceedingly, and when she is here she says she is in her paradise. She personally attends all the monastic hours in her splendid private oratory above the choir."[3]

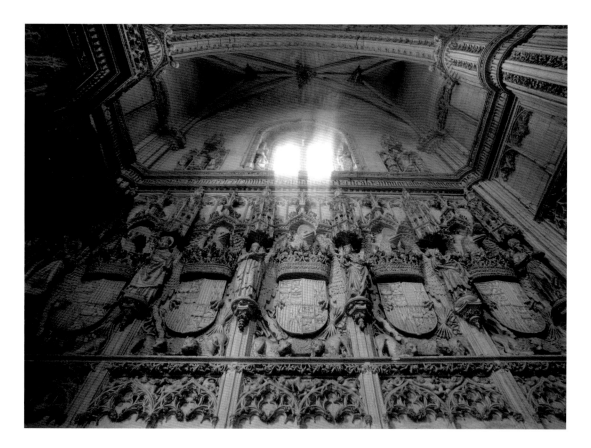

The Spanish court had no fixed location, so there was no single style for the royal residences. The court stayed in castles, residences within monasteries as mentioned above, and, in Andalucia, traditional Moorish palaces such as the Alcázar in Seville and, later, the Alhambra. Isabel's surviving household accounts clearly show her preferences. The names of her embroiderers and carpenters are nearly all Spanish, and, among the latter, *mudéjar* and Muslim names stand out. The miniaturists are Castilian, French (from Paris or Picardy), or English (Antonio el Inglés), and an analysis of their work shows it all to be in the Flemish or northern French manner, quite distinct from the Italianate in style and ornamentation. The mingled Castilian taste for *mudéjar* forms and northern painting is seen in a charming devotional painting by Pedro Berruguete (c. 1450–1500, fig. 12), whose composition is derived from Jan van Eyck, but executed in the style of Rogier van der Weyden. Whereas Jan van Eyck would juxtapose Romanesque and Gothic architectural styles to symbolically suggest the difference between the Old and New Testaments, Berruguete substitutes a Renaissance style for the Romanesque and, most dramatically, introduces a flat *mudéjar* ceiling. The artist had no hesitation about mixing three distinct styles—a good example of the kind of stylistic overlapping that occurred in art at that time.

In the important architectural projects carried out in territories ruled by the crown of Castile, the role of the queen was more pronounced than Ferdinand's; his participation was greater in projects related to the crown of Aragon.[4] The king was most concerned with the implementation of artistic forms through architecture, and only in certain cases did he seem to show any satisfaction in owning works of art, particularly tapestry and jewelry. The sincere religious devotion of the queen, however, found expression, among other things, in the acquisition and commissioning of religious paintings, though her enthusiasm for collecting went beyond pure piety.[5] Her preferred model was northern European and, particularly, Flemish art. In fact, in all her important collections, objects are either Castilian with a northern influence or, indeed, Flemish. This taste for northern art had already been established in the court of Isabel's father, John II, who owned religious art by Rogier van der Weyden, among other artists. The close commercial relations between Spain and Flanders—Spain exported wool, iron, and other primary materials and in return purchased manufactured products—extended to the art trade, as Spain imported Flemish painting, tapestries, metalwork, manuscript illumination, and sculpted wooden altarpieces.

Isabel employed painters who were northern themselves or worked in a northern aesthetic. The artist Francisco Chacón, employed from the beginning of her reign, is known from a single work that clearly follows the northern style. Melchor Alemán, Juan de Flandes, Michel Sittow, Antonio el Inglés, and Felipe Morras of Picardy are names that suggest northern origins. Perhaps the most important, for the influence he would have on later Spanish painting, was Juan de Flandes (act. 1496–1519).[6] We do not know in detail where he was from or where he trained, but his works show a profound familiarity with the painting of Hugo van der Goes and his school and with the manuscript illumination of Ghent-Bruges related to the Master of Mary of Burgundy. Many panels are documented or attributed to Juan de Flandes, particularly three major altarpieces, two of which were commissioned by the queen. Perhaps most famous is the polyptych known as the *Retablo de la Reina*, whose panels were found in a cupboard when the queen's estate was inventoried shortly after her death. Another important work is the altarpiece dedicated to Saint John the Baptist for the church of the Cartuja de Miraflores in Burgos, whose panels are dispersed today in collections in Europe and the United States. Finally, Bishop Juan Rodríguez de Fonseca commissioned the artist to expand the principal altarpiece in the cathedral at Palencia, a project that occupied the artist until his death; in these panels, still in the cathedral, one

witnesses a certain hispanicization with no loss of the virtues of the artist's early apprenticeship in Flanders.

Juan de Flandes's Flemish heritage is most apparent in the small paintings from the queen's *Retablo;* almost like codex miniatures, they are executed with a northern minuteness of detail but with visible brushstrokes and less precise drafting. In the splendid *Christ Calming the Storm* (see pl. 11), for example, with its complex iconographic meanings, we see an unparalleled realism in the foam on the waves. In his *Descent of the Holy Spirit* (pl. 43), the architectural setting is very simple, but it is clearly an attempt to reproduce a model more Italian than northern, and a nearly unique example in his work of the modernization of an artistic language learned early on. The light emanating from the Holy Spirit is intangible, but time weighs tangibly on the building it illuminates. This concern with light as a creator of atmosphere is even more evident in the artist's altarpiece for the Palencia cathedral.

The Spanish monarchy promoted two types of portraits. Representational portraits were calculated to represent the king and queen as they wanted to be seen by their subjects. These were symbolic images, not direct likenesses, and appeared on architecture, seals, and frontispieces of books. They often showed the king and queen seated together at the same level to promote the idea that they ruled with equal power. The effectiveness of the message was such that, even today, to present an intelligible vision of the king and queen, one must resort to images created in their time, although these certainly would not be recognized as their corporeal selves.

The true embodiment of members of the royal family was found in more intimate portraits, those sent to married members of the family residing abroad, in England or Portugal, for example, or kept in the crown's palaces. It is significant that Juan de Flandes was among those artists chosen to paint these more personal images, a sign of his considerable familiarity with the royal family (for example, the copy of the portrait of Isabel in the Palacio Real, pl. 44). In an example of portraiture mixing with religious imagery, *Miracle of the Loaves and Fishes* from the queen's altarpiece (pl. 42), includes Isabel's portrait among the group of people listening to Christ.

The taste for northern painting was not limited to the royal palace but was widespread throughout other elements of Castilian society. When the mother superior of the royal convent of Las Huelgas commissioned the *Virgin as Mater Omnium* along with portraits of herself and of the royal family, she turned to Diego de la Cruz (fl. c. 1475–1500), probably the most important artist working in the Hispano-Flemish style in Burgos.[7] Pedro Berruguete, whose work we have already discussed, showed little change in his Hispano-Flemish artistic language, even after a trip to Italy.

Political and military events throughout Ferdinand and Isabel's reign focused royal interests on the south. The conquest of Granada in 1492 was such a significant milestone that a pomegranate (*granada*) was added to the monarchs' coat of arms, and they changed their future burial site to that city. Isabel apparently intended to be buried in Toledo, at San Juan de los Reyes, which she had founded. Ferdinand, as king of Aragon, would otherwise have been buried, like his ancestors, in the monastery at Poblet. But there was no room at Poblet, and perhaps that was the excuse for seeking a new location for the royal mausoleum. The selection of Granada as the site of the Catholic Monarchs' tomb held a profound significance. The fall of the city followed a ten-year war that yielded the first significant Christian victory in Europe over the Muslims in those years and meant the end of the centuries-long Islamic presence on the Iberian Peninsula. The final triumph converted Granada into a city emblematic of the new Christian order, and Christian art and architecture were introduced within a short time. After Isabel's death in 1504, her favorite devotional

PLATE 43

JUAN DE FLANDES (ACT. 1496–1519)
Descent of the Holy Spirit

1501–2
Oil on panel, 8⁷⁄₁₆ × 6¼ in. (21.4 × 15.8 cm)
© Patrimonio Nacional, Palacio Real, Madrid (10002023)

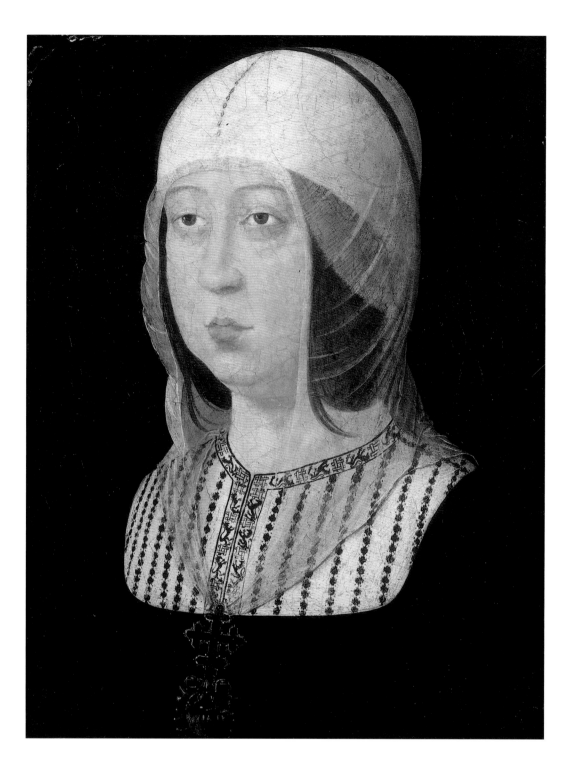

PLATE 44

AFTER JUAN DE FLANDES (ACT. 1496–1519)
Portrait of Isabel la Católica

c. 1497
Oil on panel, 14³⁄₁₆ × 10¼ in. (36 × 26 cm)
© Patrimonio Nacional, Palacio Real, Madrid (10010174)

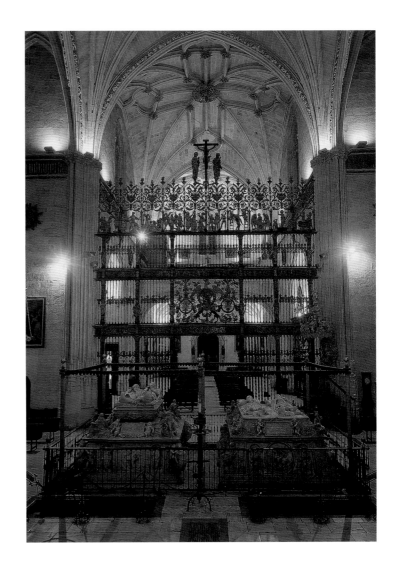

Fig. 13 Tomb of Ferdinand and
Isabel, Royal Chapel, Granada.
© Archivo Fotográfico de la Capilla
Real de Granada

paintings were sent to the city to adorn a new Royal Chapel in the cathedral of Granada (fig. 13); its construction was begun after her death, its design following the model of the cathedral of Toledo. The tomb, by the Italian sculptor Domenico Fancelli (and not finished until after Ferdinand died in 1516), holds a central place within the chapel.

Without a doubt the political enterprise with the greatest national and international resonance was the conquest of Granada. It came at the expense of the Muslims, who were advancing on all fronts in the Mediterranean, the Balkans, and even the East, where they had occupied India, making the Spanish accomplishment the exception to the trend. The crown established a new Inquisition and compelled a religious unity that culminated in the expulsion of the Jews from the peninsula in 1492. These Christian accomplishments led Pope Alexander VI to give Ferdinand and Isabel the title "The Catholic Monarchs" in December 1492. From the modern perspective, Columbus's arrival in America and its immediate consequences are seen as the principal achievement of the reign of Ferdinand and Isabel. But that was not the view at the time.

It should be remembered that there were many Atlantic voyages during that period: the Portuguese had followed the coast of Africa and arrived in India. The Canary Islands, known since classical times, were the subject of disputes between Spain and Portugal in the fourteenth century. In the fifteenth century, the Spanish crown, the Church, and the nobility all claimed parts of the islands; the crown finally claimed sovereignty in 1488. One aspect of European occupation, which would also become a key feature of Spanish activity in the Americas, was the attempt to

PLATE 45

Letter from Queen Isabel to Christopher Columbus

Barcelona, September 5, 1493

Ink on paper, 9⁷⁄₁₆ × 8⁹⁄₁₆ in. (24 × 21.8 cm)

© España Ministerio de Educación, Cultura y Deporte. Archivo General
de Indias, Seville (Patronato, 295 n. 20)

PLATE 46

Laws of Burgos

Burgos, December 12, 1512

Manuscript, 11⅝ × 8¹¹⁄₁₆ in. (29.5 × 22 cm)

© España Ministerio de Educación, Cultura y Deporte. Archivo General de Indias, Seville (Indiferente General 419, L. 4, fol. 83r–96v)

Christianize the indigenous people to avoid their enslavement by fortune hunters, pirates, and slave traders. Some of the indigenous people converted to Christianity and mixed with the conquerors, and others fell prey to slave traders who captured them and sent them to the peninsula. These raids were occasionally foiled by accusations by the Church or the intervention of royal authorities. The Spanish colonization included the establishment of cities and modest architecture based on European models, as well as the furnishing of churches with sculpture and painting of extraordinary quality imported from Flanders. As in Castile, this art pertained to the late medieval aesthetic, ignoring the Renaissance style well into the sixteenth century.

Christopher Columbus's modest expedition reached what he thought was India in 1492. One of the queen's advisors, Pietro Martire d'Anghiera, wrote of his return, "A few days ago a certain Columbus of Liguria returned from the other side of the world; he had great difficulty getting my kings to support three ships, because they thought he was saying things that were unrealistic. He has returned bringing many things as proof."[8] Columbus persisted in the belief that he had reached India until his death, but others realized he had stumbled onto something quite different. During the reign of the Catholic Monarchs, little could be done in the vast lands called America that came under Castilian domination. In time, however, the new territories became the site of the greatest colonial enterprise ever undertaken by a European state at any time in history.

Certain constants arose that would endure throughout the sixteenth and following centuries. All the early expeditions departed to the New World from the ports of the Atlantic coast of Andalusia. All matters concerning the Indies became centered in populous, wealthy Seville. Once the military occupation of the vast territories was consolidated, attention turned to how to organize life in them and what kinds of cities to construct. Several years before his death, Ferdinand convened the court in the city of Burgos and issued a document known as the Laws of Burgos (*Leyes de Burgos,* pl. 46). This first legal code for Spaniards in their dealings with the indigenous peoples of the New World prohibited mistreatment of the Indians and addressed the establishment of Spanish estates in the New World, among other issues. As first happened in the Canary Islands, conversion to Christianity was urged to raise the status of native peoples and avoid their exploitation by the Spaniards. It inevitably followed that the indigenous population became blended into a new racial type through mixed marriages with the conquerors following conversion. There is no sign that the Catholic Monarchs could have imagined this complicated legacy of their patronage of Columbus. Even after his return, there was no reflection of his voyage in the plastic arts nor any sign that the monarchs wanted to incorporate any aspect of the encounter with the New World into royal symbolism. The conquest of Granada and the eradication of non-Christian elements from Spain was for them the central achievement of their reign.

NOTES

1. A. Abad Pérez, "San Juan de los Reyes en la historia, la literatura y el arte," *Anales toledanos* (1976): 1–61; B. Martínez Caviró, *El monasterio de San Juan de los Reyes de Toledo* (Bilbao: Iberdrola, 2002).

2. Fernando Chueca Goitia, *Casas reales en monasterios y conventos españoles* (Madrid: Xarait, 1982).

3. Jerónimo Münzer, *Viaje por España y Portugal (1494–1495)* (Madrid: Polifemo, 1991), 237.

4. Santa Engracia in Zaragoza, for instance, or the tomb of San Pedro de Arbués; see Joaquín Yarza Luaces, *Reyes Católicos. Paisaje artístico de una monarquía* (Madrid: Nerea, 1993), 87–122.

5. Joaquín Yarza Luaces, "El tesoro sagrado de Isabel la Católica," in *Maravillas de la España medieval. Tesoros sagrados y monarquía,* exh. cat. (Madrid: I. Bango, 2001), 318–22.

6. The bibliography on Juan de Flandes is extensive, but see Ignace Vandevivere, *La cathèdrale de Palencia et l'église paroissiale de Cervera de Pisuerga,* Les Primitifs Flamands I, 10 (Brussels: Centre National de Recherches Primitifs Flamands, 1967); Vandevivere, *Juan de Flandes,* Europalia 85 España (Bruges: Gemeentekrediet, 1985); Elisa Bermejo, Maria José Martínez, and Javier Portús, *Juan de Flandes* (Valencia: Ediciones Rayuela, 1992); María Pilar Silva Maroto, "Juan de Flandes," in *Les primitifs flamands et leur temps* by Maryan Wynn Ainsworth et al. (Wesmael, Belgium: La Renaissance du Livre, 1994), 573–83. See also Chiyo Ishikawa, *The Retablo de Isabel la Católica by Juan de Flandes and Michel Sittow* (Turnhout, Belgium: Brepols, 2004).

7. María Pilar Silva Maroto, *Pintura hispanoflamenca castellana, Burgos y Palencia,* vol. 2 (Valladolid: Junta de Castilla y León, Consejería de Cultura y Bienestar Social, 1990), 398–400.

8. Yarza Luaces, *Reyes Católicos,* 47.

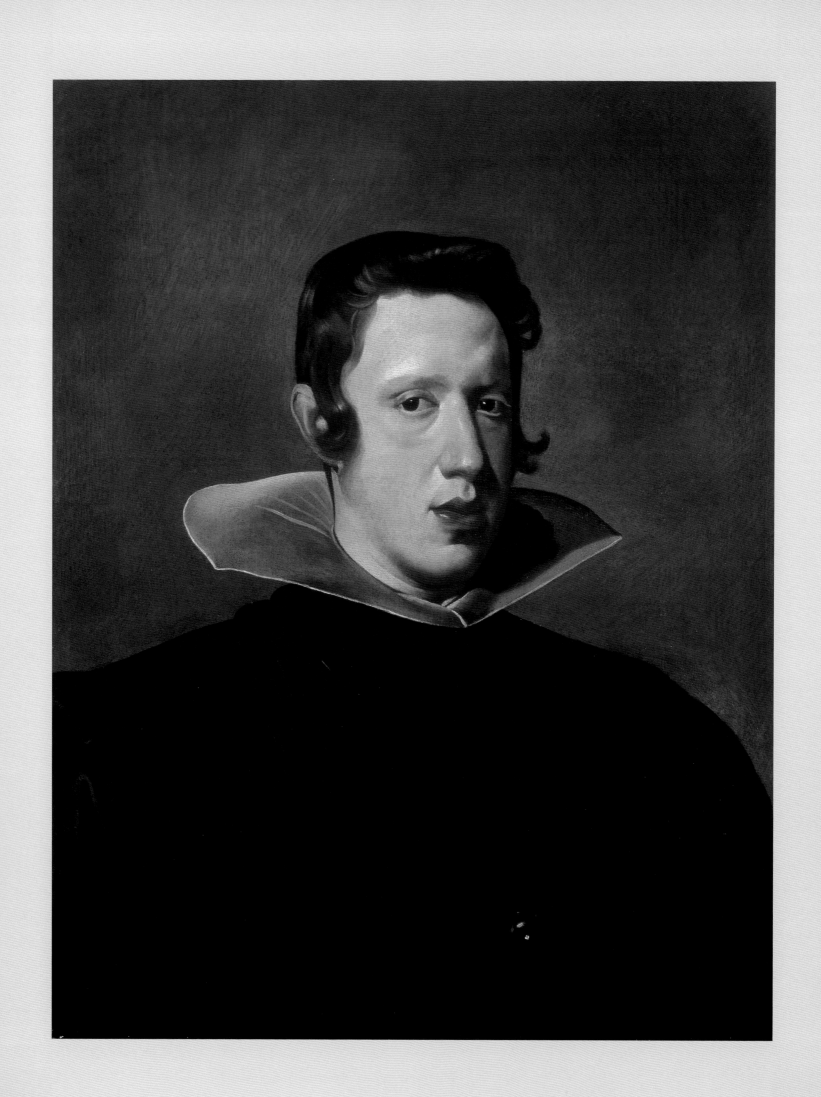

SARAH SCHROTH

Veneration and Beauty
Messages in the Image of the King in the Sixteenth and Seventeenth Centuries

WORKING IN COLLABORATION WITH COURT ARTISTS AND ARCHITECTS, the kings and queens of Spain of the sixteenth and seventeenth centuries created official "public" images of themselves that both defined and recorded their reigns. Part semblance and part symbol, these images represented the incarnation of the monarchy itself and what each individual's sovereignty stood for.[1] The images, however, were never an attempt to portray a specific personality, which would have violated notions of decorum and the strict etiquette of the Spanish Habsburg court.[2] This helps to explain why, as we move through a gallery of Spanish royal portraits today, or tour one of the royal palaces, our response to images of the kings and queens of the age of exploration can be curiously dispassionate, detached. We sense the distance between the personhood of the monarch and ourselves, much as sixteenth- and seventeenth-century viewers did, although with distinctly different emotional results, as we shall see.

Closely linked to imperialistic themes, royal portraits functioned as propagandistic devices for advancing the intellectual and political ideas the kings held dear and necessary for the governing of a series of historically separated kingdoms within their own country, in addition to the culturally disparate areas under their control in Europe and the Americas. The image had to be unique and identifiable, tied to past traditions of representation, but distinct; not to be confused with the previous ruler, or with the ruler of another state, it had to express something of its own.

The king and queen formulated an official image in three basic ways. First, they had their portraits painted, then disseminated that image widely through painted replicas, copies, or prints. More rarely, because there was less of a tradition of secular sculpture in Spain, monarchs had a portrait rendered in bronze or marble. Each of the portraits of Spanish monarchs considered here is a version of an official image, that is, an image purposely designed to convey a specific set of messages to the body politic. Note the contrast, for example, between the late *Philip IV* by Velázquez (fig. 14), the artist's private rendering of the king from life, and the official image for which it served as a model, *Philip IV in Armor* (fig. 15).[3] By definition the public *Philip IV in Armor* lacks the immediate, intimate presentation seen in the oil sketch, created by Velázquez for his workshop's personal use. Modern viewers respond more readily to the model; the official image seems stilted, aloof. We appreciate and value highly the evidence of the great artist's hand in the bust, prized for its rarity and authenticity, but it is important to remember that the general "period eye" (to borrow a term from Michael Baxandall) undoubtedly felt the official image had more power because it contained all the necessary motifs to convey a clear and effective message. The armor and general's baton, the sword and table of justice, even the curtain, when combined with Philip's

PLATE 47

DIEGO RODRÍQUEZ DE
SILVA Y VELÁZQUEZ
(1599–1660)
Philip IV

c. 1623–24
Oil on canvas, 24⁷⁄₁₆ × 19³⁄₁₆ in.
(62 × 48.7 cm)
Meadows Museum, Southern
Methodist University, Dallas,
Algur H. Meadows Collection
(67.23)

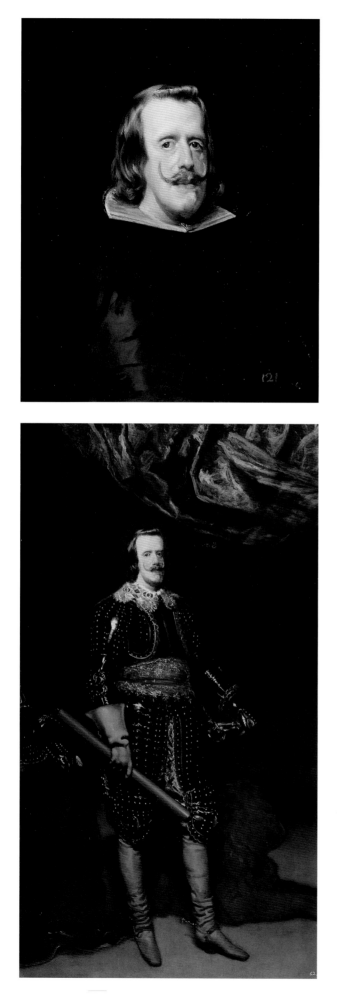

Fig. 14 Diego Rodríguez de Silva y Velázquez (1599–1660), *Philip IV*, 1654–55. Oil on canvas, 27³⁄₁₆ × 22¹⁄₁₆ in. (69 × 56 cm). © Museo Nacional del Prado, Madrid (1185)

Fig. 15 Diego Rodríguez de Silva y Velázquez (1599–1660) and workshop, *Philip IV in Armor*, 1656–57. Oil on canvas, 90¹⁵⁄₁₆ × 51⁹⁄₁₆ in. (231 × 131 cm). © Museo Nacional del Prado, Madrid (1219)

Habsburg features as originally conceived by his court portraitist, were recognized symbols of the Spanish king as defender of the faith and protector of the empire.

Take, for example, a representation of the first Habsburg king of Spain, the Holy Roman Emperor Charles V (pl. 48). This portrait is a copy of a lost original painted by Titian in 1548; the copy was made some fifty years later, during the reign of Charles V's grandson, Philip III, by the court painter Juan Pantoja de la Cruz. We know that Pantoja made at least three copies of the Titian portrait.[4] The Pantoja version after Titian represents the continual propagation, centralized by the monarchy, of a carefully crafted official image, one proven to be an effective representation of the king, even long after his death. The response by most contemporaries was not affected, as it might be today, by questions of attribution, in which the original version of a particular portrait of a king is distinguished from a copy. A reproduction served the same purpose as the original, never mind that one artist was a master of Venetian Renaissance painting, because what counted was the message implicit in the official representation of Charles V.

The second format available to the kings in the production of their image was the building of new palaces, or the redecoration and renovation of old ones, in their own taste. And finally, they formed splendid collections of works of art. Acquisitions and commissions of painted masterpieces by Juan de Flandes, Hieronymus Bosch, Titian, Jusepe de Ribera (pl. 49), and others, as well as costly tapestries and exquisite luxury objects, were placed in areas open to visitors in the various royal palaces, and read as expressions of a monarch's interests and beliefs.[5] The Spanish kings also created important collections of books, including the tomes required for study as part of their princely education, rare books from around the world on subjects they favored, and contemporary texts dedicated to or commissioned by them, such as natural histories of the New World (see the essay by Jesús Carrillo in this volume). Collected in the royal libraries, the books formed another part of their legacy as rulers. The elaborately worked jewels we see in the female royal portraits (see pls. 60, 62) and the masterfully crafted armor worn by the kings as warriors and portrait-sitters (see pls. 51, 54) were also carefully preserved and recorded as part of the collections added to by a particular king or queen, contributing yet another facet to the formulation of the public image of a monarch.

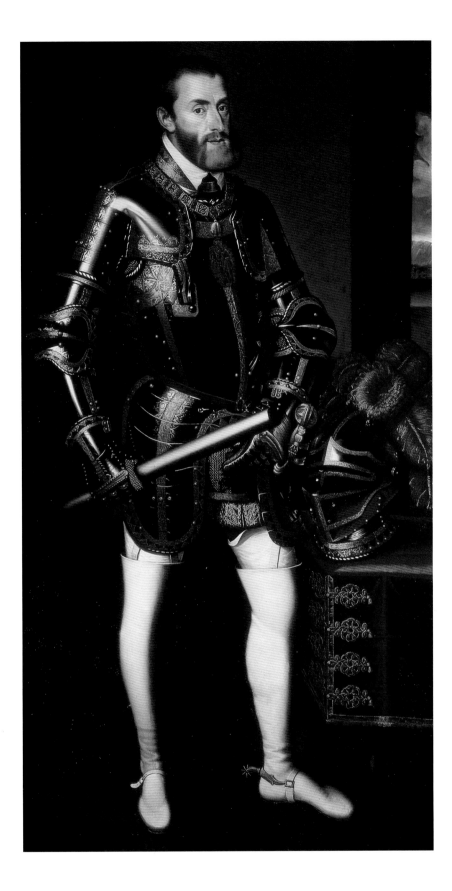

PLATE 48

JUAN PANTOJA DE LA CRUZ (C. 1553–1608)

Charles V in Armor from Mühlberg

Dated 1602

After Titian, 1548

Oil on canvas, 71⁷⁄₁₆ × 37¹³⁄₁₆ in. (181.5 × 96 cm)

© Patrimonio Nacional, Biblioteca del Real Monasterio de San Lorenzo
de El Escorial (10034482)

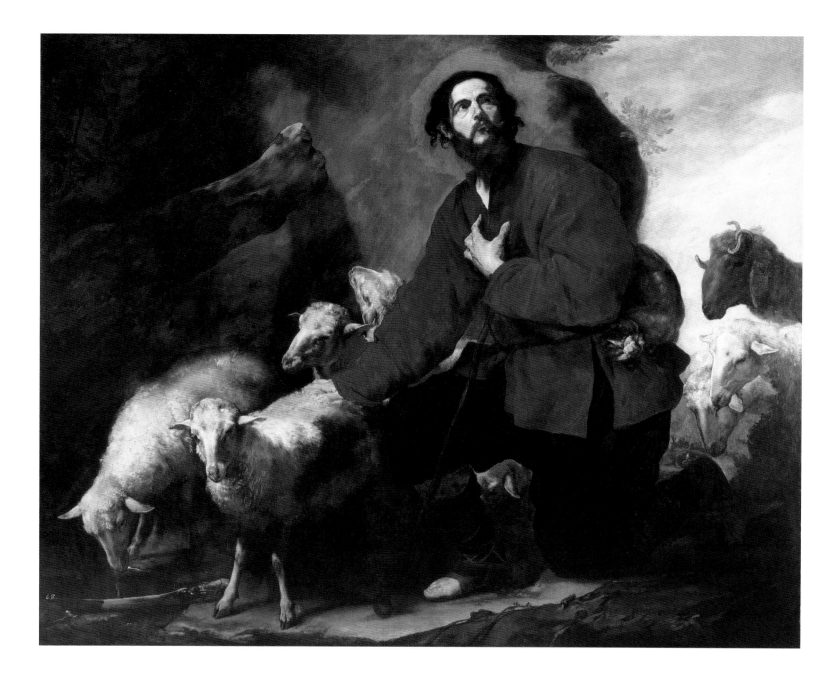

PLATE 49

JUSEPE DE RIBERA (1591–1652)
Jacob with Laban's Flock

Dated 1632

Oil on canvas, 64⅞ × 85⅜ in. (165 × 217 cm)

© Patrimonio Nacional, Real Monasterio de San Lorenzo de
El Escorial (10014695)

In this essay, I will address primarily royal portraiture. The monarchs portrayed here, in tandem with the image-makers at their courts, worked hard to successfully develop an effective monarchical iconography. The borders of their responsibility grew in the sixteenth and seventeenth centuries as the lands and peoples under their control became greater in number than under any monarch before. The king could not be everywhere at once in this enormous empire, and in his absence an image had to stand in for him, communicating what the monarch wanted to say to the various viewers of the portraits.

In recent discourse about Spanish royal portraiture, the image of the king has been considered in terms of function, iconography, political ideologies, sixteenth- and seventeenth-century concepts of beauty, realism, decorum, the consistency of the image over a period of two centuries, and its understated presentation.[6] *Spain in the Age of Exploration* provides an opportunity to add a slightly altered perspective by investigating how the artistic vocabulary of a specific group of Spanish royal portraits might embody the main doctrines of the age of exploration.

THE IMAGE OF THE KING IN THE NEW WORLD

Begin with this thought: because *Spain in the Age of Exploration* looks at Spanish works of art from the standpoint of imperialism, we can turn the topic of the image of the king around, approaching it from the viewpoint of the other side, literally, of the Atlantic. We have an advantage—we ourselves are outsiders to the rarified Habsburg court culture that produced the images; we stand on the land once ruled remotely by the kings whose images are now in the galleries. As outsiders looking in, let us try to imagine how an official portrait of the king might have functioned for New World audiences, what impact it might have had abroad in the sixteenth or seventeenth century.

Plenty of evidence indicates that royal portraits were sent abroad; less is known about how they were received or functioned.[7] We know that in Europe the royal portrait acted as a substitute for the real body of the king or queen on numerous occasions. Upon succession to the throne, oaths to the new king were sworn in front of a royal portrait displayed in the various kingdoms of Spain.[8] When one branch of the large Habsburg family married into a branch from another territory, or wed a foreigner, a portrait was made to send

Fig. 16 Pedro Perret (c. 1555–1625), *Philip IV Contemplating Portrait of Charles V*, 1622. Engraving. Frontispiece for Juan Antonio de Vera Zuñiga y Figueroa, *Epitome de la vida e hechos del invictio emperador Carlos V* (Madrid, 1622). Courtesy of the Hispanic Society of America, New York

Fig. 17 Juan de Courbes (1592–1641), *Portrait of Garcia Hurtado de Mendoza, Viceroy of Peru*, 1629. Engraving from Juan Pablo Martir Rizo, *Historia de la muy y leal ciudad de Cuenca* (Madrid, 1629). Biblioteca Nacional (R/9263 p. 227). © Laboratorio Fotográfico de la Biblioteca Nacional, Madrid

to family members back home, not only as a memento but as a substitute, to be guarded behind a curtain and spoken to, as if the absent one were present.[9] Empress María of Austria, daughter of Charles V and wife of Maximilian II, kept a number of family portraits in a special room in her quarters in the Descalzas Reales in Madrid, where she retired as a widow. Among them was the portrait produced at the French court of her beloved daughter Isabel, queen of France (see pl. 62). Or, as a print by Pedro Perret clearly shows (fig. 16), the official portrait of Charles V (based on the same lost Titian original as the Pantoja de la Cruz, pl. 48) served to evoke the memory of the virtues of the king as a model for the young prince Philip (II): "VIRTUTEM EXME" is inscribed on the frame of the official image.

An engraved portrait of Garcia Hurtado de Mendoza, fourth marquis of Cañete, viceroy of Peru from 1589 to 1596, strongly suggests that official royal portraits functioned similarly in the New World (fig. 17). The general, in his role as the king's viceroy, speaks to inhabitants of the New World (identifiable by their caps with exotic feathers) in front of a portrait of Philip II, which is "framed" and hung on a cloth of honor beneath a canopy. An eyewitness in 1621 described elites in the viceroyalty of Peru participating in a traditional ceremony of swearing oaths of loyalty to a portrait of the new monarch, Philip IV, noting that the image was "framed in gold" and "seated on a throne beneath a canopy."[10]

Swearing an oath of allegiance to your king from the other side of the earth, in unfamiliar territory and under frequently dangerous circumstances, undoubtedly colored the experience and could well have heightened the impact of the royal portrait abroad. For the Spanish soldier in the New World, the image of the king contained signs reminding him that he left Spain, in part, to support the monarch's efforts to expand his empire, secure its foreign territories, and spread the Catholic faith. Symbols used in the official royal portrait, the insignia of the Order of the Golden Fleece and the sword of justice, as well as the modest, understated presentation, were also contrived to send the message that this king was a good and just ruler who cared for his subjects and deserved their loyalty; undoubtedly this was a poignant message for New World audiences.

Another image set in the New World is Juan Bautista Maíno's *Recapture of Bahía, Brazil* (fig. 18), inspired by Lope de Vega's play of the same title.[11] The victorious Spanish general, having reclaimed Bahía from the Dutch for his king, points to a full-length portrait of Philip IV, in this case a tapestry, which is "framed" and placed under a canopy. He is asking the king, by way of his portrait, to pardon the crowd of Dutch soldiers in mid-ground, who respond to the general's speech by going down on one knee in front of the image of a king.

VENERATION AND BEAUTY

The seventeenth-century reaction to images of kings as something close to veneration is relayed by the account of the well-known writer Diego de Saavedra y Fajardo, who in 1640 described his response to a portrait of Philip IV, painted by Velázquez: "*con tan airoso movimiento y tal expresión*

de lo majestuoso, y augusto de su rostro, que
en mí se turbó el respeto, y le incliné la rodilla
y los ojos"* ([the king appeared] full of grace-
ful movement, and with such an expression
of majesty and augustness in his counte-
nance, that veneration discomposed me,
and I knelt down on one knee and lowered
my eyes).[12]

Although to modern eyes the portraits
of Charles V (pl. 48), Philip II (pl. 54), Phil-
ip III (fig. 20), and Philip IV (figs. 14, 15)
might seem to portray perfectly still fig-
ures with expressionless, frankly unattract-
ive faces, an early modern Spaniard of the
seventeenth century would have seen in the
same images a king of graceful and genteel
movement, whose "august" face, marked
by stateliness and magnificence, expressed
majestic dignity and grandeur.

Fig. 18 Juan Bautista Maíno (1578–
1649), *Recapture of Bahía, Brazil,*
1634/5. Oil on canvas, 121⅝ × 150 in.
(309 × 381 cm). © Museo Nacional
del Prado, Madrid (885)

This depiction of movement and expression in the Velázquez portrait obviously moved Saa-
vedra y Fajardo deeply. Consider the writer's verb choice: *se turbó,* the reflexive form of *turbar*—to
alarm, surprise, discompose—to make turbid, a word Oscar Wilde liked to use. Seeing the portrait
of Philip IV rendered this Spanish subject's imagination turbid, that is, made his heart beat faster,
throwing him momentarily into a confused state of thought and feeling. What agitated Saavedra
y Fajardo was *el respeto* (respect, regard, veneration, observance), a loaded word when applied to
a description of the monarchy at the time; it, like *reputación,* frequently appeared in political dis-
cussions of the day, especially when the monarchy was under attack.[13] Saavedra y Fajardo reacted
by slightly bending one knee and lowering his eyes, the same decorous gesture accorded to his
majesty if in his presence, following the norms of etiquette at the Spanish court. His response is
the same as a devoted Catholic who genuflects as he enters a church, humbly bowing in veneration
to the body of Christ in the form of the consecrated host housed in the tabernacle on the altar.

To Saavedra y Fajardo, and to the early modern loyal subject, the large, long faces, falling
noses, and protruding jaws (which we see today as the disastrous result of intermarriage) repre-
sented a special form of perfection that connoted majesty (pl. 47).[14] In the period eye of the
beholder, the Habsburg features were beautiful, at least as the portraitist painted them. Titian (as
well as Pantoja after Titian) cleverly used a full beard to disguise Charles V's exaggeratedly de-
formed jaw.[15] Compared to his appearance in real life—contemporaries say he was unable to even
close his mouth—the depiction by Titian is indeed very handsome, and a necessary departure
from reality dictated by contemporary theories of decorum in the official image.

Veneration, bowing before an image, and the act of seeing beauty in the particularities of
Habsburg features were typical responses of Spanish subjects in the age of exploration. The power
of the image described by Saavedra y Fajardo, however, is lost upon us; the impact of an image
steeped in tradition and message cannot be understood as a sixteenth- or seventeenth-century
Spaniard would have. The image had a life of its own, miraculously and mysteriously affecting the
emotions of the Spanish viewer. He knelt; we stare, looking at the brushwork.

Veneration and Beauty 109

For the twenty-first-century viewer, the Spanish royal portrait is perhaps robbed of its original power by the lack of the theatrical devices we expect to see in an image of a king. It is hard for us to believe these portraits represent rulers of the world; there is no crown, and none of the pomp and ceremony usually associated with the grace of leadership. Missing from the Habsburg royal portrait tradition are the standard symbols of wealth and kingship common in English or French court portraiture, as in the image of the Bourbon king Charles III by Maella (pl. 50).[16]

In the seventeenth-century engraving of the viceroy of Peru (see fig. 17), Mendoza's gesture points out to the indigenous people, who proffer traditional regal symbols, that Philip II is a different kind of monarch, one who needs no such conventional emblems of power, either in real life or in a portrait depicting him. The Inca must have wondered, as we do today, why the Spanish kings were portrayed so simply.

Indeed, the absence of splendor in the image of the king is a decidedly distinctive characteristic of all official portraits of the Spanish monarchs, beginning with a humble portrait of Isabel (see pl. 44). Antonis Mor's portrait of Philip II (see pl. 54) is a picture of a man so simple, understated, and stripped of attributes of royal office that it might be hard to distinguish him from any other high-ranking nobleman.[17] Even the insignia of the Order of the Golden Fleece was not exclusive to Spanish Habsburg monarchs; it can be found in portraits of nonroyal European noblemen who were members of the order as well.

But a Spanish subject of the Golden Age in Old and New Spain, as well as most Europeans of the time, would never mistake one of the royal portraits presented here as a representation of anyone else, because their tried-and-true formula would be instantly recognized. Official images issued by the king and his advisors at the courts of Charles V and his direct descendants, the three Philips, almost always show the monarch in one of two ways. In the first, he is dressed in simple black clothing, as in the framed portrait of Philip II in the background of the engraving of the viceroy of Peru (itself based on the official prototype by Sofonisba Anguissola, fig. 19). In the second, the monarch stands, full length and life size, dressed in armor, holding a general's baton. Taking an open, almost frontal stance, he turns slightly to meet the viewer with a direct gaze while posing in an interior space, which often contains a table covered in red velvet upon which a plume-topped helmet sits (fig. 20).

Unlike other European courts, there were no elaborate coronation ceremonies for the Spanish Habsburgs, but this fact cannot fully explain the consistent portrayal of the Spanish monarchs in such a restrained and sober manner over nearly two hundred years. Scholars who have wrestled with the understated presentation of the Habsburg kings have pointed to a complex series of decisions based in contemporary cultural and artistic practices. For Díez del Corral, the depiction of modesty is based on the particular structure of the Spanish monarchy and the character of its kings; the Spanish monarchs were humbled by the responsibility of keeping intact a conglomeration of distinct territories, all of which had different monarchical iconographies already in place.[18] Brown and Elliott believe it reflects a political reality: unlike lesser rulers, the Habsburg monarchs, "heads of a world-wide empire, universally recognized as the most powerful monarchs on earth," had no need to convince others or justify their positions.[19] In his classic essay revisiting the question, Brown argues that the origin of the stark simplicity of the image of the king resides in Charles V's personal taste, which his descendants more or less followed in the construction of their own images, in portraiture as well as in collecting.[20]

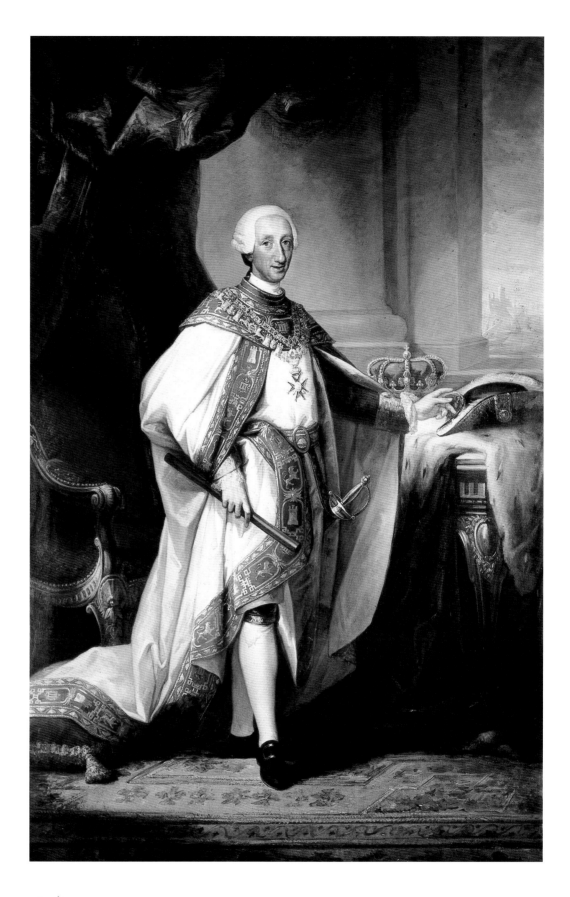

PLATE 50

MARIANO SALVADOR MAELLA (1739–1819)

Charles III Dressed in the Garments of His Order

18th century

Oil on canvas, 100⅜ × 63¾ in. (255 × 162 cm)

© Patrimonio Nacional, Palacio Real de Aranjuez, Madrid (10012844)

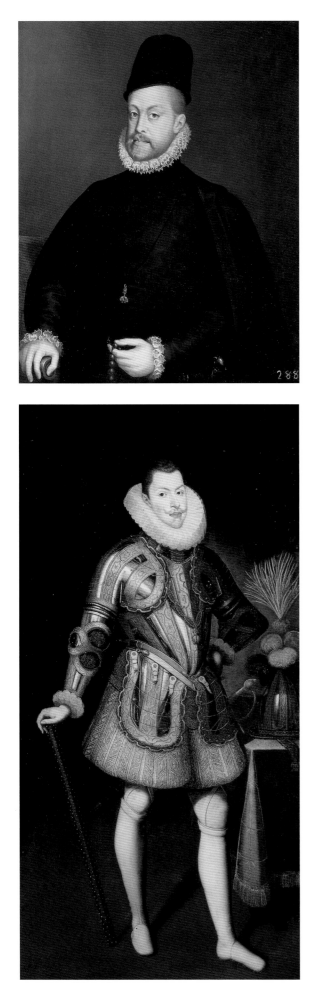

Antonio Feros directly connects the restraint and lack of kingly attributes in Spanish royal portraits to ideas found in the tutorial treatise written for the future Charles V by Erasmus, *The Education of a Christian Prince:* "A prince's prestige, his greatness, his regal dignity must not be displayed and preserved by noisy displays of privileged rank but by wisdom, integrity and right action."[21] In cultivating the Erasmian model of an ideal king, the Spanish monarchs chose an official representation that focused on the inner virtues of the ruler rather than on conventional symbols of royal authority and power. A stirring demonstration of the strict emphasis placed on the development of a prince's inner virtues is the picture commissioned by Philip II from the Flemish artist Justus Tiel, *Allegory of the Education of the Prince* (pl. 51). In it the young heir to the throne, Prince Philip (III), wisely accepts the oversized sword of Justice, while Father Time teaches him "right action" by pushing away all forms of sensual pleasure, represented by a blindfolded Cupid.

In his art-theoretical treatise published in 1633, court painter Vicente Carducho discussed royal portraiture in terminology similar to that of Saavedra y Fajardo: *gentilidad, imitación de virtudes, el decoro, el respeto, modestía y gravedad.*[22] He repeated the popular belief, following Italian Renaissance theory, that in the very early history of the genre, kings and princes alone were permitted to have their portraits painted, and then only if they had accomplished great things with honor, courage, and good government. The very notion of the portrait, then, is bonded with the ideas and virtues of kingship honored by it. Carducho scorned the contemporary practice of artists using "*insignias impropísimas*" in composing portraits of ordinary men. The symbols of "a table or chair below a curtain, the dignified bearing and posture of kings, armor with the general's baton," he claimed, should be reserved for images of kings and very great men. For Carducho and his contemporaries, therefore, it was not a matter of kings being depicted like ordinary noblemen, devoid of symbols of kingly wealth and power; rather, ordinary men were being wrongly portrayed with the attributes of royalty. The identity problem, Carducho noted, came from an "abuse" of the use of attributes, caused by "vain ambition."[23]

BREAKING DOWN THE MESSAGE

Armor and the general's baton; a table, chair, and curtain; and the grave bearing associated with the monarchy constituted those elements, what Richard Brilliant calls the "privileged properties of representation," that affected the recognition of a portrait as royal.[24] To Carducho and sixteenth- and

seventeenth-century viewers, these signs were of great worth symbolically; to see them automatically triggered the expectation that the person portrayed was a monarch. If combined with the recognizable Habsburg features, then, there could be no question about the sitter's identity. In this section, I will examine each of these iconographical elements separately and together as devices invented (or adapted from previous traditions) by the monarchs and their court as vehicles to drive messages about their monarchies. In interpreting these I will consider the impact of the imagery on New World audiences.

The first attribute mentioned by Carducho as appropriate for an image of the king is armor. And yet the rich symbolism of armor has been largely overlooked by art historians; it is the purview of a few specialists, usually curators of museums with arms and armor collections or passionate collectors. Here I will apply specialist studies to a selection of portraits to shed light on the importance of the specific armor chosen by kings for their official images.

The primary purpose of armor is protection; its promise of invulnerability was the wish of all men in battle.[25] For the warrior, armor was a second skin; to be successful, it had to be invincible against attack, but must also breathe and fit the body perfectly.[26] There is a story told of Charles V, who, upon trying on a suit of armor made for him in Mantua, declared it was "more precious to him than a city" and warmly embraced the armorer, Caremolo Madrone, saying "if he had taken measurements a thousand times, the armor would not fit better."[27]

It is one thing to commission a suit of armor for battle; it is another to be portrayed in armor in an official image representing the incarnation of the Spanish monarchy. Long after it had become totally impractical due to the advent of firearms and long-range weapons, elaborate personalized armor was still worn in royal portraits (see figs. 15, 20).

Armor has a multitude of abstract meanings as an iconographical symbol: war, authority, courage, victory, power, rank, status, entitlement, and wealth. In Old and New Spain, armor also represented imperial dignity and image, because it was closely linked to both branches of the Habsburg family, whose patronage allowed for the greatest technological and artistic innovations in the master craft of armor making. Emperor Maximilian I (1459–1519) established the first royal armory at court in Innsbruck in 1504, and Ferdinand II of Tyrol (r. 1579–1581) was the first to systematically collect armor, soliciting pieces from the most powerful rulers and well-known warriors of his day.[28] Maximilian I, the Holy Roman Emperor at the time of the Council of Trent, seems to have established the iconic emperor-knight image in his official portrait by Bernhard Strigel (c. 1460–1528), three versions of which are preserved in the Kunsthistorisches Museum, Vienna.[29]

The dynastic tradition continued in representations of Maximilian's grandson Charles V, who even as a child of about twelve was portrayed in a technically innovative "fluted" suit of armor, famed for its lightness, designed especially for Maximilian.[30] In the image by Tiel (pl. 51), Charles V's own grandson, the young prince Philip (III), is represented at the same age similarly wearing the very latest in armor fashion—a highly embossed and gilded suit thought to be the work of the Milanese armorer Lucio Picinino.[31]

Charles V perpetuated the official image of the armor-clad Habsburg ruler after inheriting the dual titles of Holy Roman Emperor and king of Spain. He commissioned the greatest portrait painter of his time, Titian, to produce his own set of official images in armor. In a calculated move to immortalize himself in the role of the victor after the important battle against the German Protestants at Mühlberg on April 24, 1547, the king commissioned Titian to paint two portraits in which he wears his actual battle armor (pl. 52). One was the epoch-making equestrian portrait

(fig. 21); the other was a standing, three-quarter-length image of the emperor in the same outfit. Before the latter portrait was lost, it was copied many times, each time further publicizing the victory.[32] Pantoja's copy dates from 1602 (see pl. 48).

In Pantoja's image, Charles V wears victory-parade armor, which is made of selected parts of the complete garniture used on the battlefield at Mühlberg. Garniture, a customized set of supplementary and interchangeable elements added to the basic armor pieces for multiple field and sporting functions, was the crowning achievement of the armorer's craft and the height of fashion in the sixteenth century.[33] This splendid suit was designed for the king by Desiderius Helmschmid, the third generation of a distinguished family of master armorers who had made Augsburg the leading German center for the manufacture of armor.[34] It exemplifies an innovation developed in Augsburg known as bluing, in which the plates were heated to extremely high temperatures until oxidation occurred, turning the metal blue. Seen in the portrait (but not in the overcleaned armor itself—subject to later tastes for the knight in "shining" armor), bluing, besides being an effective tool against rust, gave a stunning look of luxury when combined with etched and gilded borders.[35] Helmschmid's master craftsmanship was an essential part of Pantoja's version of Charles V's portrait, the armor rendered with as much skill and attention as the emperor's features themselves.

As we can see from Titian's equestrian portrait, in the victory ride after the battle was won, the king wore only the breastplate (cuirass), shoulder and sleeves (pauldron and upper and lower cannon), and armor for the area from the waist to the upper thigh (fauld and tassets); his legs are not protected with the greaves worn in battle. Pantoja repeated this presentation of Charles V without greaves and extended the portrait to full length. The emperor's riding boots with golden spurs and the absence of greaves would have signified to sixteenth- and seventeenth-century audiences that the royal sitting was executed after this important battle had been won.

Note that the full-length portraits of all four Habsburg kings have essentially the same pieces of garniture, without leg defenses. All are depicted wearing a similar form of the kid leather, knee-high Spanish riding boot, as if they had just dismounted from their horses and agreed to sit for the court portraitist. The supple white or doe-colored boots that reach the upper thigh, with golden spurs, are symbols of equestrianism and, in particular, the king's mastery of the horse, perfected at the Spanish court in the *haute école* of riding. Fernando Checa Cremades and José Miguel Morán remind us that the inscription for horse in Andrea Alciato's *Emblemata* (Augsburg, 1531) is "one which does not know how to flatter";[36] in other words, to look good on a horse, one must have acquired skill and control through much training and practice, which was part of every prince's education. The root for the word "knight" in most Romance languages is horse; the true knight was a fighter on horseback. Kings took great care to protect their sizable investment in their mounts, animals they admired and enjoyed and upon which they depended in battle.[37] Horses were sheathed in armor with identical decorative motifs as the king's garniture, made by the same royal armorer (pl. 53).

The depiction of Charles V in the Mühlberg armor propagandized a strategic victory for his reign, which both increased the territorial holdings of the Spanish empire and defended the Catholic faith against Reformation heretics. The battle was not to protect the homeland but the concept of empire and the one true faith. Thereafter portraits of Spanish kings in armor embodied the dual message of empire and faith, one particularly relevant to audiences in the New World in the age of exploration and conquest. The empire made its largest territorial gains during the reign of Charles V (1516–56) in the New World, and it is not hard to imagine a dual interpretation of the symbol of armor in his portrait: the Spanish *conquistadores* would have seen inspiration and a

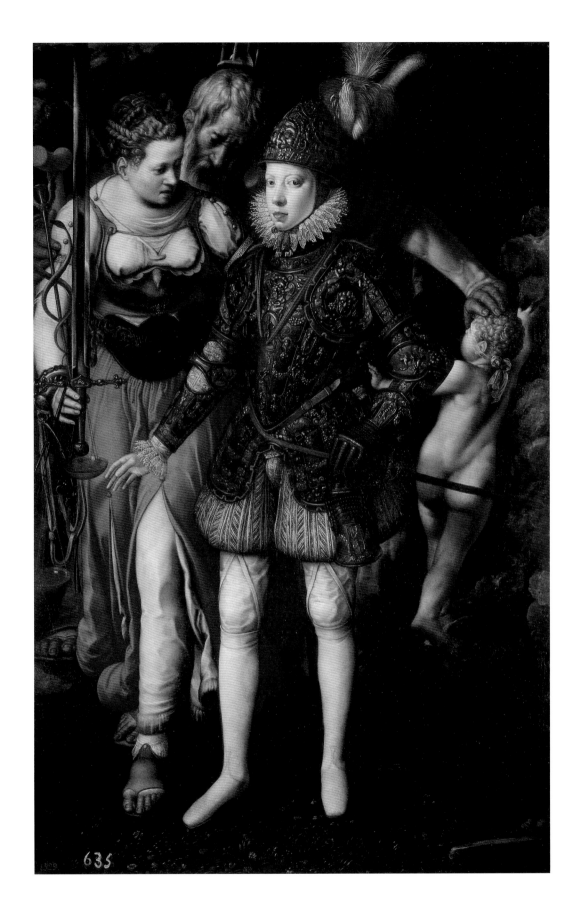

PLATE 51

JUSTUS TIEL (ACT. 1589–1630)
Allegory of the Education of the Prince (Philip III)

c. 1590

Oil on canvas, 62⅝ × 41⁵⁄₁₆ in. (159 × 105 cm)

© Museo Nacional del Prado, Madrid (1846)

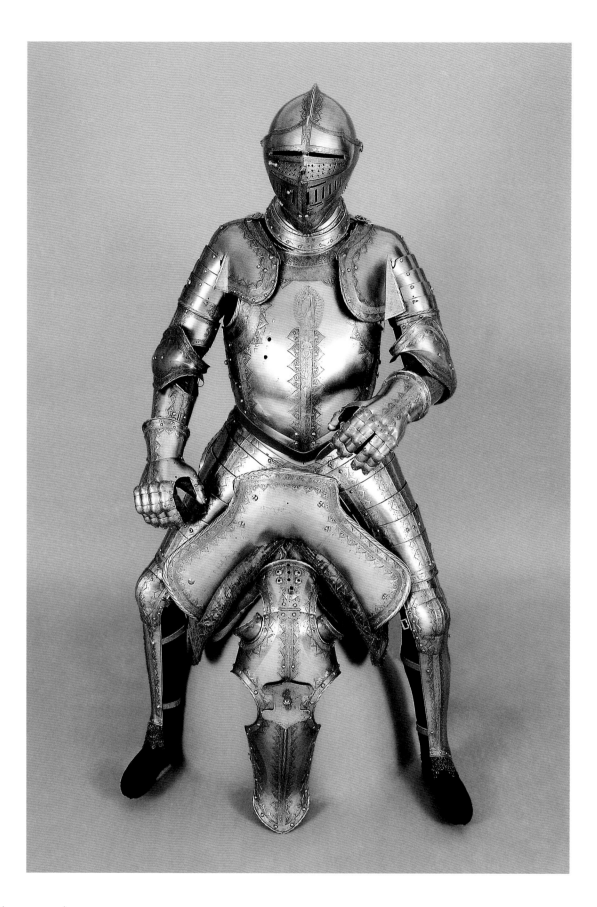

PLATE 52

DESIDERIUS HELMSCHMID (1513–1579)
Equestrian armor of Charles V from Mühlberg

Dated 1544

Etched steel, gold, wood, cloth, 74 × 24 × 28¾ in. (188 × 61 × 73 cm)

© Patrimonio Nacional, Real Armería, Palacio Real, Madrid

(19000287, 19000288, 10037774)

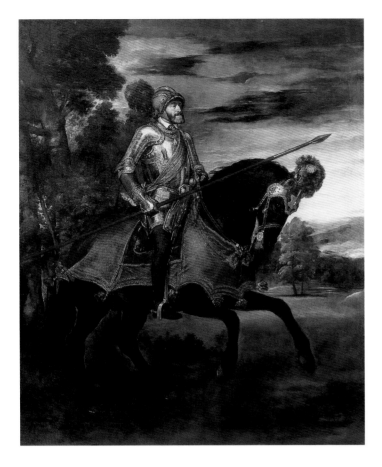

Fig. 21 Titian (Tiziano Vecellio, c. 1485–1576), *Equestrian Portrait of Charles V in Battle of Mühlberg,* 1548. Oil on canvas, 130¹¹⁄₁₆ × 109¹³⁄₁₆ in. (332 × 279 cm). © Museo Nacional del Prado, Madrid (410)

model of strength and courage, while settlers and the newly sub-jugated Aztec, Inca, and Maya peoples would have been reminded to whom they owed their allegiance. In Charles V's time, Spain's territorial conquest in the Americas extended to Mexico in 1524, when Cortes defeated the Aztecs; Spanish settlements in Paraguay and Colombia; expeditions into Florida; and the discovery of the Mississippi in 1539. In this period, Ecuador, Bolivia, and Chile became possessions of the Spanish crown. Buenos Aires was founded in 1535; Pizarro in 1543 defeated the Incas in Peru, after twenty years of fighting; and the Mayas were subdued in Guate-mala and the Yucatán by 1541.

In the early official image of Charles V's son, Philip II (1527–1598), by Antonis Mor (pl. 54), the king is also depicted in armor worn in the field during a significant battle and preserved in the royal armory since its making (pl. 55). Philip II wore this suit at the famous battle of Saint-Quentin, a significant victory over the French, won on August 10, 1557, the feast day of Saint Law-rence. All foreign dignitaries and persons connected to the Span-ish court were made ever-conscious of this battle by this portrait and its numerous copies,[38] and by Philip II's vow to the saint to build a great burial place for his royal ancestors, which became the monumental project of the basilica, monastery, library, and palace of El Escorial. The religious paintings commissioned or purchased for El Escorial by Philip II reflect his taste for Venetian art, his religious fervor, and his conservatism. Philip followed the traditions of patronage and portraiture set by his father, but introduced a new dimension to both. The permanent display of thousands of pictures in his palaces became a marked characteristic of his reign.[39] In this way, the acts of mega-collecting (to borrow Jonathan Brown's term) and exhibiting contributed to Philip's "official" image.

The differences in the full-length portraits of Charles V by Pantoja after Titian and of Philip II by the Flemish painter Mor would have spoken volumes to a sixteenth-century Spanish subject about the willful ambitions and ideals of Philip II's monarchy. Like his father, Philip II's firm war-rior stance is proud and accomplished, and the expression on his face is indeed imperial, but more stern and challenging, his gaze more direct, as if his sovereignty depended on unrelenting force. His left hand rests on the sword hilt, the entire length of the scabbard is made visible, and he seems poised to draw it at any moment.

The sword is believed to be the first true edged weapon; useless for hunting, it was designed to kill men.[40] An essential component of a complete harness of armor, the sword was regarded as one of the most noble of weapons and as a status symbol since the Middle Ages. With razor-sharp metal edges meant to produce deep wounds in close, brutal hand-to-hand combat, it signified bold bravery as well as strength. Although Philip II is protected by kilos of iron, the sword in the image of the king implies that he fought face-to-face to defend God's honor. This direct confrontation, a ritual developed by the chivalric knights in accordance with an epic code of behavior, was still conducted for the sake of faith.[41] Ultimate courage, boldness, and epic religious tradition were the messages communicated by the sword; these were messages of encouragement for the Spanish subject in the New World.

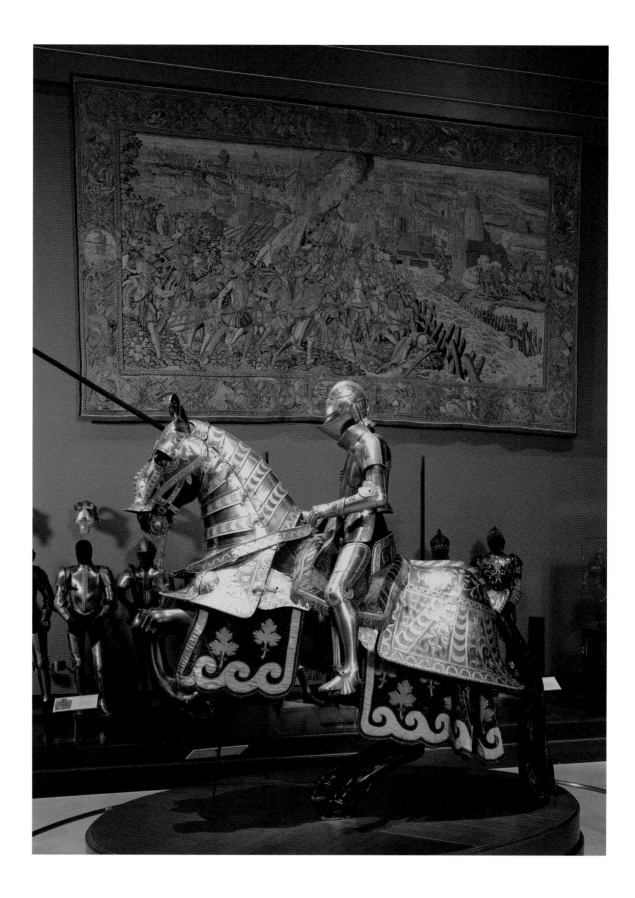

PLATE 53

WOLFGANG GROSSCHEDEL (1517–1562)
AND KUNZ LOCHNER (C. 1510–1567)
Equestrian armor for Philip II

C. 1554

Etched steel, gold

© Patrimonio Nacional, Real Armería, Palacio Real, Madrid (19000317)

For Spaniards it was also a signifier of national pride. Toledo was one of the three greatest bladesmithing centers in the world in the sixteenth and seventeenth centuries, with a reputation for producing blades of superb quality. The delicately twisted hilt of curving shapes and the gold-threaded wrapped handle are synonymous with the highest craftsmanship in Toledo, signifying luxury and wealth. After the use of long-range weapons became widespread, the sword became an honorific item, but remained part of the royal image. Charles V, Philip II, and Philip IV are shown with hand placed on the sword hilt; Philip III no longer touches the sword itself, a gesture no doubt referring to his pacifist views. During his reign, peace treaties were signed with the English, French, and Dutch.

The sword was also an emblem for justice. In Tiel's *Allegory of the Education of the Prince,* the prominence given the sword in the narrative and composition makes it clear that the virtue of justice and its wise allocation was one of a prince's most important lessons.

Another symbol for justice and majesty in the image of the king is the table covered with a red velvet cloth.[42] Gállego points out that the table found in royal portraiture would never have been confused with an ordinary worktable used for writing or eating. It refers to the "*bufete*" described in contemporary accounts of royal audiences, a table in front of which the king stood throughout the long function. The table in Empress María's portrait by Pantoja (see pl. 63) calls attention to the fact that she was known for being "superior in justice" according to her biographer, Rodrigo Mendes Silva.[43]

The missing table in Antonis Mor's portrait of Philip II is not an oversight. In addition to creating an image of a king determined to further his father's imperialistic projects, Mor wanted to communicate that Philip II did so with a newfound religious justification, a heightened conviction of his individual kingly role as defender of the Catholic faith. In presenting Philip II, Mor employed some of the pictorial strategies found in northern European fifteenth-century devotional paintings.[44] The king is isolated against a dark ground, removed from a narrative context or other indicators of space, such as the ubiquitous table, or the window and floor seen in the images of Charles V, Philip III, or Philip IV. The strong frontal light is focused on the figure without penetrating into the background. On some level, consciously or not, viewers must have recognized the pictorial format normally used to cultivate an emotional state for religious meditation and prayer. Antonio Feros has demonstrated a marked change in the attitude toward the monarchy in Philip II's reign, when the propaganda machine "sacralized" the image of the king.[45]

The protective links of mail, the armor of the crusades, beneath Philip II's steel cuirass are given pictorial significance by the cadmium red ribbons tied around Philip's impressive biceps; they are perfectly reflected in his breastplate. Mail was a holdover from medieval times, when it was effective against swords; it became useless once the crossbow was invented in the late fourteenth century.[46] Around that time, Philip II's ancestor, Philip the Good, duke of Burgundy, created a post-crusade knighthood, the Order of the Golden Fleece, dedicated to the medieval chivalric deeds of "defending, guarding, and maintaining the tranquility and prosperity of the public and increasing the honor of the true Catholic faith."[47] Another motivation was to celebrate the union of Flanders and Burgundy with Philip's marriage to Isabel of Portugal in 1430. By creating an organization for the powerful elite of the numerous scattered territories now united under his control, Philip the Good encouraged their piety, loyalty, and cooperation for the common good, in spite of disparate traditions and languages.

Mor artfully intertwined the two symbols by suspending the insignia of the Order of the Golden Fleece from a ribbon of the same bright red as the armbands around the "crusader" mail

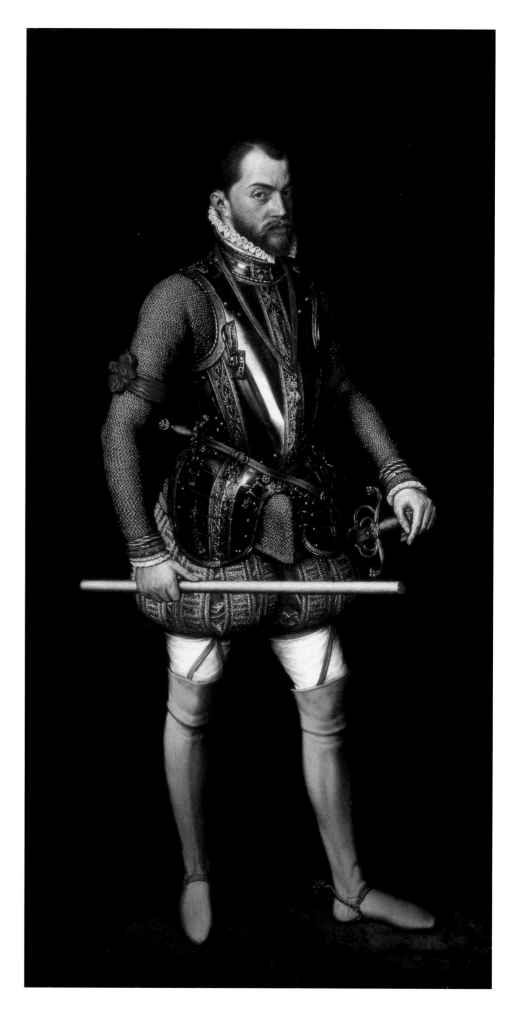

PLATE 54

ANTONIS MOR (1516/20–1576?)
Philip II

c. 1557
Oil on canvas, 77¹⁵⁄₁₆ × 41⁵⁄₁₆ in. (198 × 105 cm)
© Patrimonio Nacional, Real Monasterio de
San Lorenzo de El Escorial (10014146)

PLATE 55

DESIDERIUS HELMSCHMID (1513–1579)

"Flowers" garniture of Philip II

c. 1549

Etched steel, gold, 68½ × 26⅜ × 22⁷⁄₁₆ in. (174 × 67 × 57 cm)

© Patrimonio Nacional, Real Armería, Palacio Real, Madrid (19000327)

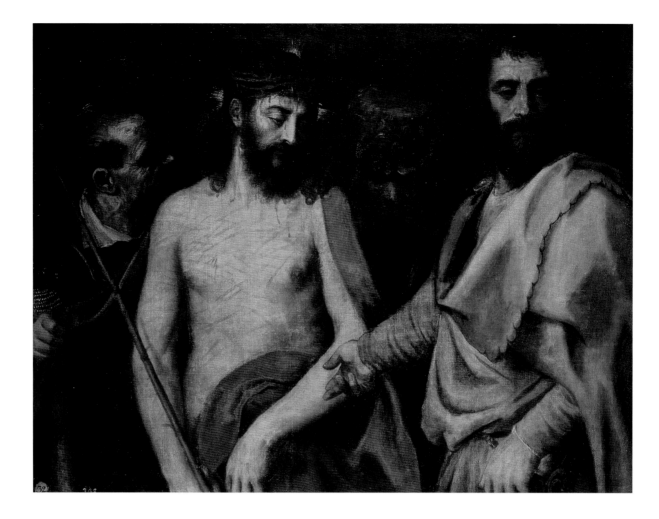

PLATE 56

TITIAN (TIZIANO VECELLIO, C. 1485–1576)
Ecce Homo

Dated 1580

Oil on canvas, 33¹⁄₁₆ × 44⅛ in. (84 × 112 cm)

© Patrimonio Nacional, Real Monasterio de San Lorenzo de El Escorial (10014723)

sleeves. Whenever pictured on a king of Spain in the sixteenth and seventeenth centuries, the little golden symbol signified the hereditary office of grand mastership of the order, which had passed from the last duke of Burgundy to the house of Habsburg in 1477. Always present in all versions of the official image of the king, whether portrayed as a man in black or as commander-in-chief, the order is a dual symbol of empire and unity, Catholicism and piety, dynastic lineage and goodness. The king who wears it by heredity is taught to protect and care for his loyal subjects.[48] A viewer in the New World contemplating the messages inherent in these symbols, we can imagine, would have responded with respect and veneration, and would perhaps have taken a sense of security and comfort from the image.

In his official image, therefore, Philip II is pictured as the Christian knight, ready to do battle against heretics, dedicated to defending the Catholic faith at all costs, just as his ancestors who led the crusades had done. At home, the fight with the "infidel" was against the Moors, a conflict which began in the eleventh century and was only finally and decisively won by Ferdinand and

Isabel in 1492. The impact of the memory of that victory is evident in the charming double portrait of Philip II's sons, Diego and Philip (pl. 57), commissioned by the king from his court portraitist, Alonso Sánchez Coello. The *infantes* are practicing the art of war with canes and a Moorish-style shield, which was still being produced in the sixteenth century (pl. 58). The older prince holds the shield, the oldest form of protective armor, invented in Paleolithic times even before the bow, as if about to teach little Philip its function as a break for a shock of blows.[49]

The general's baton, when combined with battle or victorious parade armor, is an iconographical element borrowed directly from ancient and Renaissance portraits of the twelve Roman emperors, copies of which in marble and paint were popular decorations for royal and noble palaces and gardens throughout the period. The message is simple: the sitter is the ruler of an empire even greater than Rome's.[50]

As late as Philip IV, Saavedra y Fajardo chose to describe the countenance in the image of the king as "august," meaning imperial, derived from Augustus Caesar, the expression recorded on the sculpted faces of the Roman emperors. Even though the title of Holy Roman Emperor passed to the Austrian branch of the Habsburg rulers after Charles V, all his descendants were depicted as emperors, holding a general's baton, dressed in armor, bare head waiting only for a helmet rather than the sumptuous crown seen in Empress María's portrait (pl. 63). The notion of empire is ever present in the construction of the images of the kings of Spain in the sixteenth and seventeenth centuries. Images of the king in armor with the general's baton propagandized the concept of the invincible ruler leading his armies with all-encompassing authority. The combination of symbols was meant to glorify the conquest of new territories, exalt the battle against heretics, and even justify slavery for bringing gold and silver to the crown's coffers, which in turn would support the strengthening of the monarchical system, Spain's imperial ambitions, and defense of the faith. In the case of Philip III (see fig. 20), however, the general's baton has become manneristically elongated and seems to function as an elegant walking stick. The traditional symbol has been transformed into an expression of the king's intention to not wage war.

In addition to referring to holy war and the defense of the empire, armor was a symbol of status. The making of armor was extremely costly and labor-intensive, requiring the skills of several master craftsmen and numerous workshop assistants. The complex process began with an unfinished bar of steel, which was heated and hammered by one man into flat plates, and cut by another assistant into rough shapes designed by the royal armorer to fit the king's chest, arms, and waist.[51] The plates were put back into the fire to soften them for more hammering over metal forms, or "dies," formed like a chest, arm, or thigh, to achieve the final shape. A complete garniture could be made of dozens of pieces, not only for body parts of the man, but those of his horse. A trial fitting followed to make sure the various parts were comfortable, movement was reasonably fluid, and most importantly for defense, that no gaps appeared where the parts overlapped. Flaws were corrected with repeated filing and hammering until the fit was perfect.

Next the plates were passed on to another master craftsman responsible for polishing or bluing the steel, which would have blackened from smoke during repeated firings. The final stage was the addition of decorative engraved, etched, or embossed work. As this embellishment became the distinguishing feature of a suit of armor, the head of the workshop himself usually executed the rich damascened decoration. Much like a silversmith, he drew a pattern on the reverse side of the plates, which he punched from the inside to gradually shape the raised design on the outer surface, demonstrating skill and precision, and often inventiveness, if he was not copying the pattern from a book. Further decorative motifs would be etched or engraved directly into the steel. Finally, still

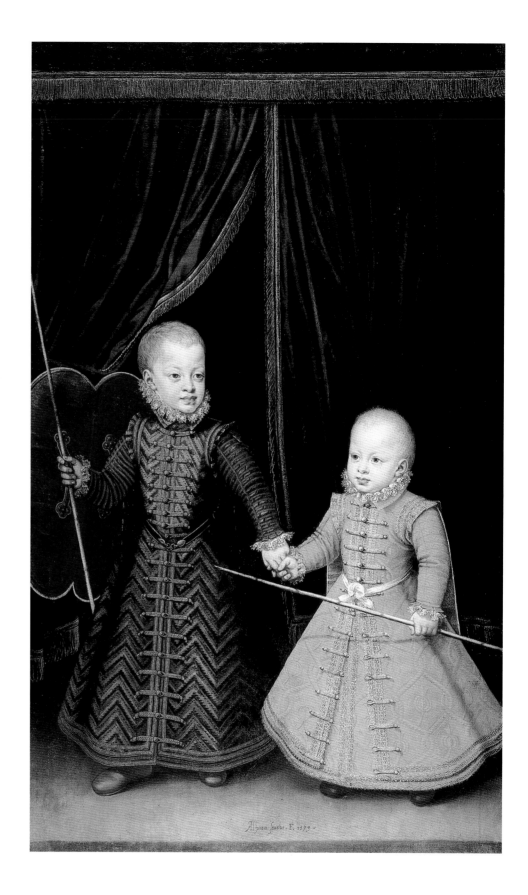

PLATE 57

ALONSO SÁNCHEZ COELLO (1531/2–1588)
Infantes Philip III and Diego Playing with a Shield

1579
Oil on canvas, 66¹⁵⁄₁₆ × 40⁹⁄₁₆ in. (170 × 103 cm)
© Patrimonio Nacional, Monasterio de las Descalzas Reales, Madrid (00612071)

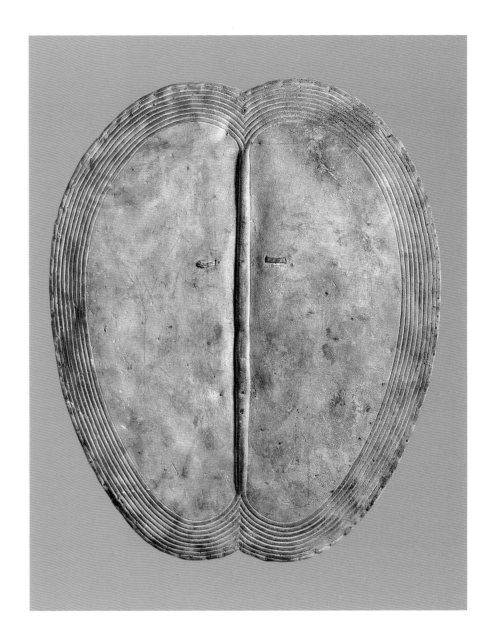

another craftsman would gild areas of the decoration with strips of the thinnest beaten gold or silver leaf.

In 1559 Philip II decided to purchase the entire collection of armor that had belonged to his father in Valladolid, valued not only for its rich symbolism of Charles V's triumphs and its personal use by the king, but also for the pieces he had commissioned from the Helmschmid family and Filippo Negroli, and the armor received as diplomatic gifts or inherited from Charles's father, Philip I of Castile, and his grandfathers, Emperor Maximilian I and the Catholic Monarchs. In the world of the court, this acquisition gave to the collection of armor an added dynastic character and established armor, after tapestries, as the most important part of the Spanish royal collections.[52] Some fifteen years earlier, Philip II had commissioned original watercolor drawings as a visual record of the complete sets of garnitures made for the Spanish kings (fig. 22), which testifies that the royal armory was inventoried more carefully and in greater detail than paintings in the royal collection.[53]

Commissions of armor, as status symbols and for their collectability, reflected the connoisseurship of the owner. Charles V's armor for Mühlberg is ornamented with a sober repeating chevron pattern, carefully organized on the surface, and damascened with gold fillets to great

Fig. 22 *Inventario iluminado*, 1544–88, garniture for Charles V. Watercolor drawing, 17 × 12⅜ in. (43 × 31.5 cm). © Patrimonio Nacional, Real Armería, Palacio Real, Madrid (N18)

decorative effect. The result creates a serene splendor in accord with the emperor's taste. From the time he was twenty-five years old, Philip II began to demonstrate his own distinctive taste in armor that broke with the family tradition. From 1550 he patronized the Grosschedel family of Landshut, and slightly later, his taste shifted again when he switched allegiance to another armorer, Kunz Lochner (see pl. 53).

Reflecting the taste of the individual as well as a political message, the armor in the portrait of Philip III by López Polanco (fig. 20) shows a marked departure from the sober decoration of the armor of Charles V and Philip II. Here bands of gold-leafed scrollwork cover almost the entire surface, making the blued steel only a background for the rich and elaborate decorative bands. The purely ceremonial armor has evolved into "spectacular male body jewelry"[54] never intended for field use. Although commissions for ceremonial parade armor were common from the kings of Spain, such as the superb example made for Charles V by the great Renaissance master Filippo Negroli (see pl. 28) and the miniature Spanish suit belonging to a son of Philip III (pl. 59), it was the exception rather than the rule, until the time of Philip III, for a Spanish king to be depicted in a fancy suit of armor for an official portrait. The functional white collars on his father and grandfather, worn to protect the neck from rubbing against the steel, become on Philip III a highly fashionable and very wide starched collar, with delicate lace cuffs appearing at the wrists, transforming his armor into a metal imitation of the lines of ordinary dress costume.[55] The fact that Philip chose to be depicted in ceremonial rather than field armor is another direct reference to the pacifist foreign policy of his reign.[56] As previously noted, his left hand does not rest on a sword, but is placed jauntily on his hip, which adds to the dandylike stance created by his baton-cum-walking stick. The official image of Philip III was conceived around the time Cervantes wrote *Don Quixote* (1603–5) in Valladolid, where in lieu of taking to battle, the king and his court temporarily transferred from Madrid, from 1601 to 1606. In Valladolid Philip entertained in a grand style with an endless succession of religious and secular fiestas; "*quijote*" is a contemporary term in the royal inventories for the piece of armor protecting the thigh (*cuish*).

Philip III's face is rendered as a mask, which combined with the cutout shape of the body and expensive, overly decorative armor, is a purposeful reference to official portraits of Elizabeth I.[57] Like the opulent, doll-like images of the Virgin Queen, the monarchical iconography of Philip III's portraits conveys the message of an inaccessible king whose court is run by favorites and whose grandeur elevates him above his subjects, another form of deification.

The portrait of his sister, Isabel Clara Eugenia, by Frans Pourbus (pl. 60), expresses the new grandeur of Philip's court, which was a reaction against the severe style of his father. Governor of Flanders from 1598, Isabel Clara Eugenia is depicted in a richly brocaded dress, with a sumptuous curtain and chair behind her, the signs of royalty mentioned by Carducho. Her right hand is resting on the head of her dwarf, a figure/attribute that regularly appears in Spanish royal portraits of the sixteenth and seventeenth centuries. Ideal adult companions for the royal prince

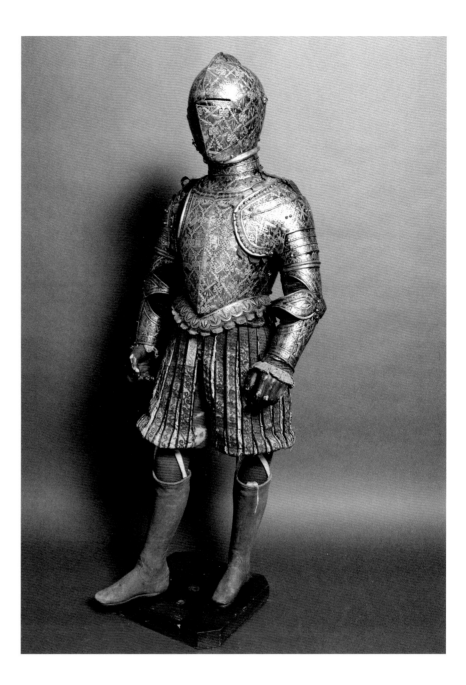

and princesses due to their size, dwarfs occupied a special place as members of the court house-hold. Famed for being sincere, the dwarf was allowed to speak frankly without consequence. Etiquette of the court demanded that a dwarf never be laughed at, which implies a charitable motive.[58] As an attribute in an official portrait, therefore, the dwarf represented loyalty, sub-servience, charity, and truth.

Within the extravagance of Isabel Clara Eugenia's portrait is a small detail that sends a big message—the jeweled cross she wears around her neck is a symbol of her duty to uphold the Catholic faith in a region of growing Protestantism. Her dedication to the special practices of Spanish Catholicism is also revealed in the use to which she put an extremely costly gift she received in the 1580s from Carlo Manuel, duke of Savoy—a magnificent gold and etched rock-crystal box encrusted with pearls, enamels, and other precious stones (pl. 61).[59] Though it had been meant to hold jewels, she made it into a reliquary casket for the head of Saint Hermenegildo, a demonstration of her extreme piety and veneration of the saints. She donated it to the cache of relics in El Escorial, which numbered in the thousands.

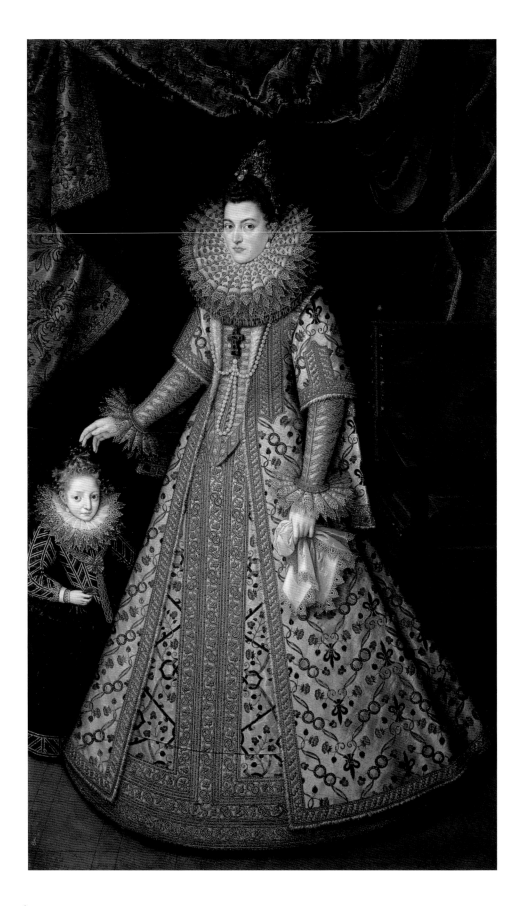

PLATE 60

FRANS POURBUS THE YOUNGER (1569–1622)
Isabel Clara Eugenia

Dated 1599
Oil on canvas, 87¹³⁄₁₆ × 52⅜ in. (223 × 133 cm)
© Patrimonio Nacional, Monasterio de las Descalzas Reales, Madrid (00612215)

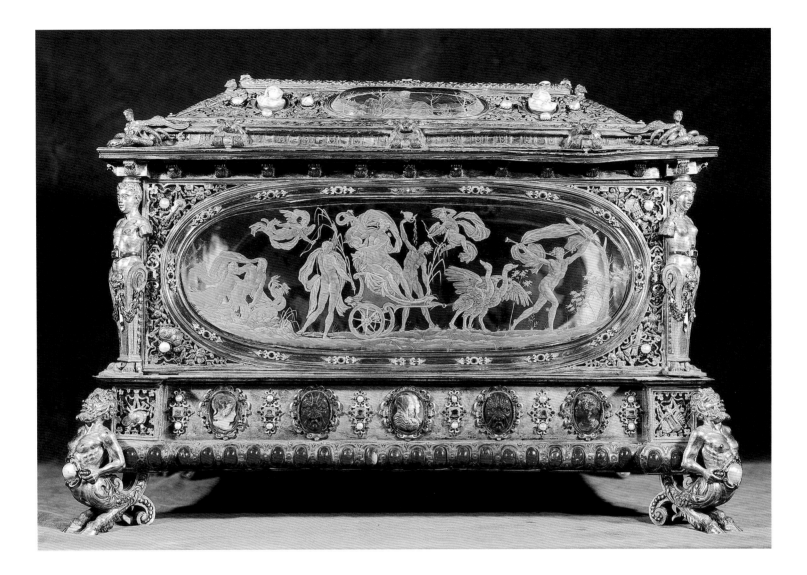

PLATE 61

Reliquary casket of Isabel Clara Eugenia

Milan, 1585

Restored in 1887 by Alfred André

Silver gilt, gold, rock crystal, enamel, pearls, precious stones, hard stones,

14¹⁵⁄₁₆ × 23¼ × 16¹⁵⁄₁₆ in. (38 × 59 × 43 cm)

© Patrimonio Nacional, Palacio Real, Madrid (10012357)

Even though it dates from the restrained period of Philip II, an earlier portrait of Isabel of Austria by Joris van Straeten (pl. 62) is even more luxuriant, with its gown with swan-feathered sleeves. But it is not Spanish; this is an official portrait issued from the French court of Isabel of Austria, queen of France from 1570 to 1574. Even the palette is different—court portraitists from Spain favored blacks, reds, and gold; the dominant use of emerald green in the curtain in Isabel of Austria's portrait, a favorite background color of François Clouet, identifies the picture as French, as does its utter lack of religious symbolism.

Around the time of Empress María's death, Pantoja de la Cruz painted an official portrait of her wearing the traditional garb of a Habsburg widow, the habit of a reformed Franciscan nun (pl. 63). When her husband Maximilian II died, the empress chose to leave Central Europe for Madrid and a secluded life at the Descalzas Reales, where she could devote herself to prayer and work for the defense of the Catholic faith, that is, the political interests of the Austrian Habsburgs, by using her considerable influence on her nephew, King Philip III, and other members of the court.[60] The luxurious imperial crown on the table is a direct reference to her sacrifice and her rank; her biographers stress her renowned lineage, forged through blood and marriage to three emperors: she was the daughter of Charles V, daughter-in-law of Ferdinand I, and wife of Maximilian II. Other costly luxury items connected to her past life were put to new use in the convent setting. María converted an elaborate silver jewel box made for her by Wenzel Jamnitzer, for example, into a vessel for the relics of Saint Victor (pl. 64).

The empress's attire, the habit of a cloistered nun (she never took vows), and the rosary beads in her hand can be interpreted as symbols constituting a female armor of piety. The garb, representing her choice to retire in a reform convent, and the other acts of extreme piety demonstrated by the empress commanded authority, honor, and respect, which in turn enabled her to gain great political influence. In her funeral sermon, delivered in 1603, Fray Jerónimo de Florencia argued that Empress María fought for the defense of Catholicism like a male warrior.[61] The symbolism in this female portrait (repeated more than a century later in a sketch of the empress by Francisco Goya, pl. 65) corresponds to the same messages of modesty, empire, and faith broadcast by the public images of the Habsburg kings.

There is one more symbol in the image of the king that had a lasting significance in the New World. On the breastplate of Charles V's armor, high up near the neck, appears an embossed image of the Virgin in a mandorla emitting rays of light. According to Harold Wethey, this practice seems to have begun only after Charles V was crowned Holy Roman Emperor in Bologna in 1530.[62] The image of the Virgin would have been a clear signifier to others of the Spanish monarchs' special devotion to the cult of Mary, and it operated as a Catholic badge separating him, in battle and in image, from the heretics he was fighting. On the back of the cuirass of the Mühlberg armor is an engraved image of Saint Barbara, illustrating royal belief in the saints as intercessors.

By the time of Philip II and Philip III, the image of the Madonna on the breastplate assumed the specific iconographical meaning of the Virgin of the Immaculate Conception, the Woman of the Sun standing on a crescent moon. The inclusion of the mandorla of the Immaculate Conception in the decoration of their armor was a declaration of the crown's stance on the controversial subject; both kings fought especially hard with Rome and others to accept the immaculate conception of Mary as church doctrine.[63] Particularly in Mexico, viewers would have connected this symbol to the miracle of Our Lady of Guadalupe, who appeared in 1531 to the *Mexica* Juan Diego Perón in a similar form, but with the addition of the vibrant colors of the New World.

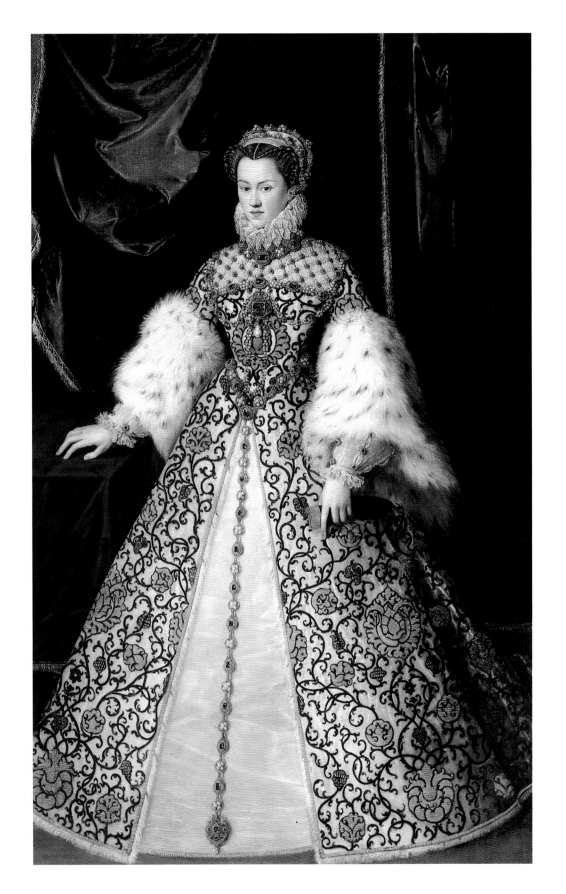

PLATE 62

JORIS VAN STRAETEN (ACT. C. 1540–80)

Isabel of Austria, Archduchess of Austria

1573

Oil on canvas, 73¹³⁄₁₆ × 47¼ in. (187.5 × 120 cm)

© Patrimonio Nacional, Monasterio de las Descalzas Reales, Madrid (00612227)

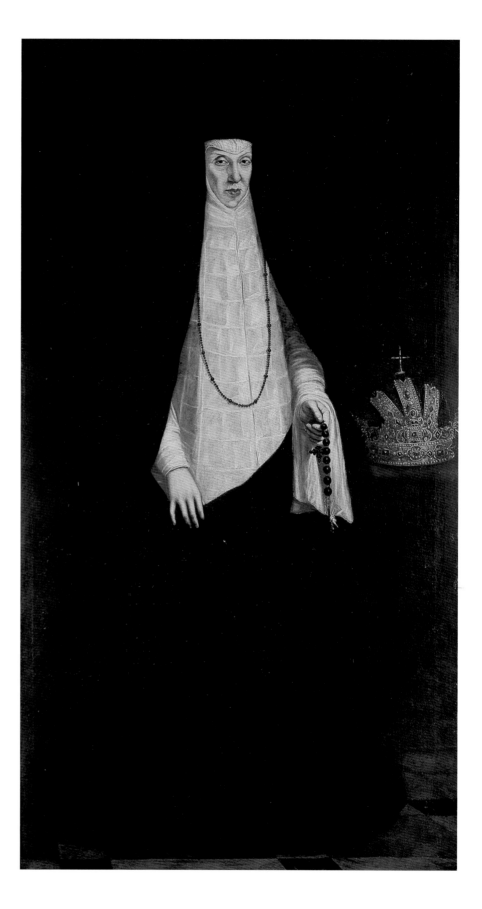

PLATE 63

JUAN PANTOJA DE LA CRUZ (1553–1608)

Empress María of Austria

Late 16th century

Oil on canvas, 72¼ × 40⅜ in. (183.5 × 102.5 cm)

© Patrimonio Nacional, Monasterio de las Descalzas Reales, Madrid (00612225)

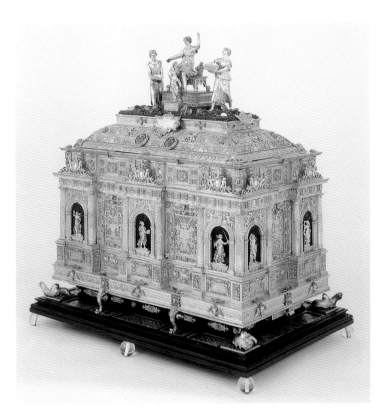

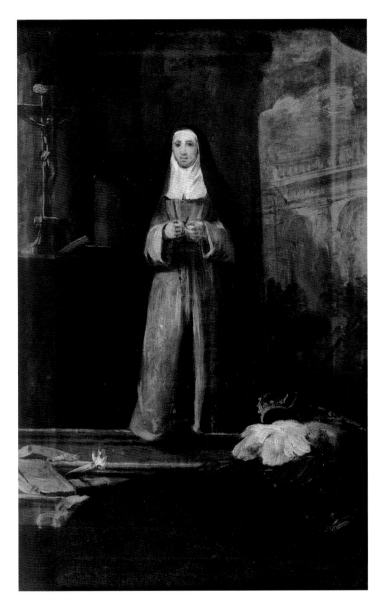

PLATE 64

WENZEL JAMNITZER (1508–1585)
Reliquary casket of Saint Victor

1556–70
Silver, enamel, jet, 23⅝ × 15¾ × 10⅝ in. (60 × 40 × 27 cm)
© Patrimonio Nacional, Monasterio de las Descalzas Reales, Madrid (00612650)

PLATE 65

FRANCISCO JOSÉ DE GOYA Y LUCIENTES (1746–1828)
Empress María of Austria

n.d.
Oil on canvas, 19⅞ × 13¾ in. (50.5 × 35 cm)
© Patrimonio Nacional, Monasterio de las Descalzas Reales, Madrid (00610687)

Veneration and Beauty 133

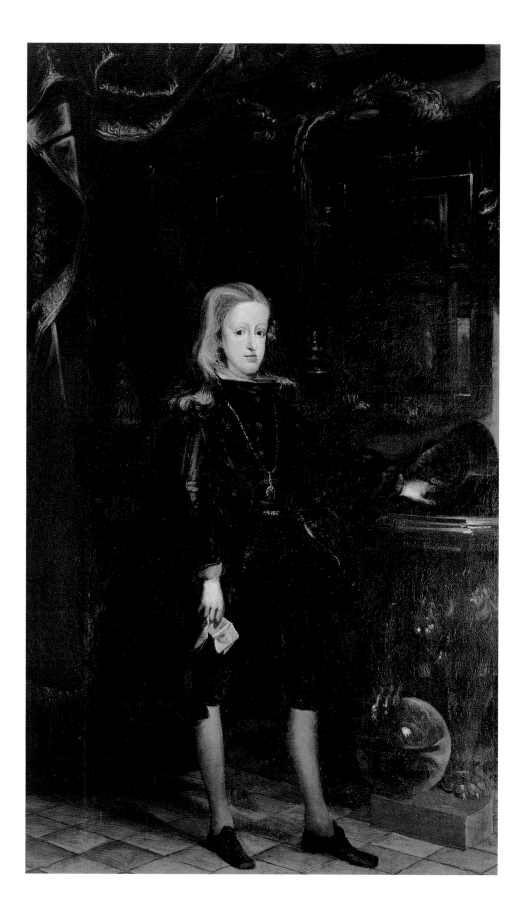

PLATE 66

JUAN CARREÑO DE MIRANDA (1614–1685)
Charles II

c. 1671

Oil on canvas, 81⁵⁄₁₆ × 48⁷⁄₁₆ in. (206.5 × 123 cm)

© Patrimonio Nacional, Real Monasterio de San Lorenzo de El Escorial (10014143)

The official image of the Spanish king as Christian warrior, whose only royal attributes were armor, general's baton, riding boots, and the table and sword of justice, began to wane during the reign of Philip IV, and finally died out altogether with the end of Habsburg rule. The great Diego Velázquez painted Philip IV in this manner only twice, as far as we know—once in the equestrian portrait for the Hall of Realms in the Buen Retiro palace in 1635 and, near the end, in the image of the king in military dress by Velázquez and his workshop (see fig. 15), which coincides with the greatest period of military and economic crisis in the reign.[64] Indeed it is the fullest display of garniture among the images of the Spanish kings. The left gauntlet is worn, while its mate for the right hand rests on the table, and the legs are covered to the knees in an elaborate jamb that echoes the layers held together by the shiny rivets in the pauldrons, or shoulder coverings. The armor in Philip IV's portrait relays a message that the "reputation" of the Spanish monarchy, symbolized by the lion at his feet, will be restored through renewed war against its enemies. The lion, a new addition to the Habsburg portrait iconography, is an allegorical reference to the Spanish kings' claim to be descendants of Hercules, and to the loyalty of the king to the imperialist goals of the Spanish monarchy. Philip IV is fighting to the end in an attempt to preserve Spanish dominance in Europe and the New World; he is the "new Hercules" wrestling the Nemean lion.

Unfortunately, Philip IV was fighting a losing battle, and his son and heir to the throne, Charles II, "the bewitched," was judged unfit to govern, let alone fight (pl. 66). Unable to produce an heir, Charles became the last in the line of the Spanish Habsburgs to rule Spain. The subsequent generation, the Bourbons, dropped the illusion as well as the understated manner of royal portraiture, preferring instead the flamboyant baroque tradition used in the rest of Europe.

NOTES

1. Julián Gállego, *Visión y símbolos en la pintura española del Siglo de Oro* (Madrid: Cátedra, 1972), 276.

2. Most recently discussed by Miguel Falomir Faus, "Imágenes de poder y evocaciones de la memoria: Usos y funciones del retratro en la corte de Felipe II," in Museo del Prado, *Felipe II: Un príncipe del renacimiento: Un monarca y su época* (Madrid: Sociedad Estatal para la Conmemoración de los Centenarios de Felipe II y Carlos V, 1999), 203–27.

3. Jonathan Brown, *Velázquez: Painter and Courtier* (New Haven: Yale University Press, 1986), 229.

4. Harold Wethey, *The Paintings of Titian*, vol. 2, *The Portraits* (London: Phaidon, 1971), 193.

5. The fundamental study on this subject is Jonathan Brown and J. H. Elliott, *A Palace for a King: The Buen Retiro and the Court of Philip IV* (New Haven: Yale University Press, 1980, new edition forthcoming).

6. See Juan Miguel Serrera, "Alonso Sánchez Coello y la mecánica del retrato de corte," in *Alonso Sánchez Coello: Vida y obra* (Madrid: Museo del Prado, 1990), 53; Fernando Bouza Álvarez, "Ardides del arte: Cultura de corte, acción política y artes visuales en tiempos de Felipe II," in Museo del Prado, *Felipe II*, 63; Falomir Faus, "Imágenes de poder," 203–27; Gállego, *Visión y símbolos*, 259–77; and Fernando Checa Cremades and José Miguel Morán, *El barroco* (Madrid: Ediciones Istmo, 1982), 197–207; Antonio Feros, "Sacred and Terrifying Gazes: Languages and Images of Power in Early Modern Spain," in *The Cambridge Companion to Velázquez*, ed. Suzanne L. Stratton-Pruitt (Cambridge: Cambridge University Press, 2002), 68–86; Jonathan Brown, "Enemies of Flattery: Velázquez's Portraits of Philip IV," *Journal of Interdisciplinary History* 17, no. 1 (summer 1986), 137–54.

7. Serrera, "Alonso Sánchez Coello," 53, and Bouza Álvarez, "Ardides del arte," 63.

8. Feros, "Sacred and Terrifying Gazes," 68–69.

9. Falomir Faus, "Imágenes de poder," 215.

10. Alejandra B. Osorio, *Inventing Lima: The Making of an Early Modern Colonial Capital, 1540–1680* (PhD diss., SUNY at Stony Brook, 2001), chap. 4, as quoted by Feros, "Sacred and Terrifying Gazes," 68.

11. Most recently discussed by Diane H. Bodart, "Le portrait royal sous le dais," in *Arte y diplomacia de la monarquia hispanica en el siglo XVII*, ed. José Luis Colomar (Madrid: Fernando Villaverde, 2003), 89–91.

12. Feros, "Sacred and Terrifying Gazes," uses the translation "I was overcome with respect" (p. 68). First quoted by Checa Cremades and Morán, *El barroco*, 198.

13. See J. H. Elliott, *Spain and Its World, 1500–1700: Selected Essays* (New Haven: Yale University Press, 1989), 69, 122–28.

14. Checa Cremades and Morán, *El barroco*, 198; Gállego, *Visión y símbolos*, 276.

15. Falomir Faus, "Imágenes de poder," 211.

16. See Brown, "Enemies of Flattery," 137–54.

17. Ibid., 146.

18. See Luis Díez del Corral, *Velázquez, la monarquía e Italia* (Madrid: Ministerio de Educación y Cultura, 1979).

19. Brown and Elliott, *Palace for a King*, 150.

20. Brown, "Enemies of Flattery," 137–54.

21. Quoted in Feros, "Sacred and Terrifying Gazes," 83.

22. Vicente Carducho, *Diálogos de la pintura* (1633; Madrid: Turner, 1979), 332–39.

23. Ibid., 336.

24. Richard Brilliant, *Portraiture* (Cambridge, Mass.: Harvard University Press, 1991), 26.

25. Helmut Nickel et al., *Art of Chivalry: European Arms and Armor from the Metropolitan Museum of Art* (New York: American Federation of Arts, 1982), 15.

26. Thomas Höft, *Shiny Shapes: Arms and Armor from the Zeughaus of Graz* (New York: Springer, 1998), 16.

27. Quoted in Walter J. Karcheski Jr., *Arms and Armor in the Art Institute of Chicago* (Chicago: Art Institute, 1995), 77.

28. Stuart W. Pyhrr and José-A. Godoy, *Heroic Armor of the Italian Renaissance: Filippo Negroli and His Contemporaries* (New York: Metropolitan Museum of Art, 1998), 146.

29. Inv. Nos. 2599, 4401, 4403: *Porträtgalerie zur Geschichte Österreichs von 1400 bis 1800* (Vienna: Kunsthistorisches Museum, 1982), 52–56.

30. Illustrated in ibid., pl. 37.

31. Jesús Urrea, *Pintores del reinado de Felipe III* (Madrid: Museo del Prado, 1993), 38.

32. Wethey, *Titian*, 193, and Fernando Checa Cremades, *Carlos V, a caballo, en Mühlberg de Tiziano* (Madrid: Museo del Prado, 2001).

33. Nickel, *Art of Chivalry*, 57.

34. See Pyhrr and Godoy, *Heroic Armor*, 1, and Karcheski, *Arms and Armor*, 31.

35. Stephen N. Fliegel, *Arms and Armor: The Cleveland Museum of Art* (Cleveland: Cleveland Museum of Art, 1998), 85–86.

36. Checa Cremades and Morán, *El barroco*, 203.

37. Nickel, *Art of Chivalry*, 56.

38. There are seven copies of Mor's image; see Stephanie Breuer-Hermann in Museo del Prado, *Felipe II*, 130–31.

39. Falomir Faus, "Imágenes de poder," 218.

40. Nickel, *Art of Chivalry*, 85.

41. Höft, *Shiny Shapes*, 72–73.

42. Gállego, *Visión y símbolos*, 260–62.

43. Magdalena S. Sánchez, *The Empress, the Queen, and the Nun: Women and Power at the Court of Philip III of Spain* (Baltimore: Johns Hopkins University Press, 1998), 65.

44. See Sixten Ringbom, *Icon to Narrative: The Rise of the Dramatic Close-up in Fifteenth-Century Devotional Painting* (Doornspijk, The Netherlands: Davaco, 1984), and Jonathan Brown, "The Devotional Paintings of Murillo," in *Bartolomé Esteban Murillo (1617–1682): Paintings from American Collections*, by Suzanne L. Stratton-Pruitt (New York: Harry L. Abrams, 2002), 31–45.

45. Feros, "Sacred and Terrifying Gazes," 72–73.

46. Nickel, *Art of Chivalry*, 16.

47. Guy Stair Sainty, quoting from the first statutes of the order issued in the 1430s; see www.chivalricorders.org/orders/other/goldflee.htm.

48. The Order of the Golden Fleece does not appear in the portrait of Philip IV by Velázquez and workshop (fig. 15), which may be explained by the fact that the canvas is unfinished. Nevertheless, there is in the history of the picture a reference to the king as defender of the faith and head of a unified kingdom of many parts; traditionally the picture is believed to have been made as a diplomatic gift to the queen of Sweden, who had converted to Catholicism.

49. Nickel, *Art of Chivalry*, 15.

50. Elliott, *Spain and Its World*, 7–26.

51. Discussion of the stages of armor making is based on Fliegel, *Arms and Armor*, 73–75.

52. See Museo del Prado, *Felipe II*, 371.

53. *Inventario illuminado*, Real Armería, Palacio Real, Madrid. The sheets devoted to the drawings made of Philip II's famous mask-garnitures are illustrated and discussed in Pyhrr and Godoy, *Heroic Armor*, 168–69.

54. I borrow this marvelous descriptor from Fliegel, *Arms and Armor*, 97.

55. Höft, *Shiny Shapes*, 86.

56. On foreign policy during the reign of Philip III, see Antonio Feros, *Kingship and Favoritism in the Spain of Philip III, 1598–1621* (Cambridge: Cambridge University Press, 2000), 143–54.

57. See Sarah Schroth, "Re-Presenting Philip III and His Favorite: Changes in Court Portraiture, 1598–1621," *Boletin del Museo del Prado* 18, no. 36 (2000): 39–50.

58. See Erika Tietze-Conrat, *Dwarfs and Jesters in Art* (London and New York: Phaidon, 1957), 23, and Julián Gállego, "Manías y pequeñeces," in Museo del Prado, *Monstruos, enanos y bufones en la corte de los Austrias* (Madrid: Museo del Prado, 1986), 15–24.

59. See Patrimonio Nacional, *IV Centenario del monasterio de El Escorial: Iglesia y monarquía* (Madrid: Patrimonio Nacional, 1986), 164–65, which corrects the prior notions of provenance for the piece.

60. Sánchez, *The Empress*, 46–49.

61. Ibid., 63.

62. Wethey, *The Paintings of Titian*, 87.

63. See Suzanne L. Stratton, *The Immaculate Conception in Spanish Art* (Cambridge: Cambridge University Press, 1994).

64. Salvador Salort Pons, *Velázquez* (Rome: Fundazione Memmo, 2001), 254.

Giving Life to Geography
Natural History and the Spanish Worldview

Armadillo de Indias.

"*The World Is Only One and Not Many*"
Representation of the Natural World in Imperial Spain

IN 1524 FADRIQUE ENRÍQUEZ, ADMIRAL OF CASTILE, and a loyal supporter of the young Charles I in the Revolt of the Comuneros, wrote to an unknown correspondent about the general disorder and decline of nature in his times.[1] For Don Fadrique, recent earthquakes, droughts, and famines foretold the nearing end of the world. He was not alone in this apocalyptic interpretation of current natural events. His voice was one among many prophets and astrologers all over Europe who were predicting that major catastrophes would coincide with a conjunction of planets in Pisces that year.[2]

Chaos and the collapse of the traditional order spread throughout Europe in a period that witnessed peasant revolts in Germany, the Lutheran challenge to papal authority, and the invasion of Italy, homeland of the old Roman empire, by French, Spanish, and German troops. This feeling of disorder was particularly acute in Spain. The fragile equilibrium maintained by Isabel and Ferdinand in the late fifteenth century had been disturbed both by the newly installed Habsburg dynasty, which aimed to impose its power over the Spanish kingdoms as if they were subordinate territories, and by the local aristocracy, which wanted to recover its former autonomy and privileges by exploiting the temporary weakness of the monarchy. Although by 1524 the Comuneros had been completely repressed and the new King Charles was safely enthroned, for old Don Fadrique the dissemination of sedition among Castilians and the corruption of the moral and ideological principles that had led to the glorious conquest of Granada in 1492 had a counterpart in the natural catastrophes then devastating Europe. The year 1522 had been particularly bad: earthquakes destroyed the Andalusian city of Almería, provoked panic in central Italy, and shook the Castle of Saint John at Rhodes, even while under siege by the Turks. The seeds of entropy that infected men were also in nature, and nothing could be done to restore the balance.

When Chancellor Mercurino Gattinara, instigator and champion of King Charles's imperial ambitions, asked the humanist Pietro Martire d'Anghiera, author of the first history of the discovery of America, about the apocalyptic prophecies of 1524, he brushed them aside as mere superstitions.[3] Another famous Spanish humanist, Juan Luis Vives, shared Pietro Martire's view and strongly recommended that his readers reject the interpretation of world events according to the stars.[4] Don Fadrique's correspondent shared this opinion. Arguing against Don Fadrique's apocalyptism, he encouraged him not to look for evil in nature—earthquakes, plagues, and floods—but in men alone, recommending, above all, repentance and conversion: "Neither the world nor the elements and visible things should be blamed but only men."[5] This necessarily meant, he added, a stoic acceptance of shifting political circumstances and a complete submission to the authority of new institutions, namely the empire.[6] The anonymous writer described the historical

destiny of the monarchy of Charles I, whose realm, he predicted, would expand over the entire earth, including, of course, Jerusalem.[7] Don Fadrique's interpretation of a declining world was thus replaced with an equally eschatological view in which both nature and history were to play a role in the glorious destiny of the Spanish empire.

Despite the efforts of ideologists to portray the world as the stage for Charles V's imperial expansion, Don Fadrique's somber view, a reminder of the futility of mundane ambitions, cast its shadow over the Spanish monarchy throughout the sixteenth century. The ghost of decadence seemed to be inscribed in the blueprint of the Spanish imperial enterprise from its inception and was interpreted as such when its decline actually took place one hundred years later. We find traces of this pessimism in Philip II's taste for Hieronymus Bosch's gloomy rendering of the world and the senseless struggles of humankind (as seen in a tapestry owned by Philip and loosely based on Bosch's *Haywain Triptych;* see pl. 68). The role of pessimism as a catalyst of absolute power was, we should not forget, one of the most ubiquitous principles of political thought in the sixteenth and seventeenth centuries.

The construction of the Spanish empire as a territorial power, the largest to ever exist, required both a positive redefinition of nature and its translation into recognizable and functional representations. Don Fadrique's allegorical view of nature, which many of his contemporaries shared, would be replaced with a forceful image of the world that would encourage the collective action of the Spaniards. If Pliny once argued that knowledge always followed the eagles of empire, it was also true that, without such knowledge, their flight would not be possible in the first place. But this general reappraisal of the natural world involved the development of epistemological, technological, institutional, and economic tools whose mastery was beyond the capacities of Spanish society of the early sixteenth century. Isabel and Ferdinand and their secretaries, Cardinal Mendoza and Cardinal Cisneros, made important efforts to promote universities and to finance the translation of scientific books, but their main priority remained the legal and administrative organization of their various kingdoms and the financial structure of their state. Nevertheless, the council system they created, namely the Council of Indies and the *Casa de Contratación* attached to it, would become the main instrument of the scientific and technological policies of their successors, Charles V and Philip II.

Traces of the newly positive attitude toward nature, empirical knowledge, and technology that spread in Spain in the first half of the sixteenth century can be found in the literary texts, encyclopedias, chronicles, and histories published in Charles V's period.[8] As throughout the rest of Europe, early-sixteenth-century Spanish readers craved texts that described novelties and curiosities in both nature and foreign cultures. But the advances in learning and the improvements in the arts described by Juan Luis Vives at the beginning of the century gradually took on ideological overtones in imperial Spain. In the texts of such authors as Gonzalo Fernández de Oviedo, Pedro Mexía, and Cristóbal de Villalón, praise for contemporary achievements was systematically paired with encomiums for the Spanish nation and the deeds of the empire around the world.

Although the imperial court was an important pole of attraction for scientists, inventors, and entrepreneurs, the actual involvement of the Spanish monarchy in the promotion of knowledge was scarce and unsystematic. In the first half of the sixteenth century the influence of empire on new approaches to the natural world was mainly ideological. The most emphatic descriptions of the earth as a unified physical entity ruled by universal natural laws were delivered not in the universities but in the intellectual circles of the imperial court. The famous statement "the world is only one and not many," in the opening pages of *Historia general de las Indias* (Zaragoza, 1552),

PLATE 68

Tribulations of Human Life

Brussels, 1550–70

After Hieronymus Bosch (c. 1450–1516)

Wool, silk, gold, silver, 117⁵⁄₁₆ × 144⁷⁄₈ in. (298 × 368 cm)

© Patrimonio Nacional, Real Monasterio de San Lorenzo de El Escorial (10004012)

"The World Is Only One and Not Many" 141

derived neither from the theoretical speculations of natural philosophers nor the direct experience of a traveler. It was written by Francisco López de Gómara, a distinguished member of the court, confessor of Hernán Cortés, and chronicler of Emperor Charles. The book, conceived as imperial propaganda, was written in Castilian so that it could be read by all Spanish people, the new lords of that unified world. In this period "Spain" and the "Spanish people" existed mainly as labels used by both Castile and the emperor to legitimate their expansion (fig. 23).

Less known is a piece of Latin prose, the *Somnium,* published in the Castilian city of Burgos in 1540 by the humanist Juan Maldonado. Maldonado had followed very closely the traumatic events of the Comuneros revolt and, as early as 1522, wrote a historical interpretation of it from the viewpoint of the new imperial regime.[9] The *Somnium* recounts the oneiric flight of the author to the moon, during which he visualises the entire surface of the earth. The *Somnium* also describes a utopian society on the moon and Maldonado's landing in a native American community. What is important for our purpose is Maldonado's use of this classical topos in order to create a detached view of the world, a fictional vantage point from which to make the world an object of visual scrutiny. In the *Somnium* the earth does not appear as a collection of isolated pieces of land, as it does in Cicero's famous *Somnium Scipionis,* one of Maldonado's sources. Maldonado sees the earth as a continuously inhabited and fully intelligible surface open to imperial troops and Catholic religious orders, whose actions are already visible from above. Maldonado's fable does not teach the stoic acceptance of one's limits, as in Cicero's text, but the absence of any boundary to the visual comprehension of a boundless world.

In López de Gómara's and Maldonado's texts, the idea of empire formed a bridge between the customary, functional, and nonperspectival view of nature in everyday life experience and the abstract and strictly theoretical approach to nature found in contemporary academic texts. In both works, the existence of America as a physical place, described by López de Gómara and imagined by Maldonado, provided the means by which to conceive the world as a single geopolitical and natural entity of which both local and distant aspects were a part.

The discovery and conquest of America was the main stimulus for the compilation of knowledge about nature in the new Spanish empire.[10] The descriptions of American species found in the texts and reports of the Spanish chroniclers, officers, and explorers probably form the largest corpus of literature on the natural world of the sixteenth century. The discovery of America was, in fact, an important stimulus in the revival of the ancient genre of natural history. America was the central object of the two most ambitious natural history projects of the European Renaissance: *Historia general y natural de las Indias* (1535–49) by Gonzalo Fernández de Oviedo and the *Historia natural de Nueva España* (1576) by Francisco Hernández.

Gonzalo Fernández de Oviedo's *Historia general y natural de las Indias* perfectly illustrates the connection between the revival of natural history and the ideological context of the Spanish

Fig. 24 Gonzalo Fernández de Oviedo (1478–1557), *De la natural hystoria de las Indias.* Toledo, Remo de Petras, 1526. Huntington Library, San Marino, California (RB 75626)

empire. Born to a family of bureaucrats (*letrados*) associated with the Castilian monarchy, Oviedo (1478–1557) traveled throughout Europe in the early period of Spain's political expansion. After the cancellation of a trip to Italy as secretary to the renowned Gonzalo Fernández de Córdoba, *El Gran Capitán,* in 1513 Oviedo joined the largest expedition to date to the American mainland as royal notary and mining supervisor, remaining, with a few interruptions, in the New World until his death.

When Oviedo, an experienced writer of chivalric novels and genealogical accounts of the Spanish monarchy, proposed the compilation of a great natural history of America to the emperor in 1526, it was very much his own idea. The royal chronicler Pietro Martire d'Anghiera, who had included various sections on American plants and animals in his *De orbe novo* (Alcalá, 1516–30), had just died, and Oviedo hoped to fill his vacancy. He presented himself as a new kind of author, one suitable for the new imperial era. The title of the summary version of his larger project, *De la natral hystoria de las Indias,* refers directly to Pliny's *Natural History.* The dedication of the work to the emperor was an obvious imitation of a similar protocol followed by Pliny 1,500 years earlier (fig. 24).

The quickness with which this condensed version, the so-called *Sumario* of 1526, was translated and disseminated tells much about Oviedo's awareness of the potential demand for such texts. However, it would take six more years, one more trip to Spain, and new presents to the emperor (a thorough genealogical history of the Spanish monarchy) before he received an official appointment as royal chronicler, charged to write both a history of the deeds of the Spaniards and a comprehensive description of the plants and animals that inhabited the new Spanish possessions.[11] The document so instructing him was laconic regarding the scope of his tasks, and it was Oviedo himself who defined the content of his work in the following years.

The fifty-volume *Historia general y natural de las Indias* is too complex to analyze in detail here. I shall only highlight a few features that are relevant for this account of the relationship between natural history and empire. The first is Oviedo's ability to devise a textual framework that would convey a systematic description of American nature. In the early sixteenth century there were many models for the writing of handbooks dealing with specific natural issues such as hunting, horse breeding, or farming. The *Obra de agricultura general compilada de diversos autores* by Gabriel Alonso de Herrera (Alcalá, 1516), is a good example of such a treatise. There were no contemporary models, however, upon which Oviedo could fashion his all-embracing work on nature.

Going beyond the obvious precedents of Pliny's *Natural History* and the writings of Pietro Martire d'Anghiera, *Historia general y natural de las Indias* shows Oviedo's attempt to develop an entirely new literary structure that directly connected descriptions of nature both to a historical account of the discovery and conquest and to a telling of the experiences of Spaniards in America. Oviedo explicitly linked his task as a natural historian with the activities of other agents of the imperial enterprise, namely soldiers and missionaries. The very visibility and intelligibility of

American nature is made to derive from the action of these agents. According to Oviedo, what should be admired was not so much the differences of the American landscape, but the infinite amount of new things and territories both seen and known on behalf of the Castilian crown in such a short time. The *asombro* (wonder) and *espanto* (shock) initially provoked by American nature were replaced rhetorically with the admiration accorded the unheard-of feats of the writer's compatriots: "This being said, and bearing in mind the little time passed since the first Christians came to these lands, I am not amazed by the many things that are still ignored as much as I am by the great amount that are already known in such a brief period of time."[12]

No obvious precedent for the description of natural phenomena existed in Spanish literary and academic contexts. Oviedo filled a vacuum with an eclectic but very effective mix of discursive methods: the ekphrasis learned during his stay at the Italian courts of the late quattrocento, the subjective Petrarchan poetry fashionable in the aristocratic circles of Castile and Aragon, the pragmatic tone of military language, the specialized jargon of botanists and experts in agriculture, and the impassive forensic language of notaries and judges.[13] First-person experience is common to all these discursive models. The autoptic "I have seen," the essential trope of travel writing since Herodotus, supports the veracity of accounts of either distant, rare, or new phenomena, and provides *enargeia* (vividness) to the description of such undefined entities. Autopsy, thus, is the rhetorical style par excellence for speaking about the unfamiliar and the ambiguous. This mode of speech acquired a different meaning, however, when used on behalf of the empire, or to defend the focused view of local inhabitants (as Oviedo was, after living in America for twenty years) against the exotically inclined gaze of authors writing from Spain.

For Oviedo, the language of "experience" was the distinctive idiom of Spanish imperial power. The recent feats of the crown, as he praised them in the introduction to the second part of the *Historia general y natural de las Indias,* had granted to Spain leadership of the world and muted the echoes of Rome's past glory. This Hispanic era was, according to Oviedo, one of action and experience. After its first formulation in Sánchez de Arévalo's *Compendiosa historia* in the fifteenth century, the idea of the natural disposition of Spanish Goths toward action, as opposed to the Roman taste for wordy self-celebration—paradoxically borrowed from a Roman accusation of the Greeks—had become a topos of Spanish chauvinism.[14] It was within this ideological context that Oviedo proudly stated in Book I of the *Historia general y natural* that his work was the outcome of thousands of experiences and dangers, whereas Pliny pointed to the hundreds of books upon which he relied in constructing his own history.

At the same time, the language of experience was the "natural" language with which to speak about nature. By discrediting any external gaze, Oviedo was doing more than undermining the authority of his predecessor Pietro Martire d'Anghiera, who had never visited America, or merely preventing any future challenge to himself from Spain. He was also defining the New World as an autonomous and self-contained entity, bearing its own labels and demarcations: that is, a natural entity, in the Aristotelian sense, on the same level as the Old World. Moreover, by locating everyday experience as the main criterion for the recognition and nominal identification of American species—manatee, iguana, crocodile—he was also framing American nature within the predictable and the familiar, thus replacing the boundless desiring gaze that until then had been projected upon the newly discovered lands.

The third feature to note in Oviedo's natural history is its ecological or environmental approach to nature. According to Oviedo, the trees and plants covering the New World could not be without the qualities and virtues that nature offered elsewhere in the world, even if only

Fig. 25 a, b Early copy after Gonzalo
Fernández de Oviedo (1478–1557),
volcano image (left) and depiction of
pole dance (right) in *Historia general
y natural de las Indias, parte III*,
16th century. © Patrimonio Nacional,
Real Biblioteca, Palacio Real, Madrid
(II/3042)

monkeys were "able to understand them and know which of them are good for their use."[15] All those nameless species could be neither accidents nor monsters since, as was visually manifest, they were constituents of the specific nature of the place—"these cannot be without properties because they cover most of this land."[16] The basic principle of Oviedo's approach to nature was thus the belief that plants, animals, and human communities were "naturally" linked to their local environment by a distinct semiotic network, which was equally naturally recognized by all members of the network. Proficiency in the comprehension of this code was acquired through continuous experience. This approach was shared by one of Oviedo's contemporaries, Pedro Cieza de León, author of *Crónica del Perú* written in Lima and published in Seville in 1553. Cieza de León consistently described the plants and animals of the Peruvian region as part of a specific landscape and climate, and in relation to their use by human communities. This ecological consideration of nature as a complex network of local relationships, rather than a stable system of universal rules, is linked with the vindication of experience mentioned above, and connects with the taste for the singular and the specific in Spanish Renaissance painting.

Finally, the last but more exceptional feature of Oviedo's work is the important role played by images in his descriptions of American natural species and of the customs and rituals of native communities (fig. 25 a, b).[17] The only other contemporary work on American nature printed in Spain containing illustrations taken directly from nature is Cieza de León's *Crónica del Perú*

Fig. 26 Pedro Cieza de León (1518–1554), *Primera parte de la crónica del Perú*. Seville, 1553. Huntington Library, San Marino, California (RB 55848 fol. 135r)

(fig. 26). Gianbattista Ramusio, the Venetian editor of Hernan Cortés, Cabeza de Vaca, Francisco de Jerez, and Oviedo, among other Spanish writers on America, complained in the introduction to the third volume of his *Navigazioni e viaggi* about the scarcity of visual material on American nature, which his readers were eagerly demanding.[18] The underdevelopment of the printing industry in Spain in the first half of the sixteenth century and the mainly narrative framework of most texts on the Spanish expeditions to America may explain this lack. Oviedo's works are exceptional in this regard. The four woodcuts contained in the brief *Sumario* of 1526 were the first images of American phenomena to be published in Europe (fig. 27). Nine years later, in the 1535 edition of the first part of *Historia general y natural de las Indias*, Oviedo offered an unprecedented series of illustrations of American plants and animals. The role of these schematic images was to support the written text, and they bear very little information in them (fig. 28). In a later revision of this text, intended to appear with the remaining second and third parts of *Historia general y natural*, Oviedo decided to increase the informational value and autonomy of the images, and eliminated their previous subjugation to the text (fig. 29). Neither this revision nor the second and third parts of the work were printed in Oviedo's time. When José Amador de los Ríos finally published the complete edition of *Historia general y natural de las Indias* in 1851, he removed all the original images, replacing most of Oviedo's drawings with nineteenth-century versions and gathering them at the end of each volume. Fortunately, for the most part Oviedo's images of American natural phenomena and native customs have survived in original manuscripts preserved at the Academy of History, Madrid, and the Huntington Library, Los Angeles, and in manuscript copies made immediately after his death, today kept in the Library of the Royal Palace, Madrid, and the Colombina Library, Seville.[19]

Despite Oviedo's efforts to define *Historia general y natural de las Indias* as an extension of the global imperial enterprise, his text expressed the specific conditions of living in and writing from America. When he tried to publish his complete work in 1549, his "proto-creole" view was not recognized by the metropolitan institutions that had appointed him as chronicler fifteen years earlier. The fully realized *Historia general y natural de las Indias* was not published, and Oviedo went back to Santo Domingo, where he died in 1557.

By the mid-sixteenth century, the intense activity of soldiers, friars, traders, and colonists, and the quick progress of military conquest, surpassed the initial attempts of such individuals as Oviedo or Cieza de León to provide a suitable representation of America. Their intention to describe the natural environment at the same pace at which it was being discovered and to record events as they were occurring necessarily involved their failure. A single point of view could no longer embrace the complexity and extension of American reality, and no individual could have sufficient mobility and organizational capacity to cope with the immense amount of information constantly produced in America. The new circumstances required more specialized and circumscribed points of view. The work of the Sevillian doctor Nicolás Bautista Monardes, *Historia medicinal de las cosas que se traen de nuestras Indias Occidentales que sirven en medicina* (Seville, 1574), is the best example of this changing situation.

Fig. 27 Gonzalo Fernández de Oviedo (1478–1557), *De la natural hystoria de las Indias.* Toledo, Remo de Petras, 1526. Huntington Library, San Marino, California (RB 75626 fol. 52v)

Fig. 28 Gonzalo Fernández de Oviedo (1478–1557), *Historia general y natural de las Indias*, part 1. Seville, Iaum Cromberger, 1535. Huntington Library, San Marino, California (RB 55597 fol. 98r)

Fig. 29 Gonzalo Fernández de Oviedo (1478–1557), *Historia general y natural de las Indias, book XI, chapt. VII*, 1539–48. Huntington Library, San Marino, California (HM 177 fol. 78r)

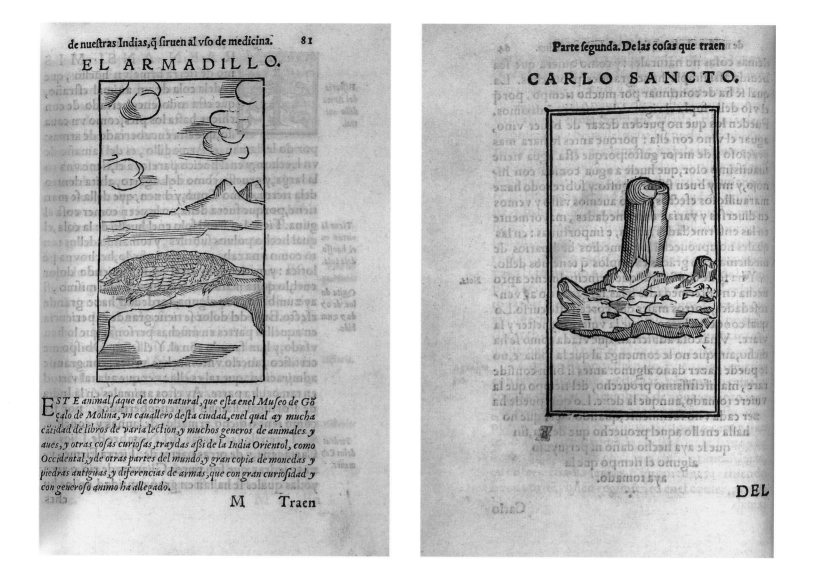

Fig. 30 a, b Nicolás Bautista Monardes (c. 1512–1588), illustrations from *Historia medicinal de las cosas que se traen de nuestras Indias Occidentales que sirven en medicina.* Seville, Alonso Escrivano, 1574. Huntington Library, San Marino, California (RB 5300 part II, fol. 64v and fol. 81r). The only zoological illustration in Monardes's book is of the armadillo, whose tail bones were said to be effective in curing earaches. The "carlo sancto" was employed in remedies for toothache, epilepsy, and syphilis.

The search for medicinal herbs and plants had been a main impetus for botanical investigation in America since the early period of discovery. Martire had collected in his *De orbe novo* all available information about possible medicinal uses of particular species, but Oviedo harshly criticized his tendency to identify American plants with Old World species and offered instead his own explanation of the properties of local flora. Trade in American medicinal plants seemed to be a promising business, and even the Fuggers, Charles V's bankers, lent money to the emperor to obtain a monopoly in the trade of *coyoacán,* a plant supposedly effective in the treatment of syphilis. The Fuggers even paid doctors and chemists all over Europe to stimulate demand for *coyoacán.*[20] Monardes himself was quite active in the trade of this and other medicinal species brought from America.

Historia medicinal is not a compendium of all American natural phenomena as Oviedo's *Historia general y natural de las Indias* was intended to be, but a specialized treatise on pharmacological botany that describes in detail American medicinal species and their therapeutic uses. This was particularly helpful given the great confusion and skepticism regarding the properties of the many new species brought from America. From his vantage point in Seville, Monardes could not only collect the botanical species but also match them with the reports of different informants as they arrived from America. Monardes's book soon became famous all over Europe; nineteen translated editions appeared during his lifetime. The book contains numerous woodcuts representing

the species whose properties are described in the text (fig. 30 a, b). The realist language of these images is identical to the language used by contemporary botanists to describe local species, and Monardes's book was thus a very effective vehicle in the process of assimilating American nature with the patterns of European culture.

Less known is *Tractado de las drogas y medicinas de las Indias Orientales* by Cristóbal Acosta (Burgos, 1578).[21] Like *Historia medicinal, Tractado de las drogas* was authored by a doctor in medicine writing for other practitioners or chemists. In this case the area of study was the East Indies, or Portuguese India. Like Monardes's book, its scope is practical, and it employs a plain language, frequently making morphological and therapeutical comparisons with European species. Although exotic, most of the species described by Acosta—pepper, cinnamon, clove, etc.—were already part of European botanical knowledge. The mission of *Tractado de las drogas* was, therefore, not so much to identify new species, as was Monardes's task, but to add firsthand directions for the identification and use of already known ones.

Unlike Monardes, who always worked from Seville, Acosta traveled to India and perhaps China, gaining direct knowledge of the original environment of the species he described. Born either in Ceuta, Tangier, Cabo Verde, or another Portuguese settlement in Africa, Acosta went to Goa in 1568 as a doctor with the new Portuguese viceroy Luiz de Ataide. He stayed in India until 1572 and, finally, settled in Burgos, Castile, in 1576 as physician of the city. Despite having lived in India for four years, Acosta took most of the information in his book from *Coloquios de los simples y drogas y cosas medicinales de las Indias, y algunas frutas que por aquellas partes se crían,* by the Portuguese Garcia da Orta, whom he had met in Goa. Acosta's original contribution is mainly the images, taken directly from the plants, which illustrate many of the botanical species described (fig. 31 a–c).

This new trend in books on the natural world, highly descriptive, specialized, and practical, coexisted with the works of a new generation of scientists trained in the reformed university milieu of the sixteenth century. The efforts at the beginning of the century by Isabel and Ferdinand and, especially, by Cardinal Cisneros, were producing results fifty years later. The University of Alcalá de Henares, created by Cisneros in 1499, was to play an important role in this regard. Although natural philosophy was not a particularly important topic in Alcalá, the humanist recovery of Greek and Roman sources stimulated by Antonio de Nebrija provoked a revolution in the traditional approach to natural matters and medicine. Arabic Galenism, based on Avicenna's *Canon* and dominant in the fourteenth and fifteenth centuries, was gradually replaced with the so-called humanist Galenism based on philological analysis and discussion of ancient texts, namely Aristotle, Dioscurides, and Theophrastus. One of the main contributions in this regard was the 1518 Alcalá edition of Jean de Ruel's Latin version of *De materia medica* by Dioscurides, with an appendix containing a Castilian translation of the Greek and Latin names of plants and remedies contained in the text. Andrés Laguna's illustrated edition of Dioscurides's treatise, published in 1555, is the best example of this trend in humanist Galenism; his work relates more to contemporary European trends in botany, such as the work of Pietro Andrea Mattioli, than to the Spanish scientific tradition.

The most influential scientists and doctors of the second half of the sixteenth century were in some way connected to the University of Alcalá. Many of them showed a particular interest in the American natural world: Francisco Bravo, who finally settled in Mexico City, where he published *Opera medicinalia* (1570), the first book on medicine ever produced in America; Juan Fragoso, author of *Discurso de las cosas aromáticas, árboles y frutales que se traen de la India Oriental* (1570); the educational reformer Juan Huarte de San Juan; and Francisco Hernández, author of *Historia*

Fig. 31 a–c Cristóbal de Acosta (c. 1515–1592), title page and botanical illustrations from *Tractado de las drogas y medicinas de las Indias Orientales*. Burgos, M. De Victoria, 1578. Huntington Library, San Marino, California (RB 253296)

Ordinance for the Description of the Indies

San Lorenzo El Real, July 3, 1573

Manuscript, 8⁷⁄₁₆ × 12³⁄₁₆ in. (21.5 × 31 cm)

© España Ministerio de Educación, Cultura y Deporte. Archivo General
de Indias, Seville (Indiferente General 427, L. 29, fols. 5v–66v)

natural de Nueva España and of a translated edition of Pliny's *Natural History,* of whom we will talk below. This new generation of scholars and scientists developed more systematic and autonomous methods of organizing information about the natural world that would depart both from the all-embracing scope of the works by Oviedo and Cieza de León and from the practicality of the treatises by Monardes and Acosta.

A new attitude with regard to science can also be observed in the Spanish crown. King Philip II had a clear awareness of the close relationship between knowledge and power, and, from the 1560s, he developed an active policy both to support and to control scientific knowledge (pl. 69). This was part of the crown's ambitious attempt to regulate all realms of life—economic, military, cultural, religious, etc.—in the immense territories under Philip's rule. An increasing number of the aristocratic and intellectual elite shared this positive attitude with regard to science. By the mid-sixteenth century, scientific knowledge was seen as appropriate for a cultivated Spanish gentleman. Juan Lorenzo Palmireno's contemporary treatises on courtly etiquette list natural history and mathematics as part of the ideal education of a young Spanish nobleman.

There were practical reasons for this new official interest in mathematics, science, and the natural world. Without enough mathematicians, engineers, and cosmographers to sustain its enormous dominions, the Spanish monarchy was forced to import Italians, Germans, Portuguese,

and Flemish professionals to perform the necessary work. To many at court, it was obvious that the survival of the Catholic monarchy depended on a general reform of education, especially in scientific and technical matters. Works calling for urgent educational reform—by Juan Huarte de San Juan, *Examen de ingenios para las ciencias* (Examination of Instruments for the Development of the Sciences, 1575); Pedro Simón Abril, *Apuntamientos de cómo se deben reformar las doctrinas* (Notes on How Education Should Be Reformed, 1589); and Oliva Sabuco de Nantes, *Coloquio de las cosas que mejoran el mundo* (Dialogue on the Things That Improve the World, 1587)—bear witness to this general awareness.

From the 1570s, Juan de Herrera, architect of the monastery of El Escorial, took over the central coordination of scientific policy for the monarchy. He tried to promote a network of schools of mathematics throughout the country, but it was never implemented due to a lack of enthusiasm in local councils. Finally, in 1582, he was able to create an academy of mathematics attached to the royal court and devoted to the training of professionals in cosmography and military engineering. The Royal Academy of Mathematics based its teaching in the Renaissance idea that the correct performance of any discipline necessarily required intense theoretical training. Herrera was also charged with creating a lectureship in natural history and botany, but the shifting interests of the king at the end of his life prevented this from happening.

Another stimulus to the increased attention given to the sciences was the urgent need to increase the profits obtained from the exploitation of American natural resources. The Council of Indies, drastically reformed at the end of the 1560s under the direction of Cardinal Espinosa and Juan de Ovando, led this enterprise. The first step was the systematic compilation of information about the different regions of the immense Spanish possessions in America. The method devised for this task bore no resemblance to the individualist practices of the chroniclers of Oviedo's generation thirty years earlier. When Juan López de Velasco was appointed royal chronicler and cosmographer by the Council of Indies in 1571, no reference was even made to Oviedo's work. Instead of seeking the subjectivity of the local inhabitant, claimed by Oviedo to be the most suitable and truthful, the Council of Indies produced a long fixed questionnaire, to be filled in by any soldier, explorer, or officer of the crown, which disregarded the specific place or circumstance in which the information was obtained. The centralized archival system set up by Philip II and his councils for the compilation and organization of the immense amount of information arriving from every corner of his monarchy in the end replaced the local and subjective point of view of the individual colonist.

The classification structure of the questionnaire did not correspond to traditional taxonomies in natural history or botanical treatises. Its form derived from the work of López de Velasco's predecessor, the cosmographer Alonso de Santa Cruz, who had prepared a set of instructions for explorers and navigators before his death in 1567.[22] Coming after more than eighty years of chaotic colonial administration and financial bankruptcy, the questionnaire was designed to fulfill the particular needs of the crown at that stage of the colonization process: to improve political control over its territories and to reap greater benefits from the exploitation of American natural resources. Using a plain vocabulary that could be understood by anyone, the questions mainly referred to practical issues; at the end, the reporter could add any information he considered important. The completed questionnaires were carefully collected by the Council of Indies and compiled in the *Casa de Contratación* in Seville. Today they are known as *Relaciones geográficas de las Indias,* the name given to them by the nineteenth-century explorer and scientist Marcos Jiménez de la Espada.

It is within this context that Francisco Hernández's *Historia natural de Nueva España,* the most ambitious such project undertaken by the Spanish monarchy, should be understood. The

high standards reached by Spanish botanical and medicinal knowledge in Hernández's generation, and the organizational capacity of the Council of Indies after Juan de Ovando's reform, made it possible. The direct support of the king and of distinguished members of the royal court, such as Benito Arias Montano and Juan de Herrera, was essential to Hernández's accomplishment. Hernández, the highest medical authority at Philip II's court, was charged with reforming medical practice in all the territories of the Catholic monarchy. Despite the great fame gained by Hernández's work in his time, its content has been properly assessed only in the last two decades. It was never printed in its complete form and the main copy, preserved in the library of El Escorial, was destroyed during a fire in 1671.

What makes *Historia natural de Nueva España* different from previous Spanish attempts is that, in spite of its many peculiarities, it is an actual botanical treatise—and zoological to a lesser extent—in the same humanist and scientific tradition as the works by Laguna and Mattioli. Unlike Oviedo, Hernández worked within the framework of a perfectly defined genre and used with ease the highly developed idiom of contemporary botany. The same applies to the illustrations. Hernández did not have to strive to define the role of images with regard to the text, as Oviedo did in the different stages of *Historia general y natural de las Indias;* he could simply follow the standard scheme employed by Laguna in his edition of Dioscurides. Unlike Oviedo or Cieza de León, Hernández could focus on botanical and medicinal uses of the species and leave aside explanations of natural and cultural environments. That information was now being collected by the Council of Indies by means of the questionnaires.

Born in 1515, Francisco Hernández was exposed to the new trends of humanist Galenism while he was a medical student at Alcalá. He continued his training and practice in Seville and at the hospital of the Monastery of Guadalupe in Extremadura, one of the main centers of medical practice in Spain, where he developed a taste for empiricism by attending dissection sessions in the new Vesalian fashion. His ambition led him to the Hospital Santa Cruz in Toledo. An important meeting point for intellectuals, artists, and scientists, the city of Toledo for Hernández was a step toward the royal court.[23]

In 1567 Hernández was appointed royal doctor, and only two years later the king commissioned him to travel to Mexico to compile an ambitious work on the flora of Mexico and Peru. There is an enormous difference between the very precise and detailed orders given to Hernández and the vague document released thirty-seven years earlier for Oviedo's similar mission. The viceroys of the two regions received similar instructions from the king to support Hernández´s expedition.

Hernández departed from Seville in 1571. The expedition, projected to last five years, took seven. The members of this first scientific mission of the colonial period included Hernández's son, a cosmographer, a few painters (both native and Spanish), chemists, scribes, and native interpreters. For more than three years the party collected data throughout Mexico. In 1574, Hernández settled in Mexico City to organize the material, to experiment with the properties of the collected species, and to write the book. Apparently, he was preparing a Nahuatl version of the Latin text for the use of the locals and started a Spanish edition that was never finished.[24] The original intention of extending the project to Peru was probably reconsidered due to the unforeseen complexities of such an undertaking and a lack of financial resources. Under pressure from an impatient Philip II, Hernández prepared his natural history in a sixteen-volume Latin manuscript and sent it to the king in 1576. He stayed in Mexico one more year, finishing several texts on Mexican history and archeology, starting his Spanish and Nahuatl translations of his natural history, and working

on an ambitious translation of Pliny's *Natural History* which he had started before arriving in Mexico. As Hernández noted, the translation of Pliny's work and his own description of Mexican nature were part of one and the same task, since, with the two of them, both the Old and the New Worlds would be united in one continuous description. This imperial dream, shared by Oviedo, López de Gómara, and Maldonado, finally was realized, at least in book form.

The history of Hernández's manuscript once it was received by Philip II in Madrid shows the absence of a proper "center of calculation," using Bruno Latour's famous term, in which incoming scientific material was collected, processed, and disseminated.[25] Instead, Philip II by then had developed a dead-end notion of knowledge which prevented *Historia natural de Nueva España* from being more than a mythical collection of exotica. The king hung its illustrations on the walls of his palace to impress foreign visitors, including Filippo Segha, ambassador to the pope, who saw them during an official reception at El Escorial and immediately mentioned them to his friend the famous naturalist Ulisse Aldrovandi.

The sixteen volumes of the manuscript initially were kept in the king's private collection and, later, sent to the Council of Indies for inspection. In spite of Hernández's complaints and Juan de Herrera's efforts, the royal decision was that only a summary of the work should be published. From 1580 to 1582, the Neapolitan doctor Nardo Antonio Recchi was commissioned to make this selection. When Recchi left Spain for Rome in 1589, he took with him a copy of the manuscript summary, which eventually was published by the Accademia dei Lincei in 1651 under the title *Rerum medicarum Novæ Hispaniæ thesaurus, seu, Plantarum animalium mineralium mexicanorum historia.* After finishing his work, Recchi sent Hernández's volumes back to the library at El Escorial, where they were recorded by Fray José de Sigüenza in his *Historia de la orden de San Jerónimo* (1605).

The library fire of 1671 destroyed all sixteen volumes. The only direct information of their content is a complete index of the work with an explanation in Latin of the native designations for the Mexican species, *Index alphabeticus plantarum Novæ Hispaniæ.* This was copied by El Escorial librarian Andrés de los Reyes in 1626 at the request of the antiquarian Cassiano dal Pozzo, who by then was trying to publish Recchi's selection in Rome. The index is kept today at the School of Medicine at the University of Montpellier. There is also a set of sixty pictures copied from the original illustrations of Hernández's manuscript, bound together with a rich collection of Renaissance botanical illustrations in the so-called Codex Pomar, preserved in the library of the University of Valencia (pls. 67, 70). These copies were ordered by Philip II to please Jaime Honorato Pomar, professor of medicine and chief gardener of the Royal Alcazár in Madrid.

A second manuscript copy that Hernández had kept for himself together with other minor works of Mexican subjects has fortunately survived. In fact, it is recorded that Hernández returned from Mexico with four volumes to add to the manuscript he had delivered to the king the previous year, as well as twenty-two other volumes concerning Mexican subjects. A five-volume manuscript containing Hernández's copy of *Historia natural de Nueva España* was in the hands of his son until it was sent to the library of the Imperial College of Madrid sometime before 1629. After the rediscovery of the manuscript in the late eighteenth century, it was rebound in six volumes and divided between the National Library of Madrid and the Library of the Ministry of Finance, where they are today.[26]

Francisco Hernández's work, as we have noted, was the largest natural history written in the Renaissance, its botanical section consisting of 893 text pages with more than 2,071 illustrations (according to the index copied by Andrés de los Reyes). It describes more than 3,000 plants,

PLATE 70

FRANCISCO HERNÁNDEZ (1517–1587)

"Argemone"

Atlas of Natural History (Codex Pomar), 16th century

Manuscript with illustrations, 13⅜ × 9⅝ in. (34 × 24.5 cm)

© Biblioteca Històrica, Universitat de València (ms. 9)

40 quadrupeds, 229 birds, 58 reptiles, 30 insects, and 35 minerals. The methodological difficulties inherent in the classification of such an enormous amount of information surpassed any previous European experience in either botany or zoology. European science of the era was unable to assimilate that number of new species. From the beginning of the sixteenth century, European botanists had been struggling to incorporate into their classification the six hundred species, according to Otto Brunfels (c. 1488–1534), that were not recorded in the treatises of Dioscurides or Theophrastus. The 3,000 new Mexican species were obviously beyond their capacities.[27]

Hernández tried to overcome this limitation by devising a hybrid system that combined Mexican terms and the European alphabetical classification tradition. This was not simple, because Hernández did not merely add a list of Nahuatl names transcribed into the Latin alphabet. Rather, he assimilated the native terms to refer to groups of species within a general classification system, itself based on European class categories defined by the properties and virtues of the plants. Jesús Bustamante has pointed out the many changes and corrections existing in Hernández's original manuscript, evidence of his difficulties in producing this hybrid taxonomy.[28] Hernández admired some aspects of Aztec medicine, but he did not intend to compromise his overall approach to the natural world. His eclectic solution sprang from an absolute confidence in the superiority of European science. His tactic was that of methodical observation according to the most modern European trends, and his scope was universal, as he tried to overcome the limitations of a merely pharmacological approach such as Monardes's earlier *Historia medicinal.*

As it happened, Hernández's classification system was not accepted in Spain. When Recchi made his selections for the summary in 1580–82, he reorganized the contents according to more orthodox standards. Hernández's efforts to assimilate American nature within Europe's most sophisticated systems of scientific knowledge brought about a work that, paradoxically, was not recognized by his contemporaries, even if it did evoke a fascinated admiration. The fate of Hernández's treatise echoes to some extent that of Gonzalo Fernández de Oviedo's *Historia general y natural de las Indias* forty years before. Despite the reforms to the overseas administration of the Spanish monarchy under Philip II, it did not recognize a text that bore traces of interacting, on its own terms, with another environment and another culture.

Interestingly enough, it was a text not directly related to court circles that succeeded in producing an image of American nature that was accepted by most contemporaries: *Historia natural y moral de las Indias* (1590) by the Jesuit José de Acosta (1539–1600). Acosta lived in Peru from 1571 to 1587, first as a visitor and then as *provincial* of the Jesuit order. His theological and philosophical training combined the strict principles of the Council of Trent with the analytical skills and the inquisitiveness of Renaissance humanism. The book was immediately translated into Italian (1596), French (1597), Dutch (1598), German (1601), Latin (1602), and English (1604).

Acosta's material on the natural world is rarely original. He borrowed from Oviedo, Cieza de León, and López de Gómara, depending on the region. The overall depiction of American nature that he achieved, however, was much more coherent and articulate than that of any of his predecessors. By the end of the sixteenth century, the Church, or at least some of its institutions, had obtained a perspectival view of America that the Spanish monarchy was unable to attain, despite its efforts, from Pietro Martire d'Anghiera to Francisco Hernández. In fact, Spanish institutions did not assimilate the extent of the immense work on the natural world undertaken in the early colonial period until the eighteenth-century Enlightenment, when members of the Bourbon regime reclaimed their Renaissance ancestors.

NOTES

1. Fadrique Enríquez, *Epístola moral que el Sr. Almirante de Castilla embió a un hombre docto, con su respuesta escrita en el año 1524* (Biblioteca Nacional de Madrid, ms. 7075). The addressee is usually identified as Gonzalo Fernández de Oviedo, based on a statement found in fol. 8r, in which the correspondent is said to be the author of the *Quinquágenas*. The card catalogue of the Biblioteca Nacional of Madrid confirms this identification, but the library's general inventory of manuscripts records another, probably earlier, attribution: *"Esta es una muy notable que el muy ille. Sr. Almirante de Castilla envió al autor de las sobredichas Quinquágenas Luis de Escobar."*

2. Paola Zambelli, "Fine del mondo o inizio della propaganda? Astrologia, filosofia della storia e propaganda politico religiosa nel dibatito sulla congiunzione del 1524," in *Scienze, credenze occulte, livelli di cultura* (Florence: Leo S. Olschki, 1982), 291–369.

3. Ibid., 349–52.

4. Juan Luis Vives, "De veritate fidei christiana," chap. 20, in *Opera Omnia*, ed. Lorenzo Riber (Madrid: Aguilar, 1948), 2: 1505–6.

5. Fadrique Enríquez, *Epístola moral,* fol. 43r.

6. Ibid., fol. 35v.

7. Ibid., fol. 23r.

8. José Antonio Maravall, *Antiguos y modernos. La idea de progreso en el desarrollo inicial de una sociedad* (Madrid: Alianza, 1986).

9. Alejandro Coroleu and Jesús Carrillo, "The Dream of the Spanish Empire: Juan Maldonado's *Somnium* (1541)," *Albertiana* 3 (2000): 141–57.

10. José Pardo Tomás, *Oviedo, Monardes, Hernandez: El tesoro natural de América: Colonialismo y ciencia en el siglo XVI* (Madrid: Nivola, 2002).

11. Juan Pérez de Tudela, "Vida y escritos de Gonzalo Fernández de Oviedo," introduction to his edition of *Historia general y natural de las Indias* (Madrid: Biblioteca de Autores Españoles, 1959), cxviii.

12. Gonzalo Fernández de Oviedo, *Historia general y natural de las Indias,* introduction to Book 9, ed. Juan Pérez de Tudela (Madrid: Biblioteca de Autores Españoles, 1959), 1:278.

13. Jesús Carrillo, "Cultura cortesana e imperio: El libro del blasón, de Gonzalo Fernández de Oviedo," *Locus Amoenus* 4 (1998–99): 137–54.

14. Robert Brian Tate, *Ensayos sobre la historiografia peninsular del siglo XV* (Madrid: Editorial Gredos, 1970), 80.

15. Fernández de Oviedo, *Historia general y natural,* 1:278.

16. Ibid.

17. Jesús Carrillo, "Taming the Visible: Word and Image in Oviedo's *Historia general y natural de las Indias,*" *Viator* 31 (2000): 399–431.

18. Gianbattista Ramusio, "Discorso di messer Gio. Battista Ramusio sopra il terzo volume delle *Navigazioni e viaggi,*" in *Navigazioni e viaggi,* ed. Marica Milanesi (Turin: Einaudi, 1985), 5:3–19.

19. Jesús Carrillo, "The *Historia general y natural de las Indias* de Gonzalo Fernández de Oviedo (1535–1549)," *Huntington Library Quarterly* 65, nos. 3–4 (2003): 321–44.

20. Raquel Álvarez Peláez, *La conquista de la naturaleza americana* (Madrid: CSIC, 1993), 114.

21. Cristóbal Acosta, *El tractado de las drogas de Cristóbal de Acosta* (Burgos, 1578), vol. 2 of *Tractado de las drogas y medicinas de las Indias Orientales,* ed. Raúl Rodríguez Nozal and Antonio González Bueno (Madrid: Agencia Española de Cooperación Internacional, 2001).

22. Álvarez Peláez, *La conquista de la naturaleza americana,* 133.

23. José María López Piñero and José Pardo Tomás record a curious episode in Hernández's biography while he was in Toledo. Working with the famous painter and architect Nicolás Vergara, he altered the nervous system of a dog so that it could neither bark nor make any other sound; see López Piñero and Pardo Tomás, *La influencia de Francisco Hernández, 1515–1587, en la constitución de la botánica y la materia médica moderna* (Valencia: Instituto de Estudios Documentales e Históricos sobre la Ciencia, 1996), 41.

24. Ibid., 49.

25. Bruno Latour, *Science in Action: How to Follow Scientists and Engineers through Society* (Cambridge, Mass.: Harvard University Press, 1987).

26. Jesús Bustamante, "The Natural History of New Spain," in *The Mexican Treasury: The Writings of Dr. Francisco Hernández,* ed. Simon Varey (Stanford: Stanford University Press, 2000), 27–40.

27. López Piñero and Pardo Tomás, *La influencia de Francisco Hernández,* 57.

28. Bustamante, "The Natural History of New Spain," 29–30.

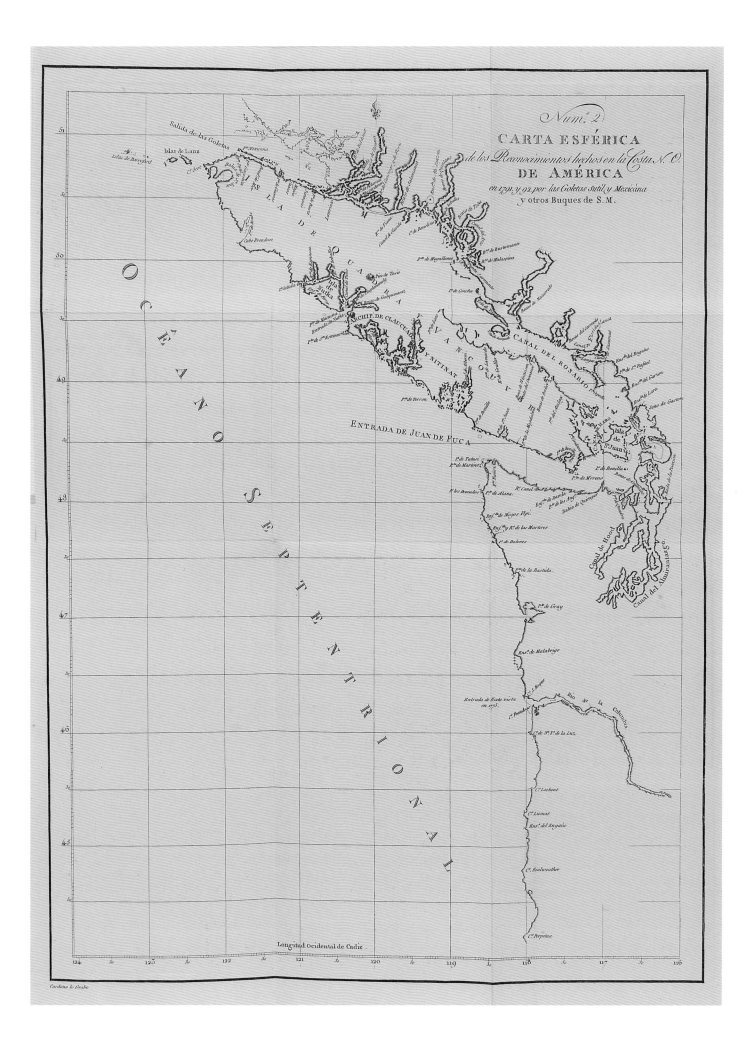

Num.ª 2
CARTA ESFÉRICA
de los Reconocimientos hechos en la Costa N. O.
DE AMÉRICA
en 1791. y 92. por las Goletas Sutil y Mexicana
y otros Buques de S. M.

OCÉANO SEPTENTRIONAL

ISLA DE QUADRA Y VANCOUVER

Salida de las Goletas
Islas de Lanz
Islas de Berryford

Cabo Frondoso

Isla de Nutka

ARCHIP. DE CLAUCUAT
NYNITINAT

ENTRADA DE JUAN DE FUCA

CANAL DEL ROSARIO

Isla de S.ᵗ Juan

Canal de Hood
Canal del Almirantazgo

P.ᵗᵃ de Gray

Ens.ᵃ de Malabrigo

Entrada de Ecete vista
en 1775.

Rio de la Columbia

C.ᵒ Lookout

C.ᵒ Lucuat
Ens.ᵃ del Engaño

C.ᵒ Fairweather

C.ᵒ Perpetua

Longitud Ocidental de Cadiz.

Cardano lo Grabo

Spanish Science and Enlightenment Expeditions

FEW HISTORICAL EVENTS ARE SO DEEPLY MARKED by unresolved debate as the European arrival in the New World. From 1492 conquerors and missionaries, discoverers and colonizers, chroniclers, naturalists, and royal officials reached the opposite shores of the *mare tenebrarum*. Finding themselves in a radically different and unintelligible landscape, they were all united by their distance from and memory of their native land; their interactions with hitherto unimagined peoples; their contact with radically new and complex cultures and worldviews; and their provincial desire for wealth and social ascent.

Since that time, countless texts have delved into the questions raised by European contact with the American continent. Social, economic, moral, and religious aspects have dominated the debate, leaving little room to focus on other fields of human endeavor that, inevitably, also form part of the history of the New World. The role played by technical and scientific activities in the configuration of the new space and culture born on both sides of the Atlantic is one of these semiforgotten histories. The scientific dimension was present from the beginning, and not only because it furnished a new stage, a new nature.

The emerging modern state of Spain had to assimilate, control, and exploit lands and environments, as well as tackle unforeseen problems—geographic, technical, social, economic, and political. Thus, an ever-growing army of royal subjects and employees assumed increasingly important roles. In the new cities of the viceroyalties, a huge number of diverse professionals—naval pilots, cosmographers, military engineers, architects, physicians, and university professors from new and old institutions—began to rewrite modern culture on the American continent as they created their own New World traditions. Their dynamism should not be forgotten: Mexico City, for example, had a printing press twenty-seven years before Madrid, with a production much larger than that of many European cities, and university-based medical education was established in the viceroyalty of New Spain almost two centuries before occurring in New England.

The European science projected upon the American continent became blended with the cultural realities and milieu of the new societies that formed there. Throughout the colonial period, the work of famous individuals such as Francisco Hernández, Cotton Mather, Carlos de Sigüenza y Góngora, Benjamin Franklin, Joseph-François Lafitau, or Alexander von Humboldt cannot be understood without taking into account their interaction with a Creole intelligentsia that was conscious of its emerging role as a local elite.

We know and recognize, therefore, a science in America, not only an America that existed as a passive subject for the examination of the European traveler and expeditionary.[1] We have had to learn how to see in a different way, not looking at the history of science only as a collection of

PLATE 71

Map of the Northwest Coast
Atlas para el viage de las goletas sutil y mexicana al reconocimiento del Estrecho de Juan de Fuca en 1792, 1802
Printed book with engravings, 11¹³⁄₁₆ × 8⁷⁄₁₆ in. (30 × 21.5 cm)
© Patrimonio Nacional, Real Biblioteca, Palacio Real, Madrid (Map 478)

biographies of secular saints, or as a string of events that follows humanity on its path toward the conquest of the spirit.[2] We now recognize thousands of archival documents that address scientific and technical activities, most of them related to economic projects or to the solution of concrete problems. Intermingled with the bureaucratic files of an incipient modern state that was attempting to organize an empire, we find laws, ordinances, decrees, reports, and descriptions that speak of epidemics and floods in the cities and of the measures taken to deal with them; of the construction of aqueducts, dams, roads, and fortifications; of the development of cartographies and new navigational routes; of the experimentation with new methods of amalgamation in silver mines; of projects to exploit quinine tree woods or coca plantations; or of designing sugar mills. In sum, a still partially told story lies scattered in the bundles of papers preserved in Spanish and American archives. A deep connection binds the history of scientific activities in and the historical development of that complex universe created by the Spanish empire on both sides of the Atlantic during the period from 1492 to 1819. In this essay I will review a portion of this history, that which took place during the eighteenth century and whose protagonists were those scientists who left the religious cloister and the academy in order to become expeditionaries and adventurers.

EXPEDITIONARY SCIENCE

Scientific expeditions of the eighteenth century were organized for the systematic gathering of information according to a set of previously established formal guidelines and in conformity with contemporary disciplines of knowledge. Because of their number—more than sixty during the century (see table 1, page 186)—as well as their geographic scope, diverse objectives, and societal impact, scientific voyages came to define and characterize in large measure the projection of the Spanish crown in the Americas throughout the century.[3] The scientific expedition played a central role as a vehicle of knowledge and intervention in an empire that stretched, literally, over half the world, embracing geographies and landscapes connected by maritime routes that crisscrossed all the oceans. Although expeditions clearly were not the only type of scientific activity undertaken, their preparation and development, as well as encounters between the explorers and Creole minorities, permit the construction of an original and mature history.

The history of scientific expeditions in the Americas begins with the Spanish naturalist Francisco Hernández (1530–1587), who was sent to New Spain by Philip II in 1571 (see the essay by Jesús Carrillo in this volume). This voyage bore many of the traits that would characterize the great explorations of the eighteenth century. Hernández's expedition, sponsored by the king and designed by his closest advisors, maintained a latent conflict between the interests of the crown and the intellectual mission of the naturalist-physician. The project focused mainly on two concerns of the crown: first, to find and exploit the pharmacological resources of American flora, both as new products and as possible substitutes for those that traditionally came to Europe from the Orient; and second, to study medical practices in the overseas territories and verify the therapeutic properties of native medications. To accomplish these ends, the expedition was granted extensive political powers.

In turn, the intellectual project of Hernández, a physician, underwent continuous redefinition as the expedition advanced through the new territories. Fully imbued with the ideals of a Renaissance man, Hernández attempted to encompass the totality of knowledge of the natural world that was unfolding before his inquisitive eyes. The rather alchemistic mystery of the relationship of an object and its name—hence the interest in the nomenclature of the Nahuatl culture—the role of plant and animal iconography, the quest for an apt visual language for scientific description,

and the study of the ancient Aztec culture were his main interests. In organizing the expedition from the metropolis, the crown incorporated into the scientific project, and the task of the explorer himself, a political program that, while not in total opposition to the scientific mission, created a degree of tension whose source was the political and reforming control of the institutions created by the crown and the new ideas emanating directly from the circles of influence closest to the king.

The link between political power and science that began in the sixteenth century with the birth of academic institutions that for the first time were neither monastic or ecclesiastic became fixed during the seventeenth century with the founding of the Royal Society of London (1660) and the French Academy of Sciences in Paris (1666). Within the Hispanic world this link acquired distinct characteristics, among them, paradoxically, its limited and fragile institutionalization. Institutes of science would not be formalized in Spain until well into the eighteenth century. Charles V protected astronomers and engineers, and Philip II, who organized Hernández's voyage, built a complete alchemical laboratory at El Escorial and established various acclimation gardens throughout his territories. But neither ruler fomented the institutionalization that confers a certain degree of autonomy to the scientist.[4] (The very failure to disseminate the materials painstakingly prepared by Hernández is largely due to this.) In summary, science in the Spanish monarchy, more so than at any other court, was linked to the launching of concrete projects specifically designed to fulfill multiple missions, among which those of political control and reform were of no small importance.

During the first decades of the eighteenth century the rivalry between London and Paris occasioned the organizing of the first scientific experiment on a global scale. The objective was to elucidate the exact shape of the earth and thus establish Newton's superiority over Descartes. This required the organizing of two expeditions, one to the line of the equator, and the other to the North Pole (or as close as possible), to measure and compare a degree of the meridian arc. The expedition to the North Pole headed for Lapland in 1736 under the direction of Pierre-Louis Moreau Maupertuis, while the voyage to the equatorial line, led by Charles-Marie de La Condamine and Pierre Boulanger in 1735, sailed toward Peru and territories in the domain of the Spanish crown. Not wanting to waste the opportunity presented by this great international project, Spain demanded that two of its best young officers accompany the French scientists to Peru.[5] Jorge Juan and Antonio de Ulloa would thus become engines for change and transformation in the Spanish navy, which in turn became the loyal arm of the crown, intent on modernizing its empire, a process that has been defined as the militarization of Spanish science. From that time, interest in scientific pursuits and their capacity to modernize the empire and its institutions became a constant that would reach its peak in the last quarter of the eighteenth century, in the reigns of Charles III and Charles IV.

TERRITORIAL CONTROL

It is no surprise that the scientific expeditions of the Enlightenment focused, though not exclusively, on the control of territory,[6] in accord with the new logic of international politics. The transformation of baroque Continental empires into maritime and commercial powers facilitated, among other things, a profound transformation of the various technologies associated with the Spanish navy and navigation in general. Shipbuilding became "mathematized," and new nautical instruments were now astronomically based (pls. 72, 73). Therefore, navigation became more precise but also much more complex. The art of seafaring, fundamentally based on personal

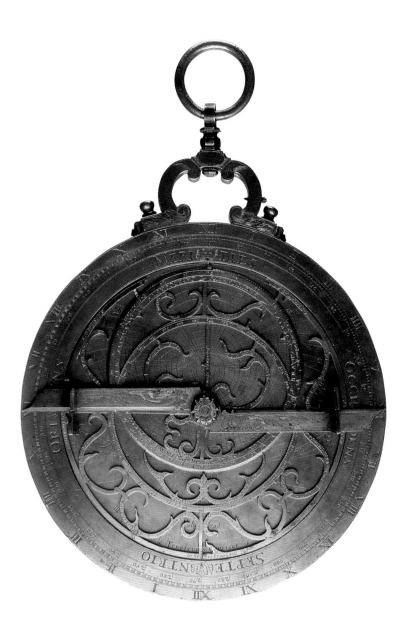

PLATE 72

CORNELIUS VINCH (ACT. 1599–1625)
Planispheric astrolabe

>Naples, c. 1620
>Brass, diam. 9 1⁄16 in. (23 cm)
>© Archivo Fotográfico, Museo Arqueológico Nacional, Madrid (52.079)

Vinch, an instrument maker from Antwerp, lived and worked in Naples, then under Spanish rule. His elegantly designed devices were in demand among European nobility.

PLATE 73

FERDINAND BERTHOUD (1727–1807)
Marine chronometer

>Paris, 1787
>Brass, 13 3⁄8 × 4 3⁄4 in. (34 × 12 cm)
>© Museo Naval, Madrid (I-1332)

For centuries navigators at sea had known how to calculate latitude but not longitude, which would have fixed their exact location. Powerful rulers, including Philip II, offered rewards for a method to determine longitude, but it was not until the 1730s that an English clockmaker, John Harrison, perfected the marine chronometer. Berthoud, who published many works on horology, gained renown for creating instruments far more portable and elegant than the early prototypes.

experience, became the science of navigation. Astronomy was used to resolve mariners' most pressing problems, such as the figuring of latitude and longitude, and the elaboration of a more precise cartography with the aid of calculations and instruments that embodied the perfect combination of the artisan's virtuosity with Newtonian laws and principles of nature. These new technical and conceptual tools compelled the remaking of virtually all the maps of the known coastlines of the current geostrategic scenario, which now included the Pacific Ocean. The Spanish crown, which owned the most extensive overseas empire, set off to chart its possessions through large expeditions organized from the Iberian Peninsula in combination with other, more localized undertakings through its maritime departments in the Americas. As a result, the Spanish navy drafted hundreds of charts and maritime routes, and astronomically positioned ports, bays, capes, and reefs from Alaska, the Strait of Juan de Fuca, and California all the way to the Strait of Magellan, and from the Caribbean Islands and the Gulf of Mexico to Patagonia, along with the Philippines and some archipelagos in the Pacific.

Many of the scientific-technical elite of the Enlightenment were also members of the military. The modernization of many branches of knowledge in eighteenth-century Spain was paralleled by the militarization of their practitioners. While the influence of the Jesuits diminished, that of army and naval engineers increased. The Corps of Military Engineers was founded in 1711 and the Royal Military School of Mathematics of Barcelona in 1720. These institutions produced the specialists who built fortifications, roads, and docks, and also those who drafted the cartography of the empire. The Spanish navy founded its midshipmen's school in Cádiz in 1717; it was revitalized with a new syllabus and the leadership, from 1753, of Jorge Juan and the French-born Louis Godin, who had participated in the 1735 expedition to Peru. The mariners who produced the nautical charts of the empire came from these institutions.

THE CONTROL OF NATURE

Another vast scientific area—natural history—underwent expansion during the eighteenth century, and it too would effectively contribute to the control of the empire's territories. The botanical gardens that emerged in the Renaissance combined two great passions, observation of nature and collecting. For a king, the acquisition of natural objects from remote lands for his gardens and natural history collections, just as much as the accumulation of paintings or palaces, was a symbol of his power. In the eighteenth century this fashion extended to the court and erudite circles; everyone, from the notable members of the academies and local societies to the nobility and great philosophers of the Enlightenment, developed a taste for the study of plants. Beginning in the mid-eighteenth century, botany enjoyed a particular advantage: it possessed a scientific language of its own, which was easy for laymen to learn, making the grand book of nature accessible to an audience that rapidly extended throughout the cities of old Europe and into the colonial domains. The classification system developed by the Swedish botanist Carl Linnaeus (1707–1778), with all its simplicity but also its arbitrariness, was discussed and argued in erudite circles throughout Europe.

Published polemics were translated and disseminated in the Hispanic world. In the third edition of the *Biblioteca botánica* (Amsterdam, 1751), Linnaeus wrote: "Spanish flora are unknown to us. Those often rare plants from the fertile lands of Spain have scarcely been introduced. It is painful that such botanic barbarousness could exist in the most learned centers of Europe even in our time." Nonetheless, at the end of the century, two testimonies came to reflect a very different situation. In 1797 the French academic Étienne-Pierre Ventenat wrote in the pages of the *Magazin*

encyclopédique: "If Linnaeus were still alive today, far from reproaching Spaniards, he would distinguish them among the scholars of Europe. These men of unusual merit, who honor the fatherland that gave them birth, have surpassed the limits of human knowledge in all scientific disciplines, especially in botany. In fact, this interesting branch of natural history is cultivated today in Spain as fervently and in such a generalized manner as in the rest of the European states."[7] A few years later, another scientist and explorer provided an explanation for this turnaround in opinion. In 1811 the German naturalist Alexander von Humboldt wrote in his *Essai politique sur le royaume de la Nouvelle Espagne* (Paris, 1811): "No European government has invested a larger amount of money to advance the knowledge of plants than the Spanish government. Three botanical expeditions to Peru, New Granada, and New Spain . . . have cost the Spanish state around two million francs. In addition, they have established botanical gardens in Manila and in the Canary Islands. The commission charged with the design of the Güemes canal was also assigned the task of examining the plant products of the island of Cuba. This research, conducted for twenty years in the most fertile regions of the new continent, not only has enriched the spheres of science with more than four thousand new plant species, it has also contributed greatly to the popularity of natural history among the inhabitants of the country."[8]

Indeed, during the second half of the eighteenth century the Spanish crown made a crucial bet on botany, both as a science in the service of the state and as an example of a science both useful and without theological problems. (Nonetheless, Spanish botanists conceived their field as the best path for knowing the work of the Almighty.) The support afforded botany by the state, its lack of philosophical contentiousness, and its connection to projects of health reform allowed the consolidation of a scientific community capable of undertaking overseas ventures and initiated a process of institutionalization that led to the founding of the Royal Botanical Garden of Madrid.

The antecedent for the great botanical expeditions organized by the Spanish crown after 1770 can be found in the 1754 South American expedition led by José de Iturriaga. Included among its members was the Swedish botanist Pehr Löfling (1729–1756), a favorite disciple of Linnaeus. The expedition was charged with settling a boundary dispute between Spain and Portugal over the line between Venezuela and Colombia in the region of the Orinoco River. In effect, the 1750 peace treaty between the two powers had made possible the first voyages of naturalists to South America. Löfling died in Venezuela from fever, but his appointment served, nonetheless, as an incentive to new explorers and heralded to Europe the bounty of the natural universe of the Americas and the possibilities of its exploration (pl. 74 a, b).

THE ROYAL BOTANICAL EXPEDITION TO THE VICEROYALTY OF PERU

An organized policy of botanical expeditions to the Americas did not begin until well into the reign of Charles III. Between 1777 and 1788, an expedition led by Hipólito Ruiz (1754–1816) and José Pavón (1754–1840) was deployed to the viceroyalty of Peru. Their voyage was impelled by an initiative of the French government, whose finance minister, Anne-Robert-Jacques Turgot, adhered to physiocratic economic principles that maintained society should be governed according to an inherent natural order. Believing that a greater knowledge of natural history and geography would benefit their economy, the French requested permission for the botanist Joseph Dombey to travel to Peru. Whether fearing that the project was actually a mission of political and economic espionage, a surveillance of new natural wealth not yet under the full control of the Spaniards, or whether the Spanish government truly became conscious of the need for Madrid to lead this type

PLATE 74 a, b

COMMISSIONED BY PEHR LÖFLING (1729–1756)
"Vulgo: Cerezas de Indias"
"Vulgo: Piña agridulce"

 Expedition to the Limits of the Orinoco (1754–61)
 Watercolor and pencil on paper, 18⅜ × 12¹⁵⁄₁₆ in. (46.6 × 32.9 cm)
 © Archivo del Real Jardín Botánico, Madrid, CSIC (Div. II, 30, 15)

PLATE 75

ISIDRO GALVEZ Y GALLO (1754–1829)
"Calyplectus acuminatus"

Royal Botanical Expedition to the Viceroyalty of Peru (1777–88)
Watercolor, ink, and pencil on paper, 14⁹⁄₁₆ × 10 in. (37 × 25.4 cm)
© Archivo del Real Jardín Botánico, Madrid, CSIC (Div. IV, 754)

PLATE 76

FRANCISCO PULGAR (ACT. 1784–1815)
"Sida retrorsa l'héritier"

Royal Botanical Expedition to the Viceroyalty of Peru (1777–88)
Watercolor and ink on paper, 14¾ × 10¼ in. (37.5 × 26 cm)
© Archivo del Real Jardín Botánico, Madrid, CSIC (Div. IV, 1002)

of expedition, the Spanish crown transformed the French initiative into its own enterprise. Charles III's *cédula real*, or royal decree, outlined the objectives of the expedition: "As it goes unto the profit of my service, and also of my vassals, the methodical examination and identification of the natural products of my realms in America, not only to promote the progress of the physical sciences, but also to dispel the doubts and adulterations that exist in medicine, painting, and other important arts, and to augment commerce and to create herbaria and collections of natural products, describing and outlining the plants that may be found in these, my fertile domains, in order to enrich my Museum of Natural History and the Botanical Garden of the court." This was, therefore, the first expedition organized under the auspices of the Royal Botanical Garden of Madrid, recently installed in the Paseo del Prado, which was developing into the central institution of

Hispanic botanical knowledge. Traveling with the botanists Ruiz and Pavón were two painters selected by the Royal Academy of Fine Arts of San Fernando, José Brunete and Isidro Galvez. They were given the assignment of "copying nature exactly, with no presumption to correct or adorn it, as is the habit of some artists who include adornments they draw from their imagination."

The journal of the Ruiz and Pavón expedition contains all the classic elements of Enlightenment-era voyage narrations. The writers are unrestrained in the face of an unfamiliar nature unfolding before their eyes and fascinated by its fecundity and diversity: "The perpetual fragrance and aroma of the genus of the orchid delights and vivifies the senses in such a manner that the land seems to invite one to stay there forever." Anecdotes abound about the harshness of the voyage, earthquakes and floods, the diversity of native cultures, and everyday life in colonial cities.

Among other things, the botanists did not fail to study the effects of coca (*Erythroxylon coca*), a plant well known among the Indians and around the mining centers. It, along with tobacco, was considered "a vicious plant for the enjoyment of the Indians" but one also capable of curing "spells of dysentery; checking diarrhea, promoting the flow of blocked menstruation after childbirth, when boiled and taken in the form of an infusion; used as a powder mixed with sugar, it alleviates indigestion and strengthens the teeth." After traveling through a good part of the viceroyalty of Peru and into Chile, the expedition returned to Cádiz in 1788, and initiated a rather tortuous course regarding the publication and dissemination of its results.[9] Even so, this expedition achieved international stature due in part to the publication by Hipólito Ruiz of several monographs with more than 1,900 plant descriptions and 650 drawings (pls. 75, 76).[10] Currently, the Royal Botanical Garden of Madrid houses 2,264 drawings and 3,000 herbarium sheets related to the expedition.

THE ROYAL BOTANICAL EXPEDITION TO NEW GRANADA

José Celestino Mutis (1732–1808), personal physician to the viceroy of New Granada (present-day Colombia), was perhaps the most influential Spanish botanist of his time. Educated in Madrid during the early days of the Royal Botanical Garden, Mutis was an enthusiastic follower and defender of Linnaeus, with whom he actively corresponded.[11]

Mutis arrived in Bogotá in 1761, working in botany and mineralogy in addition to his practice of medicine. He actively disseminated and argued the most recent scientific theories in his constant quest for intellectual independence, adopting a model that was very different from that of the centralized control imposed by the institutions of the crown. He resisted collaboration with the Ruiz and Pavón expedition to Peru and also refused to accept the position as chief physician of the viceroyalty, the highest authority on public health matters. His periodic requests for crown support for botanical studies were turned down until 1783 and the establishment of the royal botanical expedition to New Granada. Mutis made the undertaking a genuinely American venture. He established a base for his expedition in the city of Mariquita, north of Bogotá, and from there he directed the various tasks associated with the exploration, collection, herbarization, and illustration of plants. Accompanying him was the painter and naturalist Francisco Javier Matis (1774–1851), whom Humboldt lauded as most likely the best painter of plants in the world. Later, in Bogotá, the expedition was consolidated as a stable group that included young members of the leading Creole classes. This informal academy maintained a garden for the cultivation and acclimation of plants as well as an important botanical library, whose impressive inventory of more than nine thousand volumes led Humboldt to place it among the most important private

PLATE 77

Map of Loja Province (Ecuador) showing location of *Cinchona* trees,
source of quinine

1769
Wash drawing, 11¹³⁄₁₆ × 16⅛ in. (30 × 41 cm)
© España Ministerio de Educación, Cultura y Deporte. Archivo General
de Indias, Seville (MP. Panama, 179)

botanical libraries in existence, second only to that of the renowned Joseph Banks, president of
the Royal Society of London. In this sense, Mutis and his expedition represented a Creole model
for the adoption of modern European scientific postulates. Under his influence, university medi-
cal studies were reorganized, the building of an astronomical observatory was completed in
Bogotá, and the Patriotic Society of New Granada, an assembly of erudite and scientific men from
the region, was created.

Among its numerous activities, the expedition investigated plants possessing commercial
value, whether in pharmacology or in the areas of food, spices, or dyes. Of special note is his work
on the genus *Cinchona*, the name Linnaeus gave to the trees whose bark produced quinine (in

Fig. 32 *Passiflora.* Royal Botanical Expedition to the Viceroyalty of New Granada (1783–1810), under José Celestino Mutis. Tempera on paper, 21⁷⁄₁₆ × 14¹⁵⁄₁₆ in. (54.5 × 38 cm). © Archivo del Real Jardín Botánico, Madrid, CSIC (Div. III, 2043)

homage to the countess of Chinchón, the wife of the viceroy of Peru in the seventeenth century and the first person, according to popular belief, to be healed by the bark of this tree). This "bitter gold," as quinine was known at the time, was a perfect example of a new type of natural wealth from the New World, capable of revolutionizing Western pharmacology (pl. 77). So numerous were its attributes in combating diverse illnesses that Mutis proposed establishing a government business to regulate commerce of the cinchona tree forests, a trade between Europe and the Americas that had already begun to flourish. Mutis published *El arcano de la quina* (1828) to divulge the properties of the *Cinchona* and to engage in a polemic with Ruiz and Pavón, who had also worked and published on the subject. The first part of Mutis's book dealt with errors in the utilization of quinine, a veritable obsession on Mutis's part, because, according to him, confusion of the species led to the prescription of erroneous treatments. Mutis went on to distinguish seven different species of *Cinchona,* four of which were effective in medicine. In addition, he noted that the use of ineffective species had promoted the general idea of the inadequacy of quinine as a treatment. In the second part of his book, Mutis described the benefits of quinine and its organoleptic characteristics as well as techniques for distinguishing the four useful *Cinchona* species. The third part of the book analyzed in detail problems regarding the therapeutic properties of quinine and the appropriate administration of it in treating various illnesses. Mutis's work represents the serious, scientific labor of a physician who, confronted with the undisciplined use of a medicinal product with important therapeutic qualities, attempted to standardize both the identification and classification of the original species as well as their therapeutic effects and administration. It is an exemplary work for the epoch.[13]

The iconographic program of the New Granada expedition is impressive not only because of the large number of illustrations produced but also because of their perfection (fig. 32). The illustrators implemented a methodical plan of work that went from simple sketching in the field to detailed drawing of all the plant parts; finishing touches included names, labeling, and watercolor highlights. These methods were the successors of both a scientific, standardizing fervor and the original style and culture of the Hispanic-American baroque. Today, the Royal Botanical Garden of Madrid holds more than 20,000 sheets representing 2,738 different taxa and 6,717 drawings of 6,000 species identified by the expedition. Mutis's work is a reflection of his words: "There is still much to be learned, and, even more amazingly, there is much that we must know in order to put that which we already know to good use."[12]

THE ROYAL EXPEDITION TO NEW SPAIN

The royal botanical expedition to the viceroyalty of New Spain (1787–1803) had its genesis when documents of Francisco Hernández, chief physician to Philip II, who had traveled in Mexico from 1571 to 1576 to study its flora and fauna, were found among the belongings of Jesuits expelled from the Spanish territories in 1767. The discovery of these papers was perceived as a reaffirmation of the scientific endeavors newly encouraged by Charles III and his court through the Royal Botanical Garden. Its director, Casimiro Gómez Ortega (1740–1818), organizer of the botanical expeditions,

PLATE 78

"Banisteria laurifolia"

Royal Botanical Expedition to the Viceroyalty of New Spain (1787–1803),
under Martín Sessé and José Mariano Mociño
Watercolor, ink wash, and pencil on paper, 9⅝ × 6¼ in. (24.5 × 15.8 cm)
© Archivo del Real Jardín Botánico, Madrid, CSIC (Div. V, 79)

PLATE 79

"Convolvulus queretarensis"

Royal Botanical Expedition to the Viceroyalty of New Spain (1787–1803),
under Martín Sessé and José Mariano Mociño
Watercolor, ink, and pencil on paper, 9⅝ × 6½ in. (24.5 × 16.5 cm)
© Archivo del Real Jardín Botánico, Madrid, CSIC (Div. V, 47)

was commissioned to update and publish the Hernández manuscripts. At the same time, Martín de Sessé (1751–1808), a physician residing in Mexico, proposed a botanical expedition whose goals would be to catalogue colonial natural historical resources and to reform the healthcare system in the new Hispanic territories through the endowment of a botanical garden and a botany professorship at the university in Mexico City. In geographical terms, the project would range from Guatemala to California and Vancouver Island; one of the naturalists, José Mariano Mociño (1763–1819), had already participated in a naval expedition to the Northwest Coast. The project represented another encounter between the reform politics of the crown and the Creole minorities, between the new classification-based European science and the traditional indigenous herbology of the new territories. Today, the 1,335 drawings and 3,500 species (200 new genera and 2,500 new species) from the expedition to New Spain kept in the Royal Botanical Garden of Madrid (not counting the collections held in other archives) give a sense of the scope of its activities (pls. 78, 79).

Vicente Cervantes (1755–1829), a pharmacist and botanist, took the post of professor at the new botanic garden in Mexico City. A disciple of Gómez Ortega and a committed Linnaean, Cervantes was perceived as a threat to the traditional methods of teaching medicine. Some Creole writers, in particular the priest José Alzate, defended the traditional form of science based on the observation of nature and the utilization of natural products. Alzate criticized botany as an exclusively taxonomic science, founded on the artificiality of the Linnaean system, which focused on incidental traits and neglected the study of plant properties and utility. He defended the quality of Creole scientific work, which was rooted in the practices of the indigenous cultures. Indignant that Cervantes and his followers assumed that there had been no botany in New Spain, Alzate traced the scientific tradition in Mexico as descending directly from the work of Francisco Hernández in the sixteenth century and from the indigenous cultures. This, he argued, provided the necessary foundation for the correct understanding of nature: "Did the Mexican Indians cultivate a medicinal botany? Those who attempt to revile them, labeling them as barbarians, idiots, etc., do not realize that in so doing they are diminishing the honor due to the Spanish nation. There is a big difference between conquering a civilized nation and subduing a barbarous one. The greatest triumph, the foremost honor crowning our nation was the conquest of a people knowledgeable of the natural sciences, as it is now clearly demonstrated everywhere. . . . It is not the same to cultivate plants as a hobby or for utilitarian purposes as to cultivate them to study their properties and for the benefit of humanity, which is the true definition of a botanist." Alzate continues: "And, do we need another botany that is not medicinal? Do the excessive expenses and the protection the kings provide for the botanists so that they can travel to different countries have any other goals? Is not the health of their subjects the primary motive for all of this? Otherwise, they would be satisfied with their leisure gardens."[14] With this understanding of science as more functional than aesthetic, Alzate linked this useful knowledge of nature, this authentically practical science, to the understanding of nature in the indigenous world, that very world which had supplied Europe with the medicinal uses of the most significant plants, especially the quinine-producing tree, the most important plant of the eighteenth century. The same can be said about Alzate's defense of indigenous agricultural knowledge, which European expeditionaries had met with skepticism.

The Expedition in California

With its home base established in Mexico City, the expedition's members fanned out throughout the viceroyalty of New Spain to study its flora and fauna. To cover more territory, the expedition separated into groups. One headed for the Tarahumara Mountains, through the western range of the Sierra Madre, and the Tepehuanes Sierra toward Aguascalientes. Another group reached this latter city by way of Sinaloa and Ostimuri, the missions of the Yaqui River, and Tepic. Meanwhile, the naturalist José Longinos (c. 1750–1803) undertook the exploration of both Californias, Baja, where the Jesuits founded their missions, subsequently administered by the Dominicans, and Alta, where the Franciscans began establishing settlements in 1769. From the port of San Blas, established to supply California and explorations of the Northwest Coast, Longinos reached Loreto, the capital of Baja California, and from there he headed south along the peninsula to survey mines, the southern coastline, and, crossing the Sea of Cortés, the provinces of Sonora and Sinaloa. In March 1792, Longinos set out alone for the Franciscan missions of Alta California. In April he reached the San Francisco de Borja mission, and from there he sent to the capital two boxes of materials he had gathered. He also visited San Diego, San Juan de Capistrano, San Gabriel, San Buenaventura, Santa Barbara, La Purísima Concepción, San Luis, San Antonio, La Soledad, San Carlos de Monterrey, and, finally, San Francisco. Longinos was amazed by the many different languages spoken in localities relatively near one another, and in his diary he tells of the Chumash Indians, who lived along the coast near the Santa Barbara Channel and first came into contact with Spaniards in the sixteenth century. Longinos described their houses, customs, canoes, clothing, and so forth, and found their culture superior to that of other California Indians, which he attributed to the possible arrival of Chinese or Japanese ships to those shores. He sent back abundant zoological materials, compiled numerous medicinal plants, remarking upon the diverse uses the Indians made of them, and completed a detailed inventory of local products with commercial potential. Longinos also addressed the study of sources of oil, tar, and other volcanic substances he encountered near the San Gabriel mission.

Mociño in the Northwest Coast

Spain had initiated the exploration of the coast north of California in 1774. The reasons were various, ranging from the drive that pushes all empires to tirelessly broaden their domains, the real or imagined threats of other powers, and improbable geographical reports such as the existence of a passage, in the Northern Hemisphere, connecting the Atlantic and the Pacific Oceans. In truth, the Russians were expanding south through Alaska, and false stories of the existence of manuscripts about voyagers who had found the Northwest Passage circulated by word of mouth in the European courts. And with these tales traveled word of a new market to be exploited: the fur trade. Any of these motives sufficed to initiate a race among the maritime powers. Thus, within scarcely two decades, Spain, Russia, and Great Britain would meet on the coasts of present-day Oregon, Washington, British Columbia, and Alaska. The first expedition, from Mexico, was commanded by Juan Pérez in 1774 and was followed by the voyages of James Cook (1776) and Francisco de la Bodega y Quadra (1775 and 1779).

Toward the end of the next decade, a minor incident between English and Spanish crews prompted the signing of a treaty of nonaggression between Spain and Great Britain. This led to the organization of an expedition in 1792 under the leadership of Bodega y Quadra for the purpose of meeting with English Captain George Vancouver at Nootka Sound (on Vancouver Island) to carry out the accord. Joining the crew were Mociño and his assistant, José Maldonado, in their

PLATE 80

JOSÉ CARDERO (1776–1811?)
Nootka Port

 Malaspina Maritime Expedition (1789–94)
 Watercolor and sepia ink on paper, 9¹³⁄₁₆ × 16⁹⁄₁₆ in. (25 × 42 cm)
 © Museo de América, Madrid (2.270)

role as naturalists, and the painter Atanasio Echeverría. During his stay at Nootka Sound, Mociño studied the flora and fauna of the region and compiled ethnographic descriptions of the indigenous cultures, which were published as *Las noticias de Nutka*. This account is undoubtedly one of the most remarkable testimonies about Northwest societies during the earliest moments of acculturation. Additionally, Mociño composed a catalogue of plants and animals identified according to Linnaean method by himself and Maldonado, as well as a vocabulary of local Indian words that, he believed, shared a common root with the Aztec language.

 Mociño rejoined the royal expedition in Mexico in 1793, and for ten more years he and his fellow naturalists continued their travels throughout California, Mexico, and Central America. At the conclusion of the expedition, in 1803, Sessé and Mociño returned to Spain to pursue publication of their findings. Times were not good for Spanish science: political turmoil, reactionary developments stemming from the French revolution, and finally Napoleon's invasion of Spain were disrupting scientific endeavors of all kinds. After Sessé's death in 1808, Mociño took charge of their edition of *Plantæ Novæ Hispaniæ*. After the French invasion, Mociño took refuge for a

time in Seville, before being forced into exile in Montpellier in 1812. The expedition specimens remained in Madrid, but Mociño had possession of the drawings. In Montpellier he met the Swiss botanist Augustin de Candolle, who estimated that the number of plants drawn by the expedition approached 1,400. Conscious of the importance of the work, de Candolle held it in safekeeping for Mociño when improvements in the political climate allowed him to return to Spain. After receiving permission to return to Spain in 1817, Mociño asked that de Candolle dispatch the drawings to him. Fearful for their safety, de Candolle, who by that time had transferred to the botanical garden at Geneva, mobilized a cadre of volunteers in the city to copy more than a thousand of the drawings. Thanks to the availability of these copies, de Candolle was able to identify 17 new genera and 272 new species. Three hundred of the drawings are considered type genera on which the names of some new species are based.

Mociño's personal collection of original expedition drawings passed from hand to hand in Barcelona (where the naturalist died in 1820) until 1981, when the Hunt Institute at Carnegie Mellon University acquired a good part of them. The collection numbers close to 2,000 botanical and zoological watercolor drawings and sketches, of which 1,800 are botanical; the rest depict fish, birds, insects, reptiles, and small mammals.[15]

ALESSANDRO MALASPINA'S VOYAGE AROUND THE WORLD

The most influential of the Spanish exploring expeditions is recorded in the million pages of the *Viaje científico y político de las corbetas Descubierta y Atrevida . . .*, as the Malaspina expedition was called. Carried out under the direction of Alessandro Malaspina (1754–1810), a commander of Italian origin, the expedition offers an extensive and profound view of the American world at the end of the eighteenth century. This real yet fantastical image of an overseas empire that had been in the making for three hundred years is also a reflection of the degree to which the empire used modern science as a foundation and a rationalizing premise for its international activity.

In the court of the Spanish Bourbons, particularly in the final years of the reign of Charles III, mariners and navigators ascended to positions of growing influence. This phenomenon was common to other European monarchies and not surprising, as each struggled for maritime supremacy over other trading empires. In Spain, the naval academy took on a greater scientific focus and more elite curriculum, first through the establishment of an observatory in 1790 and later with the introduction of a program of advanced studies analogous to a doctorate in mathematics and astronomy. The organization of hydrographical expeditions throughout the empire put young officers in an exceptional position to acquire in-depth knowledge of all the monarchy's territories. This elite group of officers, trained as astronomers and cartographers, became incorporated into the European scientific community through intense activity in institutions such as the British Royal Society or the French Academy of Sciences; they also went on to occupy important administrative positions in the government of the Indies. The officer Antonio Valdés, for example, was in charge of both the Navy and Indies ministry. In the same fashion, supervisors of the various maritime branches, key figures in the commercial exchange, defense, and the articulation of policies regarding the Americas, were all naval officers. This cohort of officers shared the ideals of the late stage of the Enlightenment; they awaited the opportunity for political power, but the violent winds of the Napoleonic invasion and the decay of the Spanish monarchy during the first decade of the nineteenth century would cancel those ambitions. Some officers, like Dionisio Alcalá Galiano, died in combat; others met their destiny in exile, like Malaspina, who was banished to his native country, or Felipe Bauzá and José Mendoza y Ríos, who took refuge in England, the

PLATE 81

JESSE RAMSDEN (1735–1800)

Quadrant

London, c. 1750

Malaspina Maritime Expedition (1789–94)

Brass, metal, h. 32⅞ in. (83.5 cm), radius 23¼ in. (59 cm)

© Museo Naval, Madrid (I-779)

Ramsden was widely acknowledged as the best maker of scientific instruments
in Europe in the eighteenth century.

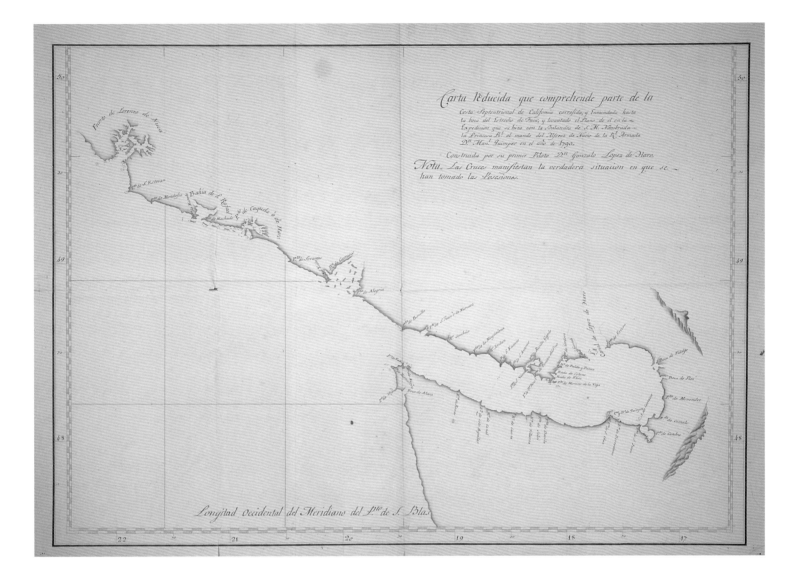

PLATE 82

Map of the West Coast of North America

1790
Quimper Expedition (1790)
Ink on paper, 19⁵⁄₁₆ × 27⁹⁄₁₆ in. (49 × 70 cm)
© España Ministerio de Educación, Cultura y Deporte. Archivo General
de Indias, Seville (MP. Mexico, 427)

perpetual enemy of the Spanish empire but where, nevertheless, they commanded prestige among their scientific colleagues.

The scientific component of Malaspina's journey was not only the culmination and perfection of the extensive expeditionary activities we have reviewed in the preceding pages. Its hydrographic results, exceedingly important and unsurpassed by any other European navy at that time, completed the work of numerous peninsular and viceregal expeditions. Regrettably, the enormously diverse natural history collections amassed by the expedition made few repercussions in the scientific community since the long process of study and dissemination remained unfinished for decades. The only scientific publication produced during the period was a treatise on the health of the ship crews written by the expedition's physician. The ethnographic descriptions collected by

the expedition—highly valuable, since many of them were made during the first contact between Westerners and the indigenous cultures—have been recovered for science only as primary sources for anthropologists.

Nonetheless, the significance of the scientific project reaches beyond its concrete results in the fields of cartography or natural history. As demonstrated by Juan Pimentel, the foremost specialist on Malaspina's thought, during the eighteenth century the marriage of political thought with the new scientific language was deep and enlightening.[16] A rigorous language of science, linked to that of mathematics, insofar as was possible, had inspired political thinkers such as Montesquieu, Rousseau, and Adam Smith.

No review of the expedition can omit the personal and vital aims of its commander, a man hurled by the currents of history to the task of envisioning an empire. Reviewing Malaspina's biography—his Italian origins, his education in Rome and Malta, his time at the midshipmen's school at Cádiz—or his intellectual journey, it appears that he had been preparing for his fate all his life. By comparison with some of his expedition companions, such as Tadeo Haenke, the Central European naturalist who became absolutely Americanized, Malaspina did not succumb to fascination with the exotic and refused to relinquish his responsibility, which began and ended in the political action of the Spanish crown. His envisioning of the empire according to a new set of principles of natural philosophy gave an experimental dimension to the political-scientific voyage. In his *Axiomas políticos sobre la América,* Malaspina formulated this process; there would be "a decalogue of the scientific knowledge of a realized politics, still another transfer of the Newtonian style and method to the human order."[17] The experiment, borne out in the text of the *Axiomas políticos,* constituted both Malaspina's diagnosis of the maladies of the empire and his theoretical expression of it as an enlightened body governed by reason and justice. The next step, the voyage, in effect functioned as the material verification and gathering of data. The conclusion would come in the political action of reform: "These principles will fall far from those beautiful veracities that, although they represent the great ideas of their authors, are only useful as an excessively faithful mirror that instills horror at its very sight and makes us faint altogether, faced with the impossibility of improvement." Malaspina's indictment of colonialism could not have been more severe: "In the end, all conquerors have destroyed first the conquered country, then themselves, and finally their country of origin."[18]

The voyage itself, carrying Malaspina and some of the best elements of the Spanish navy of that time, along with a select team of painters and naturalists, lasted five years and covered virtually all the territories of the Spanish empire. The corvettes *Descubierta* and *Atrevida,* so christened in honor of the *Discovery* and the *Resolution,* two of the vessels commanded by the English navigator James Cook, left Cádiz in 1789 and headed for Montevideo and Buenos Aires, in the Río de la Plata viceroyalty. They continued down the coast of Patagonia, past the Falkland Islands, and then rounded Cape Horn, reaching the island of Chiloé, on the Chilean coastline. Afterward, they followed the Pacific coastline to Acapulco and the port of San Blas, in Mexico. From there, they continued the exploration of the Northwest Coast all the way to Alaska and later sailed south past Vancouver Island and the Northwest coastline until they reached the California missions. The ships returned to San Blas before crossing the Pacific Ocean to the Philippines, passing the Marianas archipelago. They made a brief visit to Macao and then set sail for the British colony of Sydney, in Australia. For the return trip, they again crossed the Pacific, sailing to the port of Callao, in Peru, after making a brief stop at the Tonga archipelago. After once again rounding Cape Horn, the expedition arrived back in Cádiz on September 21, 1794.

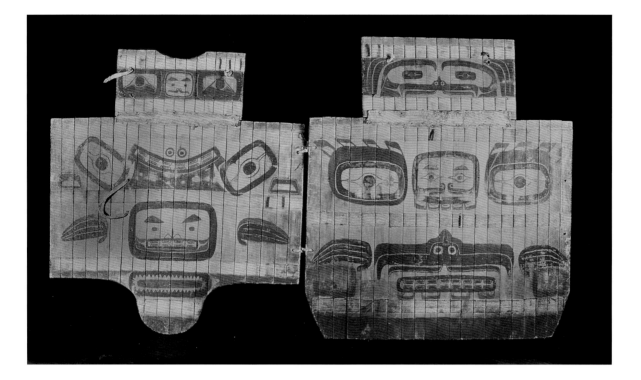

Among the various objects collected by Spanish explorers were carved and painted helmets and body armor, which were part of Tlingit battle dress and represented specific clan affiliations. The images of animal and spirit figures painted on wooden slats gave protection and supernatural power to the wearer.

PLATE 83

Breastplate and backplate

Tlingit or Chugach (Pacific Yup'ik)
Collected c. 1775–92, southeast Alaska, possibly by Bodega y Quadra Expedition
Painted wood with leather and vegetable fiber, 23¼ × 43⅜ in. (59 × 110.2 cm)
© Museo de América, Madrid (13.914)

PLATE 84

Helmet

Tlingit
Collected c. 1775–92, southeast Alaska
Painted spruce with leather, 8⅞ × 13 × 11 in. (22.5 × 33 × 28 cm)
© Museo de América, Madrid (13.911)

The native people of the Northwest Coast astutely traded and sold handmade objects to European visitors. Before being collected at Nootka Sound, this bird-shaped rattle with four faces painted on its side might have been used to bridge the spirit and human worlds. The flute is nonfunctional and might be a copy of an instrument brought to the Northwest Coast by visitors, yet the carved figures surely reference a Tlingit story. Inlaid abalone shell may have been acquired in trade with the Spanish, who brought the highly prized shells from California.

PLATE 85

Flute

Tlingit
Collected c. 1775–92, southeast Alaska
Wood with abalone shell, h. 15³⁄₁₆ (38.5 cm)
© Museo de América, Madrid (13.388)

PLATE 86

Rattle

Nuu-chah-nulth (Nootka)
Collected 1792, west coast of Vancouver Island, British Columbia, probably by José Mariano Mociño, Bodega y Quadra Expedition
Painted wood, 6⅛ × 18⅛ in. (15.5 × 46 cm)
© Museo de América, Madrid (13.897)

What did Malaspina discover during the 1,851 days of his voyage throughout the territories of the Spanish empire? Upon his return to Spain, he showed a more melancholic attitude, more nuanced and conscious of the complexity of the world he had seen in the Americas, which he contemplated with the political disillusionment of a man of action and the philosophical indifference of a scholar. He had discovered a space and a society in constant tension, where strong historical currents collided. The baroque society inherited from the Habsburg monarchy well knew how to integrate under their authority a diversity of peoples and landscapes, both in Spain and the rest of Europe. An example of this stabilizing element is the Jesuits, whose work was not limited just to the missionary realm; they attempted to establish a conceptual order for all the Americas. They charted maps of the territories, from Baja California to Paraguay and Patagonia, and astronomically located the most important cities. Under the iron fist of their paternalistic authority, the missionaries described the flora and fauna, educated the Creole minorities, and compiled indigenous vocabularies and grammars; they translated the sacred texts into those languages and reproduced the "city of God" in the converted Indians' settlements.

Malaspina personally met the Creole intellectuals who, in cities such as Lima, Quito, Bogotá, and Mexico City, challenged excessively Eurocentric interpretations of Enlightenment principles and attempted to build an original body of thought based on key tenets of their own traditions. He had already gathered data that confirmed his most pessimistic conclusions, which he poured into his *Axiomas*. For example, he compared the territories of the viceroyalty of La Plata with those of the United States. If, on one hand, their natural wealth was similar, on the other, their economic and political disparity was evident. In the north, the conqueror was followed by the cattle rancher, and he in turn by the merchant and the industrialist; whereas in Buenos Aires, "milk and meat are the fruits of nature rather than of industry."

Upon his return to Spain, Malaspina wrote the official version of the diary of his voyage, in which he pondered the political reforms he deemed necessary. To the argument for continuous expansion of the empire, he counterposed the need for a geostrategic analysis that would demarcate its boundaries, and even reduce it. Instead of uniformity, he saw the need for colonial administrations to adapt their policies according to the circumstances of each territory; instead of perceiving the colonies as mere sources of income for the crown, the possibility existed of their equality with the metropolis. Along with the relentless indictment embodied in his *Axiomas políticos*—"the reunion of the Americas with Spain should seem impossible. . . . Everything concurs to demonstrate that such a reunion was a vicious one, better yet, imaginary"—he signaled the only feasible course in the preamble to his diary: "Emancipated, let us say, in such a manner that the colonies must be considered a proportional rather than a secondary part of the monarchy."[19] He proposed recognizing the indigenous peoples that constituted nations in the unassimilated territories and leaving those already conquered under the paternalistic control of the missionaries, such as the Franciscans he had seen in California. In addition, he recognized the role of the secular clergy in maintaining social harmony as intermediaries between the different social groups.

Superimposed on this were the enormous rationalizing, bureaucratic, and centralizing efforts of the Bourbon rulers throughout the eighteenth century. With enlightened despotism, they imposed a new brand of order that energized and unified their realms. Trade was liberalized, taxes became harsher, efforts were made to limit the role of the church as the mediator of social tensions, and the military was increasingly entrusted with the internal stability of the territories. The presence of the crown was broadened by a bureaucratic, centralizing network. All these reforms clashed with the conciliatory, malleable, and complex practices that permeated the colonies.

The documentation Malaspina collected in America revealed the dense framework of political, economic, social, and scientific activities that shaped the landscape of Creole culture. Intent on assembling as many details as possible about the viceroyalties, the expedition conducted informational surveys in every area, collecting statistics on the economy, commerce, and new and traditional sources of wealth, the population, geography, geostrategic aspects, and much more. This data would create an integrated view of the viceroyalties.

Scarcely a year after his return Malaspina was incarcerated, charged with plotting against the prime minister Manuel Godoy, the king's favorite (pl. 87). The expedition's records—the natural history descriptions, drawings, and herbaria, the political and economic documentation, the descriptions of ethnographic materials—followed the same path into oblivion to which its assemblers were relegated (pl. 88).

THE ROYAL PHILANTHROPIC VACCINE EXPEDITION

This review of the enlightened expeditions organized by the Spanish crown cannot omit the most singular of all voyages. The Royal Philanthropic Vaccine Expedition (1803–6), as it was known, was a truly exceptional feat.[20] Its objective was to bring to the colonies the smallpox vaccine developed by the British physician Edward Jenner seven years earlier, in 1796. The Spanish crown and America were once again the protagonists in an event whose ambitious objectives, geographical scale, organizational complexity, and ultimate success made it as extraordinary as it was unknown. Confronted with a disease that periodically created major epidemiological crises in the colonies, the empire responded with the rationality of a modern state through its organization of the vaccine expedition.[21] Geographically, it would circumnavigate the globe, reaching the Philippine archipelago and continental interiors.

In the days before refrigeration, vaccines could be preserved and transmitted only by "arm-to-arm" inoculations, in which the pustular material of the vaccination site on one individual's arm was transferred to the arm of an unvaccinated person. The vaccine expedition carried twenty-two children from a Spanish orphanage, who preserved the vaccine through sequential inoculations, with two children vaccinated in turn every ten days during the voyage. In this way, the new prophylactic method, combating one of the most dire diseases of the epoch, was introduced throughout the empire. The logistical management of the expedition was put to the test by the changing social conditions found in the various regions visited. One can imagine the organizational complexity of the endeavor, which involved the successive placement of the orphaned children and their matrons in widespread locales. One can also imagine the difficulties of the long voyage by sea and land, and the local polemics regarding the acceptance or rejection of the vaccine.

To provide continued access for future generations, it was essential that the dissemination of the vaccine be institutionalized in the various regions. This was accomplished with the creation of vaccination boards, which kept records of the vaccinations performed and preserved the serum for later inoculations.

EPILOGUE

Inevitably, many actors, initiatives, expeditions, and achievements have been left out of this essay. This is both unavoidable and unfortunate, because the list of scientific and technical endeavors sponsored by the Spanish crown during the eighteenth century on both sides of the Atlantic—a unique scope for this type of activity—is impressive. For example, we have not spoken of the mineralogical expedition to Chile and Peru commanded by the Heuland brothers (1795–1800),

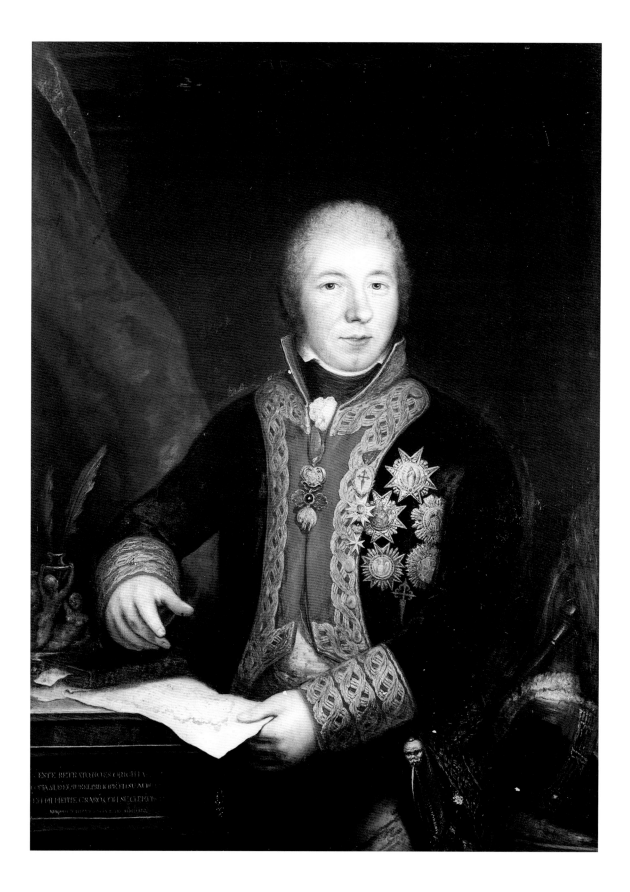

JOAQUÍN INZA (1736–1811)
Manuel Godoy

Dated 1807

Oil on canvas, 44⅛ × 31⅞ in. (112 × 81 cm)

© Patrimonio Nacional, Palacio Real de Aranjuez, Madrid (10023131)

PLATE 88

JOSÉ GUÍO Y SÁNCHEZ (D. 1804)
"Perú lima culta Passiflora"

Malaspina Maritime Expedition (1789–94)
Print from natural plant and watercolor on paper, 20¼ × 13⁹⁄₁₆ in. (51.5 × 34.5 cm)
© Archivo del Real Jardín Botánico, Madrid, CSIC (Div. VI, 91)

nor of the travels of Thaddeus Nordenflicht, who went to New Spain (1788–98) with geologists, engineers, and other German technicians to reform silver mining practices in that colony. We have not mentioned the 1780–81 expedition of Félix Azara, whose works on the fauna of the Paraguayan region were a decisive influence on Darwin and his evolutionist ideas. We have not paused to talk about more obscure events such as Dupaix's archaeological expedition to Mexico to study Aztec culture (1805–7); or the count of Mopox's voyage to Cuba to promote the economy and development of the island (1796–1802). A different, but no less significant contribution was the chemical research of the Elhuyar brothers, Fausto and José, who discovered tungsten in 1783.

Thus, toward the end of the eighteenth century, Spain possessed an established system of institutions, personnel, and scientific practices that encompassed every existing discipline and affected all regions. Many of the scientists belonged to the international network of scientific academies in Paris, London, and elsewhere, and were efficient vehicles for the transmission of knowledge and training to new generations. This was the case, for example, of the Spanish engineer Agustín de Betancourt, who was a professor in the new École Polytechnique of Paris and eventually became director of the corps of engineers in Russia. But the scientific momentum realized by Spain in the age of Enlightenment was derailed by geopolitical events. The Napoleonic invasion, war with France, and civil war disrupted the Iberian Peninsula during almost the entire nineteenth century. The empire was dismembered, and the economy declined. Natural history collections were relegated to the basements of institutions, the scientific results of so many expeditions condemned to oblivion, invisible to European science.

A few conclusions can be drawn from this account. First, the Hispanic history of the eighteenth century was constructed by scholars, scientists, and expeditionaries as much as by the monarchy. As in other countries, scientists became necessary heroes in Enlightenment Spain in the construction and survival of the empire. As Alessandro Malaspina declared, the destiny of the metropolis was one and the same as that of the colonies, and the failure of the metropolis to understand this reality brought about its own decline.

The Spanish crown utilized scientific activities to promote processes of reform. The expeditionaries and scientists were agents in service to the crown, the centralized state power; they were efficient and loyal instruments in the organizational and centralizing processes of an empire that encompassed a conglomerate of territories and peoples. In the outlying zones, scientific and technical activities not only attained an extraordinarily energizing societal role, but through the polemics they generated also came to enhance our understanding of the social phenomena relevant to scientific work.

NOTES

1. The most recent consideration of this topic is Carlos Acosta Rizo, Nicolás Cuvi, and Xavier Roqué, *Ciencia entre España e Hispanoamérica. Ecos del siglo XX* (Barcelona: Centre d'Estudis d'Història de les Ciències, UAB, 2003).

2. Antonio Lafuente, "La ciencia periférica y su especialidad historiográfica," in *El perfil de la ciencia en América. XI Congreso Interamericano de Filosofía,* ed. J. J. Saldaña (Mexico City: Cuadernos Quipu, 1986), 31, and Antonio Lafuente, Alberto Elena, and M. L. Ortega, eds., *Mundialización de la ciencia y la cultura nacional* (Madrid: Ediciones Doce Calles, 1993).

3. Juan Pimentel, *Testigos del mundo. Ciencia, literatura y viajes en la ilustración* (Madrid: Editorial Marcial Pons, 2003).

4. Javier Ordóñez, *Ciencia, tecnología e historia* (Madrid: Fondo de Cultura Económica, 2003).

5. Antonio Lafuente and Antonio Mazuecos, *Los caballeros del punto fijo. Ciencia, política y aventura en la expedición geodésica hispanofrancesa al Virreinato del Perú en el siglo XVIII* (Barcelona: Ediciones del Serbal, 1987); Juan Pimentel, *Viajeros científicos. Tres grandes expediciones al Nuevo Mundo. Jorge Juan, Mutis, Malaspina* (Madrid: Nivola, 2001).

6. See Ángel Guirao de Vierna, "Análisis cuantitativo de las expediciones científicas españolas con destino al Nuevo Mundo," in *Ciencia, vida y espacio en Iberoamérica,* vol. 3, ed. José Luis Peset (Madrid: Consejo Superior de Investigaciones Científicas, 1989), 65–94.

7. Antonio González Bueno, *Tres botánicos de la ilustración: Gómez Ortega, Zea, Cavanilles. La ciencia al servicio del poder* (Madrid: Nivola, 2002), 7; Francisco Javier Puerto Sarmiento, *La ilusión quebrada. Botánica, sanidad y política científica en la España ilustrada* (Madrid: El Serbal-CSIC, 1988).

8. Alexander von Humboldt, *Ensayo político sobre el reino de la Nueva España* (Mexico City: Editorial Porrúa, 1984).

9. Arthur R. Steele, *Flores para el Rey. La expedición de Ruiz y Pavón y la "Flora del Perú" (1777–1788)* (Barcelona: Ediciones El Serbal, 1982).

10. The first three volumes of *Flora peruviana et chinesis* were published in 1798–1802; the final two volumes were not published until the 1950s; see Iris Engstrand, *Spanish Scientists in the New World: The Eighteenth-Century Expeditions* (Seattle: University of Washington Press, 1981), 8 n 13.

11. Pimentel, *Viajeros científicos.*

12. José Celestino Mutis, *El arcano de la quina.* Facsimile of the first 1828 edition (Madrid: Fundación Ciencias de la Salud, 1998). See also Hipólito Ruiz, *Quinología. Suplemento a la Quinología.* Facsimile of the first 1792 edition (Madrid: Fundación Ciencias de la Salud, 1992).

13. Quoted in Pimentel, *Viajeros científicos,* 82.

14. Quoted in José Luis Peset, "Las polémicas de la nueva botánica," in *La Real expedición botánica a Nueva España* (Madrid: Consejo Superior de Investigaciones Científicas, 1987). The bibliography on this expedition is very lengthy. Of special note is Xavier Lozoya, *Plantas y luces en México. La Real expedición científica a Nueva España (1787–1803)* (Barcelona: Ediciones del Serbal, 1984).

15. http://huntbot.andrew.cmu.edu/HIBD/Departments/Collections/Torner.shtml.

16. Juan Pimentel, *La física de la monarquía. Ciencia y política en el pensamiento colonial de Alejandro Malaspina (1754–1810)* (Madrid: Ediciones Doce Calles, 1998).

17. Ibid., 17.

18. See also Manuel Lucena and Juan Pimentel, eds., *Los "Axiomas políticos sobre la América" de Alejandro Malaspina* (Madrid: Sociedad Estatal Quinto Centenario, 1991), and Blanca Sáiz and D. Manfredi, *Alejandro Malaspina. La América imposible* (Madrid: Compañía Literaria, 1994), 144.

19. Alessandro Malaspina, *Viaje científico y político a la América Meridional, a las costas del Mar Pacífico y a las Islas Marianas y Filipinas . . .* (Madrid: Ediciones El Museo Universal, 1988).

20. The most extensive study of this expedition is Susana María Ramírez, *La salud del imperio. La Real expedición filantrópica de la vacuna* (Madrid: Fundación Jorge Juan, 2002), winner of a Jorge Juan Foundation International Award for the Best Doctoral Dissertation. A classic on the same subject, recently reedited, is Gonzalo Díaz de Yraola, *La vuelta al mundo de la expedición de la vacuna* (Madrid: Consejo Superior de Investigaciones Científicas, 2003).

21. Toward the end of the eighteenth century, the city of Santa Fe de Bogotá, for example, suffered two smallpox epidemics whose mortality rate exceeded 13 percent. According to the most conservative estimates, the chain transmission of the vaccine carried out by the expedition resulted in the immunization of a half million persons.

TABLE 1

Spanish Scientific Expeditions of the Eighteenth Century

Date	Personnel	Reign	Place	Zone	Objective
1735–42	La Condamine, Boulanger, Godin, Jorge Juan, Antonio de Ulloa	Philip V	Ecuador	Viceroyalty of Peru	Astronomical
1745–46	P. Quiroga	Philip V	Patagonia	Viceroyalty of Río de la Plata	Cartographic
1753–56	Marqués de Valdelirios	Ferdinand VI	Paraguay	Viceroyalty of Peru	Boundaries
1754–56	Löfling	Ferdinand VI	Cumaná	Viceroyalty of New Granada	Botanical
1754–60	Iturriaga	Ferdinand VI	Orinoco	Viceroyalty of New Granada	Boundaries
1758	Cavantús	Ferdinand VI	Gulf of Mexico	Viceroyalty of New Spain	Cartographic
1765–67	Lángara, Casens	Charles III	Philippines	Pacific	Hydrographic
1767	Muñoz	Charles III	Gulf of Mexico	Viceroyalty of New Spain	Hydrographic
1767–68	Perler	Charles III	Patagonia	Viceroyalty of Río de la Plata	Hydrographic
1768–69	Gil de Lemos	Charles III	Falklands	Viceroyalty of Río de la Plata	Hydrographic
1768–69	Pando	Charles III	Tierra del Fuego	Viceroyalty of Río de la Plata	Hydrographic
1768–70	Casens	Charles III	Philippines	Pacific	Hydrographic
1768–70	Chappe d'Auteroche	Charles III	California	Viceroyalty of New Spain	Astronomical
1769–70	G. Guinal, Lángara	Charles III	Philippines	Pacific	Hydrographic
1770	Fagués	Charles III	Pacific	Northwest Coast	Hydrographic
1770	Hervé	Charles III	Easter Island	Viceroyalty of Peru	Hydrographic
1770–71	José de Córdoba	Charles III	Philippines	Pacific	Hydrographic
1771–72	Mendizábal	Charles III	Philippines	Pacific	Hydrographic
1772–73	Boenechea	Charles III	Tahiti	Pacific	Hydrographic
1772–73	Lángara	Charles III	Philippines	Pacific	Hydrographic
1773–74	Alvear, Mazarredo	Charles III	Trinidad	Gulf of Mexico	Hydrographic
1774	Lángara	Charles III	Trinidad	S. Brazil	Hydrographic
1774	Pérez	Charles III	Pacific	Northwest Coast	Hydrographic
1774	Villa, Saravia	Charles III	Philippines	Pacific	Hydrographic
1775	Heceta, Bodega	Charles III	Pacific	Northwest Coast	Hydrographic
1777–88	Ruiz, Pavón	Charles III	Peru-Chile	Viceroyalty of Peru	Botanical
1778–79	Piedra	Charles III	Patagonia	Viceroyalty of Río de la Plata	Geostrategical
1779	Arteaga, Bodega	Charles III	Pacific	Northwest Coast	Hydrographic
1780–84	Viedma	Charles III	Patagonia	Viceroyalty of Río de la Plata	Hydrographic
1780–81	Azara	Charles III	Paraguay	Viceroyalty of Río de la Plata	Boundaries
1783–86	Hevia	Charles III	Florida	Gulf of Mexico	Hydrographic
1783–1810	Mutis	Charles III	Colombia	Viceroyalty of New Granada	Botanical

Date	Personnel	Reign	Place	Zone	Objective
1785–86	Córdoba	Charles III	Magallanes	Viceroyalty of Río de la Plata	Hydrographic
1785–98	Cuellar	Charles III	Philippines	Pacific	Botanical
1786–87	Moraleda	Charles III	Patagonia	Chile	Hydrographic
1787–1803	Sessé, Mociño	Charles III	Mexico	Viceroyalty of New Spain	Botanical
1788–89	Córdoba	Charles III	Magallanes	Viceroyalty of Río de la Plata	Hydrographic
1788–89	Martínez, Haro	Charles III	Pacific	Northwest Coast	Hydrographic
1788–1801	Barcáztegui	Charles III	Cuba	Gulf of Mexico	Development
1789	Clairac	Charles IV	Patagonia	Viceroyalty of Río de la Plata	Hydrographic
1789–94	Malaspina	Charles IV	Hispanic Territories	Hispanic Territories	Global
1790	Eliza	Charles IV	Pacific	Northwest Coast	Hydrographic
1790	Fidalgo	Charles IV	Pacific	Northwest Coast	Hydrographic
1790	Quimper	Charles IV	Pacific	Northwest Coast	Hydrographic
1790–91	Elizalde	Charles IV	Patagonia	Viceroyalty of Río de la Plata	Hydrographic
1790–93	Parra	Charles IV	Cuba	Caribbean	Botanical
1792	Bodega	Charles IV	Pacific	Northwest Coast	Boundaries
1792	Caamaño	Charles IV	Pacific	Northwest Coast	Hydrographic
1792	Rigada	Charles IV	Antilles	Caribbean	Hydrographic
1792–93	Churruca	Charles IV	Antilles	Caribbean	Hydrographic
1792–94	Moraleda	Charles IV	Patagonia	Chile	Hydrographic
1792–1805	Fidalgo	Charles IV	Atlantic coast of Central America, Colombia, and Venezuela	Viceroyalty of New Spain	Hydrographic
1793	Eliza, Zayas	Charles IV	Pacific	Northwest Coast	Hydrographic
1794	Meléndez-Bruna	Charles IV	Mexico	Viceroyalty of New Spain	Hydrographic
1794–95	Gutiérrez de la Concha	Charles IV	Patagonia	Chile	Hydrographic
1795–1800	Heuland	Charles IV	Chile-Peru	Viceroyalty of Peru	Mineralogy
1796–1802	Mopox	Charles IV	Cuba	Caribbean	Development
1801	Ceballos	Charles IV	Yucatán	Viceroyalty of New Spain	Hydrographic
1801	Moraleda	Charles IV	Panama	Central America	Hydrographic
1801–2	Del Río	Charles IV	Cuba	Caribbean	Hydrographic
1803	Vernaci, Cortázar	Charles IV	Philippines	Pacific	Geostrategic
1803–6	Balmis	Charles IV	Empire	Empire	Vaccination
1805–7	Dupaix	Charles IV	Mexico	Viceroyalty of New Spain	Archaeological

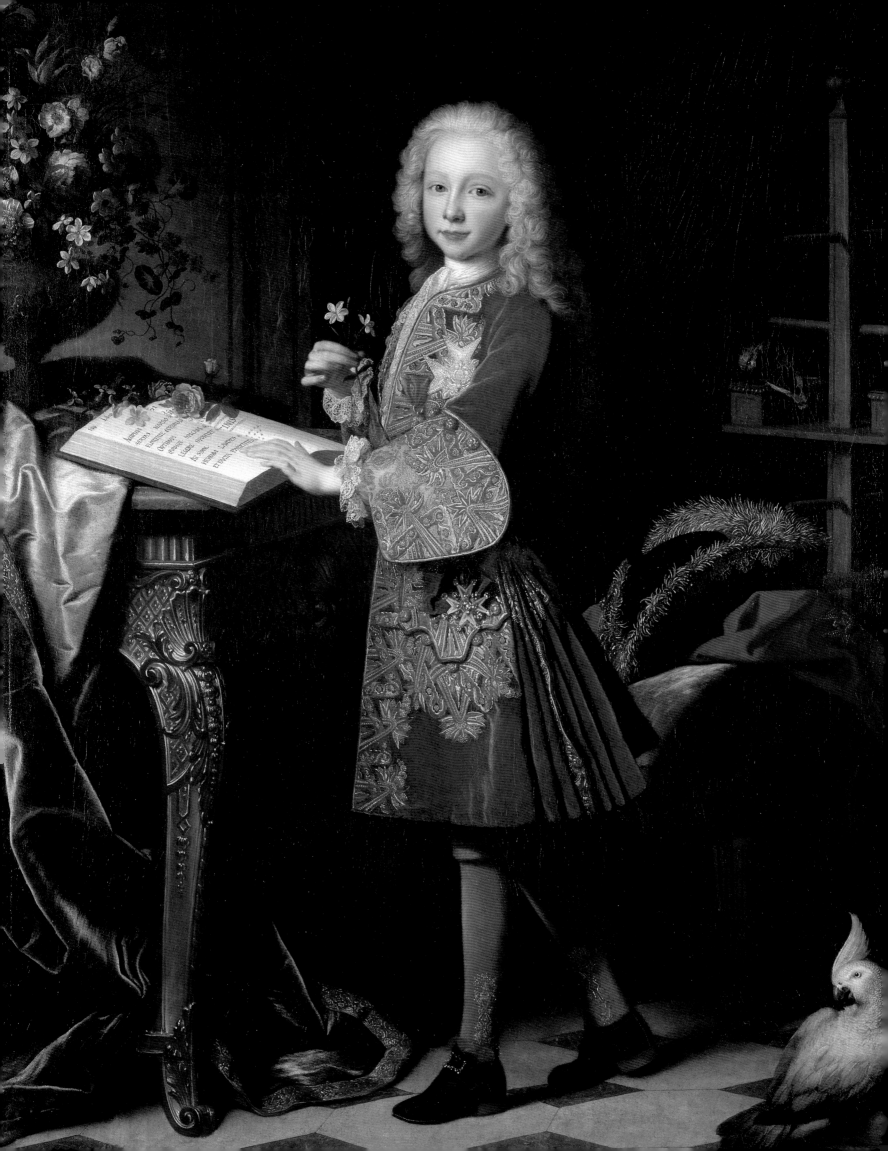

Spaces of Enlightenment
Art, Science, and Empire in Eighteenth-Century Spain

CARLUS III REX

NATURAM ET ARTEM SUB UNO TECTO

IN PUBLICAM VTILITATEM CONSOCIAVIT

ANNO MDCCLXXIV

THIS LATIN TEXT—"King Charles III / united nature and art under one roof / for the public good / in the year 1774"—is still visible today, more than two centuries later, engraved above the neo-classical entryway to the Royal Academy of Fine Arts of San Fernando in Madrid (fig. 33). In linking nature and art, the inscription alludes to the cohabitation of the Royal Cabinet of Natural History and the Royal Academy of Fine Arts in a palace purchased by the crown and renovated for their use in the early 1770s. Although the presence of these two institutions under one roof was largely a matter of fiscal expediency, the joining of the arts and sciences under royal patronage is symptomatic of the ideals of the Spanish Enlightenment and closely linked to the Spanish imperial project in the eighteenth century.

Representations of the monarch during the second half of the eighteenth century indicate the emphasis placed on uniting the arts and sciences. One such example is the large-scale allegory *Ferdinand VI as Protector of the Arts and Sciences* (fig. 34), painted in 1754 by Antonio González Ruiz (1711–1788), founding director of painting in the fledgling Royal Academy of Fine Arts. This canvas, which hangs above the dais in the main assembly room of the academy, includes a putto holding a plan of the academy's first premises in the Plaza Mayor, from which it moved into the present building in the early 1770s. Ferdinand VI (r. 1746–59) created, by royal decree, both the Royal Academy of Fine Arts and the Royal Cabinet of Natural History in 1752. Indeed, although the reign of Ferdinand's brother and successor, Charles III (1759–88), usually is cast as the age of Enlightenment in Spain, many of the projects that came to fruition during the latter's reign were begun earlier.

Unsurprisingly, representations of Charles III also employ the iconography of art and science, as in the elaborate table clock created by the French clockmakers Pierre and Philippe Charost (pl. 90). Executed in gilded bronze in 1771, this clock combines allusions to the arts and sciences with a medallion portrait of the king in profile. Furthermore, the royal habit of collecting clocks is itself a manifestation of official interest in uniting the arts and sciences, since eighteenth-century clocks are both precise mechanical instruments and lavishly embellished visual objects. More broadly, the flourishing of the decorative arts during the eighteenth century, which witnessed

PLATE 89

JEAN RANC (1674–1735)
Charles III as a Child

c. 1725
Oil on canvas, 55⅞ × 45¼ in.
(142 × 115 cm)
© Museo Nacional del Prado, Madrid
(2334)

Fig. 33 Entrance of the Royal Academy
of Fine Arts of San Fernando, Madrid.
© Museo de la Real Academia de Bellas
Artes de San Fernando, Madrid

Fig. 34 Antonio González Ruiz
(1711–1788), *Ferdinand VI as Protector
of the Arts and Sciences*, 1754. Oil on
canvas, 102⅜ × 88¹¹⁄₁₆ in. (260 × 225 cm).
© Museo de la Real Academia de Bellas
Artes de San Fernando, Madrid (683)

the creation of royal factories for the production of crystal, tapestries, and porcelain, reflects this same trend.

Thus, more than just a matter of coincidence, the interrelated histories of the Royal Academy of Fine Arts and the Royal Cabinet of Natural History have much to tell us about the cultural politics of Bourbon Spain, and about the themes of the present exhibition as they unfolded during the course of the eighteenth century. In this essay, I wish to consider the ways in which the visual arts were aligned with the natural sciences as servants of the Enlightenment and, more particularly, to examine how these two fields of endeavor were mobilized to fulfill the ends of Spanish imperial ambition during the years that the overseas empire reached its greatest extent, before beginning to crumble around 1820. As we shall see, the boundary between art and science in the eighteenth century was much less firmly drawn or policed than we might expect, and the practitioners of these disciplines employed overlapping, distinct, and sometimes antithetical means in the service of Enlightenment and empire.

To examine these issues, I first map some of the landmarks and boundaries of the Spanish Enlightenment, and I analyze Goya's portrait of the count of Floridablanca in order to begin charting the interrelation between art, science, and Enlightenment. I then explore some of the key spaces in which notions of Enlightenment and empire in Spain were produced, and reproduced, by visual images of art and science. Some of the topics I investigate are spaces in the sense of actual institutions and physical structures, such as the Royal Academy of Fine Arts, the Royal Cabinet of Natural History, and the new Royal Palace in Madrid. Others, such as eighteenth-century aesthetics and scientific methods, are spaces in the discursive sense: that is, bodies of knowledge and inquiry that both shape and reproduce the ideologies of Enlightenment and empire.

PLATE 90

PIERRE AND PHILIPPE CHAROST (ACT. AT SPANISH COURT C. 1765–1800)
Table clock with allegory of arts and sciences and portrait of Charles III

1771
Gilt bronze, 22¹/₁₆ × 11 × 7½ in. (56 × 28 × 19 cm)
© Patrimonio Nacional, Palacio Real, Madrid (10002079)

ENLIGHTENMENT, SCIENCE, AND ART

The Enlightenment in Spain is best characterized as a series of efforts to solve practical problems in fields such as fiscal policy and education by conceiving and implementing reforms based on rational principles.[1] As such, the Spanish Enlightenment was not a wholesale adoption of ideas circulating in France and Britain but a selective translation and elaboration of those concepts that fit best with the distinctive political, economic, and cultural circumstances in Spain—and an active suppression of concepts irreconcilable with Spanish conditions. In particular, the Catholic church and the monarchy had continued importance in eighteenth-century Spain, long after those institutions had been challenged and weakened elsewhere. Thus, some of the more far-reaching and philosophically speculative aspects of the European Enlightenment—ones that led to a re-thinking of the nature and place of the human person on individual, social, and cosmic scales—tended to be filtered out. This filtering was conducted with royal sanction through the activities of the Holy Office of the Inquisition, which continued to operate in Spain during this period. The Inquisition placed on its index of banned books many of the key texts of the European Enlighten-ment, including the *Encyclopédie* edited by Diderot and d'Alembert, and the complete writings of Voltaire and Rousseau.[2] French ideas became especially suspect in the years following the out-break of the revolution in 1789, which led to the execution in 1793 of Charles III's French relative Louis XVI. In spite of such impediments, however, even the most radical developments of the Enlightenment became accessible to certain (elite) members of the Spanish reading public during the second half of the eighteenth century, and particularly during its final quarter. Channels of dissemination included foreign travel and education, licenses that permitted the reading of pro-scribed books, the clandestine trade of prohibited texts, multivolume works that presented these ideas in résumé form, the flourishing of the periodical press, and translations of texts not banned by the Inquisition.[3]

Thus, by and large, pragmatic reform lay at the heart of the Spanish Enlightenment rather than an all-encompassing interrogation of traditional notions of the human person, the state, and the cosmos. Such reform tended to follow the principles of mercantilism that had been developed and exploited so effectively under Louis XIV of France by his first minister, Colbert. In the broad-est sense, the hoped-for goal of enlightened reform was a revival of Spanish imperial fortunes after the long period of decline during the final decades of the Habsburg dynasty, which came to an end in 1700 with the death of Charles II (r. 1665–1700) and the ascension to the throne of Philip of Anjou, grandson of Louis XIV and the first Spanish Bourbon monarch (r. 1700–46). The Treaty of Utrecht (1713), which brought to an end the War of Spanish Succession and legitimized the Bourbon regime in Spain, also marked the end of Spain's European empire. The eighteenth century, and particularly the years after 1750, have been described as the "Reconquest of the Americas," as the Spanish crown sought to firm up control over its New World colonies in the face of the imperial dreams of its European rivals, particularly Great Britain.[4] Both scientific and artistic projects led to the production of visual images that served these ends.

Turning first to science, the emergence of the empirical method as the basis of scientific inquiry was one of the paradigm shifts that signaled the onset of the European Enlightenment. Empiricism became known to the Spanish reading public during the second third of the eigh-teenth century through the writings of the Benedictine monk Fray Benito Jerónimo Feijoo (1676–1764), a professor of theology at the University of Oviedo. In two widely read collections of essays, *Teatro crítico universal* (9 vols., 1726–39) and *Cartas eruditas y curiosas* (5 vols., 1742–60), Feijoo summarized and analyzed the writings of such crucial figures in the development of the

empirical worldview as Francis Bacon and Isaac Newton. Typical of Spanish adherents to the principles of the Enlightenment, Feijoo saw science as compatible with faith. Such was the popularity of his texts that Ferdinand VI issued a royal order prohibiting criticism of Feijoo's ideas.

During the second half of the eighteenth century, Spaniards began to gain firsthand access to some of the seminal scientific texts of the age, such as the writings of the Frenchman Georges-Louis Leclerc, count of Buffon (1707–1788), and the Swede Carl Linnaeus (1707–1778), and adopted these ideas for their own ends.[5] After midcentury, much of the energy of Spanish science was directed toward fulfilling imperial ambition, as evidenced most overtly by scientific voyages to the New World, often sponsored by the Royal Cabinet of Natural History. In the most general sense, such expeditions served the military mandate of knowing what one had and protecting it, and the economic one of figuring out how best to exploit it. Draftsmen, often specialists in perspective or botanical illustration, were important participants in these expeditions.

Art furthered the aims of Enlightenment and empire in a variety of ways, some more obvious and some more subtle than those of science. In keeping with the pragmatic spirit of the Enlightenment, visual culture was valued above all for its usefulness. Architecture (as the most practical of the fine arts) and printmaking (by virtue of its ability to reproduce and disseminate visual knowledge necessary to science and industry) conformed nicely to the aims of the Spanish Enlightenment. In this cultural climate, the painting and sculpture that found official favor tended to serve didactic purposes by representing significant human action as a moral exemplar, or *exemplum virtutis,* in the terminology of the day. Thus, "history" painting was elevated to the preferred genre (as was generally true in Europe during this period), and models for its production were the arts of Renaissance Italy and classical antiquity. Examples of art in the service of empire include the sculptures and frescoes created to decorate the new Royal Palace in Madrid as well as the many embellishments made to the urban fabric of the capital, which were motivated by the desire to create a metropolis worthy of the vast empire under its control.

The portrait of the count of Floridablanca painted in 1783 by Francisco Goya (1746–1828) presents in visual form the central characteristics of the Spanish Enlightenment and provides insight into the interrelation between art and science during this period (pl. 91).[6] The sitter, José Moñino y Redondo (1728–1808), began his career as a lawyer and judge before serving as Spanish ambassador to Rome. In 1777 Floridablanca became prime minister under Charles III, a position he occupied until court intrigue led to his fall in 1792. As prime minister, Floridablanca was one of the leading proponents of the pragmatic reforms that lay at the heart of the Enlightenment in Spain. Furthermore, he served as protector of the Royal Academy of Fine Arts and actively promoted the activities of the Royal Cabinet of Natural History.

The commanding presence of Floridablanca in Goya's portrait is emblematic of the centralist approach taken in Spain's pursuit of enlightened reform; the Spanish Bourbons consciously borrowed this administrative style from their French relations. In Goya's painting, Charles III is present in the form of the portrait hanging in the background. The monarch gazes down benevolently on his prime minister, while the chromatic similarities of their respective costumes reinforce Floridablanca's role as the king's surrogate. These visual links between Charles and Floridablanca map a rational and effective political order in which reform occurs under the watchful eye and active direction of the prime minister and within the institutional structure of enlightened despotism.

Goya included his own likeness in the figure at the left presenting a painting to the count, who seems to have been scrutinizing it with the quizzing glass poised in his right hand. Goya looks attentively at Floridablanca, suggesting his eagerness for the approval of a man who could

substantially boost his chances of receiving lucrative court patronage at a time when the artist was just beginning his rise to prominence. Behind the count, a figure identified as the military engineer Julián Sánchez Bort looks up from diagrams that spill over his desk.[7] Legible inscriptions indicate that the drawings are plans for the Aragon canal, an important effort to improve infrastructure in which Floridablanca took a keen interest and which Bort oversaw. These plans and the canvas Goya holds provide attributes for the count's role as both protector of the Royal Academy of Fine Arts and advocate for enlightened economic reform and infrastructure projects based on scientific principles. This duality is underscored by the presence of Antonio Palomino's seminal treatise on painting, *Práctica de la pintura,* at Floridablanca's feet.[8] The plans for the canal and the painting held by Goya construct an image of Floridablanca that communicates his equal fluency with scientific and artistic codes of visual representation.

Goya's portrait of Floridablanca reinforces that the history of the Enlightenment in Spain is in large measure an institutional one. Institutional reform occurred on many levels, from the streamlining of the royal administration into five ministries in emulation of the highly rationalized and centralized bureaucracy put in place by Louis XIV of France in the seventeenth century, to the formation and spread of *Sociedades de Amigos del País* (Societies of Friends of the Nation), civic organizations composed of members of the nobility and middle classes that encouraged efforts at economic reform, broadly defined.[9] Among other activities, the *Sociedades de Amigos del País* promoted the establishment of drawing schools in the provincial capitals during the final quarter of the century in an attempt to improve the quality of Spanish manufacturing.[10] Moreover, a series of learned societies were created by royal decree during the eighteenth century, including the Royal Academy of the Spanish Language (1712) and the Royal Academy of History (1738), and, most significantly in the present context, the Royal Academy of Fine Arts of San Fernando.

THE ROYAL ACADEMY OF FINE ARTS OF SAN FERNANDO

The Royal Academy of Fine Arts was the most important artistic institution during the second half of the eighteenth century. It was officially founded in 1752, following the work of a preparatory committee that had been formed in 1744.[11] Through its primary activity—providing training in the disciplines of architecture, sculpture, painting, and printmaking—the academy promoted aesthetic principles that both intersected with and deviated from those underlying other kinds of visual representations, including those serving science and industry during this period. As we shall see, these academic principles were also deployed in the service of empire.

A fitting place to begin examining academic attitudes toward art is with the writings of Anton Raphael Mengs (1728–1779), first court painter to Charles III from 1761 until the artist's death. A native of Bohemia, Mengs had made his reputation in Italy, where he worked briefly for the future Charles III at the end of the latter's reign as king of Naples (1734–59). After arriving in Madrid in 1761, Mengs painted frescoes in the new royal palace (more on these shortly), executed religious works, and established an important portrait practice. A splendid example of his portraiture is a pair of paintings depicting the prince and princess of Asturias, the future King Charles IV (r. 1788–1808; fig. 35) and Queen María Luisa. These three-quarter-length portraits, executed around the time of the sitters' marriage in 1765, established a prototype for out-of-door aristocratic portraiture that patrons and painters (including Goya) would emulate in the ensuing decades.

Mengs's contentious relationship with the Royal Academy of Fine Arts is well documented.[12] Nonetheless, the neoclassical principles outlined in his writings and embodied in his paintings exerted a powerful influence over the academy, particularly in the years following his death in 1779.

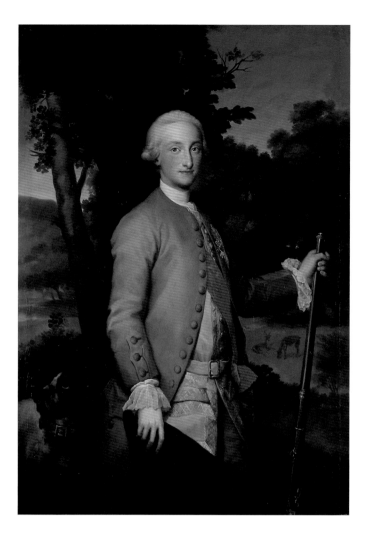

In 1781 Gaspar Melchor de Jovellanos (1744–1811), a leading *ilustrado* (promoter of the Enlightenment) and adviser to the academy, described Mengs's writings as "the catechism of good taste and the code of practitioners and lovers of the arts" and alluded to "the shadow of Mengs, the son of Apollo and Minerva, the philosopher-painter, the master, the benefactor, and the legislator of the arts."[13] Mengs's influence on young Spanish artists is seen most strongly in the work of Francisco Bayeu (1734–1795) and Mariano Salvador Maella (1739–1819), who became leading painters at court and in the academy during the final decades of the eighteenth century. So close at times were the respective artistic styles of Mengs and Maella that the latter's portrait of Charles III in the robes of his order was long considered to be by Mengs (see pl. 50).

Mengs believed, above all, that the production of visual art should be founded on rules that could be discovered and applied. As he states in a discourse outlining the general principles of an academy of the fine arts,

> The fine Arts, as liberal arts, have fixed rules, based on reason and experience, through which they attain their objective: the perfect imitation of nature. From this, it can be inferred that an entity devoted to the cultivation of these arts must not be limited to mere execution; rather, it should be mainly concerned with the theory

Fig. 35 Anton Raphael Mengs (1728–1779), *Charles IV, Prince of Asturias*, 1765. Oil on canvas, 59¹³⁄₁₆ × 43⁵⁄₁₆ in. (152 × 110 cm). © Museo Nacional del Prado, Madrid (2188)

and speculation of the rules because, although the arts ultimately end in a manual operation, if not guided by a good theory, they will be demoted, losing their designation as liberal arts in order to become purely mechanical.[14]

The rules of art, as they were conceived in neoclassical doctrine all across Europe during this period, were founded on three auxiliary sciences: mathematics, perspective, and anatomy. In 1763 the director of the academy, the sculptor Felipe de Castro, called for the creation of a chair in each of these disciplines, a move that Mengs influenced.[15] Since constraints of space prevent an examination of how each of these disciplines was a cornerstone for the practice of visual art at this time, I will focus briefly on mathematics.

Beginning with Newton and Leibniz at the turn of the eighteenth century, mathematics occupied an important place in Enlightenment culture, particularly in the development of the scientific method. In visual art, mathematics—and particularly geometry—had been enshrined in the early Renaissance as the foundation of the art of painting by Leon Battista Alberti, who devoted Book One of his treatise *On Painting* (1435) to this topic.[16] Castro's call for the creation of a chair in mathematics was answered in 1768 with the appointment of the leading mathematician of the day, Benito Bails, as director of the academy's *Sección de Matemáticas*. In keeping with the pragmatic spirit of the Enlightenment in Spain, Bails championed the practical application of mathematics. In 1772 the academy commissioned him to write a mathematics book for its students, the three-volume *Principios de matemáticas* (1776), an outline of Euclidian geometry for which Bails drew on his wide-ranging, ten-volume *Elementos de matemáticas* (completed in 1783).

Mathematics laid the groundwork for the artistic education offered by the academy, with students beginning their training by studying geometric forms. After mastering these principles, aspiring artists moved on to make drawings based on prints of canonical paintings and plaster casts of ancient and Renaissance sculpture before, finally, being allowed to work from live models. This highly rationalized course of study positioned drawing as the foundation of the visual arts and emphasized not innate talent or genius but mastery of a set of fixed principles and their careful application.

Grounding artistic training in the study of mathematics, perspective, and anatomy would seem to encourage the exact imitation of nature. Central to academic notions of art, however, was the concept of selective imitation, according to which the artist chose and combined the most "perfect" aspects of nature into an ideal beauty, as had been done by the artists of classical antiquity. As Mengs claimed: "If a picture contains the most beautiful parts of nature, and each one shows the truth within it, it will be a work of good taste."[17] In his oration at the 1787 prize-giving ceremony of the academy, the duke of Almodóvar invoked "the superior talent and singular merit of the immortal Mengs" in stating that the goal of aspiring artists must be "the perfect imitation of the most carefully chosen nature."[18] The previous year Diego Rejón de Silva, a court official and adviser to the academy, made the same point in a note to his didactic poem *La pintura:* "It is evident that the painter must imitate beautiful nature, choosing the best of it, and this is precisely what is found in antique statues."[19]

As noted earlier, the artistic subjects promoted by academic discourse—both in Spain and elsewhere—were ones that presented significant human endeavors. Students received training in visualizing such images in the competitions organized by the Royal Academy of Fine Arts, which repeatedly asked entrants to create works that portrayed subjects drawn from the classical past as well as from illustrious moments in Spanish history. But unlike their French contemporaries, who enjoyed substantial official patronage for history painting, Spanish artists had few opportunities for depicting such themes, aside from the substantial demand for religious painting.[20] The frescoes painted during the second half of the eighteenth century on the ceilings of the new Royal Palace in Madrid were a notable exception.

THE NEW ROYAL PALACE IN MADRID

Without question, the design, construction, and decoration of the new palace was the single most important artistic undertaking in eighteenth-century Spain (fig. 36).[21] This imposing structure was built to replace the Alcázar, a ninth-century Islamic fortress that had been the residence of Spanish kings since the fourteenth century and was modified over the centuries in keeping with shifting tastes. (The Alcázar is visible in the background of Michel-Ange Houasse's *View of Madrid with Bird Seller,* painted in the first quarter of the eighteenth century, pl. 92.) A devastating fire on Christmas Eve 1734 necessitated the construction of the new palace, planning for which commenced in early 1735. Begun during the reign of Philip V, continued under Ferdinand VI, substantially completed by Charles III (who was the first to occupy it in 1764), and altered in significant ways by Charles IV and Ferdinand VII (r. 1814–33), the new royal palace links together the eighteenth- and early-nineteenth-century Spanish Bourbon monarchs.

The project employed the most important architects, sculptors, and painters working in Spain during the second two-thirds of the eighteenth century, with the notable exception of Goya. Moreover, many of the architects and sculptors involved during the 1730s and 1740s were important figures in the founding of the academy. The collective charge governing the design and

Fig. 36 The Royal Palace, Madrid.
© Patrimonio Nacional, Madrid

decoration of the palace—sometimes stated explicitly but always implied—was to forge a metaphor for the legitimacy of the Bourbon dynasty in Spain. To this end, the Benedictine monk Fray Martín Sarmiento (1695–1772) conceived an elaborate decorative program entitled "System of Adornment for the New Royal Palace."[22] One aspect of this plan was a series of statues of Spanish kings to decorate the exterior. These were subsequently removed shortly after Charles III ascended to the throne in 1759 and instituted a more severe, unornamented classicism as the style of his court.[23]

By 1753 construction on the palace had progressed far enough that work on the ceiling frescoes could begin. The Neapolitan painter Corrado Giaquinto (1703–1766), who was called to Madrid in 1753 and named first court painter, supervised the execution of the first major pieces.[24] Assisted by Spaniards who had studied with him in Rome, Giaquinto frescoed the ceilings of the main staircase (later modified under Charles III) and the chapel. In the early 1760s, officials summoned to Madrid the two greatest court painters of the age, Anton Raphael Mengs and Giovanni Battista Tiepolo (1696–1770), to undertake frescoes in the principal ceremonial rooms. These three artists —Giaquinto, Mengs, and Tiepolo—exercised a decisive influence over the Spanish artists such as Antonio González Velázquez (1723–1794), Francisco Bayeu, and Mariano Salvador Maella who subsequently executed major frescoes in the palace. These painters, in turn, were central figures in the general shift from foreign to native artists at court and in the academy during the second half of the eighteenth century.

In contrast to the elaborate decorative program devised by Fray Sarmiento, the ceiling decorations followed no overarching program. Nonetheless, taken as a whole, they use the language of mythology, allegory, religion, and history to represent the Spanish monarchy as the inheritor of the classical tradition, as well as the protector and promulgator of the Catholic faith.[25] Thus, the Bourbon dynasty becomes the rightful heir of a domain that extends infinitely in time and space, thereby justifying Spanish dominion over the four corners of the world as inevitable and preordained.

Several of the royal palace frescoes refer directly to imperial ambitions and achievements, including Tiepolo's *Wealth and Benefits of the Spanish Monarchy under Charles III* (pl. 93; fig. 37), painted between 1762 and 1764 on the ceiling of the Throne Room.[26] A host of allegorical figures in this work give visual form to the virtues of the Spanish monarchy, while figures around the cornice personify the Spanish provinces and regions of the world under Spanish control. This room was the symbolic center of the palace, and Tiepolo's fresco locates it as the hub of the empire, with various Spanish possessions visible from the throne and many of the figures looking in that direction. A most interesting aspect of this intricate ensemble is a section along the cornice directly across from the throne which features Columbus, Neptune, and a personification of America (fig. 38). In imaging the figure personifying America (and the two others who accompany her), Tiepolo relied on well-established allegorical conventions—dark skin, a feather headdress

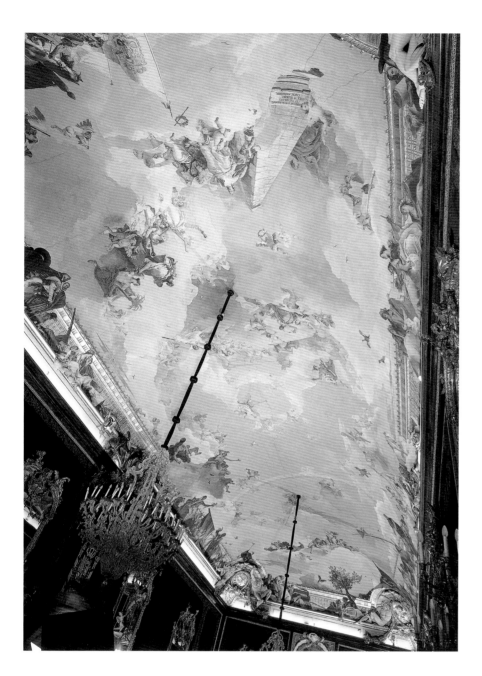

Fig. 37 View of the Throne Room
in the Royal Palace, showing *Wealth
and Benefits of the Spanish Monarchy
under Charles III* (1762–64) by Gio-
vanni Battista Tiepolo (1696–1770).
© Patrimonio Nacional, Madrid

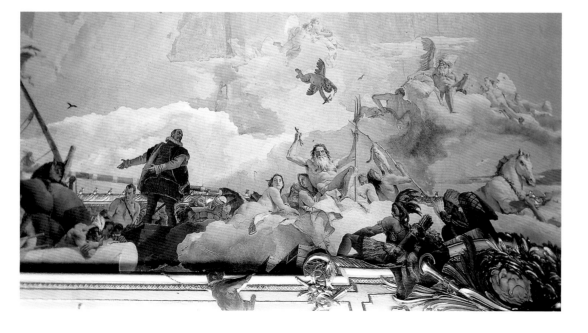

Fig. 38 Detail of *Wealth and
Benefits of the Spanish Monarchy
under Charles III,* showing
Columbus, Neptune, and America.
© Patrimonio Nacional, Madrid

and skirt, gold medallions, and an alligator-like animal (only its tail is visible)—that had been codified in illustrated emblem manuals such as Cesare Ripa's *Iconologia* (1603). The artist had portrayed America in a similar manner in the ceiling depicting Apollo and the Four Continents, painted in the early 1750s in the palace of Prince-Bishop Carl Philipp von Greiffenclau at Würzburg. But because Spain controlled large swaths of the New World, and trade with these colonies was crucial to the revitalization of its fortunes as a European power, the representation of America takes on a very particular meaning in the royal palace in Madrid.

Seated above America and her companions is the classical god of the sea, Neptune, instantly identifiable by his trident. America and Neptune are woven into a tight, pyramidal composition with a putto at its apex, thereby joining together classical mythology and baroque allegory. America looks over her shoulder in the direction of the king, as if only recently aware of his presence. Neptune's upper body is shown frontally, and he stares down full-face, suggesting a deep connection between classical god and Christian king. Within this framework, Spain's commercial interests are cloaked in a visual rhetoric that constructs imperial conquest as preordained by a cosmic order.

Another aspect of America's ideological importance is her place in the creation myth of Spain's overseas empire. Thus, as one would expect, Columbus is present here as well, appearing just to the left of the pyramid containing Neptune and America. Columbus is separated from them by a rainbow, a clear symbol of the importance of his voyages for Spanish imperial fortunes and, more particularly, for their renewal under Charles III. The Genovese explorer stands in a commanding pose and gestures toward a ship laden with exotic creatures and inhabitants of the New World, as if presenting them to the king. Drawn respectively from history, mythology, and allegory, the three figures of Columbus, Neptune, and America exemplify the complex layering of meaning found in the palace frescoes, mapping an image of empire that extends infinitely in time as well as space.

The same allegorical language underlies representations of the four continents that Francesco de Mura (1696–1782) painted in grisaille (pls. 94–97).[27] These works are replicas of overdoor decorations commissioned by Charles III during his tenure as king of Naples for the royal palace in that city. Charles presented this second set to his parents, Philip V and Isabel de Farnesio, to whom they were sent on September 23, 1738, with an explanatory note on their significance. The Spanish monarchs placed the paintings in the royal palace of La Granja de San Ildefonso, which was built near Segovia for Philip V as a reminder of his early years at Versailles. Some years later, in 1753, Mura was approached about coming to the court of Ferdinand VI to oversee the execution of frescoes in the new Royal Palace in Madrid. Unfortunately, the artist's wife seems to have resisted the idea of going to Spain, and Giaquinto was called to Madrid instead.

SPANISH SCIENCE AND THE ROYAL CABINET OF NATURAL HISTORY

The natural sciences in Spain during the eighteenth century also fostered visual representations of imperial ambition and achievement, but in a language quite distinct from the allegory of the triumphalist frescoes in the new royal palace. Although subject to different conventions and designed to meet different purposes than artistic representations, scientific imagery was also created under royal sponsorship and was no less ideologically motivated than the palace decorations. Before examining the relationship between empire and visual culture in the service of science, a few general observations regarding science, Enlightenment, and empire are in order.

PLATE 94

FRANCESCO DE MURA (1696–1782)
Allegory of Europe

Dated 1738
Oil on canvas, 14¾ × 26⁹⁄₁₆ in. (37.5 × 67.5 cm)
© Patrimonio Nacional, Palacio Real de la Granja de San Ildefonso,
Segovia (10026493)

PLATE 95

FRANCESCO DE MURA (1696–1782)
Allegory of America

Dated 1738
Oil on canvas, 14¾ × 26⁹⁄₁₆ in. (37.5 × 67.5 cm)
© Patrimonio Nacional, Palacio Real de la Granja de San Ildefonso,
Segovia (10026494)

PLATE 96

FRANCESCO DE MURA (1696–1782)

Allegory of Asia

Dated 1738

Oil on canvas, 14¾ × 26⁹⁄₁₆ in. (37.5 × 67.5 cm)

© Patrimonio Nacional, Palacio Real de la Granja de San Ildefonso,
Segovia (10026495)

PLATE 97

FRANCESCO DE MURA (1696–1782)

Allegory of Africa

Dated 1738

Oil on canvas, 14¾ × 26⁹⁄₁₆ in. (37.5 × 67.5 cm)

© Patrimonio Nacional, Palacio Real de la Granja de San Ildefonso,
Segovia (10026496)

Spanish interest in science during the second half of the eighteenth century was the product of the centralist approach to government that characterized the Enlightenment in Spain. Charles III and his prime minister, the count of Floridablanca, both took a keen interest in scientific advances. Charles had exhibited a curiosity about the natural world from an early age, as is suggested in *Charles III as a Child* (pl. 89). Painted by the French artist Jean Ranc (1674–1735), who was summoned to Madrid in 1722 and became the favored court portraitist of Charles's father, Philip V, this charming canvas shows the future king surrounded by exotic birds and plants as he confidently returns the viewer's gaze. The lavishness of the costume and setting marks the dramatic shift that took place with the establishment of the Bourbon dynasty in Spain, as the court moved away from the austerity that had marked the period of Habsburg rule (see also pl. 98). Throughout his life Charles maintained a fascination with the natural world, as manifested by his passion for hunting and his keen interest in the elephants he kept at his zoo on the grounds of the royal palace at Aranjuez.

Of the natural sciences, it was botany above all that flourished under royal patronage. It was the least problematic discipline in terms of its theological implications, and it offered clear utility, since its advances were directly applicable to medicine. The Royal Botanical Garden, founded in 1755 during the reign of Ferdinand VI, provided the institutional framework for botanical inquiry. Under Charles III, the Royal Botanical Garden was relocated to its present location on the Paseo del Prado and transformed into one of the key institutions of enlightened investigation in Spain. Luis Paret's unfinished painting *The Royal Botanical Garden from the Paseo del Prado* (fig. 39) shows the entrance commissioned from Juan de Villanueva in 1781, as well as the fashionable types who frequented the recently renovated paseo. The French traveler Jean-François Bourgoing noted the pleasures the Royal Botanical Garden offered: "Anyone may easily obtain leave to spend a few hours here, and even those who have no taste for botany will find it a most delightful retreat, overshadowed with trees and abounding with plants from all the quarters of the globe. The productions of the vegetable kingdom are arranged in squares conforming to the methods of Linnaeus."[28] Thus, in addition to offering a pleasant, verdant oasis, the garden functioned as a representation of empire in miniature, gathering and organizing in the metropolis specimens

Fig. 39 Luis Paret (1746–1799), *The Royal Botanical Garden from the Paseo del Prado*, c. 1790. Oil on canvas, 22¹³⁄₁₆ × 34⅝ in. (58 × 88 cm). © Museo Nacional del Prado, Madrid (7661)

PLATE 98

MICHEL-ANGE HOUASSE (1680–1730)

Musical Evening

Early 18th century

Oil on canvas, 21⅛ × 25³⁄₁₆ in. (53.6 × 64 cm)

© Patrimonio Nacional, Palacio Real de la Granja de San Ildefonso, Segovia (10024190)

Fig. 40 *Scleria secans.* Royal Botanical Expedition to the Viceroyalty of New Granada (1783–1810), under José Celestino Mutis. Tempera on paper, 21¼ × 14⅞ in. (54 × 37.8 cm). © Archivo del Real Jardín Botánico, Madrid, CSIC (Div. III, 187)

found throughout the colonies and ordered according to the dictates of the latest European scientific methods of classification.

Botany and empire also were intertwined through the extensive botanical expeditions to Spanish America. Conducted under royal patronage beginning in the late 1770s, these included expeditions to Chile and Peru in 1777–88 under Hipólito Ruiz and José Pavón, to New Granada in 1783–1810 under José Celestino Mutis, and to New Spain in 1788–1803 under Martín de Sessé. The last of these was intended to complete work begun in 1570 by Francisco Hernández for Philip II. Indeed, it was not until the end of the eighteenth century that the studies of Hernández finally were published. The expedition to New Granada is particularly noteworthy for the exhaustiveness and beauty of its visual archive of the native flora found in that viceroyalty (fig. 40). Led by José Celestino Mutis (1732–1808), who had gone to Santa Fe de Bogotá in 1760 as physician to the viceroy of New Granada, this expedition, like others of its kind, was motivated by a search for medically useful plants.[29]

It was a scientific explorer from earlier in the century, Antonio de Ulloa (1716–1795), who proposed in 1752 that Ferdinand VI create a centralized institution dedicated to scientific inquiry. (Navigational instruments used by Ulloa on his 1735–44 expedition to Ecuador are illustrated as pls. 99, 100.) Although founded in the early 1750s with Ulloa as its first director, the Royal Cabinet of Natural History languished in obscurity until 1771, when the Spanish crown agreed (after hesitating several times) to purchase the collection of Pedro Franco Dávila (1711–1786).[30] A Peruvian who had spent several decades in Paris, Dávila had amassed one of the finest collections of objects relating to natural history in all of Europe. Typical of such collections, Dávila's included not only specimens from the natural world but also bronzes, terracotta vases, medals, miniatures, and paintings.

As part of the agreement to purchase his collection, Dávila became director of the Royal Cabinet of Natural History. It was at this time that the cabinet and the Royal Academy of Fine Arts moved into the palace renovated for them by the crown. The Royal Cabinet of Natural History opened to the public in November 1776, and initial interest was so great that Dávila requested military guards to control the crowds. Following current methods of scientific classification, the organization of the nine rooms of exhibits was based on the division of the natural world into the mineral, vegetable, and animal kingdoms.[31]

By the end of the century, the Royal Cabinet of Natural History was one of the best of its kind, its growth due in large measure to the active interest the count of Floridablanca took in its fortunes. The cabinet featured objects obtained by donation and purchase as well as by exchange with similar collections in other European cities. In addition, Charles III issued a decree instructing officials in Spanish America to send to Madrid curiosities of natural history found in their territories. In April 1776, the marquis of Grimaldi, prime minister before Floridablanca, announced to Spanish colonial officials the king's *Instrucción para aumentar las colecciones del Real Gabinete de Historia Natural:*

> The King has established in Madrid a Natural History Cabinet in which are collected not only the animals, plants, minerals, rare rocks, and all that nature produces in the vast

PLATES 99, 100

SPENCER BROWNING & CO.

Octant owned by Antonio de Ulloa

> London, c. 1734
> Wood, brass, ivory, crystal, radius 8¹⁄₁₆ in. (20.5 cm)
> © Museo Naval, Madrid (I-1333)

GEMICHON

Telescope owned by Antonio de Ulloa

> Paris, 18th century
> Brass, leather, crystal, 32⅞ × 3⅛ in. (83.5 × 8 cm)
> © Museo Naval, Madrid (I-1292)

In the eighteenth century, navigators relied on newly developed scientific instruments. The octant measured the altitude of celestial bodies with more precision than its precursor, the astrolabe. Both of these instruments were used by Antonio de Ulloa, the prominent scientist and explorer.

domains belonging to H. M., but also everything that can be acquired from the unknown territories. To complete and enrich the series and collections of the Royal Museum, it is important that those individuals in charge of the provinces and towns of the Spanish realms hereupon take care of gathering and remitting to the Natural History Cabinet all curious objects which may be found in the districts under their command.[32]

Thus, like the Royal Botanical Garden, the Royal Cabinet of Natural History presented an image of the empire in miniature, one that allowed the exotic richness of Spain's overseas holdings to be gathered, scrutinized, and ordered through the conventions of European science. Such epistemological strategies, in effect, removed these objects from time. As Susan Stewart phrases it in speaking of collections in general, "The collection seeks a form of self-enclosure which is possible because of its ahistoricism. The collection replaces history with *classification*, with order beyond the realm of temporality."[33]

In addition to housing objects sent back from the New World, the cabinet instigated royally sponsored scientific expeditions during the second half of the eighteenth century, such as one to Peru and Chile in 1795–1800 to study and collect minerals, fossils, and shells under the direction of the Germans Christian and Conrad Heuland, whose collection had been acquired recently. The cabinet also played an important role in the expedition around the Pacific commanded by Alessandro Malaspina between 1789 and 1794. The objects gathered during this voyage, including those collected in the Pacific Northwest, were deposited in the collection of the royal cabinet (pls. 83–86). The fact that these and other specimens were not uncrated until years later is emblematic of the gap that often existed between the ideals of the Spanish Enlightenment and the full realization of its ambitious program. (For a fuller discussion of the Malaspina expedition, see the essay by José de la Sota Ríus in this volume.) As was typical of such expeditions, Malaspina included on his staff several artists who created an invaluable visual record of the voyage (pls. 101, 102).[34] As we shall see shortly, two of the Malaspina sketches illuminate the interrelation between images made for science and those produced according to the dictates of art.

THE VISUAL CULTURE OF ENLIGHTENMENT SCIENCE

Images were crucial elements of scientific discourse during the eighteenth century, and the visual rhetoric of Enlightenment science is symptomatic of the general privileging of vision during this period.[35] To cite just one of countless examples, Jovellanos (who was quoted earlier in discussing the influence of Mengs) states:

> The limited custom of writing and reading on the (mechanical) arts makes it difficult to explain things in an intelligible manner; hence, the need to include illustrations. A thousand examples serve to demonstrate that a pure and simple dictionary of definitions, as well conceived as it may be, cannot forgo illustrations without falling into obscure and vague descriptions. . . . A glance at the object or its representation tells much more than a page of text.[36]

A picture, as the saying goes, is worth a thousand words.

Printmaking was valued during this period not for its potential as a creative outlet (Goya is the exception in this regard) but rather for its ability to exactly reproduce visual information. This promise of visual accuracy made it an important tool in furthering a wide range of Enlightenment endeavors. In the realm of art, beginning in the 1770s, at the behest of the count of Floridablanca,

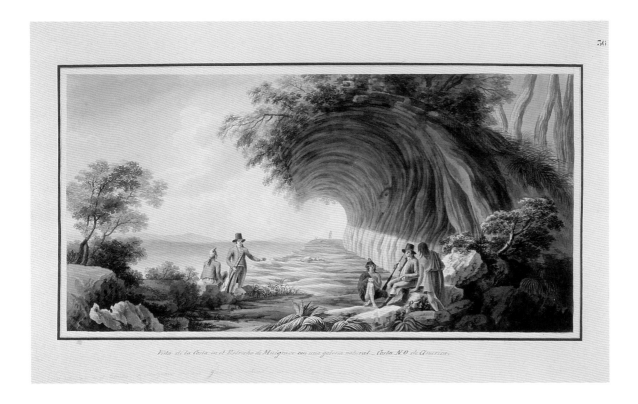

Vista de la Costa en el Estrecho de Mulgrave con una galería natural. Costa N O de América.

PLATE 101

FERNANDO BRAMBILA (1763–1834)
Natural Corridor on the Northwest Coast of America (Mulgrave Strait)

Malaspina Maritime Expedition, 1789–94
Finished drawing for engraving, 10¹⁄₁₆ × 19¹¹⁄₁₆ in. (25.5 × 50 cm)
© Museo de América, Madrid (2.273)

PLATE 102

JOSÉ CARDERO (1776–1811?)
View of Spanish Settlement at Port Nuñez Gaona (Neah Bay)

Malaspina Maritime Expedition, 1789–94
Watercolor and sepia ink on paper, 10¹³⁄₁₆ × 16¹⁵⁄₁₆ in. (27.5 × 43 cm)
© Museo de América, Madrid (2.269)

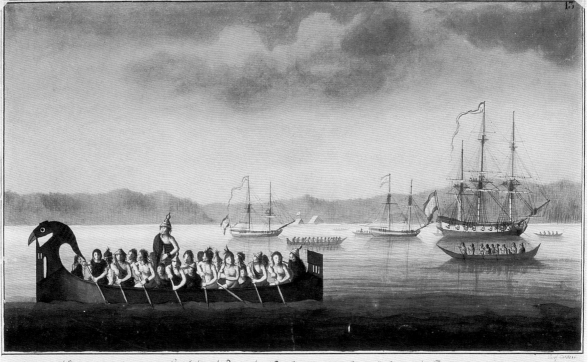

Vista del Estavlecimiento Español en el Puerto de Nuñez Gaona y gran Canoa de Guerra de Tetaku.

a series of projects employed printmaking as a way of publicizing to the rest of Europe the glories of the Spanish royal patrimony. Moreover, engravings illustrated scientific texts published by both the royal press and its private counterparts—such as the presses of Antonio Sancha, Joaquín Ibarra, and Benito Cano—on a wide variety of topics, including botany, agriculture, mathematics, astronomy, physics, hydraulics, and medicine. The benefits offered by printmaking to scientific inquiry were mentioned frequently in early discussions on the inclusion of this art form within the activities of the Royal Academy of Fine Arts.[37]

In addition to displaying objects in exhibits open to the public, the Royal Cabinet of Natural History sought to make its collections known through publishing activities. The central figure in this enterprise was Juan Bautista Bru de Ramón (1742–1799), the cabinet's painter and taxidermist for the better part of three decades.[38] Bru's training in the fine arts is particularly interesting in light of the narrative I have been tracing. He began his artistic education in his native Valencia before moving to Madrid and entering into the orbit of Mengs's disciple, Francisco Bayeu, an important figure at court and in the academy, and brother-in-law of Francisco Goya. Once in Madrid, Bru became a pupil in the Royal Academy of Fine Arts and dedicated himself above all to the study of anatomy, which became part of the academy's program in 1766, during the same period of reform that led to the institution of courses in mathematics and perspective. In the early 1770s, Bru began working as a taxidermist for the court and was the official painter and taxidermist to the Royal Cabinet of Natural History until his death in 1799. In 1795 Bru was made a member of the Royal Academy of Fine Arts as an anatomical painter.

Bru's most important enterprises were two books based on the holdings of the Royal Cabinet of Natural History. The first of these was the two-volume *Colección de laminas que representan los animales y monstruos del Real Gabinete de Historia Natural de Madrid,* published in 1784–86 (fig. 41).[39] Dedicated to the count of Floridablanca, this was the first scientific publication sponsored by the royal cabinet. It consists of a series of colored engravings depicting exhibits in the cabinet, with a few pages of description accompanying each plate. In the unpaginated prologue to the first volume, Bru outlined some of the principles governing the illustration program for the book. He limited himself to animals in the Royal Cabinet of Natural History, which he has in each case "faithfully copied from the original the colors, size, and dimensions so that the reader will be able to recognize it and measure it using the scale that each plate contains." He continues:

> I can truthfully say that my plates are exact because I do not put in them anything other than what I have seen, and that this care can contribute to a greater instruction that will leave a deeper impression, when confronted with the various descriptions, than is the case with most of the authors of antiquity, who only wrote of what they had heard.

Moreover, Bru noted that in regard to strange animals, he has "taken the utmost care to describe exactly their external form. But with common ones I have followed another method, and therefore they will be observed to be more succinct." Thus, Bru described his method as being as exact as possible in representing exceptional phenomena, whereas more common animals are depicted with a selective imitation that recalls the mimetic principles favored by the aesthetic theorists of the Royal Academy of Fine Arts.

A few years later Bru worked on one of the most interesting specimens sent from Spanish America to the royal cabinet: the fossilized skeleton of a *Megatherium americanum* (ground sloth). The remains of this bearlike animal, which lived during the Pleistocene era, were found in 1787 on the banks of the Luján River in Argentina by a local priest, who sent word of his discovery to

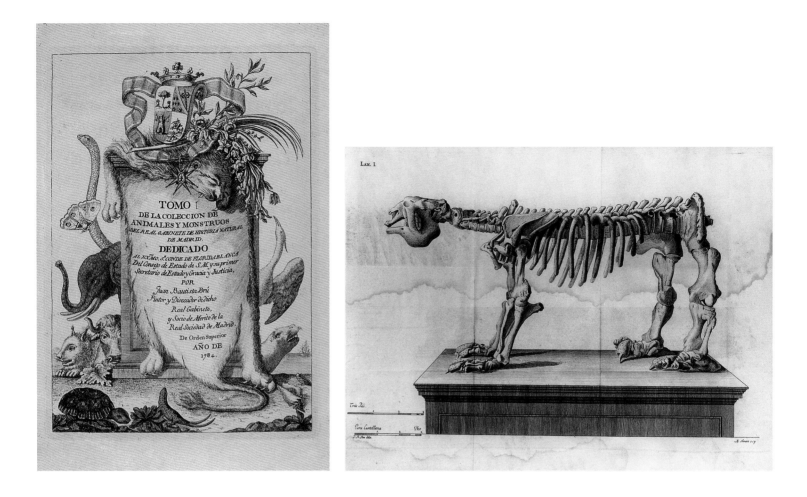

the viceroy of Río de la Plata, the marquis of Loreto.[40] In 1788 (in keeping with Charles III's in-
structions to his colonial agents) the bones were sent to the royal cabinet in Madrid, where Bru
assembled and drew them the following year in what constituted the first reconstruction anywhere
of a fossilized mammal. Although Bru imagined the *Megatherium* on all fours rather than erect
(as is now considered correct), it is still on view today in the National Museum of Natural Sciences
as he assembled it. The original wooden base was not replaced until 1989. Bru executed five images
of the *Megatherium*, which were published in 1796 as part of the book *Descripción del esqueleto de
un quadrúpedo muy corpulento y raro, Que se conserva en el Real Gabinete de Historia Natural de
Madrid* (fig. 42).[41] Such was the fame of the *Megatherium* that it attracted the attention of Thomas
Jefferson and, later, of Charles Darwin.[42]

IN THE BORDERLAND BETWEEN ART AND SCIENCE

In closing, I offer three types of visual imagery made during the age of Enlightenment that blur
the boundary between art and science. The first is found in the works produced for eighteenth-
century scientific voyages and, more particularly, in the shift that occurred when on-the-spot
visual notations were transformed into finished drawings intended as models for professional
printmakers. Consider, for example, two drawings made as part of the Malaspina expedition: José
Cardero's on-the-spot watercolor and sepia-ink sketch, *Pyre and Graves of the Family of the Current
Ankau in Port Mulgrave*, executed in 1791 (fig. 43), and the finished drawing made after it by
Fernando Brambila (pl. 103).[43] While retaining the basic information present in Cardero's image,
Brambila altered the original in a number of ways. He rejected the rigid symmetry of Cardero's
sketch by shifting the scene off-center, and he changed the scale so that the architectural and

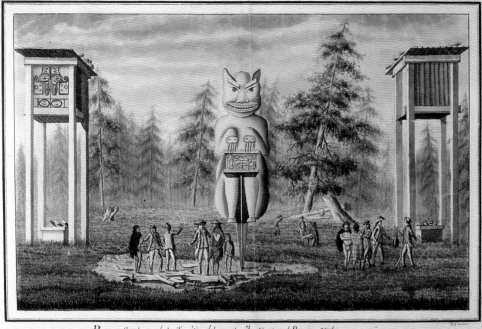

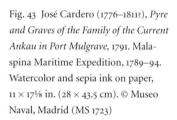

Fig. 43 José Cardero (1776–1811?), *Pyre and Graves of the Family of the Current Ankau in Port Mulgrave*, 1791. Malaspina Maritime Expedition, 1789–94. Watercolor and sepia ink on paper, 11 × 17⅛ in. (28 × 43.5 cm). © Museo Naval, Madrid (MS 1723)

Pira, y Sepulcros de la Familia del actual An Kau en el Puerto Mulgrave

sculptural elements are smaller in relation to the image as a whole. Moreover, Brambila built his image with much stronger contrasts of light and dark, and indicated a light source from the right that casts long shadows. He reduced the number of foreground figures but gave them a greater variety of poses, replacing the many competing anecdotes in Cardero's image (the figure in the background firing a rifle, for example) with two coherent figural groups. The result is a much more dramatic encounter between cultures, with each of the two groups built around a native figure who seems to offer an explanation to Malaspina's men. Strong diagonals throughout the composition add to its drama.

The cumulative result of Brambila's changes is an image that conforms more to the conventions of art than had Cardero's disarmingly straightforward sketch. It is tempting, for example, to see the figure standing in a contrapposto pose in the right background as reminiscent of the classical statues that were central to the aesthetic tenets promoted by the Royal Academy of Fine Arts. More generally, the visual properties of Brambila's image seem influenced by late-eighteenth-century notions of the picturesque, which one British writer summarized as "roughness and sudden variations joined with irregularity."[44] The aesthetic category of the picturesque had a pervasive influence on the visual representation of landscape in the decades around 1800, leading draftsmen everywhere to bend the forms of nature to the will of art. In the end, no official publication of the voyage ever appeared, yet another instance of unrealized ambitions. Brambila went on to be an important member of the Royal Academy of San Fernando as a professor of perspective, and he was elected its president in 1814.

A second example of eighteenth-century visual culture that straddles the boundary between art and science is so-called *casta* painting.[45] This artistic genre began to appear in the second quarter of the eighteenth century and persisted into the early years of the nineteenth century. Consisting of sets of canvases, most composed of sixteen scenes, *casta* paintings construct a catalogue of racial types resulting from the intermarriage in the New World of Spaniards, Indians, and blacks, the last group having begun arriving as slaves in the early sixteenth century. These

Pira y Sepulcros de la familia del actual An-kau en el Puerto de Mulgrave

PLATE 103

FERNANDO BRAMBILA (1763–1834)

Pyre and Graves of the Family of the Current Ankau in Port Mulgrave

Malaspina Maritime Expedition, 1789–94
Watercolor and sepia ink on paper, 10⅝ × 19½ in. (27 × 49.5 cm)
© Museo Naval, Madrid (MS 1726–50)

paintings achieve this pseudo-scientific aim, a consequence of the Enlightenment interest in classi-
fication, by following the dictates of art.

A set of anonymous *casta* paintings now in the collection of the Museo de América in Madrid
is typical of the genre in many ways (pl. 104 a–p). Like most such works, this group was produced
in Mexico during the second half of the eighteenth century and is neither signed nor dated.[46]
Often made for export, *casta* paintings were acquired by members of the social and political elite
and brought back to Spain as souvenirs of the colonies. In conformity with the conventions of
genre painting, these paintings purport to depict the everyday activities of anonymous figures in
a variety of settings. Some images are set out-of-doors, while others portray indoor settings, with
kitchen interiors incorporating the most detail. Figures lower on the social—and racial—scale are

shown plying a variety of trades, most often selling local food or produce, while those at the higher end play music, read, and write. Although these images give the illusion of offering insights into quotidian life in Spanish America, they are, in fact, highly conventionalized, as comparisons between sets of *casta* paintings reveal. Moreover, they rely on a rhetoric of exoticism, frequently including colorful costumes or elaborate still-life arrangements of New World fruits and vegetables, as in number twelve in the Museo de América series, which includes twenty-six numbered items and a legend naming them for the benefit of European elites.

The Museo de América set also exemplifies the system of racial classification that underlies *casta* paintings. In each small-scale canvas, an adult couple is depicted in representative costumes in a typical setting, together with the child resulting from their union. At the bottom of each painting a short descriptive inscription gives the racial identities of the three figures. The first image, for example, depicts a Spanish man and an Indian woman, and their offspring is identified as a *mestizo*. Given their intended audience, the clear message of *casta* paintings is the racial superiority of Spaniards. Spanish men (*españoles*) appear most often; the Museo de América set contains six such figures. Interestingly, no distinction is made between Creoles (those of pure Spanish descent born in the New World) and peninsular Spaniards who emigrated to the colonies. Indian women are the second most common type, appearing in five paintings in this set, while just one painting contains a Spanish woman. Indian women are depicted as the most flexible and exotic racial type, appearing in a variety of settings and costumes. Their status is adjusted to match that of the male figures with whom they are shown. The final painting in a *casta* set often depicts Indians seemingly untouched by European contact, identified in this case as "*Yndios Apaches*" from northern Mexico, and wearing multicolored feathered garments and carrying a bow. Not unlike the allegories of America painted during these same years in the ceiling frescoes of the new Royal Palace in Madrid (see fig. 38), such figures were almost as far removed from the lived realities of the colonial artists who painted them as they were from the Spanish viewers who might have seen the exported paintings.

Thus, as with other topics that have been examined in this essay, *casta* paintings served the ideological ends of empire by imposing order on the phenomena of the New World, in this case by constructing and reinforcing notions of racial and cultural hierarchy. They do so through a fascinating interplay of art and science. Made by American artists usually for European consumption, they conform to academic conventions of art making and sometimes relied on European prints for motifs.[47] At the same time, they responded to the impulse of Enlightenment science to order and classify.

Similar interrelations of art and science underlie the work of the greatest Spanish still-life painter of the age, Luis Meléndez (1716–1780), and point to the fluidity of the boundary between art and science in Enlightenment culture.[48] Meléndez was the son of Francisco Antonio Meléndez (1682–1752), a portrait miniaturist at the court of Philip V but not an official and salaried court painter (*pintor de cámara*). The elder Meléndez is perhaps best remembered for his call in 1726 for the founding of an academy of art and for the role he played on the preparatory committee

PLATE 104 a–p

Casta paintings (following pages and detail, facing page)

Mexico, 18th century
Oil on copper, 14³⁄₁₆ × 19⁵⁄₁₆ in. (36 × 49 cm)
© Museo de América, Madrid (50–65)

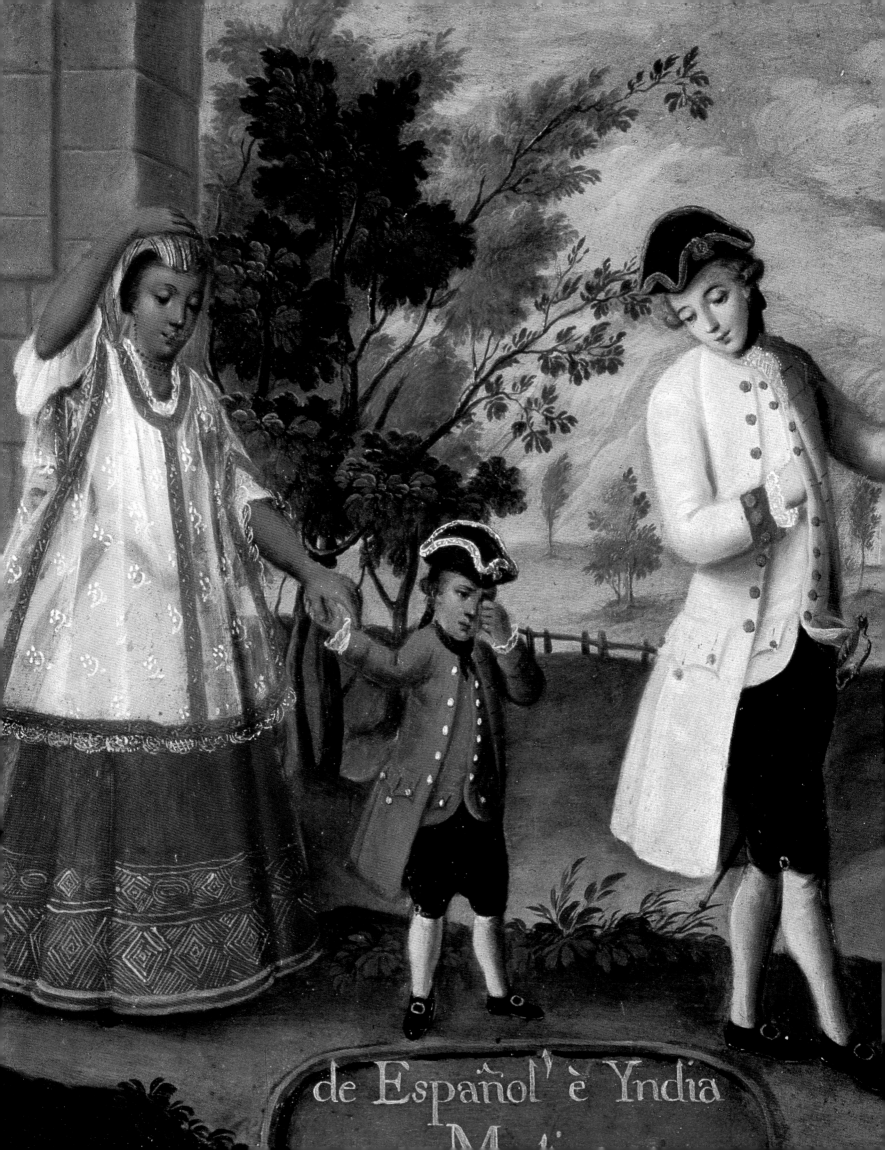

de Español è Yndia

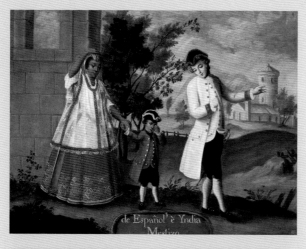

de Español è Yndia
Mestizo.

de Español i Mulata
Morisco.

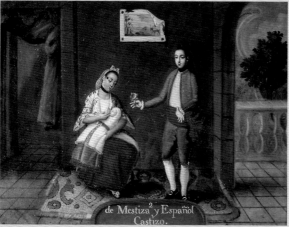

de Mestiza y Español
Castizo.

de Español y Morisca
Albino.

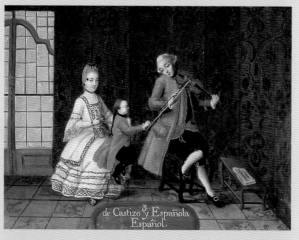

de Castizo y Española
Español.

de Español y Albina
Negra Torna atras.

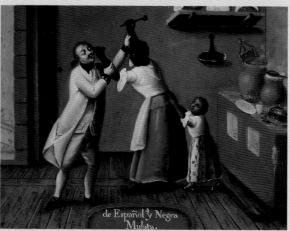

de Español y Negra
Mulata.

De Yndio y Negra
Lovo.

De Lobo y Negra
Chino.

13
de Arvarrasado è Yndia
Barsino.

10
de Chino è Yndia
Canbujo.

14
De Varsino è Yndia
Canpa mulato.

11
De Yndia y Cambujo
Tente en el Aire.

15
De Yndio y Mestiza
Coyote.

12
De Tente en el Aire
y Mulata, Albarrasado

Frutas d la Nueva Espª

16
Yndios Apachs.

PLATE 105

LUIS MELÉNDEZ (1716–1780)
Still Life with Peaches and Grapes

c. 1771
Oil on canvas, 13⅜ × 18⅝₁₆ in. (34 × 46.5 cm)
© Patrimonio Nacional, Real Monasterio de San Lorenzo de El Escorial
(10014645)

PLATE 106

LUIS MELÉNDEZ (1716–1780)
Still Life with Madroños

Mid-18th century
Oil on canvas, 14³⁄₁₆ × 19 in. (36 × 48.2 cm)
© Patrimonio Nacional, Palacio Real de la Granja de San Ildefonso,
Segovia (10027684)

PLATE 107

LUIS MELÉNDEZ (1716–1780)
Still Life with Cheese and Honey Pot

18th century
Oil on canvas, 14⅜ × 19½ in. (36.5 × 49.5 cm)
© Patrimonio Nacional, Palacio Real de Riofrío, Segovia (10066526)

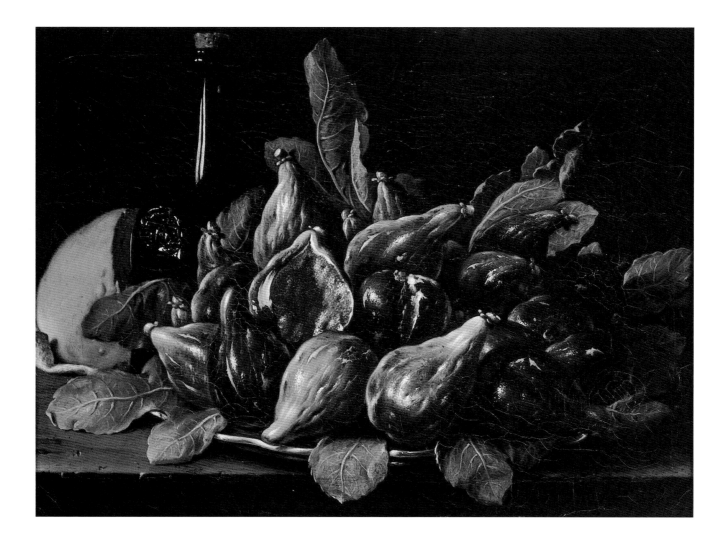

PLATE 108

LUIS MELÉNDEZ (1716–1780)
Still Life with Figs

1771
Oil on canvas, 13⅜ × 18⁵⁄₁₆ in. (34 × 46.5 cm)
© Patrimonio Nacional, Real Monasterio de San Lorenzo de El Escorial (10014649)

that laid the groundwork for the official founding of the Royal Academy of Fine Arts in 1752. Unfortunately for both father and son, the elder Meléndez was forced from the preparatory committee in 1748 after he denounced its activities. Luis, a student in the school of the provisional academy at the time of his father's difficulties, was expelled from the school instituted by the preparatory committee, and barred from the royal academy once it came into existence. Moreover, Luis was unable to land an appointment as a court painter, a position for which he applied in 1760 and 1772.

These circumstances forced Luis Meléndez to work on the margins of the institutions that supported the creation of visual art at this time and probably influenced his decision to turn to still life rather than the more elevated—and lucrative—genres of portraiture and religious painting. The centerpiece of his oeuvre is a series of forty-four still-life paintings that (according to an early-nineteenth-century inventory) hung in the royal palace at Aranjuez.

Meticulous and matter-of-fact, Meléndez's still lifes render the depicted objects as exactly as possible (pls. 105–8). Sharply lit against dark backgrounds, the subjects are precisely drawn to communicate maximum visual information. The exacting replication is quite different from the selective imitation advocated by Mengs and his followers. Rather, the high degree of detail typical of Meléndez's style reflects his training as a miniaturist and is aligned with the visual rhetoric of natural history images. Moreover, there is no suggestion of a symbolic dimension to these works. They are devoid of references to the *vanitas* tradition of still-life painting, which employed objects such as skulls, burning candles, and hourglasses to recall the transience of human life and the futility of human vanity. Instead, they rely on a rhetoric of objectivity that is reinforced by Meléndez's own description of his subject matter. In his 1772 petition for appointment as court painter, Meléndez referred to the room decorated by these works: "Its representation consists of the four seasons of the year, or more properly the four elements, in order to decorate a cabinet [*gavinete*] with all the species of comestibles that the Spanish climate produces in these four elements."[49] Thus, as Eleanor Tufts noted in her trailblazing study on Meléndez, these still lifes are best understood in relation to contemporary interest in natural history and, more particularly, in botany.[50] Although Meléndez's paintings now are exhibited in contexts that frame them as works of art, their meaning is significantly altered if we remember that they once formed part of a cabinet of natural history owned by the future Charles IV and his wife, María Luisa.[51]

EPILOGUE: THE SEPARATION OF ART AND SCIENCE

The rapidly expanding holdings of the Royal Cabinet of Natural History, and physical problems with the rooms that it occupied, necessitated its relocation by the mid-1780s. In 1785, Juan de Villanueva—the same architect who had renovated the facade of the palace jointly occupied by the Royal Cabinet of Natural History and the Royal Academy of Fine Arts, and built the entryway to the Royal Botanical Garden (see fig. 39)—was commissioned to draw up plans for a building that would house the cabinet as well as several other recently formed scientific institutions. The

Fig. 44 Main facade of the Museo Nacional del Prado, designed by Juan de Villanueva. © Museo Nacional del Prado, Madrid

Vista de la Rotunda del R.ˡ Museo.

site for the new building was on the recently constructed Paseo del Prado, adjacent to the Royal Botanical Garden and the Royal Astronomical Observatory (begun in 1790 and also designed by Villanueva). Construction languished for several decades, exemplifying once again the gap that often existed between the ambitious aims of the Spanish Enlightenment and their fulfillment.

After being severely damaged during the Napoleonic invasion (1808–14), Villanueva's still unfinished structure was transformed under Ferdinand VII (r. 1814–33) into the Museo de Ciencias y Artes del Prado, uniting art and science once more under a single roof (fig. 44). Over time, the Museo del Prado came to exhibit only works of art, as indicated by Brambila's marvelous depiction of the rotunda on the main floor, which demonstrates his mastery at rendering perspective (pl. 109). The scientific exhibits were dispersed among a range of institutions. This separation was typical of the intellectual specialization that began in the nineteenth century and has accelerated ever since. Still among the Prado's prized exhibits, however, is the so-called Treasure of the

PLATE 110

ANTONIO CARNICERO (1748–1814)
Charles IV

18th century
Oil on canvas, 59¹³⁄₁₆ × 42½ in. (152 × 108 cm)
© Patrimonio Nacional, Real Monasterio de la
Encarnación, Madrid (00621508)

Dauphin, a collection of gems and other precious objects that had belonged to the Great Dauphin Louis, father of the first Spanish Bourbon king, Philip V. These objects were donated to the Royal Cabinet of History by Philip's grandson, Charles IV (pl. 110). Their presence among the exhibits of the Museo del Prado provides a trace of the structure's original purpose and the role played by the eighteenth-century Bourbon monarchs as patrons of science as well as art.

NOTES

1. The most complete and accessible accounts of the Spanish Enlightenment remain Jean Sarrailh, *L'Espagne éclairée de la seconde moitié du XVIIIe siècle* (Paris: Librairie C. Klincksieck, 1954), and Richard Herr, *The Eighteenth-Century Revolution in Spain* (Princeton: Princeton University Press, 1958). A compendium of more recent approaches is available in María Carmen Iglesias et al., *Carlos III y la ilustración,* 2 vols., exh. cat. (Madrid: Ministerio de Cultura, 1988).

2. On the Inquisition and the index, see Marcelin Defourneaux, *L'Inquisition espagnole et les livres français au XVIIIe siècle* (Paris: Presses Universitaires de France, 1963), and William J. Callahan, *Church, Politics, and Society in Spain, 1750–1874* (Cambridge: Cambridge University Press, 1984), 31–37.

3. See Sarrailh, *L'Espagne éclairée,* and Herr, *Eighteenth-Century Revolution.*

4. D. A. Brading, "Bourbon Spain and Its American Empire," in *Colonial Spanish America,* ed. Leslie Bethel (Cambridge: Cambridge University Press, 1987), 123. For a recent appraisal of Spain's attempt to revive its imperial fortunes, see Stanley J. Stein and Barbara H. Stein, *Apogee of Empire: Spain and New Spain in the Age of Charles III, 1759–1789* (Baltimore: Johns Hopkins University Press, 2003).

5. For an overview of the development of scientific thought during the second half of the eighteenth-century in Spain, see Manuel Sellés et al., *Carlos III y la ciencia de la ilustración* (Madrid: Alianza Editorial, 1988).

6. My reading of this portrait is a variation of one I offered in Andrew Schulz, "Satirizing the Senses: The Representation of Perception in Goya's *Caprichos,*" *Art History* 33 (2000): 151–81.

7. Alfonso Pérez Sánchez, "Pintura de los siglos XVI al XVIII en la colección del Banco de España," in *Colección de pintura del Banco de España* (Madrid: Banco de España, 1988), 75–76.

8. Antonio Palomino, *Práctica de la pintura* (Madrid: Viuda de Juan García Infancón, 1724), vol. 2 of *El museo pictórico y escala óptica* (1715–24).

9. The first such society was formed in the mid-1760s; by 1808, there were some one hundred more (François López, "Las Españas ilustradas," in Iglesias et al., *Carlos III y la ilustración,* 1:105–6).

10. These schools are mentioned frequently during the 1780s and 1790s in the triennial summaries of the academy's activities. See Claude Bédat, *L'Académie des Beaux-Arts de Madrid, 1744–1808* (Toulouse: Le Mirail, 1973), 368–80. Systematized instruction in drawing was one element in a broad spectrum of official efforts during the Enlightenment to improve education at all levels, from the creation of schools for deaf-mutes, to the reform of university curricula for the upper-middle classes.

11. The fundamental history of the academy is Bédat, *L'Académie des Beaux-Arts.* See also Andrés Úbeda de los Cobos, *Pintura, mentalidad e ideología en la Real Academia de Bellas Artes de San Fernando. 1741–1800* (Madrid: Editorial Universidad Complutense, 1988), and Catherine Whistler, "On the Margins in Madrid: Some Questions of Identity at the Real Academia de Bellas Artes de San Fernando, 1744–1792," in *Art and Culture in the Eighteenth Century: New Dimensions and Multiple Perspectives,* ed. Elise Goodman (Newark: University of Delaware Press, 2001), 76–89.

12. See Mercedes Agueda Villar, "Mengs y la Academia de Bellas Artes de San Fernando," in *Actas del segundo simposio sobre el Padre Feijoo y su siglo,* 2 vols. (Oviedo: Centro de Estudios del Siglo XVIII, 1983), 2:445–76, and Whistler, "On the Margins in Madrid," 82–85.

13. Gaspar Melchor de Jovellanos, "Elogio de las bellas artes," in *Obras publicadas e inéditas de D. Gaspar Melchor de Jovellanos,* ed. Candido Nocedal (Madrid: Atlas, 1963), 1:360.

14. Anton Raphael Mengs, "Discurso sobre la constitución de una academia de las artes," in *Obras de D. Antonio Rafael Mengs, Primer Pintor de Cámara del Rey,* trans. José Nicolás de Azara (Madrid: Imprenta de la Gazeta, 1780), 394.

15. Bédat, *L'Académie des Beaux-Arts,* 176–79.

16. A Spanish translation of *On Painting* was published in 1784 in a volume that also contained Leonardo's writings on art: *El tradado de la pintura por Leonardo da Vinci, y los tres libros que sobre el mismo arte escribió Leon Battista Alberti,* trans. Diego Antonio Rejón de Silva (Madrid: Imprenta Real, 1784).

17. Mengs, "Reflexiones sobre la belleza y gusto en la pintura," in *Obras,* 20.

18. *Distribución de los premios concedidos por el rey nuestro señor a los discípulos de las tres nobles artes* (Madrid: R.A.B.A.S.F., 1754–1832), 1787, 62 and 67.

19. Diego Antonio Rejón de Silva, *La pintura. Poema didáctico en tres cantos* (Segovia: Don Antonio Espinosa de los Monteros, 1786), 90.

20. For a classic study of painting and artistic institutions in France, see Thomas E. Crow, *Painters and Public Life in Eighteenth-Century Paris* (New Haven: Yale University Press, 1985).

21. The standard source on the construction of the new palace is Francisco de la Plaza, *Investigaciones sobre el Palacio Real Nuevo de Madrid* (Valladolid: Departamento de Historia del Arte, Universidad, 1975).

22. Martín Sarmiento, *Sistema de adornos del Palacio Real de Madrid,* ed. Joaquín Álvarez Barrientos and Concha Herrero Carretero (Madrid: Sociedad Estatal de Conmemoraciones Culturales, 2002).

23. Some of the relief sculptures that were part of Sarmiento's decorative scheme for the palace are on display at the Museum of the Royal Academy of Fine Arts of San Fernando and the Museo del Prado.

24. On Giaquinto in Spain, see Irene Cioffi, "Corrado Giaquinto at the Spanish Court: 1753–1762. The Fresco Cycles at the New Royal Palace in Madrid" (PhD diss., New York University, 1992).

25. An invaluable resource in exploring the iconography of the royal palace frescoes is Francisco José Fabre, *Descripción de las alegorías pintadas en las bóvedas del Real Palacio de Madrid* (Madrid: D. Eusebio Aguado, 1829).

26. For a recent assessment of this work, see the entry by Keith Christiansen in Keith Christiansen et al., *Giambattista Tiepolo, 1696–1770,* exh. cat. (New York: Metropolitan Museum of Art, 1996), 325–28. See also Leslie Jones, "Peace, Prosperity, and Politics in Tiepolo's *Glory of the Spanish Monarchy,*" *Apollo* 114 (1981): 220–27. On Tiepolo in Spain, see Catherine Whistler, "G. B. Tiepolo at the Court of Charles III," *Burlington Magazine* 128 (1986): 199–203.

27. On the presence of these and other works by Mura in Spain, see Jesús Urrea Fernández, *La pintura italiana del siglo XVIII en España* (Valladolid: Departamento de Historia del Arte, Universidad, 1977), 335–52.

28. Jean-François Bourgoing, *Modern State of Spain* (London: for J. Stockdale, 1808), 249.

29. See María Pilar de San Pío Aladrén, *Mutis and the Royal Botanical Expedition of the Nuevo Reyno de Granada,* 2 vols. (Barcelona: Lunwerg, 1992).

30. The classic history of the Royal Cabinet of Natural History is Agustín J. Barreiro, *El Museo Nacional de Ciencias Naturales (1771–1935),* ed. Pedro M. Sánchez Moreno (1944; Madrid: Ediciones Doce Calles, 1992).

31. The National Museum of Natural Sciences in Madrid includes a permanent exhibition that re-creates the flavor of the Royal Cabinet of Natural History during the final decades of the eighteenth century.

32. María de los Angeles Calatayud Arinero, *Pedro Franco Dávila: Primer director del Real Gabinete de Historia Natural fundado por Carlos III* (Madrid: Consejo Superior de Investigaciones Científicas / Museo Nacional de Ciencias Naturales, 1988), 95–96.

33. Susan Stewart, *On Longing: Narratives of the Miniature, the Gigantic, the Souvenir, the Collection* (Durham, N.C.: Duke University Press, 1993), 151.

34. See Carmen Sotos Serrano, *Los pintores de la expedición de Alejandro Malaspina,* 2 vols. (Madrid: Real Academia de la Historia, 1982).

35. On the importance of vision to Enlightenment culture, see, among other sources, Martin Jay, *Downcast Eyes: The Denigration of Vision in Twentieth-Century French Thought* (Berkeley: University of California Press, 1993). Speaking of the seventeenth and eighteenth centuries, Michel Foucault wrote, "Natural history is nothing more than the nomination of the visible" (*The Order of Things: An Archeology of the Human Sciences* [New York: Vintage Books, 1973], 132).

36. "Instrucción u ordenanza para la nueva escuela de matemáticas, física, química, mineralogía y nautical," in *Obras publicadas e inéditas de Jovellanos,* 2:411.

37. Bédat, *L'Académie des Beaux-Arts,* 236.

38. On Bru, see José María López Piñero, *Juan Bautista Bru de Ramón. El atlas zoológico; El megaterio; y Las técnicas de pesca valencianas. 1742–1799* (Valencia: Ayuntamiento de Valencia, 1996).

39. Juan Bautista Bru de Ramón, *Colección de laminas que representan los animales y monstruos del Real Gabinete de Historia Natural de Madrid,* 2 vols. (Madrid: Andrés de Sotos, 1784–86).

40. Angel Montero, *La paleontología y sus colecciones desde el Real Gabinete de Historia Natural al Museo Nacional de Ciencias Naturales* (Madrid: Consejo Superior de Investigaciones Científicas, 2003).

41. Juan Bautista Bru de Ramón, *Descripción del esqueleto de un quadrúdedo muy corpulento y raro, que se conserva en el Real Gabinete de Historia Natural de Madrid* (Madrid: Viuda de Don Joaquín Ibarra, 1796).

42. On Jefferson, see José María López Piñero and Thomas F. Glick, *El megaterio de Bru y el Presidente Jefferson: Una relación insospechada en los albores de la paleontología* (Valencia: Instituto de Estudios Documentales e Históricos sobre la Ciencia, 1993).

43. Brambila joined the expedition in Acapulco in September 1791, after it left the Northwest.

44. Uvedale Price, *An Essay on the Picturesque as Compared with the Sublime and the Beautiful, 1794–98;* quoted in Christopher Hussey, *The Picturesque: Studies in a Point of View* (London: Archon Books, 1967), 14.

45. For an overview of *casta* paintings, see María Concepción García Sáiz, *The Castes / Las Castas Mexicanas,* exh. cat. (Monterrey: Museo de Monterrey; San Antonio: San Antonio Museum of Art; Mexico City: Museo Franz Meyer, 1989–90). This catalogue contains images and documentation for fifty sets of paintings. See also Ilona Katzew, ed., *New World Orders: Casta Painting and Colonial Latin America,* exh. cat. (New York: Americas Society, 1996); Magali M. Carrera, *Imagining Identity in New Spain: Race, Lineage, and the Colonial Body in Portraiture and Casta Paintings* (Austin: University of Texas Press, 2003); and Ilona Katzew, *Casta Painting: Images of Race in Eighteenth-Century Mexico* (New Haven: Yale University Press, 2004).

46. Some *casta* paintings were made in Peru and Ecuador.

47. On the use of European sources, see Ilona Katzew, "Los cuadros de castas: noticias sobre fuentes posibles en grabados y pinturas europeas," in *Arte, historia e identidad en América: Visiones comparativas* (Mexico City: Universidad Nacional Autónoma de México / Instituto de Investigaciones Estéticas, 1994), 3:731–40. Katzew discusses and illustrates the second painting in the Museo de América set (fig. 43) and relates it to European works of art that depict a woman nursing an infant.

48. The groundbreaking study on Meléndez is Eleanor Tufts, *Luis Meléndez: Eighteenth-Century Master of the Spanish Still Life, with a Catalogue Raisonné* (Columbia: University of Missouri Press, 1985). See also Juan J. Luna and Eleanor Tufts, *Luis Meléndez: Still-life Painter of the Eighteenth Century,* exh. cat. (Dallas: Meadows Museum, Southern Methodist University, 1985); Janis Tomlinson, "The Provenance and Patronage of Luis Meléndez's Aranjuez Still Lifes," *Burlington Magazine* 122 (1990): 84–89; and Peter Cherry and Juan J. Luna, *Luis Meléndez: Bodegones* (Madrid: Museo Nacional del Prado, 2004).

49. Tufts, *Meléndez,* 22. While Tufts translates *gavinete* as "sitting room," I have rendered it as "cabinet."

50. Ibid., 25

51. See María del Carmen Espinosa Martín, "Aportaciones documentales a los bodegones de Luis Meléndez," *Boletín del Museo del Prado* 10 (1989): 67–77.

Spanish Habsburg Dynasty, 1504–1700

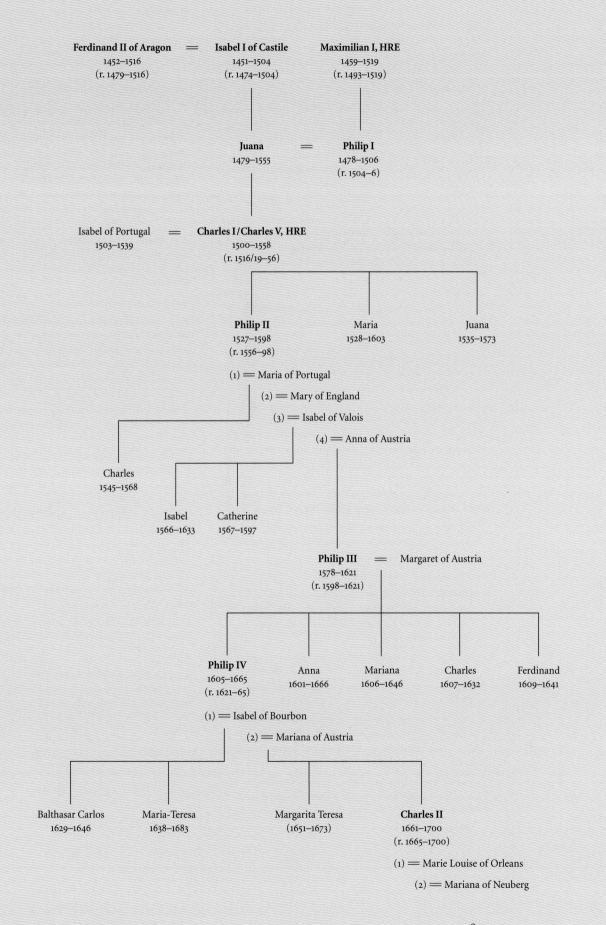

Ferdinand II of Aragon ══ Isabel I of Castile Maximilian I, HRE
1452–1516 1451–1504 1459–1519
(r. 1479–1516) (r. 1474–1504) (r. 1493–1519)

Juana ══ Philip I
1479–1555 1478–1506
 (r. 1504–6)

Isabel of Portugal ══ Charles I / Charles V, HRE
1503–1539 1500–1558
 (r. 1516/19–56)

Philip II Maria Juana
1527–1598 1528–1603 1535–1573
(r. 1556–98)

(1) ══ Maria of Portugal
(2) ══ Mary of England
(3) ══ Isabel of Valois
(4) ══ Anna of Austria

Charles
1545–1568

Isabel Catherine
1566–1633 1567–1597

Philip III ══ Margaret of Austria
1578–1621
(r. 1598–1621)

Philip IV Anna Mariana Charles Ferdinand
1605–1665 1601–1666 1606–1646 1607–1632 1609–1641
(r. 1621–65)

(1) ══ Isabel of Bourbon
(2) ══ Mariana of Austria

Balthasar Carlos Maria-Teresa Margarita Teresa Charles II
1629–1646 1638–1683 (1651–1673) 1661–1700
 (r. 1665–1700)

(1) ══ Marie Louise of Orleans
(2) ══ Mariana of Neuberg

Spanish Bourbon Dynasty, 1700–1819

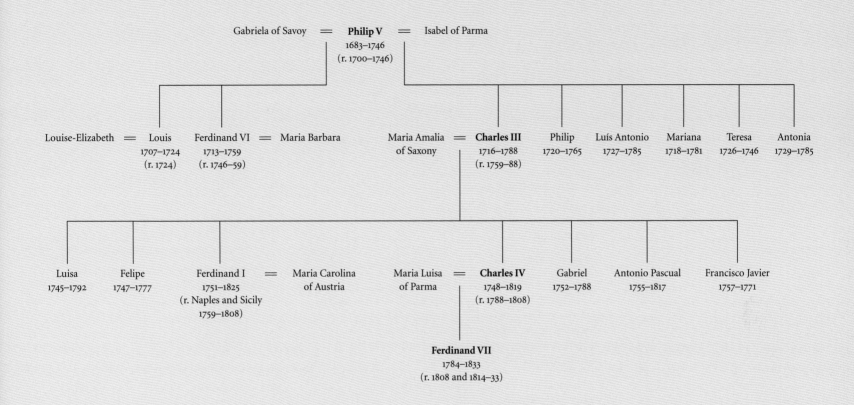

Gabriela of Savoy = **Philip V** = Isabel of Parma
1683–1746
(r. 1700–1746)

Louise-Elizabeth = Louis 1707–1724 (r. 1724) Ferdinand VI 1713–1759 (r. 1746–59) = Maria Barbara Maria Amalia of Saxony = **Charles III** 1716–1788 (r. 1759–88) Philip 1720–1765 Luís Antonio 1727–1785 Mariana 1718–1781 Teresa 1726–1746 Antonia 1729–1785

Luisa 1745–1792 Felipe 1747–1777 Ferdinand I 1751–1825 (r. Naples and Sicily 1759–1808) = Maria Carolina of Austria Maria Luisa of Parma = **Charles IV** 1748–1819 (r. 1788–1808) Gabriel 1752–1788 Antonio Pascual 1755–1817 Francisco Javier 1757–1771

Ferdinand VII
1784–1833
(r. 1808 and 1814–33)

Selected Bibliography

General Reference and History

Boruchoff, David, ed. *Isabel la Católica, Queen of Castile: Critical Essays.* New York: Palgrave Macmillan, 2003.

Callahan, William J. *Church, Politics, and Society in Spain, 1750–1874.* Cambridge: Cambridge University Press, 1984.

Cañizares-Esguerra, Jorge. *How to Write the History of the New World: Histories, Epistemologies, and Identities in the Eighteenth-Century Atlantic World.* Stanford: Stanford University Press, 2001.

Carr, Raymond, ed. *Spain, a History.* New York: Oxford University Press, 2000.

Elliott, John H. *Imperial Spain, 1469–1716.* 4th ed. New York: Penguin, 2003.

———. *The Old World and the New, 1492–1650.* Rev. ed. Cambridge: Cambridge University Press, 1992.

———. *Spain and Its World, 1500–1700: Selected Essays.* New Haven: Yale University Press, 1989.

Feros, Antonio. *Kingship and Favoritism in the Spain of Philip III, 1598–1621.* Cambridge: Cambridge University Press, 2000.

Fuentes, Carlos. *The Buried Mirror: Reflections on Spain and the New World.* New York: Houghton Mifflin, 1992.

Greenblatt, Stephen. *Marvelous Possessions: The Wonder of the New World.* Chicago: University of Chicago Press, 1991.

Hanke, Lewis. *The Spanish Struggle for Justice in the Conquest of America.* Dallas: Southern Methodist University Press, 2002.

Herr, Richard. *The Eighteenth-Century Revolution in Spain.* Princeton: Princeton University Press, 1958.

Kagan, Richard L. *Urban Images of the Hispanic World, 1493–1797.* New Haven: Yale University Press, 2000.

Kagan, Richard L., and Geoffrey Parker, eds. *Spain, Europe, and the Atlantic World: Essays in Honour of John H. Elliott.* Cambridge: Cambridge University Press, 1995.

Kamen, Henry. *Empire: How Spain Became a World Power, 1492–1763.* New York: Harper-Collins, 2003.

———. *Philip of Spain.* New Haven: Yale University Press, 1997.

Liss, Peggy K. *Isabel the Queen: Life and Times.* New York: Oxford University Press, 1992.

Lynch, John. *Bourbon Spain.* Oxford: Blackwell, 1989.

———. *The Hispanic World in Crisis and Change, 1598–1700.* Oxford: Blackwell, 1992.

———. *Spain, 1516–1598: From Nation State to World Empire.* Oxford: Blackwell, 1992.

Pagden, Anthony. *European Encounters with the New World: From Renaissance to Romanticism.* New Haven: Yale University Press, 1993.

———. *Lords of All the World: Ideologies of Empire in Spain, Britain and France c. 1500–c. 1800.* New Haven: Yale University Press, 1995.

———, ed. *Facing Each Other: The World's Perception of Europe and Europe's Perception of the World.* Aldershot, Hampshire, Great Britain and Burlington, Vt.: Ashgate/Variorum, 2000.

Parker, Geoffrey. *The Grand Strategy of Philip II.* New Haven: Yale University Press, 1998.

———. *Spain and the Netherlands, 1559–1659.* London: Penguin, 1979.

Pierson, Peter. *The History of Spain.* Westport, Conn.: Greenwood, 1999.

Robertson, William, and William Hickling Prescott. *The History of the Reign of Emperor Charles V.* 2 vols. London: George Routledge, 1857.

Sánchez, Magdalena S. *The Empress, the Queen, and the Nun: Women and Power at the Court of Philip III of Spain.* Baltimore: Johns Hopkins University Press, 1998.

Soly, Hugo, and Wim Blockmans, eds. *Charles V, 1500–1558, and His Time.* Antwerp: Mercatorfonds, 1999.

Stradling, Robert A. *Philip IV and the Government of Spain, 1621–1665.* Cambridge: Cambridge University Press, 1988.

Thomas, Hugh. *Rivers of Gold: The Rise of the Spanish Empire.* London: Weidenfeld and Nicolson, 2003.

Yarza Luaces, Joaquín. *Reyes Católicos. Paisaje artístico de una monarquía.* Madrid: Nerea, 1993.

Painting, Prints, Drawings, Sculpture, Decorative Arts, and Architecture

Alonso Sánchez Coello y el retrato en la corte de Felipe II. Madrid: Museo del Prado, 1990.

El arte en la corte de Felipe V. Madrid: Fundación Caja Madrid, 2002.

Arte y saber, la cultura en tiempos de Felipe III y Felipe IV. Valladolid: Ministerio de Educación y Cultura, Dirección General de Bellas Artes y Bienes Culturales, 1999.

Brown, Jonathan. *The Golden Age of Painting in Spain.* New Haven: Yale University Press, 1991.

——. *Kings and Connoisseurs: Collecting Art in Seventeenth-Century Europe.* Princeton: Princeton University Press, 1995.

——. *Painting in Spain, 1500–1700.* New Haven: Yale University Press, 1998.

——. *Velázquez: Painter and Courtier.* New Haven: Yale University Press, 1986.

Carrera, Magali M. *Imagining Identity in New Spain: Race, Lineage, and the Colonial Body in Portraiture and Casta Paintings.* Austin: University of Texas Press, 2003.

Checa Cremades, Fernando, ed. *El Real Alcázar de Madrid. Dos siglos de arquitectura y coleccionismo en la corte de los Reyes de España.* Madrid: Comunidad de Madrid, 1994.

Cherry, Peter, and Juan J. Luna. *Luis Meléndez: Bodegones.* Madrid: Museo Nacional del Prado, 2004.

Christiansen, Keith, et al., *Giambattista Tiepolo, 1696–1770.* Exh. cat. New York: Metropolitan Museum of Art, 1996.

Chueca Goitia, Fernando. *El Palacio Real de Madrid.* Madrid: Patrimonio Nacional, 1998.

Las colecciones del Rey. Pintura y escultura, IV centenario del Monasterio de El Escorial. Madrid: Patrimonio Nacional, 1986.

Colón de Carvajal, J. Ramón. *Catálogo de relojes del Patrimonio Nacional.* Madrid: Patrimonio Nacional, 1987.

Davies, David, ed. *El Greco.* London: National Gallery, 2003.

Díez del Corral, Luis. *Velázquez, la monarquía e Italia.* Madrid: Ministerio de Educación y Cultura, 1979.

Domínguez Ortiz, Antonio, Concha Herrero Carretero, and José A. Godoy. *Resplendence of the Spanish Monarchy: Renaissance Tapestries and Armor from the Patrimonio Nacional.* New York: Metropolitan Museum of Art, 1991.

Domínguez Ortiz, Antonio, Alfonso E. Pérez Sánchez, and Julián Gallego. *Velázquez.* New York: Metropolitan Museum of Art, 1989.

Fe y sabiduría, la biblioteca, IV centenario del Monasterio de El Escorial. Madrid: Patrimonio Nacional, 1986.

Felipe II. Un monarca y su época, un príncipe del Renacimiento. Madrid: Museo Nacional del Prado, Sociedad Estatal para la Conmemoración de los Centenarios de Felipe II y Carlos V, 1998.

La fiesta en la Europa de Carlos V. Madrid: Sociedad Estatal para la Conmemoración de los Centenarios de Felipe II y Carlos V, 2000.

García Sáiz, María Concepción. *Las castas mexicanas: un género pictórico americano.* [Milan]: Olivetti, 1989.

El Greco of Toledo. Toledo: Toledo Museum of Art, 1982.

Herrero Carretero, Concha. *Catálogo de tapices del Patrimonio Nacional, siglo XVIII. Reinado de Felipe V.* Vol. 3. Madrid: Patrimonio Nacional, 2000.

Hughes, Robert. *Goya.* New York: Alfred A. Knopf, 2003.

Iglesia y monarquía, IV centenario del Monasterio de El Escorial. Madrid: Patrimonio Nacional, 1986.

Iglesias, María Carmen, et al. *Carlos III y la Ilustración.* 2 vols. Exh. cat. Madrid: Ministerio de Cultura, 1988.

Ishikawa, Chiyo. *The Retablo of Isabel la Católica by Juan de Flandes and Michel Sittow.* Turnhout, Belgium: Brepols, 2004.

Jordan, William B., and Peter Cherry. *Spanish Still Life from Velázquez to Goya.* London: National Gallery, 1995.

Junquera de Vega, Paulina, and Concha Herrero Carretero. *Catálogo de tapices del Patrimonio Nacional.* Vol. 1. Madrid: Patrimonio Nacional, 1986.

Katzew, Ilona, *Casta Painting: Images of Race in Eighteenth-Century Mexico.* New Haven: Yale University Press, 2004.

——, ed. *New World Orders: Casta Painting and Colonial Latin America.* Exh. cat. New York: Americas Society, 1996.

Luna, Juan J., and Eleanor Tufts. *Luis Meléndez: Still-life Painter of the Eighteenth Century.* Exh. cat. Dallas: Meadows Museum, Southern Methodist University, 1985.

The Majesty of Spain: Royal Collections from the Museo del Prado and the Patrimonio Nacional. Mississippi: Mississippi Commission for Cultural Exchange, 2001.

A la manera de Flandes. Tapices ricos de la corona de España. Madrid: Patrimonio Nacional, 2001.

Meyers, Bernard S., and Trewin Copplestone, eds. *Art Treasures in Spain: Monuments, Masterpieces, Commissions, and Collections.* New York: McGraw-Hill, 1969.

Miguel-Angel Houasse, 1680–1730. Pintor de la corte de Felipe V. Madrid: Ayuntamiento de Madrid, Delegación de Cultura, Patrimonio Nacional, 1981.

Ortega Calderón, José Maria. *Todo el Prado.* Madrid: Museo del Prado, 1996.

Palomino, Antonio. *Lives of the Eminent Spanish Painters and Sculptors.* Translated by Nina Ayala Mallory. Cambridge: Cambridge University Press, 1987.

Pérez Sánchez, Alfonso, and Eleanor A. Sayre. *Goya and the Spirit of Enlightenment.* Boston: Museum of Fine Arts, 1989.

Ruiz Gómez, Leticia. *Catálogo de las colecciones históricas de pintura veneciana del siglo XVI en el Real Monasterio de El Escorial.* Madrid: Patrimonio Nacional, 1991.

Sancho, José Luis. *La arquitectura de los sitios reales. Catálogo histórico de los palacios, jardines y patronatos reales del Patrimonio Nacional.* Madrid: Patrimonio Nacional, 1996.

Sarmiento, Martín. *Sistema de adornos del Palacio Real de Madrid.* Edited by Joaquín Álvarez Barrientos and Concha Herrero Carretero. Madrid: Sociedad Estatal de Conmemoraciones Culturales, 2002.

Stoichita, Victor I. *Visionary Experience in the Golden Age of Spanish Art.* London: Reaktion Books, 1995.

Stratton-Pruitt, Suzanne L. *Bartolomé Esteban Murillo (1617–1682): Paintings from American Collections.* New York: Harry N. Abrams, 2002.

———, ed. *The Cambridge Companion to Velázquez.* Cambridge: Cambridge University Press, 2002.

Tomlinson, Janis. *Francisco Goya: The Tapestry Cartoons and Early Career at the Court of Madrid.* Cambridge and New York: Cambridge University Press, 1989.

———. *Francisco Goya y Lucientes, 1746–1828.* London: Phaidon, 1994.

———. *From El Greco to Goya: Painting in Spain, 1561–1828.* New York: Harry N. Abrams, 1997.

———. *Goya in the Twilight of Enlightenment.* New Haven: Yale University Press, 1992.

Tufts, Eleanor. *Luis Meléndez: Eighteenth-Century Master of the Spanish Still Life, with a Catalogue Raisonné.* Columbia: University of Missouri Press, 1985.

Wethey, Harold E. *The Paintings of Titian.* London: Phaidon, 1969.

The Word Made Image: Religion, Art, and Architecture in Spain and Spanish America, 1500–1600. Fenway Court no. 28. Boston: Isabella Stuart Gardner Museum, 1998.

Science, Cartography, Navigation, and Expeditions

Álvarez Peláez, Raquel. *La conquista de la naturaleza americana.* Madrid: CSIC, 1993.

Asensio Menéndez, Lucilo. *Juan de la Cosa, caballero del mar.* Galizano, Cantabria: Globotech, 1991.

Barreiro, Agustín J. *El Museo Nacional de Ciencias Naturales (1771–1935).* Edited by Pedro M. Sánchez Moreno. 1944. Reprint, Madrid: Ediciones Doce Calles, 1992.

Brown, Steven C., ed. *Spirits of the Water, Native Art Collected on Expeditions to Alaska and British Columbia, 1774–1910.* Seattle: University of Washington, 2000.

Carlos V, la náutica y la navegación. Madrid: Sociedad Estatal para la Conmemoración de los Centenares de Felipe II y Carlos V, 2000.

Columbus, Christopher. *The Four Voyages of Columbus: A Documentary History.* Translated and edited by Cecil Jane. 1930–33. Reprint, New York: Dover, 1988.

Dunn, Oliver, and James E. Kelley, Jr., trans. *The Diario of Christopher Columbus's First Voyage to America, 1492–1493, Abstracted by Fray Bartolomé de las Casas.* Norman: University of Oklahoma Press, 1989.

Engstrand, Iris H. W. *Spanish Scientists in the New World: The Eighteenth-Century Expeditions.* Seattle: University of Washington Press, 1981.

La expedición Malaspina 1789–1794, viaje a América y Oceanía de las corbetas "Descubierta" y "Atrevida." Madrid: Ministerio de Defensa, 1984.

Fernández de Oviedo, Gonzalo. *Historia general y natural de las Indias.* 5 vols. Edited by Juan Pérez de Tudela. Biblioteca de Autores Españoles, nos. 117–21. Madrid: Ediciones Atlas, 1959.

Galván, Javier. *Pacific Islands, The Spanish Legacy.* Madrid: Ministerio de Educación, Cultura y Deporte, 1998.

García Franco, Salvador. *Instrumentos náuticos del Museo Naval.* Madrid: Ministerio de Marina, 1959.

Gerbi, Antonello. *Nature in the New World, from Christopher Columbus to Gonzalo Fernández de Oviedo.* Translated by Jeremy Moyle. Pittsburgh: University of Pittsburgh, 1975.

Hayes, Derek. *Historical Atlas of the North Pacific Ocean: Maps of Discovery and Scientific Exploration, 1500–2000.* Seattle: Sasquatch Books, 2001.

Higueras Rodríguez, María Dolores. *Catálogo crítico de los documentos de la expedición Malaspina (1789–1794) del Museo Naval.* Vols. 1–3. Madrid: Instituto de Historia y Cultura Naval, 1985–.

Howgego, Raymond John. *Encyclopedia of Exploration to 1800.* Potts Point, Australia: Hordern House, 2003.

Humboldt, Alexander von. *Ensayo político sobre el reino de la Nueva España.* Mexico City: Editorial Porrúa, 1984.

Instrumentos científicos del siglo XVI. La corte española y la escuela de Lovaina. Madrid: Fundación Carlos de Amberes, 1997.

Kendrick, John. *Alejandro Malaspina, Portrait of a Visionary.* Montreal: McGill-Queen's University, 1999.

Lamb, Ursula. *Cosmographers and Pilots of the Spanish Maritime Empire.* Great Yarmouth, Norfolk, Great Britain: Galliard, 1995.

López Calderón, María del Carmen. *Catálogo de instrumentos náuticos y científicos del Museo Naval.* Vol. 2. Madrid: Ministerio de Defensa, 1998.

López Piñero, José María. *El arte de navegar en la España del Renacimiento.* Barcelona: Labor, 1979.

López Piñero, José María, et al. *Diccionario histórico de la ciencia moderna en España.* 2 vols. Barcelona: Península, 1983.

López Piñero, José María, and José Pardo Tomás. *La influencia de Francisco Hernández, 1515–1587, en la constitución de la botánica y la materia médica moderna.* Valencia: Instituto de Estudios Documentales e Históricos sobre la Ciencia, 1996.

Lozoya, Xavier. *Plantas y luces en México. La real expedición científica a Nueva España (1787–1803).* Barcelona: Ediciones del Serbal, 1984.

Madrid, ciencia y corte. Madrid: Consejería de Educación y Cultura, 1999.

Malaspina, Alessandro. *Viaje científico y político a la América Meridional, a las costas del Mar Pacífico y a las Islas Marianas y Filipinas.* Madrid: Ediciones El Museo Universal, 1988.

Olson, Wallace M. *Through Spanish Eyes, Spanish Voyages to Alaska, 1774–1792.* Auke Bay, Alaska: Heritage Research, 2002.

Ordóñez, Javier. *Ciencia, tecnología e historia.* Madrid: Fondo de Cultura Económica, 2003.

Padrón, Ricardo. *The Spacious World: Cartography, Literature and Empire in Early Modern Spain.* Chicago: University of Chicago, 2004.

Palau, Mercedes, Marissa Calés, and Araceli Sánchez, eds. *Nootka, regreso a una historia olvidada.* Barcelona: Lunwerg, 1998.

Palau, Mercedes, Freeman Tovell, Pamela Sprätz, and Robin Inglis. *Nutka 1792, viaje a la Costa Noroeste de la América septentrional por Don Juan Francisco de la Bodega y Quadra, Capitán del Navío.* Madrid: Dirección General de Relaciones Culturales y Científicas del Ministerio de Asuntos Exteriors, 1998.

Palau de Iglesias, Mercedes. *Catálogo de los dibujos, aguadas y acuarelas de la Expedición Malaspina 1789–1794 (donación Carlos Sanz).* Madrid: Ministerio de Cultura, Dirección General de Bellas Artes, Archivos y Bibliotecas, Patronato Nacional de Museos, 1980.

Pardo Tomás, José. *Oviedo, Monardes, Hernandez. El tesoro natural de América. Colonialismo y ciencia en el siglo XVI.* Madrid: Nivola, 2002.

Pérez-Mallaína Bueno, Pablo E. *Spain's Men of the Sea: Daily Life on the Indies Fleets in the Sixteenth Century.* Translated by Carla Rahn Phillips. Baltimore: Johns Hopkins University Press, 1998.

Pimentel, Juan. *Testigos del mundo. Ciencia, literatura y viajes en la Ilustración.* Madrid: Editorial Marcial Pons, 2003.

———. *Viajeros científicos. Jorge Juan, Mutis, Malaspina. Tres grandes expediciones al Nuevo Mundo.* Madrid: Nivola, 2001.

Ramírez, Susana María. *La salud del imperio. La real expedición filantrópica de la vacuna.* Madrid: Fundación Jorge Juan, 2002.

Sánchez Garrido, Araceli. *Indios de América del norte, otras culturas de América.* Madrid: Museo de América, 1991.

Sellés, Manuel, et al. *Carlos III y la ciencia de la Ilustración.* Madrid: Alianza Editorial, 1988.

Smith, Pamela H., and Paula Findlen, eds. *Merchants and Marvels: Commerce, Science, and Art in Early Modern Europe.* New York: Routledge, 2002.

Sota Ríus, José de la. *Tras las huellas de Malaspina, crónica de una expedición de la Ilustración española.* Madrid: Lunwerg, 2002.

Sotos Serrano, Carmen. *Los pintores de la expedición de Alejandro Malaspina.* 2 vols. Madrid: Real Academia de la Historia, 1982.

Spanish Pacific, from Magellan to Malaspina. Madrid: Ministerio de Asuntos Exteriores Dirección General de Relaciones Culturales, 1998.

Varey, Simon, ed. *The Mexican Treasury: The Writings of Dr. Francisco Hernández.* Stanford: Stanford University Press, 2000.

Vaughn, Thomas, E. A. P. Crownhart-Vaughn, and Mercedes Palau de Iglesias. *Voyages of Enlightenment: Malaspina on the Northwest Coast, 1791/1792.* Portland: Oregon Historical Society, 1977.

Armor

Cuneo, Pia, ed. *Artful Armies, Beautiful Battles: Art and Warfare in Early Modern Europe.* Leiden and Boston: Brill, 2002.

Pyhrr, Stuart W., and José-A. Godoy. *Heroic Armor of the Italian Renaissance: Filippo Negroli and His Contemporaries.* New York: Metropolitan Museum of Art, 1998.

Quintana Lacaci, Guillermo. *Armería del Palacio Real.* Madrid: Patrimonio Nacional, 1987.

Soler del Campo, Álvaro. *Real Armería Palacio Real.* Madrid: Patrimonio Nacional, 2000.

Manuscripts and Documents

Gante, Pedro de. *El catecismo.* Madrid: Testimonio, 1992.

González García, Pedro, ed. *Archivo General de Indias.* Madrid: Lunwerg, 1995.

Herbert, John R. *1492, An Ongoing Voyage.* Washington, D.C.: Library of Congress, 1992.

Las leyes de Burgos. Cuyo original se encuentra en el Archivo General de Simancas. Madrid: Testimonio, 1991.

Márquez Rodiles, Ignacio. *La utopía del renacimiento en tierras indígenas de América: Pedro de Gante, Vasco de Quiroga, Bernardino de Sahagún.* Puebla: Benemérita Universidad Autónoma de Puebla, Universidad de las Américas–Puebla, 2001.

Trueba, Alfonso. *Fray Pedro de Gante.* Mexico: Jus, 1959.

Contributors

JESÚS CARRILLO CASTILLO

Associate Professor of History and Art Theory, Universidad Autónoma de Madrid

JOSÉ DE LA SOTA RÍUS

Director, Fundación para el Conocimiento de Madrid

CHIYO ISHIKAWA

Chief Curator of Collections & Curator of European Painting and Sculpture, Seattle Art Museum

RICHARD L. KAGAN

Chair, Department of History, The Johns Hopkins University, Baltimore

JAVIER MORALES VALLEJO

Cocurator of the exhibition on behalf of the Patrimonio Nacional, Madrid

BENJAMIN SCHMIDT

Associate Professor of History, University of Washington, Seattle

SARAH SCHROTH

Senior Curator, Duke University Museum of Art, Durham, North Carolina, and Adjunct Associate Professor, Art and Art History Departments, University of North Carolina, Chapel Hill, and Duke University

ANDREW SCHULZ

Associate Professor of Art History, Seattle University

JOAQUÍN YARZA LUACES

Professor, Universidad Autónoma de Barcelona

Index